Jackson Pollock

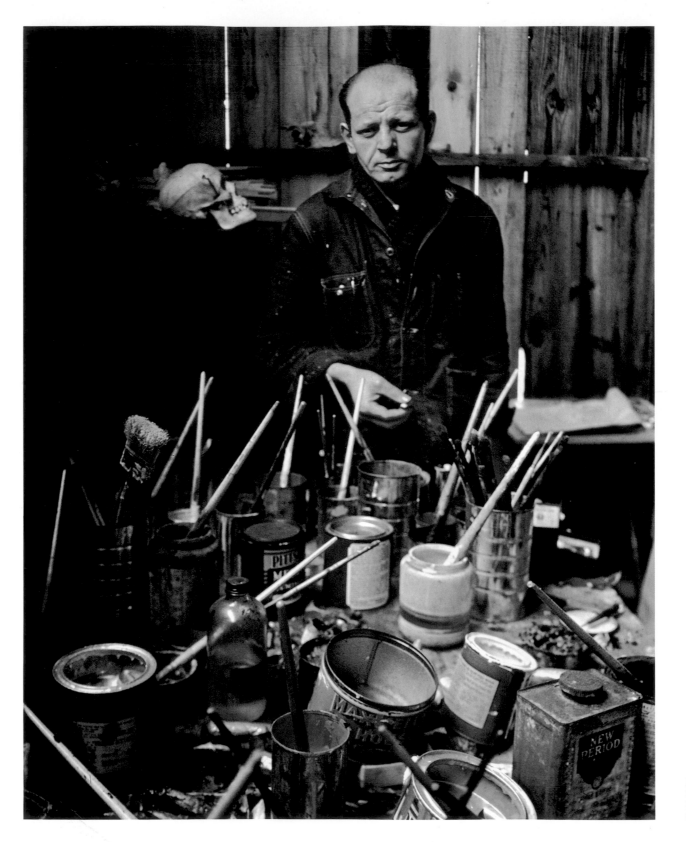

Jackson Pollock in his studio
in The Springs, East Hampton,
Long Island, 1949. Photograph:
© Arnold Newman.

Jackson Pollock

Kirk Varnedoe

with **Pepe Karmel**

Tate Gallery Publishing

First published on the occasion of the exhibition *Jackson Pollock*, organized by Kirk Varnedoe, Chief Curator, with Pepe Karmel, Adjunct Assistant Curator, Department of Painting and Sculpture, The Museum of Modern Art, New York, November 1, 1998 to February 2, 1999.

This edition accompanies the exhibition at the Tate Gallery, London, March 11 to June 6, 1999, and is distributed outside the United States and Canada by Tate Gallery Publishing Limited, Millbank, London SW1P 4RG, England.

ISBN 1-85437-275-0 (clothbound, Tate Gallery) ■ ISBN 1-85437-276-9 (paperbound, Tate Gallery) ■ Printed in Italy

The exhibition in New York was made possible by NationsBank and BankAmerica. ■ Generous support was provided by The Henry Luce Foundation, Inc. ■ The reconstruction of Pollock's studio for the New York exhibition was made possible by EXOR America (Agnelli Group). ■ The Museum of Modern Art gratefully acknowledges the support of the Eugene V. and Clare E. Thaw Charitable Trust and an anonymous donor. ■ Additional funding was provided by TDI. ■ An indemnity for the exhibition has been granted by the Federal Council on the Arts and the Humanities.

This catalogue is made possible through the generosity of The David Geffen Foundation.

Produced by the Department of Publications, The Museum of Modern Art, New York ■ Edited by David Frankel, with Harriet Bee and Jasmine Moorhead ■ Designed by Steven Schoenfelder, New York ■ Production by Marc Sapir ■ Printed by Stamperia Valdonega, Italy

Front cover and clothbound edition's endpapers: Pollock working on a painting on glass, in November of 1950. Frames from a color film by Hans Namuth and Paul Falkenberg. Pollock ultimately erased this version of the painting and reused the glass to produce *Number 29, 1950* (plate 176). ■ Back cover: Jackson Pollock. *Number 32, 1950*. Enamel on canvas. 8 ft. 10 in. x 15 ft. (269 x 457.5 cm). Kunstsammlung Nordrhein-Westfalen, Düsseldorf. See plates 178 and 179.

Contents

The painter should not paint what he sees, but what will be seen.

—Paul Valéry

Foreword

Glenn D. Lowry

The Museum of Modern Art takes pride in its long association with the work of Jackson Pollock. We were the first museum to purchase a Pollock painting (*The She-Wolf*, 1943, acquired 1944). Curator Dorothy C. Miller featured Pollock in the exhibition *15 Americans* in 1952. In 1956 Pollock was to inaugurate a series of exhibitions of artists at mid-career; following his death, this planned survey was reconceived and augmented to become his first posthumous retrospective. In 1967, William S. Lieberman organized a retrospective of Pollock's work that was widely influential on younger artists and that, with Francis V. O'Connor's work in the catalogue's chronology, established a new basis for Pollock studies. Bernice Rose organized for the Museum a landmark exhibition of his drawings, in 1980. Through Sidney Janis, Pollock's last dealer and a great benefactor of this Museum, we acquired, in 1968, *One: Number 31, 1950*, the densest of the three monumental canvases the painter created in 1950. In the 1970s, working with Pollock's widow Lee Krasner, William Rubin acquired for the Museum a suite of works that complemented the existing holdings and assured that the collection of The Museum of Modern Art would be the best representation of this exceptional oeuvre.

In light of the new scholarly literature on Pollock, and the intense fascination with his legacy among artists, Kirk Varnedoe has now planned a freshly conceived retrospective study for this Museum. This, the first American retrospective of Pollock's art in more than three decades, will be the most complete showing ever mounted of his work in all media. As a key figure between early modern art and the innovations of the past fifty years, Pollock seems an appropriate focus of our attention now, as the Museum prepares for a new building that will help vault us into a new millennium and renew our commitment to the best in contemporary creativity. We are extremely grateful for the generous support of NationsBank and BankAmerica, whose sponsorship affirms the importance of presenting this great artist's work in the most effective fashion possible. My special thanks go to our Trustee Thomas W. Weisel, for his enthusiasm and encouragement in this regard. We are grateful to The David Geffen Foundation for generously supporting this publication, and to The Henry Luce Foundation, Inc., the Eugene V. and Clare E. Thaw Charitable Trust, an anonymous donor, and TDI for further contributions that helped ensure the quality of the project. Our gratitude also goes to EXOR America (Agnelli Group) for making possible the reconstruction of Pollock's studio. The exhibition has also benefited from partial indemnification by the Federal Council on the Arts and the Humanities; thanks to Alice Whelihan and her staff for making this support possible. The Tate Gallery, London, will share this exhibition with us, and we offer thanks to Nicholas Serota, Director, and his staff. We owe a special debt of gratitude to the lenders who have shared with our public the works in their charge. Finally I wish to thank Kirk Varnedoe, whose dynamic leadership of the Department of Painting and Sculpture since 1988 has enabled the Museum to continue and strengthen its commitment to the ideals of modern art.

Preface & Acknowledgments

Kirk Varnedoe

This book, published on the occasion of a major Pollock exhibition organized by The Museum of Modern Art, New York, and also appearing at the Tate Gallery, London, was conceived both as a record of the exhibition and as something more. The book is intended to provide the best available visual documentation of Pollock's achievement. An unprecedented number of color reproductions of key works from every phase of Pollock's career and in all media is augmented by a large complement of oversize reproductions and full-page, exact-size details. In this regard, this publication should complement the 1978 catalogue raisonné prepared by Eugene V. Thaw and Francis V. O'Connor, mostly illustrated in black and white and now out of print. The book also stands as a guide to Pollock's life and to the critical debates that have surrounded his work and its legacy. It will be supplemented, in this regard, by a second publication, centered on a scholarly symposium to be held at The Museum of Modern Art in January 1999, that will give scholars a chance to confront their ideas with the evidence of the assembled works. The resulting volume will make available a variety of new approaches to Pollock and will include a more complete bibliography and an exhibition history. A key element will be the study of Pollock's methods and materials currently being prepared by James Coddington, Chief Conservator of The Museum of Modern Art, in collaboration with Carol Mancusi-Ungaro, Chief Conservator of The Menil Collection in Houston.

A great many people lent invaluable aid in the preparation of this publication and exhibition. Jason McCoy, the artist's nephew and principal of Jason McCoy Inc., was a friend from the outset; he and Stephen Cadwalader helped with matters relating to the artist's estate and the location of works in private collections. Joan Washburn, Director of Joan Washburn Gallery, with Sean Cleary, have also assisted us greatly with matters relating to Pollock's estate. Lucy Mitchell-Innes and her assistant, Rebecca Friendly, helped us locate works in private collections and aided with valuations. Robert Miller, William Acquavella, and Larry Gagosian have all lent generous assistance. Further afield, we have received help from Roberta Entwistle and Anthony d'Offay. Robert Mnuchin of C&M Arts has supported the project from an early stage.

Eugene V. Thaw, co-author with Francis V. O'Connor of the Pollock catalogue raisonné, has given valuable advice and encouragement. We also appreciate the assistance of Charles Bergman, Executive Vice President of The Pollock-Krasner Foundation. Helen Harrison, Director of The Pollock-Krasner House and Study Center, assisted by Chris McNamara, has been both hospitable and helpful with countless inquiries.

For archival research we are indebted to Judy Throm, Chief Reference Librarian of The Archives of American Art, Smithsonian Institution, Washington, D.C. We have relied even more frequently on the assistance of her colleagues at the Archives' New York Regional Center: Stephen Polcari, Director, Valerie Komor, Archivist, and Nancy Malloy, Reference Specialist. Museum personnel, collectors, dealers, and private curators around this country and abroad helped us gain

access to works in public and private collections. Special thanks in this regard to William S. Lieberman, Jacques and Natasha Gelman Chairman of Twentieth Century Art at The Metropolitan Museum of Art, and to his colleagues Nan Rosenthal, Consultant, Tricia Paik, and Ida Balboul; and at the Whitney Museum of American Art to Barbara Haskell, Curator of Painting and Sculpture, and Adam Weinberg, Curator of the Permanent Collection, and Anita Duquette, Manager of Rights and Reproductions. Thomas Krens, Director of the Solomon R. Guggenheim Museum, graciously resolved several scheduling conflicts that threatened to deprive us of essential works from the Guggenheim's collection; Lisa Dennison, Deputy Director and Chief Curator of the Guggenheim, and Bernard Blistène, at the Musée national d'art moderne, Centre Georges Pompidou, made significant sacrifices in a planned joint exhibition. Thanks, too, to Bridget Evans of the Photographic Services Department of the Guggenheim. In Venice, Philip Rylands, Deputy Director, Peggy Guggenheim Collection, was extremely helpful, as were that institution's Chief Conservator, Paul Schwartzbaum, and Renata Rossani, Administrator.

We were fortunate to have received hospitality and aid from our colleagues in museums from Boston to Washingon: Jock Reynolds, then Director of the Addison Art Gallery; Richard Field, Curator, Department of Prints, Drawings and Photographs, and Joachim Pissarro, The Seymour H. Knox, Jr., Curator of European and Contemporary Art, at the Yale University Art Gallery; Andrea Miller-Keller, then Curator of Contemporary Art, Wadsworth Atheneum, Hartford; Paul Schweizer, Director, and Deborah Winderl, Registrar, Munson-Williams-Proctor Institute, Utica; Brenda Richardson, then Deputy Director, Baltimore Museum of Art; Marla Prather, Curator of Twentieth Century Art, National Gallery of Art, Washington, D.C.; and James Demetrion, Director, and Phyllis Rosenzweig, Associate Curator, Hirshhorn Museum and Sculpture Garden. Research in the West was greatly aided by Trevor Fairbrother, Deputy Director for Art, Seattle Museum of Art, and Paul Schimmel, Chief Curator at The Los Angeles Museum of Contemporary Art. We also thank Gary Garrels, Chief Curator of Painting and Sculpture, San Francisco Museum of Modern Art, Jacqueline Bass, Director, University Art Museum, Berkeley, and Lynn Zelevansky, Associate Curator of Modern and Contemporary Art, Los Angeles County Museum of Art. Mary Zlot and Dee White aided us considerably in the San Francisco Bay area, as did Ru Waldrum in Los Angeles. Daniel Schulman, Assistant Curator of Twentieth Century Painting and Sculpture, Art Institute of Chicago, and Steven Prokopoff, Director, and Pamela White Trimpe, Curator of Painting and Sculpture of the Iowa University Museum, assisted with travel to Midwestern collections. We also want to acknowledge the kind help extended by Charles Wylie, The Lupe Murchison Curator of Contemporary Art, Dallas Museum of Fine Arts, and Michael Auping, Chief Curator, The Modern Art Museum, Fort Worth. We are appreciative of the aid given us by Werner Spies, Director, and Martine Briand of the Musée national d'art moderne, Centre Georges Pompidou.

In questions about Pollock's life and work, we gratefully acknowledge the contributions of Francis V. O'Connor and Jeffrey Potter; and a special thanks is extended, for their patience with our photographic research, to Arnold Newman and Peter Namuth. For digital imaging, we were lucky to work with Henry O. Bar-Levav, Mary.Lynne Williams, and Miles McManus of Oven Digital, Inc., New York; as well as Matthew Gagnon of Meyer & Gifford Architects. We greatly appreciate the assistance of Sylvia Pollock, and thank Jonathan Pollock for sharing critical unpublished material with us. Special thanks, too, go to William Rubin and Irving Sandler for editorial critiques.

Inevitably, however, our greatest demands have fallen upon the staff of the Museum. Glenn D. Lowry, Director, has supported this project unstintingly. Michael Margitich, Deputy Director for Development,

has been effective in finding sponsors. Jennifer Russell, Deputy Director for Exhibitions and Collections Support, has kept the whole vast enterprise on the rails with her unfailing good spirits. Linda Thomas, Coordinator of Exhibitions, and Eleni Cocordas, Associate Coordinator, have kept impeccable control of a mass of unruly details relating to loans and budgets. We are also grateful to Ruth Rattenbury, Head of Exhibitions at the Tate Gallery, for coordinating the transfer of the exhibition to London, and to Jeremy Lewison, Director of Collections of the Tate Gallery. The complex legal matters surrounding a project of this scope have been handled superbly by Stephen Clark, Acting General Counsel at the Museum, assisted by Kristin Whiting, paralegal.

The Museum is blessed with a wonderful collection not only of Pollock's paintings but of his drawings and prints. Margit Rowell, Chief Curator of Drawings, and Deborah Wye, Chief Curator of Prints and Illustrated Books, lent key works and greatly assisted our research. Their colleagues have also been tremendously helpful: Kathleen Curry and David Moreno, in Drawings, and Audrey Isselbacher and Starr Figura, in Prints and Illustrated Books. For research in the Museum's Archives, we depended on the extensive knowledge of Rona Roob, then Chief Archivist, assisted by Claire Dienes. In the Museum Library, we relied especially on Janis Ekdahl, Chief Librarian, Administration, Karen Mainenti, and Jennifer Tobias.

This publication has constituted a demanding project in its own right. We are especially grateful for the guiding hand of Michael Maegraith, Publisher, and the support of Harriet Bee, Managing Editor. Nancy Kranz, Manager, Promotion and Special Services, has assisted in negotiations surrounding the book, and Heather DeRonck, Senior Production Assistant, has helped to move the process along. Thanks also to Carolyn Fucile, intern. Jasmine Moorhead, Assistant Editor, has kept a keen eye on the editing of the front and back matter for the book. David Frankel, Editor, was in charge of editing the essays, and—as all writers at this Museum have come to expect—did a superb job of quietly but effectively increasing the clarity and coherence in the texts. For the appearance of the book, credit should go to Marc Sapir, Production Manager, who worked tirelessly and with great skill to assure the quality of its reproductions, and to Steven Schoenfelder, who so beautifully designed it. For the exhibition graphics and its Web site, we thank John Calvelli, Director of Graphics, Greg Van Alstyne, Design Manager, New Media, Peter Roman, and Emily Waters. In the Department of Photographic Services and Permissions, we offer warmest thanks to Mikki Carpenter, Director, and Jeffrey Ryan. At the Photographic Studio and Laboratory, we are grateful for the cooperation of Kate Keller, Tom Griesel, and John Wronn, assisted by David Allison and Lee Ewing. And, for their assistance with the cover photograph, we thank Larry Kardish and Anne Morra in the Department of Film and Video, and Kitty Cleary in the Circulating Film and Video Library. This exhibition is accompanied by an ambitious program of lectures, panels, and symposia, and by a brochure, audioguide, and Web site; for the organization of all of these, we are indebted to Patterson Sims, Deputy Director for Education and Research Support, and to Josiana Bianchi, Public Programs Coordinator. The Department of Communications has skillfully and attentively disseminated information about the exhibition; we are especially grateful to Elizabeth Addison, Deputy Director for Marketing and Communications, Mary Lou Strahlendorff, Director of Communications, Graham Leggat, and Jessica Ferraro. We appreciate the effective work of Elisa Behnk, Marketing Manager, and Cliff Brown, Marketing Coordinator. For the coordination of the opening, we are grateful to Ethel Shein, Director, Special Programming and Events.

Vital in any exhibition project, of course, is the protection and proper handling of the art. We express a deep debt of gratitude to Diane Farynyk, Registrar, for overseeing her department's extensive work on this project, and we are especially indebted to Carey Adler, Associate Registrar, for her management of the complexities of safely transporting so many valuable works; thanks also to Anna Hillen and to Terry Teagarden in

this regard. The direct handling of the works and their disposition in the galleries was supervised by Pete Omlor, Manager, Art Handling and Preparation, and Chris Engel, Assistant Manager. It is always a pleasure to work with Pete, Chris, and the excellent staff of Preparators, including Stan Gregory, Mark Williams, Harvey Tulcensky, and Gilbert Robinson.

The conservation of the works entrusted to our care has been in the exceptionally capable hands of James Coddington, Chief Conservator, assisted by Anny Aviram, Conservator. For works on paper, we have also depended on the counsel of Karl Buchberg, Conservator. James Coddington's work on this project has extended into research on Pollock's methods and materials, a project in which he has collaborated with Carol Mancusi-Ungaro, Chief Conservator of The Menil Collection in Houston. We have learned a tremendous amount from their efforts, and it has been a privilege to collaborate with them.

The demands of the Pollock project have inevitably radiated outside the limits of the team specifically working on it, and with particular frequency they have landed on the desk of my immediate staff. A special expression of appreciation goes to Madeleine Hensler, Assistant to the Chief Curator, Department of Painting and Sculpture, who has worked over and above the call of duty. Ramona Bannayan, Manager, Department of Painting and Sculpture, also contributed tremendously.

The core team working on this exhibition had as its field lieutenant Elizabeth Levine, Curatorial Assistant. She had a tremendous and complex responsibility, and handled everything thrown her way with a calm and professional attentiveness. Robert Beier, Administrative Assistant, provided invaluable help in gathering research materials and coordinating documentation. As the project advanced, we found ourselves in need of still further assistance. Our salvation came in the person of Anna Indych, Research Assistant, who provided an indispensable addition to the team, as did Kristen Erickson, Research Assistant.

Danielle Jankow, Alejandra Munizaga, Tom Ormond, and Kadee Robbins also came to our rescue.

Jerry Neuner, Director of Exhibition Design and Production, has been a key collaborator. His patience with numerous changes and his firm but flexible insistence at key stages have assured a display that was both lucid and visually appealing. We also wish to thank Mark Steigelman and Mari Shinagawa. For the important, often pressured task of framing or reframing, we have turned to the expert eye of Peter Perez, Conservation Framer.

My ultimate expression of thanks is owed to the person who has been my closest collaborator in both the exhibition and this publication, Pepe Karmel. In 1996, when my personal circumstances were such that I needed the benefit and protective reassurance of immediate and ongoing help with several projects at the Museum, I pleaded with Pepe to temporarily set aside an important writing project, and to come work with me. I am more grateful than I can say for his response, and for all the excellent work he has done as Adjunct Assistant Curator in the Department of Painting and Sculpture. It has been a tremendous pleasure to work with Pepe, and this Pollock project has been immeasurably enriched not only by his indefatigable overseeing of its every aspect, but by the originality and critical perspicacity of his ideas on the subject at hand. There is not an aspect of this effort that he has not significantly shaped or reshaped, nor any part that has not benefited from his scholarship, his creativity, and his editorial eye.

Finally, Pepe joins me in redoubling the gratitude expressed by Glenn Lowry to NationsBank and BankAmerica, to The David Geffen Foundation, to EXOR America, and to the other private patrons, foundations, and government agencies whose support made the exhibition and publication possible; and in thanking once again the lenders, whose generous willingness to share their works was the cornerstone of the enterprise.

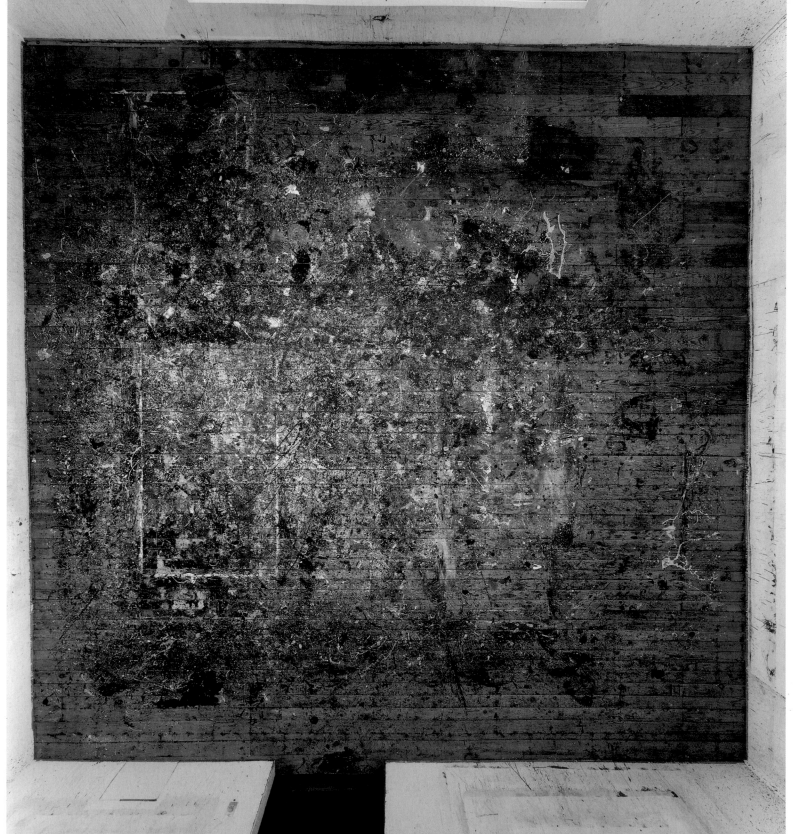

Kirk Varnedoe

Measures

Start with physical experience: it's disorienting to stand where Jackson Pollock stood. The studio, on Fireplace Road in the Springs area of East Hampton (fig. 1), is a few hundred yards from the curve where he slammed headfirst into a tree and died, thrown from the car he was driving drunk, in August of 1956. The wind used to whistle through these walls, and make the room virtually unusable all winter; so before the accident, with a little prosperity, he had fixed it up with insulation and wallboard, and put Masonite on the floor. His widow, Lee Krasner, used the workplace for decades after, but when she passed away, in 1984, the old floor was uncovered. Now one can stand again on the boards that Pollock trod, and see, by the tatters of blue or beige or aluminum paint, the ghost edges of paintings he poured out on this surface (opposite). Stand, see—and have a profound shock of disjunction. Anyone familiar with Hans Namuth's photos of the artist at work (fig. 2) must think they know this spot. They're wrong. The structure, often called a barn, is in fact more like a glorified tool shed;

Opposite: The floor of Jackson Pollock's studio, The Springs, East Hampton, Long Island. Photograph: Jeff Heatley, 1998.

Fig. 1. Pollock's studio, The Springs, Long Island, 1950. Photograph: Hans Namuth. © 1998 Hans Namuth Ltd.

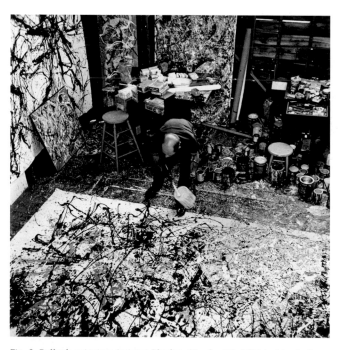

Fig. 2. Pollock painting *Autumn Rhythm: Number 30, 1950* in his studio. Photograph: Hans Namuth. © 1998 Hans Namuth Ltd.

and the working space, which Namuth's overhead shots invite us to imagine as a New York loft, feels implausibly closeted when one finally steps up into it. It's roughly a twenty-one-foot square. Physically, Pollock's big canvases just fit; experientially, they don't even come close. The surprise is like that of Monet's garden at Giverny, where the real lily-pond turns out to be bafflingly tiny in relation to the oceanic art it inspired. Even more in Pollock's studio, one simply cannot get the mind to reconcile the meager room with the transporting expansiveness of the paintings that were made there.

A similar disparity unsettles our sense of time. Though the main actors are gone, the world defined by Pollock and Krasner's home doesn't seem that distant. Plenty of friends and witnesses remain, and there are so many familiar art-world markers—a house in the Hamptons, a gallery on 57th Street, articles in *Artnews*, and so on—that continuity from then to now feels fluid. One key aspect, however—money—is incongruously out of scale. The American art world of the early '50s remained, just for that last moment, a relatively small club with stunted prospects, where even the gaudy maximum in notoriety could still leave isolation untouched and debt undented. So, despite steady dealer stipends, fervent critical support, and one-man exhibitions in midtown virtually every year since he was thirty, Pollock—easily the most famous artist of his generation—only got a step ahead of bare burgher solidity near the end of his life.[1] Embodying that lost economic epoch, the house in The Springs has a straitened coziness that seems as quaintly remote as Lincoln's log cabin.

Objectively, of course, Pollock does belong to the long-ago. The works he made in 1947–48, when he found his stride in the pouring and dripping manner that was his prime innovation, are half a century old now. Yet by a certain social and aesthetic clocking they're also just one blink away. The span from Elvis Presley's first record in 1954 through Jasper Johns's first show in 1958 formed a key divide in American life, and Pollock's car crash (like the actor James Dean's the year before) was one of its benchmarks. In retrospect, that accident says "end" as surely as Sputnik (launched the next year) says "beginning." Johns's targets and flags were on the walls of the Leo Castelli Gallery eighteen months later, and it was only a few seasons more before the cool of Pop and hard-edged Minimalism came to mock the earnest, inward ethos of the previous generation. It's convenient, then, for potted histories of American art to reckon that the whole era of Abstract Expressionist painting died—or at least exhausted its relevance to "progress"—when Pollock passed; and many go on to argue that a new era begins more or less where he leaves off. Before the curve on Fireplace Road, the story goes, water flows back toward Cubism; beyond it, onward into contemporary currents.

Inconveniently for this theory, most of the artists who had helped put America on the international map with new abstract work around 1950—Pollock's cohorts in what was known as the New York School—kept producing for years or decades more. Some, like Philip Guston, had "second lives" as figures of the 1960s and '70s; Willem de Kooning was still moving ahead in the mid-'80s. But, paradoxically, no one transcends the divide more tellingly than the man who supposedly determined it. Stopped short at forty-four, Pollock permanently straddles a cusp in cultural history. Though he epitomizes the moment passed, he has been a fever in art for decades after, and remains an unsettled issue today. It's when we try to locate him in this broader sense that the little disjunctions of experience at the house and studio—the dilemmas of measure and reckoning, the problems of proportion in matching images and realities—have larger, more challenging counterparts.

Not that there remains any serious disagreement about the stature of the art. From the moment of Pollock's first maturity, key critics and artists recognized

that his work had a special power and authenticity. Fail as it might to conform to expectations or to standard criteria, clearly it *mattered*; and this basic consensus has only grown. But intense debate as to *why* it mattered has also never waned. This is not because the work is especially "difficult" in the way that, say, Marcel Duchamp's is. There are no encrypted riddles or in-jokes to decipher, no programmatic texts to explain why it appears as it does. The "drip" or "poured" paintings seem to expose the way they were made, and in significant part to be *about* that process.[2] With no recognizable image or conventional composition, these "allover" abstractions appear to fuse how and why, means and end, instrumental method and expressive message. It's that self-evident combination of what's left out (no familiar hierarchy of marks, no ordering constraints) with what's left in (a seemingly spontaneous, even reckless laying-on of raw skeins of liquid paint) that has been so compelling to so many artists. The "artless," hands-off way Pollock deployed his medium was too uniquely a signature style for anyone to adopt directly; but the permissions it gave have percolated irrepressibly through painting, sculpture, installation and performance art, and hybrids of all of the above (not to mention the effect on musicians and writers). The range of consequences reflects in part some irresolvable contradictions at the source. Pollock's best work is inhabited by opposites: lyrical and violent, anguished and ecstatic, cathartic and obsessive, tormented and liberating, ethereal and base. Each of these properties has been motivating to one group of creators or another in turn, and we have not agreed—nor ever will—which combination of terms is "correct" or definitive. Showing a way to keep either-or judgments at bay may be among Pollock's prime legacies.

That volatility of interpretation also affects the ways Pollock gets written into history. There, too, it's long been clear that he matters; but while he's typically been reckoned an exception, in retrospect he seems to determine the rule. Because his position is so extreme, more rides on him. Pollock now looms as a central hinge between the century's two halves, a key to how we got from one to the other in modern art. As the pivot on which prologue and coda balance, he has become in history, still more than he was in life, a legitimator: validation accrues to the lineage fertile enough to have spawned him, or to followers clever enough to have properly read his message; and competing claims abound. Even more broadly, any theory of cultural modernity has to claim the summit he occupies before it can assert dominion on the territory; and in this way accounts of Pollock also become litmus tests for broader philosophical and political positions about the meanings of his epoch. Trying to write his history inevitably broaches larger queries about our own.

The art historian and critic Leo Steinberg already saw the situation clearly in 1955, when a survey exhibition at New York's Sidney Janis Gallery provided "the first opportunity to see the artist whole," and thus "as good a time as any for stock-taking." He recognized even then that an aura preceded this art. "More than any other living artist's," Steinberg wrote, "Pollock's work has become a shibboleth; I have heard the question 'What d'you think of Jackson Pollock' shouted from the floor of a public gathering in a tone of 'Are you with us or against us?'" Enemies were as vehement as supporters, who often insisted one had to know the man to understand the painting. Might this notoriety then signal art's devolution into an insider cult? All such disputations and armchair ruminations, Steinberg quickly conceded, were made moot by the exhibition itself: its effect was "utterly overwhelming. Questions as to the validity of Pollock's work, though they remain perfectly good in theory, are simply blasted out of relevance by these manifestations of Herculean effort, this evidence of mortal struggle between the man and his art."

In the face of such experience, normal critical

criteria seemed beside the point. About the works of the early 1940s, Steinberg confessed, "How good these pictures are I cannot tell, but know that they have something of the barbarism of an ancient epic. Does anybody ask whether the Song of Gilgamesh is any good?" With regard to the drip paintings of the later 1940s, the dilemma was even more acute. Their aggression seemed so uncompromising that it didn't just rebuff the standard probes—"How good are you?" and "What meaning do you have?"—but threw them back at the inquisitor, with the scale of judgment altered and the ante upped.

> Of course it is possible to carp at such painting, and not from any lack of taste or sensitivity to art, but from a love for humanistic values. Where we get stupefaction instead of enlightenment, where the mind is not confirmed in authority but rather scandalized, where, instead of rationality and freedom, we confront the apparent sport of mindless ferocity and chance, there it becomes legitimate to waive the question of the artist's merit and to enquire what it might signify for our entire culture if such work as his is indeed our best.[3]

A great deal has changed since that dramatically bleak evaluation. "Barbarism" reads like a dated overstatement about the tenor of the mid-1940s work, and certainly the poured paintings have come to seem far removed from "mindless ferocity," indeed more exultantly fuguelike.[4] Fewer and fewer viewers now find their minds "scandalized" by Pollock's canvases; other art has come to fill that role. We might even stand Steinberg's argument on its head, by averring that "a love for humanistic values" now more draws us to these paintings than spurs our recoil. Pollock's unique stature, however, and his position at the crux of key debates, have become even more salient. With the painter's glamorization since his death, the tasks that Steinberg delineated—cutting through the reputation to the force of the art itself, and moving from there to larger questions about the culture—are more pertinent than ever. And most important, the essential seriousness of Steinberg's response has been validated many times over—the scale of the challenge remains as he

articulated it. With a new retrospective just as with that 1955 reconnaissance, assessing this artist brings our basic yardsticks into question, and ultimately turns our judgments back on ourselves. Resisting measure, Pollock becomes one.

Myths

Writers on Pollock ritually lament his myth,[5] and with reason: puffery here has been hot and thick. Almost instantly, the artist's violent death remade his life into a fable of tragic destiny, and (along with tales of alcoholism and psychological troubles) fostered his canonization as an exemplary martyr in the great romantic tradition.[6] Among the prime hagiographers were those who knew him best; sample Thomas Hess, in *Artnews* less than a month after the funeral:

> His death is tragic not only because his career is cut short but because it is logical. . . . Pollock's was the tragic, logical death of a man whose greatness and strength are precisely the qualities that led him to a death that could have been avoided if he had not been so strong, or had been willing to compromise, or step backwards, or hold some strength in reserve—in other words, if he had not been Jackson Pollock. . . .
>
> Pollock's career was brief. Like Rimbaud's, it involved an excess of violence which always was colored by tough laughter and never was tainted by sentimentality; like Caravaggio's or van Gogh's, it was filled with moments of stupendous creative activity, as if the artist knew how little time he had to paint in.[7]

At a distance it may seem easy to scorn this kind of rhetoric; its excesses were already evident at the time. But it's not easy—maybe not even advisable—to isolate the man in the headlines from the painter in the studio. Myths are after all their own realities, and in Pollock's case they have been especially fertile. The force of the art came first in his career and remained essential, but press and promotion followed fast on, and form an inseparable part of the tale; to dismiss them as just ancillary fluff would be to buy into one of the most basic romances. Pollock often gets cast as the last action hero, a "natural" beat bohemian and a bastion of tortured purity and authenticity. True to his

cusp position, though, his story is actually less once-upon-a-time and more tainted with the now, specifically as regards media hype. American journalism's appetite for the production of celebrity personalities was expanding in the late 1940s and early '50s, and within this trend a special dance was tentatively forming between the mass-audience system of *Time* and *Life* and the evolving small-audience world of advanced art.[8] In that process, Pollock was not simply a cheapened victim of philistine publicity, but instead (or also) its accomplice. Whatever self-recriminations he may have felt, a significant part of him wanted celebrity, and he collaborated with its mechanisms. As one result, he became famous for being famous; from the late 1940s on, reviewers regularly began by telling their readers how publicized he was. Once that loop between reputation and success starts in motion, it gets hard to demarcate cause from effect, image from reality. The problem becomes tougher still after his death, when the *idea* of Pollock, transmitted by a variety of interpreters and abetted by imagery like Namuth's photos, had a worldwide influence that often operated independently of the paintings themselves.[9]

The problem of separating the "pure" from the "fabricated" Pollock isn't, however, just one of late or posthumous celebrity; it's intrinsic to his life from start to finish. Pollock's biography makes a great American story, but not so much for what it proves—its "logic," in Hess's sense—as for its improbability. The results were unlikely given the premises, and it seems clear that Pollock achieved what he did, not by any inborn gift of conventional facility or by fated destiny, but by a combination of strongly willed self-inventions and a small cohort's dedicated promotion. From his early fixation on being an artist through his experiments with spiritualism, politics, psychological and homeopathic therapies, and so on, Pollock—the Westerner, the drunk, the country boy, the tweedy man of the city—repeatedly tried to reinvent himself,

and often with more than a little help from his friends. He constantly sought to be "integrated," to be whole and real, and "phoniness" was an enraging personal taboo; but his was a reality always wrapped up, at several levels and often very productively, in myths and myth-making.[10] That's why it's also a great story about hopes and hustles, with a characteristically American fusion of making believe and making it happen.

None of this implies, however, that there's much to gain by "demythifying" Pollock. That approach, while it promises to wrest history from the fables, too often ends up settling for an account of the fables as a view of history. And if it's misguided to search for an unsullied purity beyond the babble, it's at least as obtuse to propose that the latter, properly decoded, is the whole story. To reckon the art's success as just a sum of the fictions it generated is to invert the evidence that it generated them because of its success—because the paintings that arose from and spawned those various fabulations are profoundly original, and demanding, and transcend them still. Also, if we treat the artist's stature as a chimera of strategic concoctions and external exploitations, we risk replacing the romance of innocent genius with another, of covert determinism; neither fits the messy contingencies of the history at hand. We shouldn't flatter ourselves with the notion that an analysis built on the dry bones of scattered documents and selective recollections could securely provide us with some superior knowledge of formerly unconscious illusions or concealed intentions. Wiser, perhaps, to consider that nobody—including Pollock himself, as well as those who helped make his myths—was either wholly aware or gullibly taken in. Whatever their inevitable blind spots, they surely knew themselves better than we can, and their immediate acquaintance with the full range of personal and material experience attendant on the creation of this art meant that, in critically important ways, they saw, more naturally and with greater ease than any of us can now muster, the line

that separated the often inarticulably complex art from its usefully tidier and more communicative packaging.

Origins

Whatever we might make of Pollock's youthful formation, he thought it should count for something in understanding him. The first advance publicity for his initial gallery exhibition was headlined "Young Man From Wyoming"[11]—a foretaste of what would become a familiar insistence on a Western background. Given this desire to capitalize on Cody, Wyoming, as his birthplace, the principal irony is not how little time he actually spent there (the family moved less than a year after his birth in January 1912) but what a peculiar version of the West the town represented. Cody had no history; it was a tract-development scheme cooked up at the turn of the century. The name came from one of the principal investors, William (Buffalo Bill) Cody, who by the time of the town's founding had parlayed a brief career as scout and hunting guide into a long and profitable one as manager and star of a traveling Wild West show, purveying a mélange of retread cowboys and deracinated Indians to urban ticket-buyers across the U.S. and in Europe. This "themed" whistle-stop was more Barnum than buffaloes, a token less of the raw frontier than of the marketability of packaged romance.[12]

Pollock's early family life was crowded—he was the youngest of five sons—and unstable. His mother's vague but goading ambition to improve her circumstances made a bad match with the limited skills and ambitions of his father. That combination of hope and haplessness kept the family on a restless trajectory, in Jackson's childhood, through a declining succession of ill-fated ventures in farming, fruit-growing, and managing a forlorn hotel. Their recurrent moving-on, zigzagging through Arizona and Northern and Southern California, strained the marriage and made the father, LeRoy, increasingly depressive. By Jackson's adolescence, when the household came to a rest in Riverside, California, LeRoy had become a permanent absentee, running distant trail crews, mailing home checks, and contacting his sons only through infrequent visits and occasional letters. Absorbed with keeping up a good appearance in the shambles, the mother, Stella, was by many accounts uncommunicative and weak at discipline, but smothering. In any event, though Jackson was her "baby," the last and most spoiled of the boys, key shaping influences on his youth seem to have been his brothers—especially the closest to him, Sande, who became his constant guide and protector, and the farthest away, Charles, whose aspirations and affectations first opened another world to his imagination.

This reads like a scenario from John Steinbeck, but improbably there was a denouement out of Henry James: from that problematic, peripatetic household, three of the five sons became painters. The eldest first: marked early by his mother's illustrated catalogues and fancies for fine things, Charles set himself on being an artist, and began in his teens by looking the part. Cultivating long hair and dandified sartorial touches, he established, for his youngest brother's forming dream world, the ideal of art as attitude, a prime avenue to a self-willed stylization of life.[13] In this way Jackson, who would later trade on the macho element of tumbleweed origins, seems first to have fixed on aesthetics as a fop's game, elegantly at odds with the hardscrabble of denim and dust in which he found himself. After Charles left home for art training in Los Angeles, when Jackson was nine, Sande and Jackson puzzled over the art magazines he sent back, as esoteric tokens of a longed-for urbanity, maturity, and self-determination. Both wound up aiming for careers in art; but Sande, like Charles, had a relatively easy aptitude for it, while Jackson had absolutely no facility to match this notion of what he might become.

His first formal training in art, such as it was, began in 1928, when he was sixteen, at Manual Arts High School in Los Angeles. The teacher, Frederic John de St. Vrain Schwankovsky, was a fatherly and

theatrical eccentric who provided his small coterie of students with an appealingly unrigorous blend of encouragement, experimentation with techniques, and earnest proselytizing on matters of the spirit. Pollock, despite his self-professed hostility to authority, became an acolyte. At that age he was an amalgam of transitory enthusiasms and stubborn contradictions. Handsomely developed physically, he was prone to hot-tempered profanity and violence (slugging an ROTC officer in one high school and a physical-education instructor in another), but was timid and unadventurous with girls and pointedly opposed to athletics. The family had been unreligious, even antireligious; but with Schwankovsky's coaxing, Jackson plunged into an infatuation for Theosophist mysticism, and traveled to hear Krishnamurti speak. He also started reading avant-garde periodicals like those Charles had sent home, grew his hair long (fig. 3), at one point called himself "Hugo," and tried (as one of his friends said) "living a European fantasy."[14] As a sometime participant in Communist meetings, and truculently at odds with his all-American California schoolmates, he wrote to his brothers Charles and Frank ruefully (but with implicit pride) that "the whole outfit think I am a rotten rebel from Russia."[15]

Fig. 3. Pollock in 1928, when he was a student at Manual Arts High School, Los Angeles.

Charles had first left home to study in 1921, and had moved on to New York in 1926, so he saw little or nothing of Jackson for several years. The baby of the family continued, though, to hold the firstborn's independence and worldliness in high respect; and at the end of the summer of 1929, Jackson broke the long silence between them by writing Charles what seems to have been a despairing cri de cœur, declaring his interest in art, his frustrations with school (he had been briefly thrown out of Manual Arts the previous spring for distributing leaflets inciting student activism), and his intentions of moving deeper into Theosophy. Charles replied at length, supportive but admonishing. Hardly tender with his sibling's budding spiritualism, he railed against "the philosophy of

escape to which you have momentarily succumbed" as "a negation . . . a religion that is an anachronism in this age." Scorning "a contemplative life that can have no value because it ignores realities," he derided American exponents of mysticism as "commercial savants." On the affirmative, he warmed to the news of Jackson's interest in art, suggesting a career in architecture, praising the Mexican muralists Diego Rivera and José Clemente Orozco, and recommending journals to read. From the sage pinnacle of twenty-seven years, Charles closed with a general exhortation to stay the course: "Do not believe so early that you are ill placed in this world and that there is nothing you are fitted to do. There are many pursuits supremely worthy of your best efforts and for which the qualities you possess, are a first necessity."[16]

Responding tardily, a week before the great stock market crash in October of that year, Jackson showed himself a chastened and dutifully learning little brother. After some bad news about further student woes (including getting kicked out of school a second time), he reflected:

I have read and re-read your letter with clearer understanding each time. Altho I am some better this year I am far from knowing the meaning of real work. I have subscribed for the "Creative Art" and "The Arts." From the Creative Art I am able to under stand you better and it gives me a new outlook on life.

I have dropped religion for the present. Should I follow the Occult Mysticism it wouldn't be for commercial purposes. I am doubtful of any talent, so what ever I choose to be will be accomplished only by long study and work. I fear it will be forced and mechanical. . . .

As to what I would like to be. It is difficult to say. An Artist of some kind. If nothing else I shall always study the Arts. People have always frightened and bored me consequently I have been within my own shell and have not accomplished anything materially. In fact to talk in a group I was so frightened that I could not think logically. I am gradually overcoming it now.[17]

The humbly resigned tone here seems to set a plodding, joyless course toward a distant and uncertain future. But the next letter shows how swiftly life can be reimagined at seventeen going on eighteen.

21

Three months later, at the end of January 1930, Jackson was just past his birthday and about to complete another term at Manual Arts when he typed to Charles, with an ostentatious denial of capitalization and aggressively unorthodox paragraph breaks:

i am continually having new experiences and am going through a wavering evolution which leave my mind in an unsettled state. too i am a bit lazy and careless with my correspondence i am sorry i seem so uninterested in your helping me but from now on there will be more interest and a hastier reply to your letters. my letters are undoubtedly egotistical but it is myself that i am interested in now. . . .

. . . i have started doing some thing with clay and have found a bit of encouragement from my teacher. my drawing i will tell you frankly is rotten it seems to lack freedom and rhythem it is cold and lifeless. it isn't worth the postage to send it. i think there should be a advancement soon if it is ever to come and then i will send you some drawings. the truth of it is i have never really got down to real work and finish a piece i usually get disgusted with it and lose interest. water color i like but have never worked with it much. altho i feel i will make an artist of some kind i have never proven to myself nor any body else that i have it in me.

this
so called happy part of one's life youth to me is a bit of damnable hell if i could come to some conclusion about my self and life perhaps then i could see something to work for. my mind blazes up with some illusion for a couple of weeks then it smoalters down to a bit of nothing the more i read and the more i think i am thinking the darker things become. . . .

i am
hoping you will flow freely with criticism and advice and book lists i no longer dream as i used to perhaps i can derive some good from it.[18]

These are the phrases of a young man with demons in search of a voice to vent them, trying on modes of abjection and world-weariness, with alternate notes of egocentrism and self-pity. Contrite autoflagellation is essayed as a way to preempt external judgments and turn insecurity and underachievement—of which there were plenty—into a mature style of self-dramatization. There's a sharp limit on what we can make of these shards of evidence, though, in reconstructing a working picture of Pollock's youthful problems. We know enough about the family and the early years to make some stock suppositions, but there's no real control on the guesswork. Clearly, on the eve of his departure for New York in 1930, his self-construction was in many respects still woefully weak and incomplete. His motivations as a kind of spiritualized slacker and pugnacious "rebel" seem to have been compounds of copycat emulation and stubborn, often aggressively defiant, internal compulsion; a need to belong and a will to stand apart, like big ambitions and a torpid disinclination to focus on work, cohabited painfully. But beyond a weakness for alcohol (established when he started drinking with trail crews the summer he was fifteen[19]), one trait seems definitive in Pollock's tentative early experience: a fixation, against all odds, on his vocation.

A cynical reckoning might say that art appealed to Pollock as a high-minded style of being that his big brother had made glamorous for him, and that involved little physical labor, no regularized professionalism, and a long, even indefinitely extended process of becoming. It was, among other things (as his disapproving father kept reminding him), a good way of putting things off; and by his own admission, it was a private solace for social deficits. But this skepticism misses the tenacity with which Pollock, despite an apparently near-total lack of talent, formed and held onto the notion that being an artist would be his life. On some deep level, independent of any clear sense of the practicalities or specifics of a career, he came to equate the idea of making works of art with the imperative of taking control of his future—literally making his mark. A fellow painter who knew him in the early years after the move to New York said,

He wanted to be an "Artist," but he didn't seem to enjoy his painting much. And he didn't do that much, either. He was ambitious—either that or extremely neurotic—and unsatisfied, frustrated. Jackson wanted recognition as a *person*, and art was the way to do it. He was so intense about it, and in everything he did in spite of emotional insecurity and aberrations. I don't think he ever thought about any career but art.[20]

In 1932, Pollock would write to his father, in

an effort to justify the worthiness—and manliness—of what he was doing, "Being a artist is life its self—living it I mean. And when I say artist I don't mean it in the narrow sense of the word—but the man who is building things—creating molding the earth—whether it be plains of the west—or the iron ore of Penn. Its all a big game of construction. . . . The art of life is *composition*—the planning—the fitting in of masses—activities."[21] The rhetoric is doubtless borrowed, and this kind of thinking can be denigrated as palmy and delusional; but Pollock was impelled by it. Art was a fantasy first, without real form, and his involvement was all need and no focus. He then had to devise ways to make something of the fixation, and—against competition and without even the rudimentary skills, technical or personal—to convince others to share his as yet imperfectly formed sense of mission.

From California to the New York Island

In September 1930, Pollock decided to give up high school, join his brother Charles in New York, and pursue a career in art. Eventually, in January 1942, he would come into the public eye as part of a group exhibition in a 57th Street gallery. But if at any point in the intervening years he had been run over by a bus, or (more likely) gotten himself killed in a drunken accident, there would be no trace of him in the history of modern art, nor any reason to look for one.

Even today, with dedicated scrutiny, the record is hard to read. Between the ages of twenty and twenty-eight, Pollock is accessible to us largely through secondhand anecdote and fragmentary evidence of uncertain date. His student efforts were destroyed or discarded, and while there's testimony to an abiding interest in sculpture (he studied stone-carving in 1933[22]), paltry results survive. Of the few paintings associated with the early and mid-1930s, about all that can be said is that they value expressiveness over truth; even when nature is the motif, style is the issue, and there's a dominant sense of art made from art.

Pollock later said that the eccentric romantic Albert Pinkham Ryder was the sole American predecessor who interested him,[23] and this influence is palpable in a murky turbulence that infiltrates even simple scenes of vacation coastlines (plates 5–7) and lends imaginings of the Old West a folk-story air of darkling phantasm (plate 2). Two small oils stand out: a lurid woman surrounded by dwarfed figures, reminiscent of the troubled lubricity of the youthful Cézanne (plate 3); and a frontal head in which the artist transformed his own boyish good looks into a shadowy, haunted self-portrait, at once geriatrically gnarled and infantile (plate 1).

We know more about Pollock's biography in the 1930s, but the index of growth isn't any more promising. Having linked achievement in work with getting a handle on life, he failed doubly. A perpetual student, he lived from hand to mouth, mostly in shared or borrowed apartments, and shuttled from one forgiving support system to another. While New York and the nation staggered through the Depression toward the onset of global war, Pollock waged a losing battle against alcoholism and failed to make much headway as an artist.

Part of his problem—and some of his luck—came from his initial choice of mentors. Not surprisingly, he followed directly in Charles's footsteps, by studying at the Art Students League under Thomas Hart Benton. In fact, with no small sense of competitiveness, he progressively took over roles Charles had enjoyed, as pet pupil and surrogate son. He became a monitor in Benton's classes, often played family handyman or baby-sitter in return for meals, and generally made himself a fixture in the Benton household, both in New York and eventually on vacations at Martha's Vineyard. The filial bond was nurturing, and bolstered Pollock when his true father died, in 1933; but it was also partly toxic.

Benton was a swaggering blowhard who curried an image as a no-nonsense son of the soil, and under

his aegis Pollock changed from longhair California swami into Manhattan cowboy, complete with boots and Stetson, conjuring roots that never were. More damagingly, the novice also tried to pace his elder's strut as a big drinker and a misogynist man's-man. Neither role fit well, or did much to serve the cause of maturation. On a strictly professional level, too, this was an untimely alliance. As a Paris-trained modernist turned Realist apostate, Benton had come to spurn any form of abstraction and all progressive developments abroad. When Charles first came to study with him, in 1926, that parochialism was winning hearts: Benton's ambitions for celebrating the nation in murals, and his shoot-from-the-hip, no-sissies-here personality, were popular and getting more so. Jackson was no less enthralled by this vision of an all-American art, and likely used his teacher's notions of picturesque labor and lowlife to filter the motley, sometimes hobo-like experiences of his various trips across the country, in the summers between 1930 and 1935. But his five semesters of apprenticeship saw the shine come off this coin. Populist antielitism and suspicion of abstract art had given Benton tenuous bonds with the political left, but as the Depression deepened, and internationalism became more of a cause, his reactionary chauvinism isolated him from the New York community. Enrollment in his classes dropped sharply after 1930,[24] and his eventual departure for the Midwest, in 1935, had the character of a sulking retreat. He left his few remaining disciples at the League disastrously unarmed for cafeteria debates with painters like Stuart Davis and Arshile Gorky, who had been keeping a close eye on Matisse, Picasso, Léger, et al. That other side was ascendant, and Pollock had hitched his wagon to the wrong horse.

Many years later, Pollock was to claim that his education under Benton served primarily as something to rebel against, but it's not that simple.[25] He arrived in New York short on skill and badly in need of discipline, and Benton's reductive formulas for turning grand Renaissance and Baroque compositions into arcs, bars, and stick figures must have given him his first intimation of mastery (see figs. 29, p. 105, and 104, p. 131). This method, which encouraged students to distill lines of order from daunting tangles of emotive upheaval, also implied that great art's essential powers lay in underlying patterns of energy and arrest, independent of representation. To isolate the play of light or the meters of recurrent axes, Pollock learned how to level solids and voids into edge-to-edge arrays of modular marks just a step removed from whole-cloth abstractions (plates 11 and 12). It's simplistic to see his later paintings as extrapolations from Benton's diagrams (much has been made of the instructor's "poles" in regard to Pollock's *Blue Poles: Number 11, 1952*, plates 214 and 215[26]), but these general notions of separating structure from story must have helped set a path.

Benton also taught "fundamental mechanical principles" that may have had a long resonance for Pollock. Discussing rhythm, for example, he held that "plastic functions are really reflective of our physiological functions":

In the "feel" of our own bodies, in the sight of the bodies of others, in the bodies of animals, in the shapes of growing and moving things, in the forces of nature and in the engines of man the rhythmic principle of movement and counter-movement is made manifest. But in our own bodies it can be isolated, felt and understood. This mechanical principle which we share with all life can be abstracted and used in constructing and analyzing things which also in their way have life and reality.[27]

Similarly, there was something valuable to be retained from Benton's homily that

the creative process is a sort of flowering, unfolding process where actual ends, not intentions but ends arrived at, cannot be foreseen. Method involving matter develops, whether the artist wills it or not, a behavior of its own, which has a way of making exigent demands, devastating to preconceived notions of a goal. Art is born not in preconception or dreaming but in work. And in work with materials whose behavior in actual use has more to do than preconceived notions with determining the actual character of ends.[28]

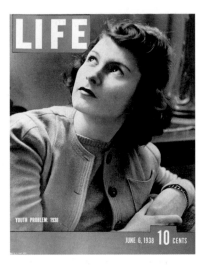

Fig. 4. A 1938 issue of *Life* magazine with Betty Fulton on the cover, photographed by Alfred Eisenstaedt.

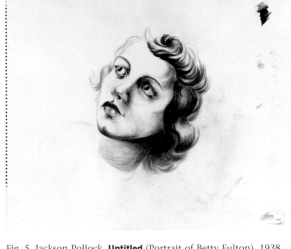

Fig. 5. Jackson Pollock. **Untitled** (Portrait of Betty Fulton). 1938. Pencil and color pencil on paper. 13¾ x 17 in (34.9 x 43.2 cm). The Metropolitan Museum of Art, New York. Purchase, anonymous gift, 1990. OT 429r.

Fig. 6. Luca Signorelli. **Christ in the House of Simon the Pharisee** (detail). 1498. Oil on panel. 10⅜ x 35⅜ in. (26 x 90 cm). National Gallery of Ireland, Dublin.

Fig. 7. Jackson Pollock. **Untitled** (detail). c. late 1937–39 (plate 14). The Metropolitan Museum of Art, New York. Purchase, anonymous gift, 1990.

More direct tutorial effects can be found in two sketchbooks Pollock executed in the late 1930s, years after both men had quit the League.[29] Benton's tastes guided the choice of painters Pollock copied—Signorelli, Rubens, El Greco, and Tintoretto—and his techniques echo in the books' blocked-out renderings of the human figure (plates 14 and 18). Pollock at first drew miserably, as Benton judged and others corroborate; but these somewhat later sketchbooks, while hardly trophies of virtuosity, have far more than only negative lessons to teach. Beyond the general predilection for grand passion and heroic muscularity, a love for stylized forms of agitation comes through in the numerous drapery studies (plates 14 and 15). All the expressive life sapped from the faceless figures and schematized gestures has been reinvested, with surplus, into these animated swaths of cloth. There's a special, clenched-teeth intensity, too, in the way multiple overlays of colored pencil lines virtually emboss the contours gleaned from fuzzy black-and-white reproductions of paintings. Benton's principles involved abstracting down to inert schematics, but here we frequently see Pollock *adding* information, and a writhing organicism, to peculiar details or bland areas of grayed-out imagery. Perhaps the clearest example is the face he "copied" from a June 1938 cover of *Life* (figs. 4 and 5): none of the tautly coiling linear precision of Pollock's version, nor any of the sculptural potency, had a cue in the mushy grisaille of the printed source. These sketchbooks are instructive, too, not just for details such as the folded-in, suggestively vaginal space in draperies (figs. 6 and 7) but for the total-page arrays of abutted frames, jump-cuts from wholes to details, and shifts of scale, style, and ambition. One of these compilations includes a remarkable self-portrait, set in a low corner of the sheet, where the face is cleft in half, the head has no top, and the draftsman refuses to look himself straight in the eye (plate 18).

A third surviving sketchbook, likely executed a matter of months later, is light years away in style and mood (plates 20–23). Again, it involves an influence Pollock had first confronted years before. Through Communist contacts in Los Angeles and Charles's earliest reading tips, Pollock had become an admirer of the Mexican mural movement—dominated by Rivera, Orozco, and David Alfaro Siqueiros—before he came to Benton. Friends of his youth, most notably his Manual Arts classmate Philip Goldstein (later Philip Guston), actually worked on walls in Mexico City in the 1930s; and his brother Sande worked briefly with

Fig. 8. David Alfaro Siqueiros. **Proletarian Victim**. 1933. Enamel on burlap. 6 ft. 9 in. x 47½ in. (205.8 x 120.6 cm). The Museum of Modern Art, New York. Gift of the Estate of George Gershwin.

Fig. 9. Jackson Pollock. **Untitled**. c. 1938–41. Gouache, color pencil, and pencil on paper. 14¼ x 10 in. (36.2 x 25.4 cm). The Metropolitan Museum of Art. Purchase, anonymous gift, 1990. OT 462r.

Siqueiros in Los Angeles.[30] Like them, Pollock saw himself staunchly on the left, and was doubtless drawn to the promise of art as a reformer's tool, uncorrupted by the capitalist market for easel-sized work.[31] For a brief period in 1936, he had a chance to act on these ideals: Siqueiros came to New York as a delegate to a congress and stayed to run a workshop that involved teams of young artists like Pollock in making huge agitprop figures for a May Day parade.[32] The ruling premise was that all materials and methods were fair game for art, and the artists experimented with new industrial paints, silk-screen printing, and brushless methods of spraying, pouring, and puddling as fresh ways of getting the job done. This liberating alteration in the idea of the studio, and of creativity, doubtless left a seed, though it would be as reductive to ground Pollock's later poured paintings in those free-form experiences as it would be to tie them to Benton's linear formulas. There were, however, as the sketchbook shows, more immediate and very different results from his renewed attention to Mexican art.

For all their talk of indigenous roots and "Aztec" stylizations, the Mexicans led Pollock back to a key aspect of European tradition. Benton had refined the religious spectacles of Rubens, El Greco, and Tintoretto into a serpentine secular mannerism. But in picturing oppression and martyrdom the Mexicans had come closer to the heart of the Counter-Reformation, in their often brutish and sadomasochistic adaptations of Christian iconography as a vivid theater of sensual suffering. Like the Vatican before them, these Marxists understood that metaphysical ideas might best be grounded, for broadest effect, in indelibly physical expressions. Siqueiros's hog-tied *Proletarian Victim* is an instance of this erotically charged propagandizing (fig. 8), and we can find its echo, ballooning breasts and all, in Pollock (fig. 9).[33]

Orozco, however, was the more consistent explorer in this vein, and not coincidentally the primary influence on the sketchbook drawings. Pollock saw

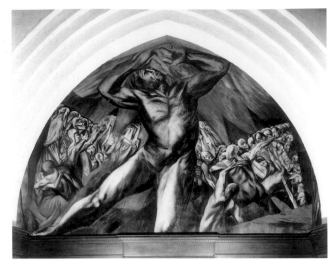

Fig. 10. José Clemente Orozco. **Prometheus**. 1930. Fresco. 25 x 30 ft. (762 x 914.4 cm). Pomona College, Claremont, California.

Orozco's *Prometheus* in Pomona in June 1930 (fig. 10), and for years after cited this grappling nude behemoth as the greatest painting in the country.[34] The triumph of frame-busting scale and expressive anguish over "good drawing," conventional proportions, and perspectival niceties must have been encouraging. He could have refreshed his admiration that autumn in New York, where Orozco was working (like Benton, a few floors away) on a cycle of murals for the New School. And finally, in 1936 Pollock, Guston, and others made a pilgrimage to see the brooding, meaty, and sometimes horrific scenes in Orozco's syncretic panorama of New World cultures, *The Epic of American Civilization,* at Dartmouth College, New Hampshire (figs. 11 and 12).

After letting that experience simmer a few years, Pollock edited out the veneer of uplift and the nominal narratives, and transported Orozco's machinery of skeletons, crucifixions, and hallucinatory perspectives into his own, wholly unmoralizing, pseudo-religious fantasies of carnal excess bound up with mortal distress (plate 23). He also blended the Mexican's iconic ponderousness with fluid expressive energies formerly sublimated in the Bentonesque studies of drapery. In

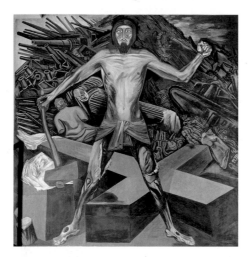

Fig. 11. José Clemente Orozco. **The Epic of American Civilization**, panel 21: **Modern Migration of the Spirit.** 1932–34. Fresco. 10 ft. x 10 ft. 6 in. (304.8 x 320 cm). Hood Museum of Art, Dartmouth College, Hanover, New Hampshire. Commissioned by the Trustees of Dartmouth College.

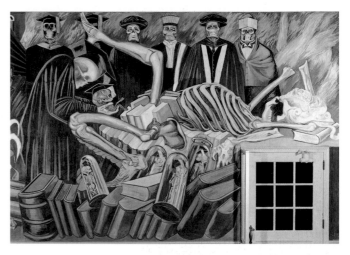

Fig. 12. José Clemente Orozco. **The Epic of American Civilization**, panel 17: **Gods of the Modern World**. 1932–34. Fresco. 10 ft. x 9 ft. 11 in. (304.8 x 302.3 cm). Hood Museum of Art, Dartmouth College, Hanover, New Hampshire. Commissioned by the Trustees of Dartmouth College.

some pages of the third sketchbook, these rhythms take on a frame-filling, labile life of their own, fusing body parts with viscous, even neo-Futurist passages of form; and the mannerist palette that earlier lurked in colored-pencil overlays now blooms into full chromatic peculiarity, with acidulous earth tones decorated by weirdly benign and delicate notes of lemon and lilac (plate 21). More than the Bentonesque analytic exercises, these pages seem the preparatory work of a painter (even though there's no direct equivalent to them among Pollock's surviving canvases). The seething strangeness of the images suggests, too, that after almost a full decade of grappling with borrowed languages in art, Pollock was beginning to vent into his work some decidedly personal, and darkly fantasist, personal energies.

Pathology and Creativity

When he worked on these three sketchbooks, Pollock was in deep emotional trouble; he had been headed that way for several years. Since his early teens he had seemed a disturbed, even at times violently contrary young man. Awkward at communication, plagued by feelings of worthlessness, and dangerously vulnerable

to drink, he had required a lot of support—and the impoverished isolation of his first years in New York can only have exacerbated these difficulties. Perversely, just when New Deal welfare stabilized his finances (the Federal Arts Project started paying him about $100 a month in August 1935[35]), an important personal nexus began unraveling. First the Bentons, then Charles, left New York that year. Sande, who had come east in 1934, took over the job of looking after Jackson, but his marriage the next summer doubtless increased the younger brother's sense of abandonment. The repeal of Prohibition, in December of 1935, made each new disappointment a more dangerous occasion. Siqueiros, with whom Pollock seemed to have a real affinity, departed in late 1936, to fight in the Spanish Civil War. An older girl on whom he had a major crush left town to get married the following spring. In July of 1937, Sande wrote Charles that the past year had seen periods of "emotional instability" following one on the other, during which their brother showed "a complete loss of responsibility both to himself and to us. Accompanied, of course, with drinking."[36]

We can't know exactly what was wrong with Pol- 27

lock; psychoanalysis is a subtle business, and trying it on a dead man is a fool's game. It's easier, though, to recapture the possibilities the epoch offered for confronting his problems. As Nazi power mounted, and especially after the Hitler-Stalin pact of 1939 sealed disillusion with Moscow, a lot of formerly ardent leftists cooled on the prospects for mechanistic social engineering. This faith was displaced by a chastened respect for the irrational component in human nature, and for the potency of mental states over material facts. In that climate, the jargon of psychology infiltrated the spaces left by a waning infatuation with Marxist accounts of art and culture. By the end of the 1930s, vaguely Freudian explanations of emotional life were common currency, and Sande need not have looked far for the pseudoclinical judgment he conveyed to Charles in 1941, that Jackson's "neurosis" stemmed in large part from "his childhood relationships with his Mother in particular and family in general." Sande identified some symptoms as "irresponsibility, depressive mania (Dad), over intensity and alcohol. . . . Self destruction, too."[37] Someone must also have noticed that relations with women were, if not a primary cause, then at least a good index of the young man's interpersonal difficulties. By the account of two girlfriends, Pollock could be a sweet, chastely tender, and hopelessly self-deluding romantic who proposed marriage unexpectedly and unrealistically; but numerous other witnesses paint him as violently vulgar and menacing with women.[38] Certainly he had little or no sexual experience when he arrived in New York, and he went through the 1930s unable ever to sustain a close relationship. It's unclear whether he ever actually bedded Benton's wife, Rita, but his frequent need to make this claim, as well as independent testimony, suggest in her "maternal" affection an erotic element that troubled his psyche.[39]

In any event, the more remarkable aspect of Pollock's personality may not have been the pathology but his ability to make so many people care for him in spite of it. His mean, volcanic temper could have him suddenly kicking dogs on the street, or shrieking abusive profanities, and a habit of destructive binges chronically required friends to collect him from hospitals or police stations.[40] Yet this boorish drunk had a shy and winning side that bred loyalty. Charles and Sande seem to have accepted early on that, from a combination of family obligation and love, they would always need to look after their problematic baby brother. Consequently their spouses, each in turn, had to share their apartment with Jackson; and Charles's wife, Elizabeth, dyspeptically assessed him as a lazy mooch who used an air of vulnerability as a manipulative charm.[41] But others were consistently, against all odds, convinced. First Schwankovsky encouraged him; then Benton in turn found himself and his family drawn to Pollock's "appealing nature," and recalled that "his personality was such that it elicited immediate sympathy."[42] After that, Siqueiros, and so on: time and again elders who saw a lot of people come and go found something special, and attaching, in this flawed young man.

For the second half of Pollock's life, however, this nexus of "amateur" support and friendship was to be supplemented by an intermittent line of professional counselors. The pivot figure between the two worlds was Helen Marot, an older woman who taught at the school where Charles had found work for Sande and Jackson as janitors. Marot had been an activist for social reform in her youth, but had then taken up the study of psychology, with a special emphasis on Carl Jung.[43] Sympathizing with Jackson, she helped persuade both him and Sande that psychotherapy could help resolve his problems. Sessions started early in 1937, but the behavior just kept getting worse, and in June of 1938 Pollock agreed to be admitted to a hospital for more drastic dry-out procedures and treatment. Three months of that brought only short-term improvement, and he went back to therapy, passing from one Jungian in 1939–40 to another from 1940 through 1943.

By then, his relationship with Lee Krasner, which began in 1941, had taken over as the prime stabilizing role in his life.

One concrete, immediate outcome of all the Jungian sessions was a letter from Violet Staub de Laszlo, Pollock's therapist in 1941, that succeeded in getting him a mental-illness deferment from the army. The longer-term effects can be (and have been) endlessly debated. Scrutinizing the drawings Pollock brought his first analyst (plates 39, 41, and 42), and worrying the broader question of Jungian influences on his painting, once fueled a minor industry of speculation and debate.[44] There's no doubt that suggestive buzzwords—"archetype," "collective unconscious," "integration"—swarmed in Pollock's thoughts, as they did in the heads of countless other artists in the late 1930s and early '40s. In American artistic circles, where Freudian chat seemed co-opted by the slick *amour fou* of Surrealists like Salvador Dali, the less sexy, more earnestly spiritual notions of Jung offered appealing reassurance that indulging private fantasy was a way to tap into august imagery of universal importance.[45] Pollock could have picked up these general frames of thinking, and turns of phrase, in a dozen different forms of dilution;[46] it would have been hard to avoid them. But nobody who knew him thought he was the type to read Jung in any serious way, and both of his analysts have said that they didn't discuss Jungian theories with him.[47]

What the counselors did provide him with, and what he seems to have had a boundless need for, was encouragement. He had known he was maladjusted for a long time, but it meant something positive for professionals to tell him it was okay, and that as an artist he could use his stumbling blocks for building. Learning to accept what he could not control became a leitmotif of self-reconstruction. Pollock's first analyst never tried to stop the drinking or otherwise "cure" him, but simply sought to be supportive; getting him to talk at all was a challenge, and looking at drawings together helped ease into it.[48] Pollock would naturally have been curious to explore these sheets—with an interlocutor unlikely to be critical of their ham-handedness or aware of their pilferings from other artists—in interpretive terms that linked their various animals, eyes, phalluses, and so on (plates 39, 41, and 42) to primal mental formations. But trying to move beyond such generalities, and to explain Pollock's art in terms of its references to Jungian concepts, is a dubious enterprise. The connections range from inconsequential to imponderable, with several trivial scribbles or ancillary details making plausible reference while the important paintings elude any persuasive link. The same is true for psychological or spiritual readings in general. There's always ambivalence as to whether Pollock was a student of his inner life, or its puppet—whether the works contain consciously coded references to doctrine or involuntary exhumations of predictable symbolic structures. But either way—the artist as illustrator or the artist as channeler—is a dead end; even at this crude stage, Pollock's art lay in turning available commonplaces into something personal, not vice versa.

Hard-drinking tough guy though he was, Pollock harbored—in addition to genuine psychological difficulties—a soft spot for mumbo jumbo. But while he may well have talked up shamanism or alchemy, and even nurtured some superstitions about ritual and healing, he never once suggested that this kind of thing shaped the way his paintings were made or should be understood.[49] (Mark Rothko, Barnett Newman, and others of the New York School, on the other hand, constantly made a point of evoking the authority of spiritual content for their art.) When Pollock's meanings are hidden, it's obvious. Images like *Bird* (c. 1938–41, plate 33), and all the like that followed in his first solo exhibition, of 1943 (e.g. plates 37, 52, 64–68), trumpet their connection to myth, archetype, and things primordial, with iconographies that invite source-hunting and with a sleeve-tugging insistence on big mysteries. But their version of the

29

unconscious—icon-driven and centered on dark oppositions or gloomy menace, to the exclusion of anything ludic—seems more impersonally of its time than revelatory of something unique to Pollock. Appealing to the "unconscious" in the early 1940s was what referring to "the masses" had been in the '30s, or what citing "entropy" would be in the '70s: a chant that summoned the cloak of some higher, universal authority to cover what often turned out to be a lot of dated art of local interest.

Early and late, Pollock was consistent in emphasizing that his art came wholly from within himself. It's too easy, though, just to point out that this is a myth—that anyone's "unconscious" is printed with the external structures of their time and culture, and only finds meaningful expression in language forms that are bound to be partly borrowed—without recognizing how the myth worked for him. It doesn't presume clinical expertise to see that his insecurities entailed some approach-avoidance (or, better, need-resentment) reactions to situations of dependency and figures of authority. Autonomy and self-reliance were Pollock's Holy Grail, in his head and in his career. Since he experienced such misery trying to submit to disciplines of learning for which he had no aptitude, the godsend, liberating idea for him was the one he got simultaneously from looking at modern art and listening to his therapists: the principle that art could ultimately depend not on acquired talents but on inner resources, no matter how disturbed that inner life was.[50] Marot and others may even have encouraged him to accept that his torments and unhappiness were the signs and fodder of his "genius."[51] But how to act on this? Internalizing the message after so many years of despondent self-flagellation, and simultaneously opening up to modern art after spending so long mired in hackneyed realism, forced a hunger for autonomy into collision with a period of maximum subservience to borrowed forms, especially from Picasso.

That authentic knot of conflict binds together the pastiched symbols of the early pictures. The critic Clement Greenberg (on whom more below) later remembered that at this time Pollock painted the kind of picture "that startled people less by the novelty of its means than by the force and originality of the feeling behind it."[52] Personal psychic energies are here vested less in symbols, or in conventional expressionist slashings and jabbings, than in a nascent and confused, but palpable, erotics of paint—squeezed, slathered and textured, pressed hard and plumped up. Thomas Hess later said of the early-'40s work,

He still takes the Big Subject as his premise; Birth, Love and Death are indicated on the canvas in rough images—an animal's head, a broken lance, eyes, the sun, a breast, "meaningless" steno-graphic signs. And then he proceeds to paint them together in a flat wall of living, opulent material. The "background" shapes become as interesting as the objects they enclose. The surfaces become mural instead of compositionally muralistic. Each part of the painting receives the same concentrated attention. Under an intense hail of strokes, the image changes and grows into a mass of crossing, shifting colors and ridges. It was as if Pollock had undergone a pictorial psychoanalysis which, by releasing his instinct for painting, had accomplished the intellectual solution to his Expressionist psychosis.[53]

Pollock the would-be sculptor seems to have found himself (in the literal and corny sense) around 1940 in the material life of his surfaces and his oils, and in the basic, making-mud-pies sense of being a painter.[54] But it was not, at first, a pretty sight. He used a lot of color without any eye for common interactions and balances, so that the palette, careening from dead grays and gloomy blacks to sickeningly pretty pinks, was consistently crude without ever becoming effectively expressive. Brushwork, too, had no "touch."[55] The primary word one would associate with these paintings, as with this period in Pollock's life, would be "struggle." Yet it would be facile just to presume that the pictures are mirrors that mime in paint his drunkenness, or wild irascibility, or wrenching emotional suffering. They were both more distant from his life (he didn't paint when drunk, and the studio seems to have been a place of concentration and calm

even in periods of upheaval) and more integral. They didn't just vent his sense of himself but turned back to alter it. Producing them, looking at them, and having others react to them changed him—and never more critically than in the early 1940s. When the wheel that had been nudged by the therapeutic permissions of self-acceptance was pushed again by encouragement from friends and peers, an engine of needy aspiration kicked into gear, and propelled Pollock, intractably uncured, from the troubles of lonely youth to the anomalies of productive maturity—a man fascinated by spiritual symbols, who was most articulate and fulfilled in handling raw matter; and a misfit whose mark in the world had to be made by manipulating some of the toughest social politics in town.

New Mentors and Motifs

In the 1930s, Pollock's closest supporters charitably indulged his crippling deficit of facility. (A kind adviser looking at his early work, Sande recalled, would have suggested he take up tennis or plumbing instead.[56]) Around 1939–40, however, that wincing tolerance began to give way to genuine interest. Bit by bit, people began to be drawn to him, not for the fragile, sweet side of his personality but for the aggressive force of originality that was finding its way onto canvas. In the summer of 1940, Jackson indicated his own uncertainty in the face of all this. "I haven't much to say about my work and things," he wrote Charles, "—only that I have been going thru violent changes the past couple of years. God knows what will come out of it all—it's pretty negative stuff so far."[57] Sande, however, who had seen Jackson's efforts since the beginning, was more impressed. "Jack is doing very good work," he had written Charles just a little before Jackson's letter. "After years of trying to work along lines completely unsympathetic to his nature . . . [he] is coming out with an honest creative art."[58] A year later, Sande still expressed deep skepticism that the emotional problems would ever be overcome, but

cited the creativity as even firmer cause for hope:

On the credit side we have his Art which if he allows to grow, will, I am convinced, come to great importance. As I have inferred in other letters he has thrown off the yoke of Benton completely and is doing work which is creative in the most genuine sense of the word. Here again, although I "feel" its meaning and implication, I am not qualified to present it in terms of words. His thinking is, I think, related to that of men like Beckmann, Orozco and Picasso. We are sure that if he is able to hold himself together his work will become of real significance. His painting is abstract, intense, evocative in quality.[59]

A fresh conjunction between assertive individuality on the one hand and receptivity to more sophisticated influences on the other was producing an unprecedented power in the work. Though this new integration emerged in the first years of psychotherapy, the most evident catalytic forces came from outside the consulting room; prime among them, in immediate personal terms, was the artist and sometime art writer John Graham, who around 1939–40 took over the role of mentor and guide that Benton had formerly filled.

Graham was another in the line of theatrical, self-invented characters who attracted the young Pollock, and he flirted with the occult in a way that fed Pollock's ongoing credulity. But his persona was constructed on a level of urbanity, and with a breadth of international associations, that Pollock had never experienced. From Russian origins and a military background kept exotically murky, Graham had apparently passed through all the right cafés and studios in Paris, and he brought with him an intimidatingly idiosyncratic vision of modern art, ballasted on the one side by arcane theoretical systems and on the other by anecdotal familiarity with the players. He also offered Pollock a new and highly instructive model of the artist's life in New York, involving circulation in high society and an adviser's role with rich collectors, far from the world of grimy garrets and the WPA. Given his wider sphere of reference and the luster of his connections, Graham's approbation carried a special

31

Fig. 13. Eskimo wooden mask, Hooper Bay Region, Alaska. University of Pennsylvania Museum of Archaeology and Anthropology, Philadelphia.

Fig. 14. Pablo Picasso. **Girl before a Mirror**. 1932. Oil on canvas. 64 x 51¼ in. (162.3 x 130.2 cm). The Museum of Modern Art, New York. Gift of Mrs. Simon Guggenheim.

authority and promise; and he was able to combine bohemian airs and worldly savvy in a way that apparently circumvented Pollock's defensive insecurities.[60]

It was Graham's 1937 article "Primitive Art and Picasso"[61] that prompted Pollock to seek him out; and when the two got to know each other, Pollock was led further into the nexus of relationships the article had proposed, between modern art's liberties, the abstracted forms of tribal art, and the depths of the unconscious mind. This might be seen as the third step in a progression: Benton had drawn on European Renaissance and Baroque art, for an ennobling of workaday American life; the Mexican muralists had added elements of indigenous, pre-Columbian imagery, and pushed toward more epic historical allegories; now Graham proselytized for a broader alliance between modern and tribal art of all kinds, as the base of a creativity concerned with ahistorical issues of psychology that linked the personal and the primordial. Graham collected African sculpture, and doubtless explained the formal links that joined it to the aesthetic innovations of early-twentieth-century Paris. But his broader interest in tribal fabrications as embodying immemorial structures of human thought, and a lost oneness with the elemental spirits of the natural world, also helped renew Pollock's involvement with Native American art.

The Indians of Pollock's childhood years in Arizona had dominantly been figures of indigence or of the tourist picturesque, but his early acquaintance with their lore, pictographs, and ceremonies had marked him. If part of his Western image was cowboy, the other part now increasingly became Indian—not so much via the tribes he had seen in his youth as through ethnological publications and New York museums.[62] The prime event was the large exhibition *Indian Art of the United States*, mounted by The Museum of Modern Art in 1941; Pollock went several times, and made sure to attend the demonstration in which Native Americans created an image on the

ground by "painting" with colored sands dropped from their fists.[63] But before that he had begun haunting the Heye Collection (now the National Museum of the American Indian) and the Northwest Coast and Inuit collections at New York's Museum of Natural History. The combinations of strong graphic rhythms, zoomorphic imagery, and myths of man-beast transformation in the art of these cultures had made a deep impression.[64] There's something disingenuous, then, in the remark he dropped in an "interview" (actually a fabricated question-and-answer statement) of 1944, allowing that "some people find references to American Indian art and calligraphy in parts of my pictures. That wasn't intentional; probably was the result of early memories and enthusiasms."[65]

Graham was also keen on a cause that would become a crusade in New York in the 1940s: the promotion of new American art as worthy of being shown—and purchased—on the same level as more established European modern work. To this end Graham planned one of the first "mixed" gallery shows, at McMillen Inc. in January of 1942. His new acquaintance Pollock was invited to take part, with a painting that was in some senses a homage to Graham's interests, and to his influence on the younger man: the swirling forms of *Birth* (c. 1941, plate 38) make unmistakable reference to Eskimo masks like the one Graham had featured in the 1937 article that had first piqued Pollock's interest in him (fig. 13);[66] and the other crucial presence in *Birth* is the main subject of Graham's article, Picasso. If the picture's torquing can be read metaphorically, it might be taken to conjure the natal pains not only of its newly self-invented author but of a fraught relationship of dependence, admiration, and envy that would keep Picasso at the center of Pollock's thoughts from then on. He had definitively broken with the defensive parochialism of 1930s realism and had accepted, in some conscious or unconscious echo of mythology, that the hero's way toward establishing the self led through a head-on battle with the biggest

Fig. 15. Pablo Picasso. **Guernica**. 1937. Oil on canvas. 11 ft. 5½ in. x 25 ft. 5¾ in. (349.3 x 776.6 cm). Museo Nacional Centro de Arte Reina Sofía.

monsters in the path. Picasso was the biggest of them all, and the crux of the confrontation came at a time when New York was filled with his presence. In 1938, The Museum of Modern Art had acquired the 1932 *Girl before a Mirror* (fig. 14), whose swelling erotic ripeness presented, with an armature of stunningly

Fig. 16. Pablo Picasso. **Head of Weeping Woman (study for Guernica)**. 1937. Pencil, color crayon, and gray gouache on white paper. 11½ x 9¾ in. (29.2 x 23.5 cm). Museo Nacional Centro de Arte Reina Sofía.

blunt black-line drawing, a vivid apotheosis of the kinds of anatomies American artists had been glimpsing in the pages of *Cahiers d'Art* for years. Then, in May 1939, *Guernica* was shown at the Valentine Gallery, along with related studies (figs. 15 and 16); and finally, the autumn of the same year saw the great Picasso retrospective organized by Alfred Barr at The Museum of Modern Art, which included the Museum's prize new acquisition, the *Demoiselles d'Avignon* (fig. 17).

Girl before a Mirror gave Pollock a lot to work with formally: its blunt contours, coruscating passages of thick paint, and raw juxtapositions of hot and cool hues gave the canvas long-distance impact and a surface life at once bitingly aggressive and creamily sensuous. The colors, the *pâte*, and the hieratic confrontation of the composition would echo through his images for years to come. The *Demoiselles*, too, branded itself in the painter's eye, not just for its mean psychic voltage but for the way its spiky linear energies violated the distinctions between volumes and space and gave the whole scene an irrepressible, discomfiting anima-

33

Fig. 17. Pablo Picasso. **Les Demoiselles d'Avignon**. 1907. Oil on canvas. 8 ft. x 7 ft. 8 in. (243.9 x 233.7 cm). The Museum of Modern Art, New York. Acquired through the Lillie P. Bliss Bequest.

leitmotifs in the drawings he brought to his analyst in this period (plates 39, 41, and 42).

Birth represents the facture of *Girl before a Mirror* yoked to the anatomies and space of the *Demoiselles* and devoured by the affect of *Guernica*; but it's both more and less than that. Pollock had jumped into modern art compulsively, in medias res, without any tutelage in Cézanne, Cubism, or any other founding disciplines.[67] When he set out to make a pastiche, then, he did it more awkwardly and less cleverly than a better-informed artist like Gorky, who had been following Picasso for years. But he did it out of a different kind of need, and with an altogether other urgency. Naked dependence and raw hostility tussle in his relation to the borrowed forms that empowered this image of new life emerging tortuously, against dominance and constriction. The picture could rightly be condescended to as clumsy, but it has an almost embarrassing force of exaggeration in the choked, spasmodic upheaval of its packed-in forms. Something authentic is at stake on that plank's surface, and it has a lot to do with the loud self-declaration of a latecomer playing catch-up, exposing a raw ambition unashamed to go over the top.

Formerly a *retardataire* realist going nowhere, Pollock landed in the public arena, with the McMillen show, as a young man on the run. And he acquired, in the process, a running mate who would be crucial in every respect to his future development. Graham had also selected Lee Krasner for the exhibition, and this young painter, who thought she knew most of her peers in the city, was struck by an unfamiliar name—Pollock's—on Graham's list. She was impressed when she saw his work, and the two quickly formed a bond.[68] Thus, beginning sometime in late 1941, Pollock entered what may have been the only truly intimate human relationship of his life. For the first time, just turning thirty, he experienced ongoing sexual fulfillment, and was able to share his art with a peer of his generation, removed from male-to-male competitive-

tion. But the key, transformative experience must have been *Guernica*. As the most notorious wedding of modern art and the mural form, it was the ideal vehicle for Pollock's transition from political issues, which had dominated his artistic milieu in the 1930s, into a new exploration of symbols of the psyche. Arriving at the end of a long period in which he (like other artists of his generation) had been caught up in debates between classical traditions and modern art, and between personal liberties and social responsibility, this painting was a huge machine for reconciling opposites. In a way that made Orozco look stagy and didactic, its violence roared off the canvas without any compromising bow to standard forms of narrative or allegory. It brought together myth-symbols of suggestive ambiguity (in the psychomachy of horse and bull) and a wrenchingly unequivocal language of extreme suffering (in the physiognomies, and especially in the preparatory studies). Pollock picked up both as

ness. She was a fellow "emerging" artist, but four years older, and ahead in advantages: a superior awareness of modern art, a good nexus of personal connections, and a greater pragmatic sense of how to succeed in New York. And she was willing to help. At the expense of her own work, Krasner poured her energy and intelligence into furthering Pollock's efforts, and added to his life an element of order that would be critical in the focused push toward recognition and success that began soon after they met.[69]

The effects of this change of life registered swiftly in the work. After the McMillen show, through a new-found contact with the aspiring artist Robert Motherwell, Pollock was introduced to the collector and heiress Peggy Guggenheim, who was about to open a new gallery called Art of This Century. In April of 1943, he and Motherwell showed some hastily made collages in an early show at the gallery,[70] and then he submitted a canvas to Guggenheim's "Spring Salon" the following month. A leap separates *Birth* from this picture, *Stenographic Figure* (c. 1942, plate 48; originally titled simply *Painting*). From sculptural to planar, from impacted to open, from strangled to voluble, from scraped crust to dancing filigree—there is an entirely new lightness of spirit, and way of working, in this wide-open and brightly colored image. The palette of turquoise, cream yellow, and red suggests a variety of sources that may have intervened. For the vibrant reds and the "shield" motifs that crop up in his work at the same time (e.g. plate 32), Pollock may have taken his impetus from the MoMA show of American Indian art. More telling, though, was the Joan Miró retrospective that immediately followed it at the Museum: the large flat color areas of Miró's work were impressive, and his phantasms offered an imagery of the erotic and the grotesque that was bizarrely removed from the hearty corporeality of Picasso's anatomies, with a freedom of shape and a wiry linear component that appealed. (The resonances of that Miró show continue to be felt in works Pollock did years later—see plates 49 and

50.) Finally, the spirit of Matisse, so unlikely a visitor to the netherworld of dark tribal mysteries and the deep unconscious, may also inhabit the high-key hues of this picture; Krasner was well aware of his work.[71]

Banishing any thickened surface paste, *Stenographic Figure* shows different ways of working overlaid one on the other, as if the picture were built up from off-register gels. A flat lay-in of shapes, angular and curved, has superimposed on it a bold alphabet of broad lines that either follow existing edges or create their own forms. Then the whole surface is covered with a teeming swarm of fine-line calligraphy in yellow, black, white, and orange, sometimes picking up existing vectors, sometimes detailing fingers or the back of a head, often suggesting writing or numerology, and generally setting the picture abuzz with a frantic infestation of spidery tics disconnected from the heavings underneath. It's a peculiar image, sometimes read as a reclining nude with her grotesque head to the left, against the black; but that gruesome cartoon profile is more plausibly seen as attached to a figure who makes a cross-armed gesture, stretching one big paw across a tabletop toward another vertical personage at the right edge.

The willed confusions of this eccentric, ugly-pretty picture introduce ways of visual thinking that will reappear, in different guises, for years to come. The definition of a form by the overpainting of a background; the dissociation of line from the task of binding an edge; the sense of *horror vacui*; and the layering from broad movements to an independent scattering of graffiti—all of these apply to later works like *The Moon-Woman Cuts the Circle* of c. 1943 (plate 52), *The Key* of 1946 (plate 109; this seems in many ways a reprise of *Stenographic Figure*), and eventually poured abstractions like *Alchemy* of 1947 (plate 126). But it's impossible to construct in this way any neat, consistent progress in Pollock's development. He seems to have experimented simultaneously, perhaps in the course of a canvas's realization, with a variety of

manners, ranging from liberated play to rigid schemes, and allowing for huge variations of palette and density. *Stenographic Figure*, for example, was really the picture that launched his career (Mondrian himself was the unlikely advocate who endorsed it, and insisted on its originality, when it was submitted to the jury for Guggenheim's "Spring Salon"[72]). But when this approbation led to Pollock getting a monographic show at Art of This Century the following November (through the heavy machinations of Guggenheim's adviser Howard Putzel[73]), he surrounded the picture with a very different kind of work.

The most ambitious new pictures of that first one-man show—*Male and Female* (c. 1942, plate 65), *Guardians of the Secret* (1943, plates 66 and 67), and *The She-Wolf* (1943, plate 68)—were darker in feeling, more hieratic, and much more congested, both in pictorial space and on their heavily reworked surfaces. For all the reckless courage of parts of its execution, *Guardians of the Secret* in particular seems freighted with an earnestly self-conscious urge toward a "big" picture of heavy portent, which overburdens the field with additive symbols and caked layers of pentimenti. Below the central slab (which, it's been noted, seems to show an upside-down frieze of stick figures[74]), Pollock principally defines the dog by painting a dark gray ground over a zone of looser scumbling below. The same over-under, smooth-turbulent relationships can be seen in *The She-Wolf*, where the canvas was evidently originally covered with thinned-out, multi-colored washes and spatters. (The picture also features Pollock's most prominently accepted early "accident"— a long drip of gray that daggers into the animal's neck.) These passages, like the episodes of "flung" paint in *Male and Female*, show that Pollock had already begun to include more free-form abstraction, and a broader liberty of material effect, as parts of his process.

In fact, in parallel with the mythic/symbolic personages and animals that dominated his first show, Pollock had already returned to the experiments with pouring, dripping, and spattering to which he had been exposed at the time of Siqueiros's workshop. One large canvas and two smaller ones from 1943 present brushed patterns of shape overlaid with skeins of line poured onto the surfaces (plates 61–63). The structures of these works are consonant with that of *Stenographic Figure*, but the final layer of filigree has now become more continuous, with poured passages of white as well as black setting up a more complex layering of rhythmic counterpoint to the brushed forms. As a form of "automatic writing," these cursive pourings—as opposed to the scrambled noodlings on *Stenographic Figure*—suggest a direct improvised "flow," without reference to ciphers or language.

By 1943, the concept of making art by "automatic" gestures—trying to abandon conscious control in order to allow unconscious areas of the mind to guide the hand—was very much in the air in New York. "Pure psychic automatism" was the royal road to fresh creativity espoused by André Breton and his Surrealist followers beginning in the 1920s. Graham would already have made Pollock aware of this in a general way, but with the emigration of Breton and others to New York after the Nazi occupation of France, the orthodox version of the doctrine became directly available. Breton himself remained aloof during his Manhattan years, but there arose within the local art world various "ambassadors," like Marcel Duchamp, as well as claques of junior emissaries, who were interested in effecting communication between local artists and the émigrés. In the circle of new acquaintances that Pollock and Krasner were meeting in the early 1940s, it was principally Motherwell and the Chilean artist Roberto Matta who espoused such contact, and proselytized for Surrealist ideas. Matta was a prize recruit of the Surrealists, with international flair, and Motherwell, a product of boarding schools and Harvard, had book learning and social skills in abundance, and a real eagerness to be an organizer. When these two asked around as to which young American

Fig. 18. André Masson. **Meditation on an Oak Leaf**. 1942. Tempera, pastel, and sand on canvas. 40 x 33 in. (101.6 x 83.8 cm). The Museum of Modern Art, New York. Given anonymously.

artists might be ripe to learn the latest Surrealist ideas, Pollock's name recurred on several lips as a prospect.[75] It was not a likely match of outlooks or personalities, but Pollock knew these men had things he needed—addresses, contacts, and information—and he joined up long enough to absorb, more or less silently, what he wanted.[76]

Pollock and Krasner fitfully tried their hand at the collective games of invention that were understood to be Surrealist devices for producing "automatic" poetry or pictures. But witty sociability and parlor games were émigré folkways unlikely to entrance Pollock, and automatism held only limited appeal for him. At the point where it would be most relevant to his use of fluid paint, Surrealist automatism involved the idea of "discovering" a figure in tangles of random, "mindless" doodling; but Pollock's first poured works seem to have been applied *over* existing figures, in elabora-

tion or partial camouflage.[77] As for specific visual sources, Pollock later told an interviewer that while he was "particularly impressed with [the Surrealists'] concept of the source of art being the unconscious," it was also true that the artists he most admired, Picasso and Miró, remained far from New York.[78] He was almost certainly interested, though, in the kind of liquefied figuration employed by the Frenchman André Masson, partially through "automatic" techniques of spilling ink and sand (fig. 18).[79] One senses in Pollock's adoptions from Picasso that he could not get comfortable with the full-bodied voluptuousness that marked, say, the Spaniard's erotic visions of Marie-Thérèse Walter in the 1930s; the master draftsman's sculpturally organic contours didn't translate into Pollock's flattened spaces and stiffened scenes. But Masson's looser line, which conveyed a dreamy sexiness that was more disembodied and indirectly evocative, had rhythms that were more adaptable.

Any such influences, however, were slow burns, not fully surfacing until years later, and hardly discernible at the time. The canvases in Pollock's November 1943 show were of their moment. The somber mien, the conjuring of atavistic myths, and the intimations of unknowable hieroglyphs all belonged to the climate of a period shadowed by war, and to an artistic milieu searching for an "abstract" subject matter evocative of matters of universal importance. Totems, lost languages, secret runes—all forms of cultural marking that "spoke" without naturalistic representation, and that appeared elementally close to ultimate human mysteries—were in favor with artists of the day who were looking for a way into an abstraction that seemed to keep a grip on significant content, as a hedge against accusations of arbitrary solipsism.[80] There have been innumerable attempts to decode these early Pollock images in terms of specific references and literal encoded meanings, but almost certainly the works were primarily intended to appear meaningful while not knowable. Gender figures of

formulas, and through the crudely labored laying-on of paint, that the sense of authentic violence came through.

The most purely "expressionist" painting of the period—the one done with headlong recklessness, virtually at a throw—is also the most astonishing of all Pollock's early works. But it didn't appear in the exhibition, because it hadn't been completed in time. In July of that year, Peggy Guggenheim had commissioned from Pollock a mural—on a subject of his choosing—to cover the wall of the entrance hall to her new apartment on East 61st Street. Pollock was excited by the prospect, and as soon as he and Lee could get the space (by surreptitiously breaking through a wall in their apartment), he put the requisite twenty feet of canvas on a stretcher (fig. 19) and prepared to go at it. Months came and went, however, and eventually the show passed without the work even being begun. With memories of *Guernica* in his mind, and with all the 1930s' ideological enthusiasms for the mural only recently gone to embers, some part of Pollock's soul must have been at least a little hesitant about committing this much time and energy to a huge decoration for an Upper East Side foyer. Besides, the notion of a subject was daunting. His easel pictures of the day were single figures or hieratic confrontations, but this long horizontal seemed to call out for the kind of narrative scene or complex crowd allegory with which he had no experience. Still, he resisted whatever temptations there may have been to fall back on the formulas of Benton or the Mexicans, and apparently never made even one trial sketch for the picture. Instead he rehearsed the possibilities in his head again and again, until finally, around New Year's Day 1944—under intense pressure to install the picture in time for a party Guggenheim had planned—he painted the whole canvas flat-out in one day and night. We

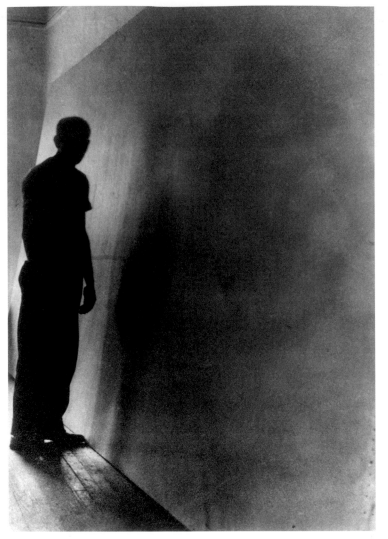

Fig. 19. Pollock in his apartment at 46 East 8th Street with the bare canvas for **Mural**, 1943–44 (dated "1943"; plates 70 and 71). Photograph: Bernard Schardt, 1943.

uncertain gender, writing that can't be read, enigmas inaccessible to the uninitiated—all were august mysteries that, like the oft-evoked moon, cast a spellbinding aura, but not enough light for detailed reading. (Three paintings in the first show had "moon woman" in the title; plates 37, 52, and 64.) The murkiness of the palette fit with this intent, as did the complex surface sense of buried layers. And all of this, of course, was the opposite of "expressionism" in any sense of raw venting from the spirit. It was despite the static

Figs. 20–22. **Mural**, 1943–44 (dated "1943"; plates 70 and 71), after the canvas was completed but before it was slightly reworked.

know from photographs (figs. 20–22) that there was some reworking afterward, but it largely involved only selective reinforcing of forms, and tidying up drips left to run in the heat of the execution. Otherwise the exploit stands. The story may provoke a reflex of skepticism—it smacks too much of legend, and seems astonishing in light of the complex organization of the painting—but it squares with the known facts, was corroborated by all those closest to the matter, and has never been refuted.[81]

Mural (1943–44 [dated "1943"], plates 70 and 71) was eventually included in Pollock's 1947 exhibition at Art of This Century, and appeared again in a show of large-scale painting at The Museum of Modern Art the same year. When Guggenheim dispersed part of her collection, though, she gave the huge canvas to the University of Iowa, and it has only infrequently been seen in international or big-city venues since its arrival there.[82] Perhaps for this reason, it is one of the least known of the artist's greatest works, and is insufficiently recognized for its extreme audacity and originality. It should properly stand with de Kooning's *Excavation* of 1950 as one of the most salient works of

fusion between the figure and abstraction in American painting; its uncoiling, leaping relentlessness rivals and complements the densely packed angularity of that picture. Tellingly in terms of their future work, de Kooning compresses a Picassoid vocabulary of the body down to a humid flesh-pit of volumes and joints, while Pollock agitates a less heatedly carnal tarantella of stick-figure vectors. The overlays and dissociations of the other early canvases—between broad planes and linear rhythms, between figure and ground—here become interlocks, with void and solid partnering in the snaking whorls. Each square foot of the surface is closely like each other square foot, yet there is inexhaustible variety; and, among the other presentiments of the poured canvases to come, the evident sense of top and bottom in this vertically painted frieze doesn't prevent it from being almost identically powerful when inverted.

This is the first of Pollock's works to address the viewer's body at a larger-than-life scale, but it's obviously made for up-close involvement, not for a billboardlike distant impact. The shallow, turbulent space resists our "getting into it," and the picture pushes its

rhythms outward. Within this wrap-around embrace, *Mural* also overwhelms by the explosive confidence of its rendering. All the scumbling, layering, and rigidity of other early work is massively blown away, and the brush rushes, bounds, and hooks across and through this brambled thicket with a coherent brio virtually unmarred either by rote repetitions or by slack idling. It's interesting to compare *Mural* with the subsequent "outtake" of its composition, *Gothic* (1944, plate 73), where the surface becomes roughly labored, the rhythms balanced, and a Picassoid sense of both matter and structure reemerge.[83] In *Mural*, by contrast, the echoes are—surprisingly—more of Matisse, in the scrolling arabesques and intimations of Kufic script. Still, despite this sense of psychic release and ornamented curvilinearity, the picture is not one that could easily be called joyous or "decorative." Pollock once talked about *Mural* in relation to stampedes in the West, perhaps recalling a brutal early experience when he saw wild horses cornered in a canyon and slaughtered.[84] And even without such specific references, there is a sense of thundering frenzy that might legitimately be associated with the war. It's in part because of this kind of uncertainty—an unstable amalgam of the destructive and the Dionysiac—that the picture seems to step so far beyond the more contrived ambiguities of the symbolic works completed just before.

Before he made this picture, as of Christmas 1943, Pollock was a novice with a good gallery and some hot word of mouth behind him. Seen with the cooler eye of retrospect, he was then, and would remain for several years more, a provincial. Yet for a moment in January, when he put down the brush after the concentrated hours moving back and forth across the twenty feet of *Mural*, and painting from the floor to as high as his reach would stretch, this man stood alone at the head of the class, not just in New York but internationally. He had redefined not only the parameters of his own abilities but the possibilities for painting, at a moment when the fortunes of modern art—and the prospects for a continued liberal ideal of modern culture—were at a nadir. There was nothing of this power and originality being made anywhere else in the war-plagued world that dim winter. And he had done it—doubtless somewhat in a spirit of desperation, having boxed out all other alternatives—by trusting himself, and leaving a lot to the inspirations that would come in the process of making.

As in all Pollock's best later art, the basic working concept was simple in the extreme, and menaced monotony. But the liberation from the demands of strict figuration—no worrying about clumsy feet or ill-drawn heads—and the escape from iconic symbolism had left him free to run on, for yard after yard, variants on a few basic motions, and to concentrate piece by piece from one end straight on across to the other, with a devil-take-the-hindmost disregard for composing the totality. The difficult thing to believe—but there stood the proof for all the doubters—was that this earnest striver, who was working so hard to make himself an Important Artist, could become a one-of-a-kind natural when he gave up on devising riddles, jumped over the insecurities and inhibitions, and let it happen. Give Putzel credit for thinking this might work; he had apparently suggested the commission on the intuition that some larger power was compressed in Pollock's easel paintings. The gamble paid off more handsomely than anyone, including Pollock, could ever have expected.

What's almost as surprising as the achievement itself, though, is that it didn't have a transforming effect on work from then on. *There Were Seven in Eight* (c. 1945, plate 74), done a year or so later, seems a conscious reprise of *Mural*, and might be considered more "advanced" because of the allover meander of surface loops and tangles (strongly suggestive of the work Pollock was doing around the same time with the printmaker Stanley Hayter;[85] see plates 93–101). Yet it seems static by comparison, with a more con-

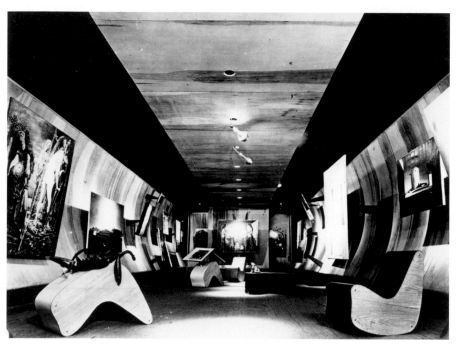

Fig. 23. Frederick Kiesler. Interior of Peggy Guggenheim's Art of This Century gallery, New York.

show had persuaded Guggenheim to put this thirty-one-year-old novice under contract, with a guaranteed stipend advanced against sales.[87] This allowed him to quit the custodial job he had taken at The Museum of Non-Objective Painting (later to become the Solomon R. Guggenheim Museum). The deal was an exceptional thing for a young American painter, and it bonded him to an eccentric dealer with an unusual gallery.

Peggy Guggenheim came from big money, was thoroughly familiar with the European art scene, and had led a flamboyant life that included marriage to the painter Max Ernst (a union just dissolving when Pollock came into the picture). Art of This Century (fig. 23) was experimental in two notorious senses: its willfully outré interior was designed, by the Austrian Frederick Kiesler, as an appropriately unconventional venue for Guggenheim's collection of modern art and for her dealings; and virtually uniquely in New York, it sought to present young American talent along with the more established Europeans she collected. This was definitely the bigger arena in which Pollock wanted to compete. The gallery was a somewhat "unprofessional" or "boutique" venture, but for that very reason attracted a lot of attention and a chic following. Increasingly disgruntled with the Europeans after her breakup with Ernst, and little acquainted with Pollock's generation, the doyenne drew a lot from Putzel, who was well informed and devoted to the new. He knew how the town worked, and those who counted knew he had a good eye; through him, contacts could be made with museum figures such as James Johnson Sweeney (who wrote the brief and generally celebratory notice for the brochure of Pollock's first show) and James Thrall

ventional "narrative" structure, episodic rhythms, and an obsessive space-crowding that now looks merely cluttered. A few cryptic notes suggesting that *Gothic* may have been conceived as part of a larger triptych are the only other indications that Pollock thought of carrying on from the exceptional point to which he had leaped in *Mural*.[86] But one can still assume that knowledge of this important anomaly traveled fast through the New York art world, and conditioned the way Pollock was thought about from then on.

Similarly, though that first exhibition at Art of This Century didn't sell well, the news that The Museum of Modern Art had bought a piece, *The She-Wolf*, must have moved like rogue electricity through the community of those who only a year or two before had been either ignorant or scornful of this upstart. Ever since Mondrian had put his support behind *Stenographic Figure*, Pollock's career fortunes had started a sharp climb. Putzel was convinced of his exceptional promise, and even before his first

41

Soby, both of whom were key in advancing Pollock's cause at The Museum of Modern Art.[88]

As this broader web of contact and interest built, Pollock's relationship with Graham became less central to his ambitions, and it was unclear—given his partnership with Krasner and the other guidance available to him—that he needed another mentor to take his place. For the new phase of his life now arriving, he would need critical voices who could solidify his standing in a milieu where, with increasing frequency, the call was being heard for a new American art to measure up to or supplant the European modern tradition made homeless by the war.

Greenberg

John Graham didn't initially share his "discovery" of Pollock with a broad range of acquaintances in the New York art world. When Krasner first saw the name on Graham's list for the McMillen show, and then went to seek him out, she found someone who hadn't moved much beyond a circle of friends formed in the days of Benton and Siqueiros. Especially in the coterie of New Yorkers who cared for advanced European art, Pollock still seemed a green autodidact.

Krasner made a point of breaking this isolation, introducing Pollock to de Kooning and other painters, including her teacher Hans Hofmann, and to a critic who had attended Hofmann's classes, Clement Greenberg. With the older, markedly European Hofmann there was apparently little rapport; Pollock curtly showed a put-up-or-shut-up impatience with his windy expositions. Their exchanges are remembered primarily for Hofmann's straight-man prompting of a classic one-line put-down: when he asked why Pollock didn't work more from nature, Pollock shot back, "I *am* nature."[89] Still, through the education Krasner had received, Pollock undoubtedly profited indirectly from Hofmann's ideas about painting and direct knowledge of the European modern tradition. From Greenberg he would have received some of the same ideas in variant

form, framed—as with Krasner, but in a very different sense—within a human and professional relationship of crucially sustaining importance. It is impossible to overestimate the role Krasner played in encouraging Pollock, keeping him together, informing his thinking, and promoting his progress. But it's easier to measure the parallel influences Greenberg exerted, for they often played themselves out in print and in the public eye. His friendship bordered at times on collaboration, and shaped both Pollock's career and the subsequent perception of it.

Greenberg started writing reviews for *The Nation* shortly before Pollock began showing at Art of This Century, and from the first mention of Pollock onward he became the critic who most assertively argued for the work's quality. Intensifying with each iteration, that support helped propel Pollock into a perceived leadership position among his generation. Several other critics wrote positively and sensitively about Pollock's work throughout the 1940s; in the end, though, Greenberg's critical vocabulary became so firmly attached to Pollock's art, and the painter's success in return so canonized the writer's judgment, that their two achievements seemed naturally bonded, in what has been venerated as a golden moment of synchrony between high-level critical thought and groundbreaking creativity.[90] But this story, remarkable in so many respects, also yielded narrowing dogma and a depressing denouement.

To his undying credit, Greenberg endorsed Pollock virtually unequivocally in the early 1940s, when this was anything but a sure bet. He didn't mind saying the early paintings were "ugly," because he recognized that the artist's disdain for taste was a plus.[91] He was also smart enough to defer to the work's unfamiliar force. "One has to learn Pollock's idiom to realize its flexibility," he said in reviewing the 1946 show at Art of This Century, "And it is precisely because I am, in general, still learning from Pollock that I hesitate to attempt a more thorough analysis of his art."[92] The

artist was, he later said, "in a class by himself," and had to be dealt with on his own terms. ("It is indeed a mark of Pollock's powerful originality that he should present problems in judgment that must await the digestion of each new phase of his development before they can be solved."[93]) Yet this humble learner also came to the task with a huge agenda he was determined to impose on the art at hand, whether or not it was even remotely appropriate.

Greenberg's theoretical baggage was marked by a long engagement with Marxism, and by an involvement with the Trotskyite debates over culture that had preoccupied a circle of New York intellectuals in the late 1930s. Having drifted from his earlier engagement with literature, he sought to use the pulpit of his articles in *The Nation* and *Partisan Review* to help push the visual arts along what he thought was the course demanded by a correct reading of modern history and modern culture. Culled from various piecemeal versions and glancing references, his vision might be sketched as follows. Up to the fourth decade of the twentieth century, art made in bourgeois society (especially in England, Germany, and America), under the conditions of modern industrialism, had been prone to an expressionism that Greenberg called "Gothic." This emotive stridency indicated a failure to cope with the stresses of capitalist modernity. What was now needed, instead, was an art of reason and balance that could rise above this emotional disorder. French modern art, a closed chapter because of the fall of France to the Nazis, was the heritage that needed resuscitation in America if the nation was ever to have an avant-garde worthy of the name. Cubism in particular provided the master model of discipline by which the new detachment could be achieved. Understood properly, its restraining rigor manifested itself in a concentration on the painting's surface that annulled pictorial depth. In this way an Epicurean repugnance for the messiness of loose emotions got linked to a belief that the self-acknowledged flatness of pictures

was a matter of historical destiny. "Tautness of feeling, not 'depth,'" Greenberg wrote, "characterizes what is strongest in post-Cubist art. The taking up of slack, the flattening out of convexities and concavities—the ambitious contemporary artist presents, supposedly, only that which he can vouch for with complete certainty; he does not necessarily exclude, but he distrusts more and more of his emotions."[94]

Greenberg declared that the easel painting—the framed "window" that had been the staple of trade in paintings for private homes—was doomed to die. "In this day and age," he revealed, "the art of painting increasingly rejects the easel and yearns for the wall."[95] He eulogized Mondrian in 1944 for carrying "to their ultimate and inevitable conclusions those basic tendencies of recent western painting which cubism defined and isolated," by pushing art "to the farthest limit of easel painting. Those whose point of departure is where Mondrian left off," Greenberg predicted, "will no longer be easel painters."[96] In elevating Pollock over Jean Dubuffet in a 1947 review, he praised the American by saying he "points a way beyond the easel, beyond the mobile, framed picture, to the mural perhaps—or perhaps not. I cannot tell."[97] But that closing pose of speculative uncertainty was disingenuous, for Greenberg was determined that this was the direction his protégé should follow. Pollock for his part was more than willing to couch his future in the terms his key supporter thought requisite. Hence the application for a Guggenheim Foundation fellowship, submitted in 1947 over Pollock's signature, but seemingly virtually dictated by Greenberg:

I intend to paint large movable pictures which will function between the easel and mural. . . . I believe the easel picture to be a dying form, and the tendency of modern feeling is towards the wall picture or mural. . . . The pictures I contemplate painting would constitute a halfway state, and an attempt to point out the direction of the future, without arriving there completely.[98]

The mural, of course, had been the prime vehicle of publicly oriented art in the 1930s; but now the form

would fill its social function in a more ingeniously indirect way. To achieve the "Apollonian blandness" appropriate to the new mural, Greenberg preached that painters would need to maintain a clear-eyed, hard-headed "detachment," and he warned that this would necessarily entail a painful separation from the mass of the unenlightened. In society at large, such aloofness meant eccentricity, "and eccentricity means isolation, and isolation means despair."

Isolation is, so to speak, the natural condition of high art in America.

Yet it is precisely our more intimate and habitual acquaintance with isolation that gives us our advantage at the moment. Isolation, or rather the alienation that is its cause, is the truth—isolation, alienation, naked and revealed unto itself, is the condition under which the true reality of our age is experienced. And the experience of this true reality is indispensable to any ambitious art.[99]

In a representative maneuver of the time, Greenberg thus sought to rationalize the gap between advanced art and "the masses" by crediting the lonely vanguard artist with privileged, personal experience of universal truth—in this case the "true reality" of the human condition under modern capitalism. With this neat jujitsu move, the problem was turned into the solution: the more one realized how miserably marginal and unappreciated the position of artists and intellectuals in America really was, the more one approached the broader realities of modern life.[100] As if reversing Henry's rallying call to his troops at Agincourt, Greenberg ennobled the embattled avant-garde as "we few, we unhappy few!"

Greenberg's ambitious, sweeping attempt to comprehend the trends of modernity and to drive the cultural fate of the nation gives him a special place in the annals of American intellectual life, and his pungent high-stakes writing about the importance of art has commanded an enduring audience. His emphases on the internal life of artistic traditions, and eventually on the self-referential nature of modern abstract painting, are often compared with the ideas devel-

oped by his fellow survivor from the leftist cultural wars of the 1930s, and the other dominant critic associated with Abstract Expressionism, Harold Rosenberg. (Playing on the German meanings of the two names, and the rival statures, the debate is often characterized as Green Mountain versus Red Mountain.) It's too simple, but not entirely untrue, to see Rosenberg as more concerned with issues of content and Greenberg with matters of form.[101] In an effort to translate the European modern tradition into new American terms, Rosenberg placed his faith in a kind of permanent revolution looking back to Dada and involving a series of anarchic individual gestures against convention. His stress was on action over reflection, and Pollock apparently felt (though Rosenberg denied it) that he himself had provided the principal impetus for the critic's much noticed 1952 essay "The American Action Painters," which stressed the existential, risk-taking, performative aspects of the new artists' headlong immersion in the act of artmaking.[102]

Greenberg loathed that essay,[103] and scorned Rosenberg's images of the autobiographical creator, as inconsistent with what he saw as the "high classical art" of the best drip paintings. Exactly to the contrary, he saw those works' progressiveness as necessarily grounded in elements of discipline absorbed from a past canon of style, and as focused by prohibitions against violating the essential nature of the medium employed.[104] Thus the innovative qualities of the drip paintings were for Greenberg "not altogether Pollock's own doing. . . . It is Pollock's culture as a painter that has made him so sensitive and receptive to a tendency [painting's move away from the easel and toward the wall] that has brought with it, in his case, a greater concentration on surface texture and tactile qualities."[105] It's perverse, given these emphases, that Greenberg wound up staking so much on the artist who was evidently the greatest rule-breaker of his time, and the one whose work was most potently evocative of spontaneous action; while Rosenberg wound up most

strongly identified with de Kooning, who of all his cohorts remained most intimately tied to European traditions (indeed Pollock liked to needle him for being a "French" painter[106]).

Greenberg's grand cultural vision, which ordained Pollock's art as the medium through which the historical inevitabilities of painting would realize themselves and the truths of the age would be revealed, remains a fascinating object of study in itself. There are major, deeply inconvenient problems with his ideas, though, and they are posed not by any rival critic or painter but by reality. In the early 1940s, Greenberg was searching for a hardheaded, skeptical artist apt to rid American art of its wild-man history, and to contend with modern urban realities through a revival of early Cubist structure and a push toward calming blandness. Instead he fell upon an unstable apostate of American regionalism who had come at the French tradition mostly through Picasso's work of the 1930s, who had little if any feel for early Cubism, and who was deeply, turbulently engaged with notions of atavistic myth and of the primordial fundaments of the unconscious mind. Greenberg's recognition of the anomaly—of Pollock's "Gothic, morbid and extreme" qualities, and of the "paranoia and resentment" in his art[107]—did nothing to alter the theoretical ideal the critic wanted the artist to fulfill; and there is a recurrent schizophrenia, throughout Greenberg's engagement with Pollock's rapid development, between his unbending certainty as to the kind of new art that was needed and his enthusiastic endorsement of the very different kind of new art emerging before his eyes.

About the things that seem to have been of most pressing concern to the young Pollock—sexuality, mystery, conflict, and metamorphosis—Greenberg remained silent or tolerantly dismissive. His visual characterizations of the early pictures were also schematic at best, and his selective judgments have not held up well over time. If Pollock's career had ended in, say, 1946, Greenberg's enthusiasms for

pictures like *Two* (1943–45, plate 80), *Totem Lesson 1* (1944, plate 81), and *Totem Lesson 2* (1945, plate 82), and his relative silence regarding *Guardians of the Secret*, *The She-Wolf*, *Mural*, and many other major pictures, would seem even more peculiar than they do now. Even later, when confronted with the visual feast of the poured abstractions, he could be more evocative of their potential deficiencies—the "over-ripe" decorative qualities of the aluminum paint[108]— than of the range of their positive qualities. Perhaps because of his residual mistrust of Surrealism, his reviews never focused attention on Pollock's exceptional new way of working with poured paint. Typically, his responses involve forceful but unexplained pronouncements of quality or weakness, salted with ennobling associative references to past greatness, usually involving Cubism.

Despite Greenberg's reputation as the arch "formalist," he actually wrote little specifically formal analysis of Pollock's art. What presses out instead is the Hegelian historicism, the overriding, predetermined notion of what *should* be happening in history, a notion that—to put it euphemistically—"conditions" what he writes. Moreover, it's not only the particularities of Pollock's art that seem narrowly accounted for, but the realities of the society that Greenberg addressed and summarized. American life doubtless had its quotients of "dull horror" and emptiness in 1947,[109] and some forms of alienation were indeed among the salient spiritual truths of the epoch. But to point to these intuitions of the intellectual's complaints as the ultimate, essential verities at a moment when a world war against totalitarian powers had just been won, when prosperity had returned after the bitter years of the Depression, and when an enormous boom in new births apparently signaled a groundswell of confidence and relief, demands a singularly determined focus. And if one does hold these to be the "true reality" of the age, it takes an even more exceptional optic to see Pollock's poured abstractions—or the earlier

mural he painted for the Guggenheim apartment—as subsuming them into the "bland, large, balanced, Apollonian art" that Greenberg yearned for as the best expression of the time.

The charmed partnership of these two ambitious men ended badly. On the printed evidence, Greenberg can hardly be accused of deserting Pollock in the mid-1950s, when the painter's inspiration began to flag; he stayed with his chosen winner long after others fell away. But after years of unremitting boosterism, Pollock was ultrasensitive to any slackening in the intensity or exclusivity of Greenberg's conviction, and the critic's perceived cooling exacerbated the anxieties that drove the artist deeper into the bottle.[110] After Pollock was gone, Greenberg claimed the role of arbiter in identifying his proper legacy. In the late 1950s and early '60s, with fresh odors of money in the air—for lucrative dealer-contracts and collector loyalties were increasingly at stake—the critic became the king-maker, anointing those who he claimed were taking up from Pollock the banner of painting's necessary progress. True to his idea of high abstraction as built on refusals and narrowing, Greenberg saw the only legitimate outcome of Pollock's poured paintings as further refinements and purifications, specifically in the stained canvases of artists like Helen Franken-thaler and Kenneth Noland, and in the Color Field painting of the 1960s. His theory of modernism having by then crystallized into an explicit argument that each medium was destined to recur to its "essential" nature, that theory could tolerate no illusion or inti-mation of space to sully the flatness of the surface—even if Greenberg himself continued to favor painters like Jules Olitski, who did not always fulfill his espoused ideals.

Having picked Pollock helped give Greenberg power. This and his role as a paid adviser gave his opinions an extra weight of intimidation for the artists whose careers he attempted to steer. Yet despite a brief run as a tyrant of taste in the early 1960s, he never

again found any way to force a synchrony between his ideas of what ought to happen in artistic innova-tion and what actually transpired. Nor has history been kind to the premise that Pollock's innovations should be positioned as imperfect, transitional proto-types for anything, least of all 1960s Color Field paint-ing. Perversely, Greenberg's dogmatic ideas of the fated course of painting instead succeeded in reverse: these reductive "formalist" schemas provided such an appealing and useful target for the next generation of historians and critics that, by being endlessly refuted and debunked, they assumed a "posthumous" impor-tance out of all proportion to their actually marginal relevance to the generative precepts of modern art. Even so, especially among those who ritually bewail the "Greenbergian hegemony," the model of his con-fidently twinned imperiums—defining quality by undefended declamations of taste, then rationalizing these by theoretical constructs of historical inevitabil-ity—has continued to exert a mesmerizing force. So, too, has his notion of mandarin elitism as an authen-tically progressive leftist position.

Perhaps this is as it should be: it's not the form of Greenberg's ideas but their affect—the sheer force of his arrogant conviction—that becomes his endur-ing legacy, because this is what mattered all along. In some senses there's a parallel here with the early paintings that brought Greenberg and Pollock to-gether: the apparatus may seem rattling and dated, but the feeling that comes through is authentic and transforming. "His confidence in his gift," the critic said of the artist in 1949, "appears to be almost enough of itself to cancel out or suppress his limita-tions."[111] The absolutism of Greenberg's obiter dicta—"the strongest painter of his generation" (1945); "the most original contemporary easel-painter under forty" (1946); "one of the major painters of our time" (1949)[112]—crucially fed the iron pride about superiority in painting that Pollock formed as a counterweight to his dogging personal insecurities. Greenberg vali-

dated him, gave him a pedigree, and goaded him on, especially toward bigger scale and more thorough-going abstraction.[113] Marx once said that the point was not just to understand history but to change it, and it's in that sense that Greenberg may have remained truest to the faith: for all the problems with his ideas about what should happen, he helped enable what did happen. He wound up wrong in most of the ways he wanted to be right, in part just because he turned out to be stunningly right in the most important way of all: Pollock *was*—for reasons that had little to do with Greenberg's rationales—the most telling artist of his generation. And Pollock thoroughly scuttled the critic's linear, determinist vision of history. On the side of inheritance and on the side of influence, his story is one of fertile impurities, improper hybrids, and unexpected idiosyncrasies, grounded in a body of work that no more fulfills some logical destiny of the past than it offers only imperfect preludes to future refinement.

Technique

Lee Krasner thought Pollock's emotional problems would ease if he were away from the familiar stresses and favorite bars of the city; so in 1945, after a summer visit with friends on Long Island, she persuaded him to move there. The timing was right: with a guaranteed stipend from his contract, and a widening circle of favorable opinion among critics and museum figures, Pollock felt he didn't have to be in the city to keep his career progressing.[114] He also loved the idea of being near the ocean, which he saw as the East Coast equivalent to the broad-horizon spaces of the West.[115] Eventually a house was found several miles from the center of East Hampton, with a small outlying barn and a few acres of land running down to Accabonac Creek. The couple floated a loan from Peggy Guggenheim, bought the property, and after getting married in October (on ultimatum from Lee[116]) moved to The Springs to live. This was a commitment to isolation:

Fig. 24. Pollock in his Model A Ford. Photograph: Hans Namuth. © 1998 Hans Namuth Ltd.

the city seemed far away, no friends lived in the area, and for the first couple of years—until Pollock bought a Model A (fig. 24), in 1948—they either walked or bicycled to get around. For a while, their life was Spartan, absorbed in cleaning the place up and making it livable; the house had only coal stoves and cold water until 1949.[117] The first year Pollock worked in an upstairs bedroom, often on the floor; *The Key* (plate 109) still bears the impress of the boards. By the summer of 1946, though, he had moved the barn and refurbished it to serve as a studio. And in that new space he began painting on the floor in a different way, dispensing liquid enamel paint directly from the can or with sticks and stiffened brushes. This changed everything.

Pollock had spent over seven years wrestling with Picasso and a few others, in an effort to charge his paintings with meaningful content and potent symbols. Those struggles would now be left in abeyance. "How?" would take over from "What?" as the prime point of genesis. Changing his self-awareness from a search for buried icons or totems to a reliance on

more pragmatic instincts about how it felt best to work, Pollock would unblock the way to a fundamentally personal, original art. And a great deal more.

The concatenation of decisions that flowed from Pollock's new praxis—the abandonment of an image in favor of a dispersed, omnidirectional network of incident, the supplanting of brushwork by an orchestration of "untouched" material—has continued to produce reverberations in and beyond painting ever since. As much as Duchamp did when he mounted a bicycle wheel on a stool or submitted a urinal to an exhibition, but with an altogether different spirit, Pollock in 1947 ruptured the existing definitions of how art could be made, and offered a new model of how one could be an artist. Spontaneity and chance, previously left lurking in either Dada nihilism or the musky netherworlds of the Surrrealists, were now brought forward into daylight as tools of concrete engagement with materials and the act of making, and submitted to a dialogue of control from which every trace of didacticism or stock symbolism had been expunged.

There is no grand incident to mark this passage— no legendary effort or single "breakthrough" picture, as with the *Mural* a few years earlier—and no letter or witness account exists to open an angle of insight into exactly when, in what frame of mind, or with what doubts or anticipations the key moves were made. In the unheated barn room, over the prime painting months of the summer and early fall, apparently with no fanfare and little or no external encouragement, Pollock enacted a series of decisions that would allow him to break with his formulas and once again step beyond his peers, and that would eventually also open entire new terrains of possibility for creators in every medium. Before the leaves fell, he had profoundly altered or even obliterated the concept of painting handed down within the Western tradition, reinvented it as a different kind of activity and object, and established a new "point of no return" within

the modern reconfiguration of culture's relation to its audiences.

Asked that year to contribute a statement to a magazine Motherwell was launching, *Possibilities*, Pollock said nothing about his paintings and dwelt almost exclusively on the manner in which he made them. His phrases record a moment of transition, addressing the methods of works already accomplished, like *Shimmering Substance* (with paint troweled on; 1946, plate 112), but also announcing key aspects of innovations to come. Even though none of what would be called the "drip" or "poured" pictures had yet been shown (and none were reproduced with this statement), he wanted it known that he had begun working in a way that was distinctly personal:

My painting does not come from the easel. I hardly ever stretch my canvas before painting. I prefer to tack the unstretched canvas to the hard wall or the floor. I need the resistance of a hard surface. On the floor I am more at ease. I feel nearer, more a part of the painting, since this way I can walk around it, work from the four sides and literally be *in* the painting. This is akin to the method of the Indian sand painters of the West.

I continue to get further away from the usual painter's tools such as easel, palette, brushes, etc. I prefer sticks, trowels, knives and dripping fluid paint or a heavy impasto with sand, broken glass and other foreign matter added.

When I am in my painting, I'm not aware of what I'm doing. It is only after a sort of "get acquainted" period that I see what I have been about. I have no fears about making changes, destroying the image, etc., because the painting has a life of its own. I try to let it come through. It is only when I lose contact with the painting that the result is a mess. Otherwise there is pure harmony, an easy give and take, and the painting comes out well.[118]

From the first display of the new paintings, in January 1948, a sense of the unorthodox way in which they were made—the apparent absence of "touch," the entertainment of chance, the spatter that seemed to indicate recklessness—captured the public imagination. And after 1950, when photographs and films of Pollock painting were widely disseminated, imagery of process became inseparable from considerations of the final product. Over the years, ideas about means and meaning have typically gotten fused, and art students

have routinely learned that this method of making constituted one of the most radical innovations in the development of twentieth-century art. Yet despite all the theoretical speculation that "dripping" has generated, we still understand imperfectly how he actually did it. William Rubin long ago contributed an exacting, thorough analysis of the roots and affinities of the resulting paintings, identifying their direct and indirect connections to aspects of Impressionism, Cubism, and Surrealism.[119] Still, between the abstracted fascination with the act that descends from Rosenberg, and the abstracted attention to form that descends from Greenberg, yawns an immense gap begging to be filled with better empirical knowledge about the basic mechanics of the "drip method."

Certainly there's been no dearth of claims as to where it came from. Max Ernst thought Pollock had stolen it from him,[120] and, as Rubin has detailed, poured paintings by a host of major and minor artists associated with Surrealism could claim priority.[121] But the internal history of spatters, drops, and liquid skeins in Pollock's own work goes back at least to 1943, and even to the Siqueiros workshop six years earlier. In any event, the plethora of possible sources makes any one of them less critical, and the particular ways Pollock used fluid paint—the orchestrations of quantities, speeds, rhythms, and densities that constitute everything in his expression—look like nothing secondhand. Even the conceptual link to Surrealist automatism, which is undeniable and which Pollock doubtless recognized, needs qualifying: Breton's adepts had used dribbling or cursive doodling as a way to conjure an image, while Pollock—as Pepe Karmel makes clear in his study in this book—tended to work the other way around.[122] In his fully developed drip method, he may sometimes have started with a loosely cartooned figure or animal, using familiar motions of rendering like an athlete doing warm-ups or a musician running scales; but he then built more free-form returns over this opening matrix as a way of dissolving the

imagery into abstraction. The only moment when he comes closer to orthodox Surrealist procedures is in the black paintings of 1951, where images do emerge (plates 205–10), and in the ink drawings begun months earlier, where (as Bernice Rose discovered) partial blots from one work were systematically used as the stimulus for another (plates 201–4).[123]

It's mechanistic to assume that the new studio fostered the new style—the space wasn't that much larger than others he'd worked in, and in any event the initial drip paintings were modestly scaled—but it would also be wrong to belittle the influence that external factors, from the new contact with nature to the end of the war, may have had on Pollock's decision to change the way he worked.[124] Whatever prompted it, the style certainly didn't evolve logically or organically out of the previous year's efforts. It's only with hopeful hindsight that we could construe any premonitions out of the blousily Matissean, semi-figurative paintings in the "Accabonac Creek Series" (plates 106–9), with their cheery thinned color; or out of the congested impastoes grouped under the title "Sounds in the Grass Series" (plates 110–13). The latter, like *Shimmering Substance* (plate 112), are usually cited as the jumping-off point for the next phase, because of their abstraction and emphasis on an allover distribution of painterly energies. But there's a lot in those troweled and incised pictures (like the "writing" in *Croaking Movement*, plates 110 and 111) that looks backward, and the leap is huge between their often finicky cuisine and even the crustiest accumulations of dominantly poured paintings like *Full Fathom Five* (plates 116 and 117) or *Sea Change* (plate 118) in 1947.

These latter, and additionally *Galaxy* (1947, plates 114 and 115), involve pouring as a final layering over previously built-up compositions, and may represent the only truly "transitional" works. In *Full Fathom Five* we can see how Pollock used the poured paint as a binder to develop a surface crusted with dropped 49

accumulations. Clusters of nails, a key, a garland of thumbtacks (their points bristling outward, porcupine style), buttons, coins, paint-tube tops, and a cigarette are all prisoners intentionally sealed within this tar-pit surface. X-rays taken by The Museum of Modern Art's Chief Conservator, James Coddington, suggest an initial top-to-bottom figure in the picture; subsequent layerings of paint and detritus may have responded to its legs-torso-head shape, until alternating layers of thickly applied oil and poured silver or black enamel left little trace of its generative structure.[125] The give-and-take, in which each new campaign of elaboration responded to the givens already on the canvas, seems to have continued to the end: earlier pourings play off the heavily slathered relief of oil paint (especially whites), while the final squeezed-out or brushed strokes of yellow-orange and mustard at the upper right take as their framing element a coiling loop of dripped black enamel.

Such pictures lend some credence to Motherwell's later suggestion that one of Pollock's routes to abstraction involved making whole paintings from passages of paint that had begun as gestures of cancellation or eradication.[126] Otherwise the loop-the-loop structures of the earliest drip work, and the recoil at the edges, may have a closer affinity to previous drawings (plates 102 and 104). In any event, the new manner seems to have been less a linear step ahead than a shuffling of the deck, involving a recursion to earlier experiments and a shift in emphasis by which what had been a secondary mode of elaboration became the principal way of building the picture. This takes nothing away from the boldness of the decision to change. Pollock had a solid career in progress, and (especially as he was shifting galleries in 1947) it could have been held an inopportune moment to rock the boat so severely. But the commitment, and conversion, hedged no bets.

When the poured paintings did get underway, the manner arrived full-blown, and then showed no standard, linear development over the next three years.

One of the smallest and earliest canvases, at roughly 19 by 14 inches and dated 1946 (plate 105), is generally consonant with one of the largest and last, in 1950, at almost 9 by 17½ feet (plates 180 and 181); and in between, works of widely varying sizes and formats are remarkably coherent in manner. This means that countless adjustments had to be made in order to reinvent the procedures, again and again in different dimensions. Gestures made within the compass of the wrist had to be translated into stretching sweeps at the maximum of the arm's reach, and vice versa. Webs spun over four feet had to be made proportionally equivalent to parallel passages of a few inches. Paint had to yield a similar line quality whether made to drizzle in toothpick thinness or thickened to hold together in broad ropes. Hence the naturalness and spontaneity of making, and the "life of its own" to which Pollock claimed to respond in each painting, existed within unspoken rules that determined, with variable but constraining parameters, what to exclude, how far to go, and when to stop, in order to stay within the basic "look" for which the artist carried a general template in his mind.[127]

After the consistency of these works, though, the other salient factor is a variety that gets slighted when we treat the "drip period" as a catchall notion. It's perverse that, picture by picture, the singular masterworks of this manner have often received less published scrutiny than early chestnuts like *Bird* or *Male and Female*—implying by default that a general account of the method could suffice for the body of these abstractions. Yet the individual paintings of 1947–50 were conceived in palettes that run from somber to gaudy, with surfaces that go from fudge to spun sugar, and in a range of emotional idioms—dark and light, snarled and nebular, aerated and choked, liquid and gritty. They are also more internally varied, as regards relations of edge to center and differentiations between sections, than the common notion of allover abstraction implies; and they were fabricated

in more heterogeneous ways. Brushwork is sometimes found, for example, both in the early laying-in of the pictures and in smaller accents or adjustments applied late in the game to fine-tune their appearance (see, for example, the dispersed spots of color accent in plates 118 and 125). Relationships of wet and dry, or matte and glossy, have critically different permutations (see plates 122, 145, and 179), and solid forms often counterpoint the general liquidity in important ways: among the pictures' signature devices, for example, are elongated "tadpoles" or spermlike shapes, standing in relief off the surface, and apparently made by squeezing oil paint or gesso from a tube with one "head" spurt and a long-stretched "tail" (see for example plates 122, 124 and 125, and 138 and 139). As for the spontaneity of the works' making, the gamut runs from work apparently done wet-on-wet, in one session, to canvases that seem to have been reworked after they were stretched,[128] with room in between for many where one layer was allowed to dry (and the picture may have been moved from floor to wall for study) before subsequent layers were added.

Finally, of course, the drip paintings are far from uniformly successful. This way of working flirted with countless possible pitfalls, where assiduous color mixing could just yield mud, linear dynamism could get lost in splotchy, airless overpouring, and the desire for allover articulation could lead to either fussiness or monotony. Krasner later recalled, still with an air of befuddled astonishment, that Pollock had on one occasion asked her about a work in progress, not simply whether it was good or bad, but "Is this a painting?"[129] Like many other modern artists before and since, he was drawn to explore edge conditions, extreme boundaries where coherence might give onto its opposite, and where fullness of meaning and total emptiness rubbed against each other. From time to time in 1948 and 1949, Pollock experimented with ways to relieve these problems by reintroducing figurative elements, in either animal (plate 147) or human

(plates 148 and 149) form, through cutouts (plates 148, 149, 154, and 155), or simply by establishing a field of bounded, filled-in shapes, as in *Summertime: Number 9A, 1948* (plate 146) and *White Cockatoo: Number 24A, 1948* (plate 140). The most dramatic and successful of these endeavors was the reconsideration of an already mounted 1949 painting, from which Pollock excised and then partially in-painted a cluster of biomorphic, Miró-like forms that create a dancing counterpoint to the densely woven congestion of the poured surface (*Out of the Web: Number 7, 1949*, plates 154 and 155).

One reason to mount a retrospective exhibition is to allow better comparative study of these commonalities and differences. But a priori, both aspects point to a high degree of self-conscious control, and to the general importance of both preconception and reflection as a balance to improvisation. Perhaps dogged by his early statement about being unaware of what he was doing when he worked, Pollock later protested, on virtually every occasion when he had a chance, that he really was the master of his means. He realized that (especially for an American audience that valued labor and craft in art[130]) the perception of the pictures as too easily made, without skill or discipline, encouraged their dismissal as emptily chaotic and arbitrary. Hence it was important to him to deny the role of the merely accidental in his work, and to insist that, through the web of decisions and reflections involved in building the picture, he eliminated what he did not want and chose what he did, turning the dialogue with chance into a matter of will and control. Yet the countless incidents of puddling or spattering that were manifestly ungoverned when first created encouraged even the most serious critics to celebrate the apparently spontaneous, heedless aspect of the process; and the generalization still persists. The dancelike movements and distant throws in Namuth's photographs have imposed a narrowed notion of what "dripping" entailed. Those actions were part

51

of the realization of one or two exceptional pictures, near the massively confident culmination of Pollock's three-year engagement with this manner. We have to look deeper into the filmed record, and into the evidence of the paintings themselves, to be reminded how often the application of fluid paint entailed a variable-speed, calligrapher's control of thicks and thins, manipulated in close quarters at only the tiniest separation from the canvas, and with a near-obsessive meticulousness (see for example plates 134 and 161; see also fig. 31).

Even within the moment recorded by Namuth (late summer and autumn of 1950) there are fundamental, instructive variations in the basic conceptions of line, shape, and meter among the three immense masterpieces Pollock realized in swift succession: the heavily muscled, black graphic attack of *Number 32, 1950* (plates 178 and 179); the blonder, denser, more lyrically curvilinear nimbus of *One: Number 31, 1950* (plates 180 and 181); and the opened-up but simplified and "jointed" cadences of *Autumn Rhythm: Number 30, 1950* (plates 182 and 183). E. A. Carmean has analyzed in depth the dialogue between these three paintings and their predecessors, pointing out links of form and method with previous works, and noting the combination of maximum expansiveness and partial recoil that moved these wall-to-wall creations beyond the extreme point of allover "pulverization" and saturated fine-grain interlace that had marked *Lavender Mist: Number 1, 1950* (plates 174 and 175) earlier that same year. The same kind of close comparative analysis, over a broader range of the paintings from 1947 onward, will confirm that what appeared to many initial viewers as a heedless, anarchic surrender to sloppy accident was in fact an intricately ordered constellation of methods—opening onto large areas of improvisation, responsive to mid-course adjustments, but shaped by discernible "rules," sharp knowledge of the variable properties of materials, and finely tuned physical skills.

Such close-order looking might also help refine the vocabulary we use to describe what's happening in the drip pictures. Long ago, for example, Michael Fried contributed an influential description of the radical nature of their line, "prized loose from the task of figuration" in such a way that it "does not give rise to positive and negative areas" and has "no inside or outside." Divorced from "bounding shapes or figures, whether abstract or representational," Pollock's poured line becomes for Fried "entirely transparent both to the non-illusionistic space it inhabits but does not structure, and to the pulses of something like pure, disembodied energy that seem to move without resistance through them." In this way, "The materiality of his pigment is rendered sheerly visual" and the pictorial field becomes wholly "optical," as distinct from the "structured, essentially tactile pictorial field of previous modernist painting."[131] But many major drip paintings are not in fact dominantly linear, and show instead an overlaid, often choked or clotted interplay of splashed field elements, where shape plays a telling role (e.g., plates 119, 132, 133, 146, 156, 158, 168, 170, and 176). And even where this is not the case, such a general idea of "line" levels the variations from filament to delta in a given vector, the scales of low and high relief, the different viscosities of enamel and oil, the edge qualities of soft bleeding or fringed leakage, and the seamless continuums that bind stretches leading onward to reservoirs of puddling and marbling—not to mention the fields of splotches, blobs, pointillist spatters, and droplet spots that sometimes trail and other times under- or overlay the webs, combs, nests, dendrites, and nebulae that line clusters conjure. All these things give the surfaces, especially at any close viewing range, an immense impurity that appeals not just to a sense of things grasped and released but to sensations of weight and volumetric swell and ebb, wonderfully corrupting the border between line and form and evoking a space of indeterminate depth with concrete, physical associations

well beyond the firings of the disembodied retina. A fuller formalism, applied to such works, would need a greater empirical inventory of effects, and perhaps as many words for "line" as the Inuit legendarily have for snow.

In *Number 1A, 1948* (plates 138 and 139), for example, both directional movement and surface relief arise dominantly from squeezed, solid spurts, darts, and stretched cords of yellow, white, and red laid over an initial scrubbing-in of sootily matte passages of black—cloudy in places, but in others vigorously linear—done with brushes, rags, and (ostentatiously, at the upper right) directly by printing with the hand. The black, white, and silver enamels poured over these bases are cast in fine, crisscrossing returns with frittered edges that never generate a dominant vector of their own, and leave a great deal of the canvas showing through, especially along the upper edge. The net result, despite the passages of puddled and marbled white and silver that are apparent close up, is a relatively dry, brambled tumbleweed, strongly dependent on the play between the elongated straight-line masses of oil and the spinning confection of drip. A variety of rhythmic accents (notably in the repeated beat of the handprints), like the variety of hues, merges into the roughly two-winged shape of what Alfred Barr called the "luna park" of overall incident.[132]

This work's neighbor in the permanent collection at The Museum of Modern Art, *One (Number 31, 1950)*, seems at first to have a similar overall tonal range yet is made in a strikingly different way. The picture is now entirely poured, without any initial lay-in, and includes no elements of squeezed or brushed paint to provide temporal accent or physical third dimension. The directional energies, accordingly, are all the product of the pouring itself, and—particularly in the recurrent, looping verticality of several black passages that stride across the field—are crucial to its more epic, sinewy pulsings of energy. With a similar but more uniform "reserve" of revealed canvas along the edges, *One* has both a more constant pizzicato of spattering in its open areas and a center more densely concealed, by an amorphous "field" of beige-green—a softer foil that allows the interlace of smoothly viscous and nimble pourings of black and white to become the dominant "figuration," and that lends the picture its impact of combined explosive riot and nebular filigreed suspension. Rather like Monet's series pictures, drip canvases like these two do have a strong family resemblance that encourages us to talk of them in terms of an ensemble, or a period. But each also involves a response to a different internal "weather," and develops a precisely varied orchestration appropriate to its scale and ambitions, as the "method"— how much, what kind, when, for how long?—is reinvented at a million different moments along the way.

Beyond knowing exactly what it was, though, we would also like to know what the drip method meant—what affect was associated with this way of painting, and what psychological resonances it bears. In fact the Pollock literature is imbalanced between a relatively slim and often inaccurate quantum of information on the process and a richly nourished tradition of interpreting it. This is not because there's any mystery about these works, in the stage-prop sense of the early pictures. The whole story here is on the surface, which has a concrete, matter-of-fact physical presence that overrides any reference to things absent. Krasner said Pollock once mentioned "veiling the figure," and that phrase has sometimes been taken as a clue to secret, symbolic figuration that was—in the terms of dime-store psychologizing—"repressed" by using pouring as a cover-up. But Pollock's phrase only referred to one 1944 painting with obvious figures and "veils" (see plate 74),[133] and extending it forward is just one more dubious instance of reading the clear imponderables of the mature work through the contrived illegibility of the early. The way some drip abstractions may actually have started with loose figuration (e.g., see figs. 30–32, p. 107, 86, p. 121, and

88–89, p. 122) is an issue of pragmatic method, not deep meaning.

Pollock worked away from the figure as an act of opening-up, not suppression. He struggled when inventing images, but succeeded when finding fresh poetries innate to materials; and for countless artists who followed—Eva Hesse comes particularly to mind—he showed how a personal art could emerge from giving up the search for "meaningful" forms and giving in to "mindless" motions that released an intuitive feel for the medium. For him, this was not just a passive surrender to gesture; he told an interviewer in 1949 that he made an effort "to stay away from any recognizable image." "If it creeps in," he said, "I try to do away with it . . . to let the painting come through."[134] Staying "in" the picture, letting it "come through," required a disciplined focus on what the materials told him as he worked; and this meant short-circuiting the encroachment of some ready formula for face or figure.

Besides "giving up" such imagery, the new method also involved a crucial break from the feedback formerly afforded by friction and resistance. Temperamentally, Pollock seemed to like pushing hard against something unyielding. The 1947 statement in *Possibilities* affirmed that he preferred the hard wall or floor beneath the canvas, just as in 1944 he had said he valued the way Benton's personality provided such strong opposition.[135] All the more remarkable, then, that his greatest achievements came by lifting away from the surface, feeling the floor beneath his feet but receiving no reciprocal "pushback" from his gestures through the air. The thicks and thins of line, which in ordinary calligraphy would token greater and lesser pressure, were reinvented in terms of a choreographed mime of distance and time.

Some basic disagreements about deeper meanings center on whether the energies poured out of Pollock's head or his body. Many metaphors have tended toward the literalization of the idea of a "stream of consciousness," or in this case a stream of unconsciousness; by this reading, the vectors of enamel are flung out in trancelike unawareness, and represent the lineaments of psychic knots, cathartically untangled and expelled in a healing ritual. Other critics, more insistent on the role of control and reflection in the method, have looked to Pollock's dance—and to the "atomized" network of energies it creates in paint—as emblematic of a less private, more explicitly social condition, associated with the precarious balance of randomness and order that is the excitement and anxiety of modern urban life.[136] In complement, the method has also been seen as telluric—a part of Pollock's feeling for nature and his desire to get close to the earth, including a sense of "gardening" the paintings below him.[137]

More recently this "earthiness" has been pointedly linked to bodily functions. The association of Pollock's pourings with peeing has long been a point of light, if coarse, humor (fig. 25); lately it has become more intently earnest. The biographers Steven Naifeh and Gregory White Smith, amassing anecdotal evidence that Pollock was prone to make an issue of urination, argue that the drip method essentially formalized what would be called in vernacular a "pissing contest" with the memory of the father, LeRoy, who had shown his young son how to draw designs in urine on a rock.[138] A parallel notion has been advanced, in less biographical, more theoretically elaborated terms, by Rosalind Krauss and Yve-Alain Bois: insisting on the horizontal plane in which the pictures were made, they link the downward spillage of liquid paint to a radical tradition of formlessness in art associated, psychically, with bodily excretion.[139] In this vision Pollock is also distanced from the more rarefied Eros of Breton's automatism, and brought into the descent of the renegade Surrealist Georges Bataille's engagement with baseness and defilement—so that, instead of leading to the Color Field canvases

Fig. 25. David Levine. **Jackson Pollock**. 1975. Ink on paperboard. 13¾ x 11 in. (34.9 x 27.9 cm). Hirshhorn Museum and Sculpture Garden, Smithsonian Institution. Gift of Bella Fishko, New York, New York, 1976.

of Morris Louis or Kenneth Noland, Krauss and Bois see the drip paintings as generating a scatological lineage of staining, as in Andy Warhol's "oxidation" paintings, made by urinating onto a metallic-paint ground. This approach to Pollock effectively recovers the concrete physicality of the drip pictures, and recasts the challenge of his "unconscious" in a form attuned to the preoccupation with body fluids in the age of AIDS—but at a cost. Making this artist the father of down-and-dirty "abjection" in contemporary art scants the lush prettiness and glamour that can characterize the poured paintings, and touts the antiorder aspects of scattering and expulsion in the drip method at the expense of the equally salient intimations of controlled sensuality.[140] The drip paintings began horizontal, but moving them to the vertical was essential to the complete idea of the process. Pollock made them down in order to put them up, and the procedure has a complexity in its wholeness that resists triage into more and less essential components.

There may be other ways, though, to think about the way Pollock's "lower body functions" link with his psyche in the production of the paintings. Moving away from the head and out into the body need not lead us only to scatology but also to the varieties of knowledge that, in the body of an athlete or dancer, are superbly organized and shaped without recourse to conscious cerebration. Movements of spectacular coordination made on the fly through a combination of innate gift and disciplined training are constantly available to us, to remind us of the fluid refinement possible within the life of the body. In working "below" rationalizing thought, in his concern for the horizontal plane and the play of corporeal weight, Pollock

releases not just excreta but this form of intelligence, which has to do with some of the greatest potentials for grace and beauty in human expression. And this, too, is translated out into the shaped and reshaped arcs on the canvas.

One metaphor for making the works that Pollock himself encouraged was that of intercourse. When asked how he knew when the work was completed, he retorted, "How do you know when you're through making love?"[141] (We can presume, given his reputation for swearing like a sailor, that he actually stated it more pithily.) That equation of painting with lovemaking is hardly original,[142] but it may have specific usefulness here, not just because of the horizontality and the impulsion of fluid, but for the physical and psychic opposites it embraces: the orchestrated and the intuitive; driving impulse and give-and-take responsiveness; urgent thrust and repetitive caress; aggressive personal catharsis and hunger for communication outside the self. To the connotations of waste and defilement it also adds implications of insemination that, while absent from Pollock's childless marriage, may be appropriate—even where the spermatic look of the pouring (e.g. plate 131) is not so evident—for his art.[143]

Similarly, Pollock himself wrote what may be the most authentically evocative, and appropriately cryptic, summation of the sources, methods, and ambitions of the drip paintings, in a fragmentary series of notes, likely made in conjunction with a radio interview that was broadcast in 1951. By this time, near the end of the period that had begun with the statement in *Possibilities* four years earlier, he was no longer content to present his methods as just the outgrowth of his personal, instinctive preferences, but wanted to explain them as necessary expressions of the epoch. "It seems to me that the modern painter cannot express this age, the airplane, the atom bomb, the radio, in the old forms of the Renaissance or of any other past culture," he opined for the microphone; "Each

age finds its own technique."[144] But either before the recording or afterward, he jotted down (and signed) a series of memory-aid catchphrases that seem to represent the most basic ideas he wanted to have associated with his work of the previous three years, and with the method that had become so notorious:

Technic is the result of a need————————
new needs demand new technics————————
 total control—————————denial of
the accident————————————
 States of order—————————
organic intensity————————
 energy and motion
made visible——————
 memories arrested in space,
human needs and motives——————————
 acceptance————[145]

Near the end of that same interview, Pollock also underlined a favorite theme. With a little whistling in the dark, against the notoriety that surrounded the way he worked, he insisted as he had elsewhere that "the result is the thing—and—it doesn't make much difference how the paint is put on as long as something has been said. Technique is just a means of arriving at a statement."[146]

Vehicles of Success

Peggy Guggenheim missed out on the glory years by deciding, in 1946, to close her gallery and move back to Europe. She gave Pollock one final exhibition in the spring of 1947, then sailed away, never to see him again. Their contract wasn't a snap to sell; his reputation as an artist traveled with a corollary reputation as a mean drunk, and $300 a month for the year-plus still left on the obligation looked onerous.[147] In all the time she had been promoting him, sales had never made up for that subsidy.[148] Eventually Betty Parsons, who had picked up other young Americans from the stable at Art of This Century—Mark Rothko, Barnett Newman, and Clyfford Still—struck a deal to handle Pollock as well, partly by getting Guggenheim to finish out the contracted stipends.

The new dealer, like the old, was a blue blood, though Parsons was primly white-glove social by comparison, and perhaps more important, a painter herself. Her gallery, while nowhere near as adventurous as Guggenheim's experiment, was also cloaked in a certain unmercantile chic. But with taste and openness that compensated for her lack of hustler instincts, Parsons had assembled a cadre of talent on the verge of profiting from the increasing cachet for new American art. Guggenheim, from her new home in Venice, organized showings of Pollock's work abroad; but she had the embittering experience of watching his new manner emerge, and his star rise dramatically, in the three landmark exhibitions at Parsons's gallery. (Feeling cheated of the credit due her early efforts, she eventually sued for paintings she thought she was owed.)

Pollock's prices rose sharply while he was with Parsons. *The She-Wolf* sold to The Museum of Modern Art for $400 in 1944; five years later, when the Museum bought its second Pollock, *Number 1A, 1948*, the price was $2,350. (The figures are partly deceptive, though, because after the war, inflation set in, and the cost of living rose sharply. In the same period, too, a good work by a major European figure might have sold for ten times what MoMA paid for *Number 1A, 1948*.[149]) The new drip manner was also remarkably well received in the press, given its challenge to traditional ideas of painting; while there was a quotient of predictable hostility, the works were greeted even by skeptics as worth paying attention to, and there was no dearth of favorable response. With every passing year in the 1940s, Pollock's name had become more broadly familiar, and more accepted as synonymous with the most provocative energies of the American avant-garde. New buyers also came to the fore. Yet even with the intense attention his shows drew from 1949 onward, major pictures were slow to find ready commitments, and his market actually languished into the early 1950s, only beginning its upward spike just before his death.[150]

Fig. 26. Pollock and Peter Blake with their model for an "Ideal Museum," at the Betty Parsons Gallery, New York, 1949. Photograph: Ben Schultz.

Pollock took an aggressive approach to pricing, but without a hard sell from the dealer to back it up, the results were not always what he hoped. This was not for lack of effort on the part of the artist or his wife; numerous reports depict them as constantly on the lookout for potential new buyers, and frequently soliciting purchases. There was a natural tension to the situation: Pollock had a high estimate of his own worth as an artist, cherished the major pictures, and balked at price concessions; but he wanted to sell the work, and thought constantly about how to market it. In this regard, for example, he tried both ends of the commercial spectrum of scale. On the one hand, he spent most of 1949 working on a series of smaller works (plates 160–67), perhaps with the idea of encouraging easier, more affordable acquisitions. Yet he also sought to revive the idea of large commissioned murals for new buildings.[151] No longer aiming just for paintings on walls, he entertained a new notion, more in line with the opened-up interiors of modern domestic architecture, of hanging or mount-

ing large pictures independently, to act as walls of their own. (This new interest in free-flowing space coincided with his own renovations: with the first flow of cash in 1949, he started tearing down walls in his own house, to open up the living space.[152])

Pollock's first substantive project in this line was the one he entered into with the architect and curator Peter Blake, for a "museum" of drip paintings, where the interior would have only mounted canvases—some with bracketing walls of mirrors to make them infinitely extensive—as wall-like dividers.[153] For the model of this fantasy building that appeared in the 1949 show at Parsons (fig. 26), Pollock even made plaster-dipped wire maquettes for sculptures to complement the reduced images of poured paintings (fig. 27). The building itself never drew a patron, but the idea worked indirectly to garner one commission, in 1950, for a painting to stand as a room divider in a new home designed by Marcel Breuer (*Untitled (Mural)*, plate 173). In this fashion, and from increasing publicity, new collectors began to find their way to his studio. During the summer following the 1949 exhi-

Fig. 27. Jackson Pollock. **Untitled**. c. 1949. Wire dipped in plaster and spattered with paint. 3 in. (7.6 cm) high. The Museum of Fine Arts, Houston. Museum purchase with funds provided by Louisa Stude Sarofim in memory of Alice Pratt Brown. OT 1049.

57

bition, Pollock formed a bond with one of these, Alfonso Ossorio, whose support and friendship would prove reliable over the long term. An artist of Philippine origin who practiced an idiosyncratic kind of surrealist assemblage, Ossorio was also a man of wealth, and a collector. He bought *Number 5, 1948* (plates 142 and 143) even before meeting the artist, and later acquired *Lavender Mist* (plates 174 and 175). To boot, he had a townhouse in Manhattan he was willing to share with or loan to Krasner and Pollock, and he eventually bought one of the choicest properties on Georgica Pond in East Hampton. An elegantly civil manner, and an interest in other artists such as Dubuffet, added to his appeal; for the first time, Pollock had a consistent patron to depend on.

Part of the fresh attention drawn by Pollock and his cohorts in the late 1940s came not from new admirers, however, but from revived opposition and derision. During the war and immediately after, pieties about creativity and freedom—and a preoccupation with other matters—had muted attacks on modern art in the public forum. The years 1946 and 1947 had been a period of relative euphoria in the United States, before the hard chill of the cold war set in. But 1948 (the year of the Berlin blockade and air lift), when the drip paintings first appeared at Parsons, proved to be a year in which old quarrels between realism and abstraction, and former suspicions about the "foreign" nature of modernism, popped back to the surface. In February, The Institute of Modern Art in Boston, which had formerly been aligned with MoMA in New York, loudly declared that it was dropping "modern" from its name, in protest against what it saw as narrowing School of Paris dogma. Reborn as The Institute of Contemporary Art, it looked forward to a more eclectic, ultimately more conservative embrace of less controversial fare.[154] By the next year, Congressman George Dondero of Michigan had begun his long-running sideshow in the House of Representatives, fulminating against

modern art as a communist plot and a menace to American values.[155] Infamy was, though, a form of celebrity for young American abstractionists, and—as Pollock's case demonstrated—even hostile publicity could be positive.

From scans of the press both local and foreign, *Time* and *Life* picked up the praise Pollock was receiving from Greenberg and others, and saw the potential for amusement in the seemingly crazy drip paintings. But where *Time* was consistently snide and dismissive (it immortalized the sobriquet "Jack the Dripper"), the editors at *Life* saw a chance to play both sides of the story. They had featured contemporary art and artists in their photo spreads, and had noted the praise of the "experts," even while often pitching the editorial tone toward incredulous sarcasm.[156] In the autumn of 1948, following up on the Boston controversy earlier in the year, the magazine organized an ostentatiously serious round-table discussion of modern art. Museum officials, critics, and cultural pundits commented in turn on a selection of paintings, including Pollock's *Cathedral* (1947, plates 120 and 121). In the edited results, published that October, the approbation of Greenberg, Meyer Schapiro, and other notables was offset—in the "balanced" approach typical of magazines like *Life*—by sniffs from across the table that the painting looked like a necktie, or would make a fine piece of decorated silk.[157]

Similarly mixed attitudes were even more in evidence when *Life*—prompted by an editor who had actually purchased a painting—then set out to do a solo article on Pollock, in the summer of 1949. The staff who worked on the piece were divided, and parts of the text and captions came out barbed;[158] but this time it hardly mattered. The two-page spread (fig. 28) and the color reproductions spoke volumes on their own. The subtitle—"Is he the greatest living painter in the United States?"—referred to the opinion of Greenberg ("a formidably high-brow New York critic"), and was likely intended as a can-you-believe-it laugh line.

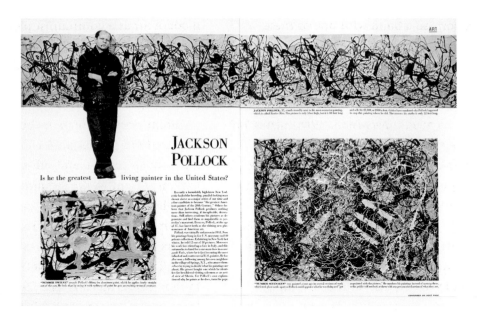

Fig. 28. Opening spread from the August 8, 1949, article on Pollock in *Life* magazine, including a photograph by Arnold Newman of Pollock and **Summertime** (1948, plate 146). Photograph: Arnold Newman/Life Magazine. © Arnold Newman/Time Inc.

Fig. 29. Pollock and **Summertime** (plate 146). A photograph taken by Arnold Newman for the *Life* article of 1949 (but not included in the final selection). Photograph: © Arnold Newman.

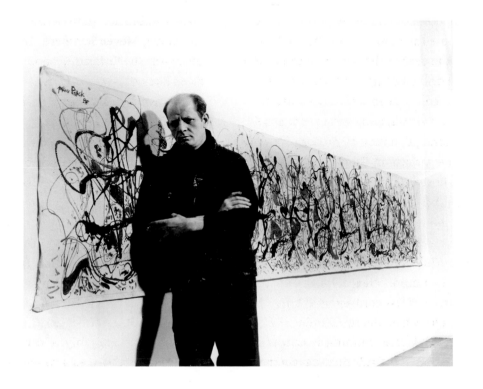

Yet just having that possibility bannered by *Life* vaulted Pollock into a unique position among his peers. And perhaps more tellingly in a medium of images, Pollock's own—especially in the opening portrait by Arnold Newman—got a chance to brand itself on a broad audience who up to that point may have thought of abstract artists as foreign, effete curiosities. Because of the length of *Summertime* (plate 146), the painting chosen as a backdrop, the portrait had to be taken in a Manhattan studio rather than in The Springs. Pollock, who had put on a tweed coat and polished loafers for the pre-article interview at the *Life* offices,[159] came to town this time in his dark work denims, to "stay in character" for the shoot. The blue-collar duds; the defiant swagger of the cross-legged pose; the surly, squinting stare-down; and the thuggy dangling cigarette—the attitude all this projected would launch a thousand imitators in the years ahead, but in 1949 that photo copyrighted it to Pollock alone. And oddly enough, it fit.

Despite the insecurities that otherwise plagued him, Pollock had already formed an arrogant cocksureness about his stature as a painter. He thought he was the best, out to "kill Picasso."[160] Leo Castelli, just beginning in the art trade then, remembered that Pollock "was very sure of himself, incredibly sure that he was a great painter, and there was no doubt about that. He would affirm it constantly, not in a blustering manner but with true conviction."[161] That certainty did not, however, necessarily bring happiness in its trail. Parsons remembered later that

he was always sad. He made you feel sad; even when he was happy, he made you feel like crying. There was a desperation about him; there was something desperate. When he wasn't drinking, he was shy; he could hardly speak. And when he was drinking, he wanted to fight. He cussed a lot, used every four-letter word in the book. . . . He thought he was the greatest painter ever, but at the same time he wondered. Painting was what he *had* to do.[162]

Success helped feather Pollock's nest (literally: after 1949, he and Krasner pumped fresh money into

new amenities for their home), but it didn't soothe the inner demons, and it didn't make him less competitive or more generous. He took his "prestige" absolutely seriously, and didn't mind letting his fellow painters feel the irritation of his growing press and purse. And when Charles and Sande (now supporting families) became gallingly aware that their former ward was the only brother headed for glory in the arts, it became equally blatant that he wouldn't offer to help them maintain their mother Stella in her old age, or otherwise share the wealth. (In the long run, his will essentially shut them all out, and put everything in Krasner's hands.)

The appearance of the *Life* article fuel-injected this difficult ego, and encouraged a fresh sense of entitlement. Only two years before, Pollock had had no automobile at all. After the article came out, he wondered out loud whether, given his rank as an artist, he didn't deserve something better than his (ostentatiously old and unfashionable) Model A.[163] So he set his sights on, and a year later obtained, the epoch's classic American emblem of "arrival": before the developing fluid was dry on Namuth's portraits of him brooding in the Model A (fig. 24), Pollock was driving a 1947 Cadillac convertible.

Performance

Pollock's career without the three huge canvases he executed in the summer and autumn of 1950 would be akin to Géricault's without *The Raft of the Medusa*. He had painted works this long before (it was the maximum length the studio allowed), but not since the 1943–44 *Mural* had he attempted anything nearly so vast and monumental. It took bravado to imagine such colossi could sell, nerve (and financial assurance) to set forth on that much blank canvas, and something unnameably miraculous to bring all three of them off, one after the other, with no apparent hesitation. Along with New Year's in 1944, and the advent of the poured paintings in 1947, this was one of the

defining moments that made Pollock Pollock.

This one, though, by incredible good fortune, is visible to us, thanks to the suite of photos taken in the studio in those months by Hans Namuth, and especially to his riveting, privileged images of the artist at work. Given the level of attentive concentration required to bring off a painting as ambitious as *Autumn Rhythm*, it is breathtaking that Pollock was able to perform—literally—at the highest level of his skills without being derailed by the self-consciousness invited by Namuth's presence, and the insistent clicking of his shutter (figs. 3–5, p. 90; 15–17, p. 94; and 19–21, p. 96). But the whole question of "performance" vexes our relationship with these remarkable photographs. Pollock had assumed "action poses" for photographers from *Life* in 1949 (figs. 30 and 31), and with Rudolph Burckhardt, earlier in the summer, he had been willing to simulate work on the already completed *Number 32, 1950* (fig. 32). He was obviously willing to act out a role as himself, in an ostensibly private situation, in order to help publicity; yet he apparently shied at first from cooperating with Namuth's project for a moment-by-moment charting of his studio activity. Memories of a key precedent—Dora Maar's photos of consecutive stages in the creation of *Guernica*, published in *Cahiers d'Art* in 1937—may have helped persuade him. Being memorialized in photos, and especially being the subject of a film, was at that time an opportunity that came to few artists, and Pollock, more than aware of the impact of the spread in *Life* a year before, may have looked on it as another way to confirm his unique position as the *chef d'école* of contemporary American art.

It was in the making of the film, and particularly the color film, that a critical line was crossed. Even with the black-and-white footage shot in the studio, which required more apparatus and more elaborate preparation than the still photos, Pollock was still able to work in his normal fashion. But when he agreed to the plan for color filming, and accepted that (because

Fig. 30. Pollock painting **Number 6, 1949** (OT 247). A photograph taken by Arnold Newman for the *Life* article of 1949 (but not included in the final selection). Photograph: © Arnold Newman.

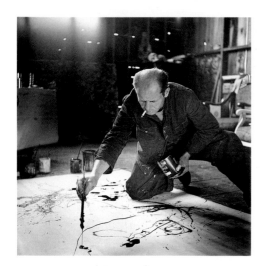

Fig. 31. Pollock at work, 1949. A photograph taken by Martha Holmes for the *Life* article of 1949 (but not included in the final selection). Photograph: Martha Holmes/Life Magazine. © Time Inc.

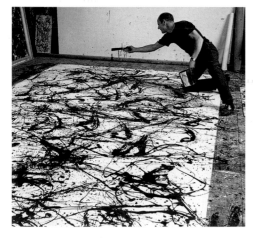

Fig. 32. Pollock painting (actually pretending to paint) **Number 32, 1950** (plates 178 and 179). Photograph: Rudolph Burckhardt.

of the greater light requirement) it would be shot outdoors, he put himself in for an intensely artificial, and excruciatingly long-drawn-out, piecemeal simulation of his way of painting. The project proceeded on weekends (the only times Namuth could work on it) through the autumn, and then came to a very bad end when the weather turned cold.

Some memorics put thc critical day in October, but the likely time, by other accounts, was the Saturday after Thanksgiving, just before the opening (on November 28) of the show at Betty Parsons's of the tremendous array of paintings that Pollock had produced over the summer. The final shooting was for a sequence of the artist painting on a sheet of glass set on sawhorses, so that Namuth, on the ground, could point the camera up at the sky and see the artist at work from behind the picture plane (see this book's cover, and figs. 50–57, pp. 112–13). The idea of working on glass intrigued Pollock, and the resultant creation—*Number 29, 1950* (plate 176)—is a one-off indication of paths not followed, with an accumulation of glass strips and pebbles that seems to borrow something from Ossorio's work, and a particularly baroque extension into three-dimensional space, via curling string and cantilevered wire screens, that anticipates later constructions by Frank Stella. But something apparently snapped in the process of painting it. When the shoot was done, Pollock fled the bone-chilling cold, and on entering the house went straight to the liquor cabinet. Pouring and then downing a full tumbler of whisky, and several more like it afterward, he put an abrupt end to more than two years of sobriety.[164] As other guests arrived, he stormed ahead into drunkenness and an increasing rage that—in contention against Namuth's admonishing attempt to control him—culminated in his overthrowing the fully laden dinner table.[165]

Knowing what we now know about the next years of Pollock's life—about the uncertain shifts in his art, about the plunge back into alcoholism and the even-

tual paralysis of his ability to create—it is impossible not to see that Saturday as a moment of poignant high tragedy. On the eve of the greatest exhibition of his life, after a season of spectacular ambition and achievement, a self-destructive act sends the artist off the edge of a spiritual sinkhole from which he will, in essence, never reemerge. The temptation is strong to see this denouement as fated, and many have—arguing, for example, that the onset of despair was the inevitable outcome of having reached the extreme limit of a chimerical dream of abstract art, and seeing in Pollock's personal collapse the symptomatic, even necessary failure of a certain dream of Abstract Expressionism.[166] It's worth stressing, however, that none of this *had* to happen; there was a constellation of "What if?" factors that, altered even a little, might have deflected the crisis, or brought the artist back from the edge.

The advent of a solo exhibition, for example, had always been a time of tremendous tension for Pollock (as for many another artist); but in the two previous years this and other difficulties had been overcome with the help of an East Hampton physician, Dr. Edwin Heller, and the tranquilizers he provided. Heller's death in a car accident, in March of 1950, had removed a crucial prop from the line of defense against anxiety. Additionally, Pollock knew that the stakes were raised exceptionally high this time, both because of the pressures of his reputation and because of the defiant (i.e., very expensive) scale of the major works. The expected postpartum depression after the show opened then became coupled with the absence (for the first time in years) of a supporting review by Greenberg, and by the mounting evidence that the show would not sell. In addition, virtually from the moment the pictures were hung, Pollock faced the "What next?" dilemma in force. After such a powerfully pushed extension of the poured abstractions, he was determined to avoid mere repetition or backsliding. But this was a very tough act to follow, and he had no distance from the weight of his reputation,

no self-deprecating humor or sense of irony about his image, that might have helped relieve the pressure.[167]

Change one or two of the external contingencies, imagine swifter progress in the development of anti-depression drugs, or give the internal pressures a subtly different inflection, and there might have been several plausible alternative scenarios for the fallout of that cold Saturday. Still, it's hard to avoid the feeling that, on the day, the long-extended process of photography and filming may have had a decisive effect. Even without Pollock's history of notions about shamanism, we could assume that, like many other artists, he harbored a protective, even superstitious feeling for the privacy of his acts of creation. The violation of that relation with his work apparently did nothing to disturb him in the early sessions with Namuth, but the cumulative effect—ending with the final staged repetition, the look through the glass picture to the lens staring back—must have raised in some degree the nagging sense of having betrayed something important, by making what had been a core, intimate possession into a faked public display. Pollock's drunken argument with Namuth, just before the table was thrown over, centered on the obsessively repeated phrase "I'm not a phony."[168]

The photographs of Pollock at work have had a tremendous influence on artists who are committed to performance as a form, and who accept a notion of the self as a construct to be manipulated in the public forum. One imagines that Joseph Beuys, for instance—who declared his interest in Pollock[169]—was strongly affected by these pictures. But, for all his ambition to collaborate in publicizing his persona and building his reputation, Pollock was not this kind of artist. Living through the collaboration with Namuth, recording the scripted words of the film soundtrack, then seeing the results on the screen and on the printed page, must have eventually given rise to some stinging intuition of inauthenticity, and worked to distance him, by a subtle but nagging gap, from his own best work.

1951 and After

It's been suggested by a journalist that Pollock's life is basically a drama in three acts: 1930–47, he searches for himself; 1947–50, he finds himself; 1950–56, he loses himself.[170] Brutal, and utterly indiscriminate at the end, but not untrue. This was not to be a career like others, with waves of slow growth or decline, and branching lines of evolution. Pollock had, in essence, one great, overpowering idea. It was an edgy proposition hardly guaranteed to produce anything worthy, but he turned out to be ideally and uniquely equipped to push it beyond its apparent limitations. It came to him at the end of 1946, produced some of the most inexhaustible artworks of the century over almost four years, and then was over as abruptly as it had begun. The emotional crash surrounding what should have been an apotheosis—the November 1950 show at Parsons—was drastic; and after that his old troubles regained a control that would not be bested. Despite some prominent aftershocks of the drip abstractions, and many honorable and interesting new essays, his art essentially dimmed along with him, all but blinking out before he drove himself—in more ways than one—to his death.

The city itself, source of energy and site of success, became an enemy. With Ossorio off in Europe, Pollock and Krasner moved into his house on Mac-Dougal Street for the duration of the Parsons show and part of January 1951. This put everything right at Pollock's doorstep—the daily awareness of lack of sales, the less-than-spectacular critical response, and the bars. Sometime near the middle of that month, he wrote Ossorio that "I found New York terribly depressing after my show—and nearly impossible—but am coming out of it now."[171] Slightly later he recapitulated, "I really hit an all time low—with depression and drinking—NYC is brutal. I got out of it about a week and a half ago. . . . Last year I thought at last I'm above water from now on in—but things don't work that easily I guess."[172] From then on, visits to

the city were problematic if not calamitous. Pollock sought out a Manhattan specialist on alcoholism a few months after this letter, and began therapy that lasted until June of 1952, including experiments with a drug intended to make him nauseous whenever he drank.[173] But then, and with another analyst in 1955, each return from Long Island to see these doctors provided a new opportunity to cruise the bars, and the schedule of consultations wound up fusing the problem with the treatment. Prolonged involvement with yet another curative program, based on quack theories of mineral equilibrium, required the patient to soak in salt baths and ingest quantities of an expensive "emulsion"; but since Pollock thought that each quart of this milky stuff would license a "balancing" quart of beer or booze, it did nothing to help the situation. The "doctor" in this regime, who wanted to double as an art dealer, wound up with a couple of terrific paintings, while Pollock just got to be a sicker drunk.[174] And the final analyst—yet another in the string who didn't see alcohol intake as part of their assignment—may have actually made matters worse, by preaching an "unrepressive" permissiveness that encouraged Pollock to think of self-indulgence as the best therapy.[175]

Initially at least, creativity proved some consolation; but its fitful absence gradually added to the torture. In that same letter to Ossorio at the end of January 1951, Pollock mentioned a new series of drawings in black on Japanese paper that he felt good about (see plates 195–98 and 201–4).[176] Some of these involved soft, often nonlinear effects of staining and blotting, and also clearly left behind the look of allover abstraction for structured compositions with intimations of figuration. For a show of sculpture by painters that spring, he made a big, ungainly papier-mâché construction with a batch of these sheets, gluing them to a chicken-wire frame to produce a one-off sport that seems to have anticipated Claes Oldenburg's *Store* constructions of 1960 (fig. 33); but he was apparently dissatisfied with the piece, let it fritter outdoors,

Fig. 33. Jackson Pollock. **Untitled**. c. 1951. Ink on rice paper soaked in Rivit glue over chicken wire mounted on wooden door. About 60 in. (152.4 cm) long. No longer extant. OT 1054.

and never pursued that vein of work. At the same time, however, in the spring and then through the summer, he expanded what he had begun in drawing by pouring black enamel, and only black enamel, onto canvas. In June he wrote Ossorio again: "I've had a period of drawing on canvas in black—with some of my early images coming thru—think the non-objectivists will find them disturbing—and the kids who think it simple to splash a Pollock out."[177] In works like *Lavender Mist* the previous year, he had brought his poured paintings to levels of complexity and sophistication that he wanted neither to replicate nor to extend. Now a new macadam plainness insulted the weavings of the dripped abstractions; Pollock had opted for a penitential austerity, and a move against the grain of everything in which he had invested himself and his career—with such acclaimed success— for three or more years. As the letter suggests, he begrudged becoming a known quantity, and relished being able to surprise people again, partly by bringing back into play some long-abandoned habits of the hand. The rhythmic patterns of *Echo: Number 25, 1951* (plate 210), for example, revivify the metrics of *Gothic*, from 1944 (plate 73), and recall the patterning

63

of several ink drawings from c. 1946–47 (plates 89–91). These are among the reasons the black paintings, however much admired, have often been taken as signs of backsliding—either by reversion to Picassoid anatomies (reawakening the troubled vocabulary of early psychic distress) or by capitulation to the influence of rivals like de Kooning.[178]

There's also, more obliquely, a possible connection with Matisse. In the same period when he developed these paintings, Pollock was involved with his friend Tony Smith on a project for a church, which Smith would design and in which Pollock's work—either in murals or in glass windows—would be the sole decoration.[179] Such reconciliations between modern art and religion were very much of the moment in the wake of World War II, and even though it's far from certain how the plan affected the black pourings,[180] it may have reinforced Pollock's interest in the Matisse chapel at Vence. That sanctuary had received a lot of attention since work began on it, in 1948, and Pollock would have been well aware not only of its stained-glass projects but also of the spare black-on-white imagery Matisse drew for the chapel tiles. His dominant impetus, though, was away from "artiness" toward a more basic, graphic directness. The new quality of the major line passages in *Echo*—broad, smooth-sided, and linked to intermittent swelling blobs—may stem from the adoption of a kitchen turkey-baster as a new tool. And Pollock used another non-art product, Rivit glue, to size the canvas prior to painting, hardening the surface and (despite the frequent assumption that the black paintings are soaked into the canvas) preventing the liquid from penetrating wholly into the cloth weave.[181]

The black paintings were realized in series on single bolts of cloth, then edited by cutting, with some final works containing what were initially adjacent but disparate ideas (fig. 34). In this fashion Pollock was able to produce a whole new body of work for his autumn show at Parsons; and extra effort, including a catalogue and a limited-edition folio of silk-screened prints, was put into marketing the event. Still, though Greenberg rallied to the flag and praised the black paintings[182]—which must have come as a shock to him—once again no one came forward to buy the important examples. And this time the unhappiness in the household was doubled: Krasner's first show at Parsons, a month earlier, failed to garner praise or sell a single picture.

This exacerbated a growing alienation. Since the aftermath of his 1950 exhibition, if not before, Pollock had been restively nurturing the conviction that Parsons didn't know how to promote his paintings effectively.[183] He liked being famous, but he thought he ought to be richer as a result, and had been mulling over how he might better capitalize on his notoriety and on the growing economic possibilities for modern American art. The proper gallery, he felt, would be one like that of Pierre Matisse, with a history of dealing major European artists. But when the chance came—Pollock's contract with Parsons expired at the end of 1951, and he started shopping for a new venue—Matisse apparently demurred. Another blue-chip possibility, however, was Sidney Janis, who had included *The She-Wolf* in his book on modern painting in 1944, and who had already shown Pollock's work in group shows. Whatever his misgivings about tales of drunken unreliability, Janis was directly in tune with the feeling Krasner expressed to him, that the potential market for Pollock had not even begun to be tapped.[184] Accordingly, in the spring of 1952, Pollock literally moved across the hall from Parsons, and signed up.

To help push the career along, Janis thought Pollock should give up on the practice he had adopted after the 1948 show, of titling pictures by number; from now on everything would—to make it easier for the viewers—have a title in words. Also, Janis felt he could do well by marketing earlier paintings that had gone unsold; and this viewpoint, combined with an

Fig. 34. Pollock's studio in 1951, with paintings of that year tacked on the wall. Photograph: Hans Namuth. © 1998 Hans Namuth Ltd.

increasing need to cover for Pollock's diminishing production, began to give his exhibitions a retrospective component. The first show at the new gallery, in November 1952, contained twelve works, but several of them were actually part of the black series from the year before, and another was essentially a large black painting covered with a splashing of bright colors (*Convergence: Number 10, 1952*, plate 213).

The major new piece, *Blue Poles: Number 11, 1952* (plates 214 and 215), appeared to be a mammoth return to the ambitions of the summer of 1950, but both its history and its appearance were actually drastically different. The previous trio of monumental works had been made in relatively brief campaigns of work, and had all retained, in varying degrees, an aerated openness. *Blue Poles* was legendarily begun with impromptu, mostly drunken "contributions" by Smith, Newman, and others, and it was worked on fitfully over a long period of time; in the end, nothing of the original "collaborations" remained, but nor did any of the aeration of the predecessors.[185] This picture makes *Autumn Rhythm* and *One* look austere by comparison. They had been grand tonal exercises, with a narrow range of earth hues inflecting armatures of black and white—a camouflage palette, which here gives way to carnival. The unified, reciprocal clustering of rhythmic loops and "knuckles" in those earlier pictures is also replaced in *Blue Poles* by a clamor of scales and directional emphases, from the lurching stagger of the final big "poles" (which get back, in drunken-sailor's parade, some memory of the pulsing frieze of the 1943–44 *Mural*) to the cascading fringes of dripping paint that coat the surface with gravity in an unaccustomed fashion. The picture lets loose many of the demons kept at bay in the earlier drip paintings—choked overlayering, riotous vulgarity of

palette, splotchy spitting of disconnected aggressions—and gets them to howl together in an orgiastic wake for the idea of poured abstraction. In so doing, it manages to step beyond simple repetition of or variation on the "classic" drip work, and to open onto a different territory of funkily crass, drooling materiality that seems more properly to belong to Oldenburg's *Store*, at the other end of the decade. It also has a different, more conflicted emotional range, well removed from the confidence of two years prior. *Blue Poles* feels instead like the last, great, transmuted burst of the shamelessly ambitious excess, mixed with manacling frustration and anger, that first made people sit up and take notice of this artist—only this time the monster that Pollock was both copying and struggling to overcome was himself.

Around the time of that initial show with Janis, in 1952, Greenberg drew up the first true Pollock retrospective, of eight major pictures ranging from 1944 to 1951, and arranged for its showing at Bennington College, Vermont. So began a long process of crowning memorialization that from then on acted as a perverse counterpoint to the decline in the artist's productivity. Pollock had already been seen at the Venice Biennale in 1950, and a monographic show was presented in Paris in 1952. Past that point, his pictures began to appear in so many venues that he could barely keep track of the showings and multilingual reviews. And the articles began to be as much about him as about his art: Robert Goodnough's 1951 piece in *Artnews* featured some of Namuth's photos of him at work, and in the February 1952 *Harper's*, Namuth's melancholic portrait of him in the Model A was printed far larger than the reproductions of his paintings. In fact, although he had ridden high on the vehicle of printed mention, Pollock seems to have developed a larger and larger paranoia about the quantity and quality of the notices he was receiving. There was an imbroglio in 1952 over Rosenberg's essay "The American Action Painters," in part because Pollock

65

saw the piece as stealing from him, and more because it seemed to boost de Kooning instead.[186] And when Greenberg appeared to retreat from his proclamations of Pollock's superiority, by praising others and by discussing him late in the essay "'American-Type' Painting" in 1955, the slight seemed crushing.[187] Still, by that point, the press, in announcing the arrival of his 1955 "retrospective" at Janis, naturally fell on the metaphor of the "champ" entering the ring.[188]

By the mid-1950s, Pollock was everywhere and nowhere. Within the New York art world there was hardly a place he could go where he did not feel his fame confirmed. Certainly it worked for him in favorite bars, where his appearances, and loutish aggressions, became anticipated sideshows. The one place it didn't work was in the studio, where he ventured less and less. In 1953, for the first time in a decade, Pollock had no solo exhibition; there was no new body of work to show. From that year till his death, he made fewer than ten new paintings. Perhaps in echo of the shows around him, these works retrospectively revisit options left behind; but where before he had worked in series, and pursued one manner over a range of extended efforts, now each of these separate confrontations with the canvas called up a different response. *Ritual* of 1953 (plate 221) recurs almost to the moment of *Birth*, with a compacted corporeal space and tortured figuration now dislocated by intrusive diagonal bars. And if Picasso is recollected here, Matisse reappears in the brighter, brushier *Easter and the Totem* of the same year (plate 220), almost in the fashion of *Stenographic Figure* following *Birth*. (In this case the proximate influence would likely have been the large Matisse retrospective at The Museum of Modern Art in 1952.) Both of these pictures were made by moving off the floor and back to the brush; but *Portrait and a Dream* of the same year (plate 216) mixes brushwork done in oil, while the picture was upright, with the poured-enamel manner of the 1951 black paintings. In the run-on series of images con-

jured in 1951, Pollock had alternated bodies and heads; for this larger effort he chose to keep the two together as a diagrammatic contrast—like a cartoon figure and its "thought-balloon"—between appearance and imagination. The area on the left has the same kind of suggestive but illegible passages of contour and fill seen before in works like *Echo*, where figuration seems constantly implied but never quite pinned down. Especially since some have speculated that the head on the right might be construed as a self-portrait, considerable interpretive energy has been given to decoding this tangle, and analyzing its relation to Pollock's psyche.[189] In this case, given the flat-footed didacticism of the A + B format, there may even—alas—be a "right" answer, of which Pollock was all too aware.

The Deep (plate 219), also painted in 1953, seems to step outside of Pollock's self-examination, and to open up to possibilities made apparent in the work of his friends—either in the "zips" of Newman's field abstractions or in the more jagged vertical "scars" of Clyfford Still's. But where these painters evoke isolated presences in vast open fields, Pollock is more explicit about clogging the foreground, folding the picture inward, and suggesting not an element of figuration against the void but a rent opening onto some dark infinite behind. Compared to the poetry of the indefinite spaces created by the drip paintings, this is melodrama, and the language of the brush doesn't hold a charge that makes up for the slackness of the pouring; but Freudians have found much to admire in the vaginal connotations of this one-time experiment.

With *White Light* the next year (plates 222 and 223), and *Untitled (Scent)* in c. 1953–55 (plate 224), Pollock returned to more familiar territory, revisiting the terrain that was originally the jumping-off point for the poured work. *White Light* recovers some of the devices, and much of the congestion, of transitional pictures like *Full Fathom Five*, while the more frothy, choppy-stroked, and multicolored *Scent* looks back, in grander ambition, to the epoch of *Eyes in the Heat*

and *Shimmering Substance*. In both cases there is an attempt to meld the lessons and techniques of 1947–50 with a strain of inquiry earlier passed over in haste. And in both cases a spiraling, twisting set of movements, especially in white, works between and around the more cursive and extended forms to suggest a writhing underneath the skin. *Search* (1955, plate 225), which with *Untitled (Scent)* stands for the total production of Pollock's last twenty months, similarly tries to make a hybrid of pouring and brushwork, and in some ways recurs to the originating language of works like *The She-Wolf*, where an initial ground of loosely poured and scumbled work was overpainted with the brush to define forms and rusticate the surface; or to the vocabulary of shape familiar from *Summertime* or *Out of the Web*. The disjunctions that divide each of these works from the other are unsettling reminders of Pollock's inability to find any consistent new course, and inevitably suggest desperate flailing. But they also speak to his dogged unwillingness to repeat himself in any simple sense, or to give in to the obvious demand then rising for the kind of painting he had earlier produced.

Outside the studio, life tumbled on through longer and longer benders, with increasing problems for Krasner (who was finally seeing expanded opportunities for her own career) and growing disaffection between the couple. We have far too much information about these years. Famous people attract attention, and while there are almost no intimates now left who knew Pollock before fame came to him, there are a host of partial acquaintances, groupies, and celebrity-spotters who still have cherished anecdotes to tell about the long, sordid decline. Yet despite that abundance of material, four years that for the world around him were full of incident scroll by in Pollock's biography

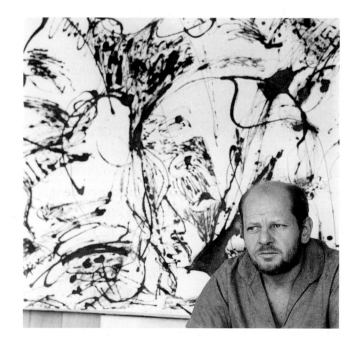

Fig. 35. Pollock with **Portrait and a Dream** (1953, plate 216). Photograph: Hans Namuth. © 1998 Hans Namuth Ltd.

monotonously and with little respite, because so much is repetition—one catastrophic binge after another—and so little merits dwelling on. It is a depressing story, and each time we reread it we feel, as in some stereotyped horror movie, that the warning signs are achingly evident, and the denouement approaches with a sickening inexorability. *Early brushes with disaster:* he crashes his Cadillac, alone, just after Christmas of 1951, and walks away from another wreck, with Franz Kline, in September of 1954. *The wrong move:* he trades two black paintings to the dealer Martha Jackson for another convertible, this time the green 1950 Oldsmobile that will be his last ride. *The physical decadence:* he injures his ankle badly in the summer of '54, starts to gain weight from inaction, breaks his ankle again eight months later, gains more weight, and so on. The last, bloated pictures Namuth took of Pollock are only five years removed from the first, but they hardly seem records of the same person (fig. 35). And finally there is inevitably the fatal girlfriend Ruth Kligman, Krasner's departure for a trip to Europe in the summer of 1956, and the ill-fated weekend visit to Fireplace Road of Ruth and her friend Edith Metzger, on Saturday, August 11: a drunken afternoon and evening, an argument about where to go, a foot too heavy on the accelerator, a curve with a destabilizing dip and soft shoulders, a few seconds of tumbling chaos, a blaring horn, autopsies, and four days later a funeral at Green River Cemetery.

Inheritance and Valuation

From one perspective Pollock's death capped a lingering decline; from another it just preceded a sharp ascent. The fame that had been building around him crystallized swiftly in the late 1950s. At the time of the accident, The Museum of Modern Art had been planning a Pollock show as the first in a series to concentrate on artists in mid-career. That became a retrospective, which subsequently traveled to London and

Rome. Market demand increased apace. With a period of fresh economic stability, prices for New York School painting started an across-the-board acceleration; but the sudden leap in Pollock's values was exceptional. The cost of a major canvas, buoying sharply just before he died, now multiplied. Having been passed up by The Museum of Modern Art for $6,000 a short while before, *Autumn Rhythm* was acquired by The Metropolitan Museum of Art for $30,000 in 1957.[190] The numbers continued to astonish through the 1973 acquisition of *Blue Poles* by the National Gallery of Australia, Canberra, for $2,000,000. And if Pollock's name has not been among the record-makers at auction in recent years, it is largely because the most sought-after canvases—larger poured abstractions from 1947–50—virtually never appear for public sale.

Yet while these cash "evaluations" started high and followed one unerring course, intellectual and artistic reckonings began in contention and shot off competitively. Fledgling art often likes to claim a good bloodline, and the recently deceased Pollock was a much-wanted parent around 1960. Extending Greenberg's vision of stained canvases as the legitimate next step from the poured abstractions, Michael Fried further insisted on Pollock as a harbinger of dematerialization, escaping from haptic illusionism toward an art of pure "opticality" realized by the Color Field painting of artists like Noland and Olitski.[191] But others saw Pollock's lessons in terms of an opposite, messily inclusive aesthetic. In 1958, Allan Kaprow published an article, "The legacy of Jackson Pollock," which argued that his most vital innovations urged artists beyond the limits of the canvas into the contingencies of the world at large.[192] Reading the paintings through Rosenberg's essay "The American Action Painters" (and, as Barbara Rose suggests, through Namuth's photos[193]), Kaprow

Fig. 36. Yves Klein. **Anthropométries de L'Epoque Bleue**. Performance at the Galerie Internationale d'Art Contemporain, Paris, March 9, 1960. Photograph: © Harry Shunk and the Estate of Yves Klein.

identified Pollock's engagement with the *event* of art-making as possibly signaling the end of painting, and as offering a stepping-off point for the Happenings that he and his friends were to begin staging. Rosenberg's evocation of a solitary, internal crisis of the spirit was thus extended (with a regain of original Dada raucousness) into a new manifesto for an extroverted group theater of playful or willfully absurd improvisation. Overseas too, in everything from the chic body-painting sessions staged by Yves Klein (fig. 36) to the more blood-and-guts actions of Viennese artists such as Hermann Nitsch, variants on this kind of fusion between art and performance followed in Pollock's wake.[194]

Stepping outside painting helped, in any event, to find some light at the edges of a very big shadow. For painters developing in the late 1950s, de Kooning opened up territory, while Pollock himself seemed to have staked all possible claims on his own terrain. His influence thus turned up in parts everywhere, and in whole nowhere, among the countless first-wave followers of the New York School. The most credible inheritors were those who, by meeting the challenge head-on with the most obvious resistance, revealed new potentials in it. Cy Twombly, for example, desiccated what had been fluid in Pollock's manner, and turned scruffily obsessive what had seemed aerated and expansive, eventually adding words and graffito pictographs into the abstract mix. Yet early (fig. 37) and late (fig. 38), Twombly stands almost alone as having taken on a Pollock-like vocabulary of cursive linear abstraction and emerged with genuinely original pictures.

A younger generation, coming to first maturity around 1959–60, was able to reexamine with a colder eye other, transmuted terms on which lessons could be taken from this behemoth forebear. As befits a good generational revolt, much of that reaction was critical, or snide. Jim Dine's *Hair* (1961, fig. 39) targeted Pollock in a way that mocked the high rhetoric

Fig. 37. Cy Twombly. **Free Wheeler**. 1955. House paint, crayon, pencil, and pastel on canvas. 68½ in. x 6 ft. 2¼ in. (174 x 190 cm). Marx Collection, Berlin.

Fig. 38. Cy Twombly. **Untitled**. 1970. House paint and crayon on canvas. 13 ft. 3⅜ in. x 21 ft. ⅛ in. (405 x 640.3 cm). The Museum of Modern Art, New York. Acquired through the Lillie P. Bliss Bequest (by exchange).

of abstraction, and satirized the chest-thumping macho of his predecessor's insistently masculine reputation. And with drier irony, Roy Lichtenstein slyly proposed a visual pun between the intricate individualized complexities of Pollock's allover abstractions and the mechanical decorative patterns produced as commonplaces by commercial designers (fig. 40). Like many artists of the 1960s, Lichtenstein seemed to suggest that—*pace* Kaprow—the real route to engagement with a larger sphere of life lay not in extending Pollock's model of "bohemian" individual actions but in countering it by an openness to the world of commercial production and industrial standardization. (That same commercial world, as Oldenburg pointed out by the fabric he chose to mount and hang as a decoration on the walls of his 1963 *Bedroom Ensemble* [fig. 41], had been swift to banalize Pollock's look.)

It proved possible, though, to reject the romantic ideals of "action painting" in general while reaffirming the importance of Pollock in particular. Artists like Frank Stella, Carl Andre, and Robert Morris looked past the drip and splatter, and beyond rhetorical claims about the spirit of the work, to extract what they felt were the radical underlying principles of the poured paintings as the bases on which new work, of a totally different feeling, could be built. Stella described his impersonally designed and systematically executed stripe paintings of 1959 as "negative Pollockism," for the way they reimagined the implications of black industrial paint and edge-to-edge uniform abstraction (fig. 42);[195] and Andre's sculptures reconceived, in terms of regular, prefabricated modules, the potentially revolutionary implications of reorienting art to the floor (fig. 43). Even Donald Judd, a committed Minimalist and no fan of painting, could write in 1967, "I think Pollock's a greater artist than anyone working at the time or since," and argue that "Pollock created the large scale, wholeness, and simplicity that have become common to almost all good work."[196]

These artists shared the feeling that, while the

69

Fig. 39. Jim Dine. **Hair**. 1961. Oil on canvas. 72 x 72 in. (182.9 x 182.9 cm). Collection Reinhard Onnasch, Berlin.

Fig. 41. Claes Oldenburg. **Bedroom Ensemble** (detail). 1963. Wood, vinyl, metal, artificial fur, cloth, paper, and other materials (this detail cloth). This detail: 15⅛ x 42 in. (38.4 x 106.6 cm). National Gallery of Canada, Ottawa.

Fig. 40. Roy Lichtenstein. **Composition I**. 1964. Oil and Magna on canvas. 68 x 56 in. (173 x 142.5 cm). Museum für Moderne Kunst, Frankfurt am Main.

ethos of anguished subjectivity surrounding Pollock's persona was dated, his way of deriving imageless form from the raw nature of non-art materials, and from engagement with real-time forces such as gravity, offered lessons for an art that might be more uncompromisingly concrete in its address. This had especially strong implications for three-dimensional work, as Morris suggested in his 1968 article "Anti Form,"[197] and as became abundantly clear in the wave of floor-oriented, scattered, and liquefied sculpture that appeared in America following the Pollock retrospective at The Museum of Modern Art in 1967 (figs. 44 and 45).[198] In keeping with broader intellectual currents of the time, attention to Pollock's work shifted from a psychological interpretation in the 1950s, to a structural reading around 1960, to an emphasis on material and process around 1970. In the latter climate, the bodily overtones of Pollock's linear pouring, which had been the stuff of a joke for Dine, could become the basis for a new organicism, based on pendulous weight and viscous industrial materials, in work like Eva Hesse's (fig. 46). And through work like Hesse's, the macho toughness Dine had satirized could seem less important than the impetus Pollock's

liquid webs provided for specifically feminist art. A guiding spirit at the genesis of Minimalist aesthetics, Pollock thus became in turn a key beacon for those who rebelled against its strictures.

Pollock was equally implicated in the work of artists who brought attention back to painting in the 1980s, from the wide-screen rhetoric of Anselm Kiefer and the alchemic fluidity of Sigmar Polke to the calligraphic poetry of Brice Marden (fig. 47). The retrospective at Paris's Centre Pompidou, in 1982, may have had a catalytic effect in this regard; by that time, though, Pollock had become a thoroughly "historicized" figure, the subject not only of critical debates and artistic appropriations but of a vast body of contentious scholarship. Largely impressionistic monographs had appeared earlier, but Francis O'Connor's chronology in the 1967 MoMA catalogue, and his later work with Eugene Thaw on Pollock's catalogue raisonné (published in 1978), established an unprecedented base of organized information. Those resources could then complement or nourish numerous efforts, beginning in the 1960s, to replace Pollock's image as an aberrant wild card with new explanations of him as a logical product of chartable influences, biographi-

Fig. 42. Frank Stella. **Die Fahne Hoch**. 1959. Black enamel on canvas. 10 ft. 1½ in. x 6 ft. 1 in. (308.6 x 185.4 cm). Whitney Museum of American Art, New York. Gift of Mr. and Mrs. Eugene M. Schwartz and purchase, with funds from the John I. H. Baur Purchase Fund; the Charles and Anita Blatt Fund; Peter M. Brant; B. H. Friedman; the Gilman Foundation, Inc.; Susan Morse Hilles; The Lauder Foundation; Frances and Sydney Lewis; the Albert A. List Fund; Philip Morris Incorporated; Sandra Payson; Mr. and Mrs. Albrecht Saalfield; Mrs. Percy Uris; Warner Communications Inc.; and the National Endowment for the Arts.

Fig. 44. Richard Serra. **Scatter Piece**. 1967. Rubber latex. c. 2 ft. 3½ in. x 41 ft. 8 in. x 25 ft. Collection The Donald Judd Estate.

Fig. 45. Lynda Benglis in her studio, creating a pigmented-latex piece for the exhibition **Anti-Illusion: Procedures/Materials**, at the Whitney Museum of American Art, New York, 1969. Photograph: Robert Fiore.

Fig. 43. Carl Andre. **144 Lead Square**. 1969. 144 lead plates. Each plate c. ⅜ x 12 x 12 in. (.9 x 30.5 x 30.5 cm); overall ⅜ in. x 12 ft. ⅞ in. x 12 ft. 1½ in. (.9 x 367.8 x 369.2 cm). The Museum of Modern Art, New York. Advisory Committee Fund.

cal determinants, or contextual circumstances.

By the mid-1990s a tonnage of new factual material was available. Shelves devoted to Pollock literature now groan under the weight of accumulated studies on virtually every aspect of his creation, reception, and life in all its phases, including a handsome and thorough monograph by Ellen Landau, and Naifeh and Smith's densely detailed, Pulitzer-prize-winning biography. A more inclusive review of all this Pollock literature, or of his broad effect on contemporary art, would be premature here: the story is ongoing, and retrospective exhibitions such as the one that occasions this sketch do their best work by opening new chapters and making past conclusions obsolete. Still, it needs acknowledging that an important part of Pollock's critical history has been the recurrent urge to sum up the story and find a moral in it. Since the artist's death, the tremendous volume of new information, and all the thorough cataloguing, has not assuaged the basic problem Leo Steinberg faced when he looked at the Janis retrospective of 1955. In fact the issue has grown proportionately: if this work has such renown and is so widely influential, what does that signify for our culture? Even people who have thought the paintings empty have found that void full of broad import. In 1958, when the first posthumous Pollock show came to London, the critic John Berger insisted that "the pictures are meaningless. But the way in which they are so is significant." In this art, Berger said, one could see nothing less than "the disintegration of our culture . . . [and] the consequence of living by and subscribing to all our profound illusions about such things as the role of the individual, the nature of history, the function of morality." Because Pollock was unable to "see or think beyond the decadence of the culture," Berger concluded, " . . . his talent will only reveal negatively but unusually vividly the nature and extent of that decadence."[199]

The problem, even in 1958, wasn't just with the art, but with the formidable impact it had already

Fig. 46. Eva Hesse. **Untitled (Rope Piece)**. 1969–70. Latex over rope, string, and wire. Two strands; dimensions variable. Whitney Museum of American Art, New York. Purchase, with funds from Eli and Edythe L. Broad, the Mrs. Percy Uris Purchase Fund, and the Painting and Sculpture Committee.

Fig. 47. Brice Marden. **Vine**. 1991–93. Oil on linen. 8 ft. x 8 ft. 6 in. (243.8 x 259.1 cm). The Museum of Modern Art, New York. Fractional Gift of Elaine and Werner Dannheisser.

had: the paintings themselves might just be dismissed as nicely decorative, Berger felt, but "his influence as a figure standing for something more than this is now too pressing a fact to ignore." It's intolerable to our minds that a phenomenon as extraordinary as Pollock, with such a broad grip on the public imagination and such a strong effect on our culture, could be just the sport of contingency, or have no further meaning beyond its own evident facts. So, as with other sensational, unexpected events (like the assassination of a president or the sudden death of a princess), we yearn for explanations, often of two contradictory sorts. On the one hand, many, like Berger, strive to understand the phenomenon as a necessary, even fated symbol of the era; on the other, subcults develop theories to show that it was just the result of a conspiracy. In Pollock's case we have had ample signs of both approaches. For a long time now his paintings have been seen as gaining their audience through their authentic, almost irresistible power to embody their epoch, in everything from existentialism to the atomic bomb. In 1964, Max Kozloff wrote:

Ultimately, Pollock . . . gave visual flesh to a whole era of consciousness in mid-century, which had striven to express its sense of fragmentation, and its fear of unleashed cataclysmic forces. One speaks of his attainment as one does of a statement that awakes an age, and organizes its imaginative energies on the vastest and most differentiated scale. As did Picasso in prewar culture, Monet in the *fin de siècle*, and Delacroix in the early Republics and Empires, Pollock, during a tragically shorter career, represented our time. Or rather, the time became aware of a vital part of itself through him.[200]

But it was also Kozloff himself who was at the origins of the paranoid alternative: in 1973, he questioned—from a chastened, post-1968 position of mistrusting governments and institutions—how much he and other Pollock-boosters had been complicitous in promoting New York School art as a form of cold war

propaganda for U.S. interests.[201] In the ensuing years, via several articles and books by other "revisionist" authors, specific curators and politicians were pinpointed as the puppet-masters of this supposed deception; and eventually a notion that used to be the exclusive province of crank philistines—the idea that modern art had been foisted on an unwitting public by connivers—became the mark of a whole *nomenklatura* of specialists who believe that, in Peter Fuller's words, "from the mid-'50s onward, Abstract Expressionism was engineered into its improbable position of cultural enthronement."[202] This leftist complaint—that those who extolled Pollock's canvases as emblems of individual freedom were dupes or lackeys of Washington's global strategy—rhymes with the old conservative grumble that the peace movement in Europe was an anti-American ploy controlled by Moscow. In fact, it now seems clear that in Pollock's day it *was* often controlled by Moscow;[203] but that doesn't diminish pacifism as an ideal, or smear those who believed in it—any more than Pollock's paintings would be tainted even if there were ever to be a convincing argument for some deluded plot to use them as anti-Communist agitprop.[204]

The popularly accepted view of Pollock is that, whatever the torments of his life, he was ultimately a big winner—the leading light in a new, worldwide "triumph" of American art that began in the late 1950s. But many of those who scorn such imperialist, commercially entangled success as largely rigged, and in any event ignoble, would prefer to distance him from it, by portraying him as an exemplary loser, his "true" talent betrayed and his "real" power subverted. In Fuller's words, "Pollock is symptomatic of the courageousness of what the Abstract Expressionists tried to do and of the enormity of their failure."[205] Accepting such accounts of tragic shortfall, though, requires looking past the achievements of the actual pictures toward some unknown, ideal art they might have been, and asks us to set the bar in terms of

other, preferred goals—such as subverting capitalism, or exposing the evils of postwar consumerism, or simply maintaining a permanent marginality—that the artist should have attained but didn't. And as such, this is not really an argument about Pollock's paintings at all, but ultimately—as with so many of the assessments of this artist, from his first appearance to the present—an argument about America.

Other painters, like Frederic Remington or Andrew Wyeth or Edward Hopper, have codified certain ideas of what Americans like to think about themselves, and thus enjoy a sweet, finally provincial standing as national artists. Along with Walt Whitman and a few others, though, Pollock stands in an entirely different class, as someone powerfully understood, at home and abroad and for better and worse in his grandeur and in his misery, to represent the core of what America is. And the story of America's attempt to define itself culturally in the last half of the twentieth century—the mix of insecurity and ambition, the internal conflicts and the ambivalence of outside observers—is written into the histories of both his career and its legacy. Innumerable efforts to explain Pollock, or to assess his achievements and flaws, have been bound up in the notion that, as much as the nation defines him, he also defines it.

The American Artist

Part of being American, of course, is having a complex about Europe. Pollock clearly did: he played out long-hair fantasies of old-world sophistication as a teen in Los Angeles, then reversed himself into xenophobic jingoism when he came to study under Benton. By the mid-1940s he said that he had gotten beyond all that. Rejecting the (then much-discussed) notion of a "specifically American" type of painting, he endorsed the contrary ideal that the aims and challenges of modern art, like those of mathematics or physics, were international.[206] Obviously, when Pollock saw himself in competition with Picasso, he felt the battle was drawn

on a level field—that good painting could be made anywhere, and that no locale (especially Europe) had a special claim. He scorned painters who flocked back to Montmartre and Montparnasse after the war, and cockily argued that the real juice was now with him and his friends in New York.[207] This personal, clubhouse competitiveness wound up dovetailing neatly with bigger forces afoot from the mid-1940s onward: work like his was seen as a key asset in efforts to expand the reach and power of the market for American art, and generally to assert that the impetus of cultural innovation had passed across the Atlantic.

Yet a good deal of Pollock's strongest support in the United States came from those who best perceived his indebtedness to the European modern tradition. From the moment of his first appearance in the early 1940s, critics linked his paintings variously to Picasso, to Miró, to Vasily Kandinsky, and to Max Beckmann; Greenberg was particularly explicit in insisting that the quality of the newcomer's art depended on its assimilation of the lessons of European forebears. And later, when European journalists became infatuated with the image of Pollock as the cowboy embodiment of Wild West America, it was American critics and historians who worked hardest to counter that superficial fantasy. Continental urges to see Pollock as a noble savage or impetuous naïf have consistently been opposed by American writers such as Greenberg and Rubin, who (especially in the latter's articles of 1967) have argued for the filiations that make this painter a legitimate heir of prewar modern art.[208]

Still, to inherit can also mean to supplant; and it seemed implicit—sometimes explicit—in the argument for Pollock's debts to prewar Europe that he (and by extension American painting) had now decisively claimed the banner of avant-garde innovation from its recently decimated source. Already in Greenberg's earliest comparisons between Dubuffet and New York School painting, just after the war, a set of tropes was established by which the superior

virility and rawness of American creativity would be contrasted to the relative effeteness and vitiation of contemporary European efforts.[209] Throughout both serious and trivial responses to Pollock in the 1950s, at home and abroad, is woven a recurrent tendency to identify certain traits—huge scale, headlong dynamism, untrammeled individualism, and (ironically, given European history after 1939) violence—as quintessentially American. Ascribed to his paintings, these characteristics cumulatively suggested a larger cultural vigor that, by implication, Europe once had and America now possessed. These overtones may be read, if one wills, into such art-historical analyses as Rubin's comparison between Pollock and the French Impressionists. His link-up between Monet's huge *Nymphéas* canvases and Pollock's few big pictures specifically countered the argument for powerful scale as an original American invention. But when he argued that Pollock's work responded to contemporary New York in the same way that Impressionism translated the energy of late-nineteenth-century Paris, the juxtaposition seemed to affirm that modernity's capital had moved to America from its historical home abroad.[210]

If Pollock was to be a point of conduit between the European past and the American future, it was crucial to identify exactly *which* European lineage he had in fact inherited. In particular terms, this was exactly the motivating point of Rubin's critiques of received ideas regarding expressionism, and proposed links to a broader range of work. The problem, though, also extended beyond questions of direct formal influence into issues of spiritual ancestry. And in this regard there have long been rationalist and irrationalist strains in arguments for Pollock's roots. The issue was joined as early as Greenberg's first attempts to separate the artist from his proximity to "Gothic" currents in Surrealism and Expressionism and then to stress his connections to Cubism's more neutral space. Some of the same alternatives of emphasis can be found continuing in the 1960s, in, on the one hand,

Rubin's construction of a newly complex art-historical genealogy for Pollock within the mainstream French modern tradition, and on the other Robert Rosenblum's proposal to reground the essential spirit and poetic feeling of Abstract Expressionism in Northern Romanticism and Symbolism.[211]

Rubin's initial aim was to counter the cliché of Pollock as a kind of natural cowboy. To this end he insisted on the aspects of reflection and control in the artist's working process, and discredited the notion that the art embodied frontier space and wildness. Stressing that Pollock spent his adult life mostly in and around New York, Rubin argued that Pollock's sense of landscape—influenced crucially by his experience of Long Island—was akin to the Impressionists' response to the environs of Paris, and stressed (echoing an earlier, parallel assertion by Greenberg[212]) that the dynamic spontaneity and inventiveness of his painting were specifically cosmopolitan. By this account, the formal links of the allover compositions to the myriad, evenly distributed accents that formed the consistent "crust" of Impressionist surfaces were tokens of a parallel mobility of sensation, and embodied the ongoing vitality of a modern tradition whose secular materialism was tied to urbanity.

Rosenblum, arguing in a different vein for connections that may have been more indirect and intuitive, proposed that the "sublimity" of New York School painting—its imageless intimations of vast scale, boundless energy, and wordlessly profound experience—drew not only on a national vein of spiritualized response to America's untamed landscape but on another kind of European tradition, independent of Paris and rooted in Northern Romanticism. In this vision, the formal connections between Pollock's poured paintings and Monet's lily ponds or Pissarro's Parisian street-views were set aside in favor of a more intangible spiritual affinity with Turner's storms and cataclysms. And the corollary argument, more or less explicit, was that the most creative postwar American

Fig. 48. Claes Oldenburg. **Yellow Girl's Dress** (from **The Store**). 1961. Muslin soaked in plaster over wire frame, painted with enamel. 31¼ x 32 x 6 in. (79 x 81.4 x 15.1 cm). Collection Eileen and Peter Rhulen.

Fig. 49. Frank Stella. **Anderstorp** (XI, 4.75X). 1981. Mixed media on etched magnesium. 9 ft. ½ in. x 10 ft. 3½ in x 15¾ in. (275.6 x 313.7 x 40 cm). Collection Stephen Foster.

art drew its basic energies, not from the urbanizing forces of modernization, but from a primordial, quasi-religious rejection of modern life in favor of a return to unreasoned awe before, and identification with, the elemental forces of nature.

Boiled down to essences (and leaving to the side for the moment the fuller complexities and extensions of both writers' contributions), these postulations about Pollock's formal and spiritual ancestry could be read to lean toward two opposing visions of modern culture, as arising either from the Enlightenment or from the opposition to it. Rubin, as a former student of Meyer Schapiro, expanded a line of investigation and explanation that linked modern art to the internationalist force of liberalizing modernization, primarily vested in France; while Rosenblum's more exalted sense of sacral and chthonic instincts was part of a rehabilitation of German Romantic thought (after a period of postwar intellectual Germanophobia in American academia). In the one vision, Pollock's best work is a song of success, showing a symphonic sophistication and an intricate, controlled complexity that are the ripe fruit of a long series of formal innovations nurtured in increasing individual freedom and cosmopolitan pluralism. In the other, it is an atavistic howl, reviving the vehement Romantic rebellion that had long lashed out against the confining conformities and deadening rationalism of modern society. Defined in this way, the two characterizations ultimately evoke alternative visions about the motive forces of modern art, and about the pluses and minuses of the European modern tradition; but they might also be taken to echo basic ambivalences as to which European legacy—that of Voltaire's civic reason or that of Rousseau's natural man—informed the American Revolution, and set the nation's character at its birth. Deciding which European art Pollock draws upon may lead us inexorably, in this way, to a debate as to the particular ways his art is American, and which America it represents.

Such broad questions, posed in theory, may not be simply resolved by appealing to praxis. But if we're interested in seeing the issue more clearly, it's instructive to turn from issues of inheritance to those of legacy—to set aside arguments about what this work may *be*, in some intrinsic or essential sense, and look at what the work can *do*, in terms of the uses other artists have made of it. Greenberg, for example, thought that avant-garde art uplifted modern culture by an absolute refusal to have any truck with the baser, commercial or "kitsch" strata of contemporary society.[213] But there's a whole vein of descent from Pollock that seems to see his specifically American modernity in more material and demotic terms, as embodied in the imagery of excess or surplus provided by his layered, dribbling deployment of hardware-store enamels. On the one hand, from Claes Oldenburg's paint-slathered plaster commodities in his 1961 *Store* (fig. 48) through Frank Stella's maximally Baroque wall-relief paintings of the 1980s (fig. 49), artists have drawn on Pollock's pourings in order to convey a sense of raucous or trashy, often explicitly commercial exuberance.[214] Whether their immediate affinities were to pulp advertising or sprayed graffiti, these artists could tap back into the particular combinations of silvers, reds, lavenders, yellows, and greens that sometimes (especially in later works like *Blue Poles*) pushed Pollock's aesthetic beyond the borderline zone of the "decorative" into an extravagance one might aptly call vulgar. In parallel, however, there's another line of extrapolation from the poured paintings that picks up more on their monochrome, beige-black-metallic aspect, and on their sense of flung dispersal, as the bases for a tougher, downbeat imagery of detritus. Both Richard Serra's and Robert Morris's scatter installations of rubber and textile industrial scrap (fig. 50) exemplify the genre in its downtown urban form, but perhaps the grimmest instances are Robert Smithson's imaginings and actions involving poured asphalt (figs. 51 and 52), where tarry

75

Fig. 50. Robert Morris. **Untitled.** 1968. Felt, asphalt, mirrors, wood, copper tubing, steel cable, and lead. 1 ft. 9½ in. x 21 ft. 11 in. x 16 ft. 9 in. (54.6 x 668 x 510.5 cm), variable. The Museum of Modern Art, New York. Gift of Philip Johnson.

Fig. 51. Robert Smithson. **Asphalt Rundown**, Rome. 1969. Estate of Robert Smithson.

Fig. 52. Robert Smithson. **Asphalt on Eroded Cliff**. 1969. Pencil and ink on paper. Estate of Robert Smithson.

black spillage is explicitly associated with spoilage and the defilement of nature.

Rubin's emblem of American scale and energy was Manhattan and Long Island, Rosenblum's more Niagara and the West; and the corresponding readings let Pollock speak either in terms of a humming civic molecularity or a roaring primordial nature. But these younger artists picked up from Pollock's "industrial" materials and thrown skeins the cues for a different imagery of city and country. Their imagery of spilling, dripping, and scattering drew from his paintings mixed messages of expansiveness and entropy that could help give form to their shifting apprehensions of excess—both tawdry abundance and gritty waste— in postwar American society. The historians looked for Pollock's American sensibility in the forms of subjectivity in his work, but many of these artists, especially after 1960, found the work rewarding for its hands-off, anti-"signature" way of conveying the unaltered quiddity of materials. General properties made expressive in Pollock's paintings, such as gravity, spillage, liquidity, motion, and "unrefined" material life, could be drawn upon to feed work with a more aggressively specific linkage to issues of industrialization, commerce, and the land, as perceived at different moments in recent American history from the onset of the 1960s, through the downbeat war-and-oil-crisis years of the late '60s and '70s, to renascent extravagance in the '80s.

This process is nowhere near conclusion. The "American" quality of Pollock's dripped abstractions will not be pinned down as something essential, embedded in them at their genesis, partly because we'll never have a more solid consensus about what the nation means than we do about how the pictures should be interpreted. It's always going to be a matter of evolving production, in which the paintings' basic forces that can't be disentangled—of spontaneous energy and layered complexity, of production and destruction—continue to generate useful metaphors relevant to an open-ended debate about a changing country and culture. As early as the 1930s, in the face of Nazi ideologies about national character in culture, Schapiro warned that all claims to propose one kind of art as more intrinsically "American" than another would inevitably represent only one interest group's attempt to muffle the noisy pluralism of ethnicities, classes, and interests that make up the country.[215] Moreover, an art like Pollock's exists in relation to its "native" milieu in the way an organism "fits" with a shifting environment: it's a matter not of neatly interlocked harmony between fixed entities but of unfolding possibilities, with surpluses, redundancies, and partial accommodations on both sides, where emerging contingencies constantly alter the way we see the interaction working.

There's no doubt, though, that Pollock's life and work will continue to be seen as quintessentially American in the same vague but forceful way that Picasso is seen as Spanish. No one would ever confound these two romances: a long reign of absinthe and *amours* on the boulevards and beaches set against a speeded-up tangle of alcoholism and angst, starting out West and ending in a wreck. But what the two do have in common is that each, in different ways and degrees, altered the *international* languages of modern art. One of the premises of twentieth-century creativity that meant the most to Pollock was the postulate, exemplified by Picasso, that subjective life, with all that it carried of local trappings and parochial character, could be the basis for an art that became part of a worldwide cosmopolitan dialogue. Matters of national pride or nationalist paranoia notwithstanding, this is the borderless community to which he aspired, and to which his achievement ultimately belongs.

Words and Pictures

The consequences of Pollock's art are now global, but they still rest, as they always have, on a sum of individual experiences. The paintings live on as art (as opposed to interesting historical documents) principally through unrecorded, nonverbal, subjective responses. This needs emphasizing again. There was a time when it seemed very important that these be pictures without words—when the man who made them and many who were drawn to them believed that trying to say what they meant was a pointless betrayal;[216] and when skeptics for their part found the works' groping inarticulateness all too typical of the low surliness of the age, as manifest in the moody stammering of James Dean.[217] By now, though, these are pictures amply wrapped with words: the many stories have themselves become a story, and cocoon the work so densely that a full-time devotee of Pollock studies might thrive without ever escaping their fabric. Yet no matter how daunting the store of verbiage on art, there is always—if the subject is indeed art—a great deal (sometimes the core) left over, and only learnable firsthand.

This is especially true of Pollock's abstractions. Since the infinity of variable incident in these pictures does not translate well through changes of scale, or hold effectively in recall, the loss in dealing with reproductions is huge. And the nature of the experience of them—the absorbing combination of immediate physicality, lack of tangible reference, and intense communication of energy unbalanced between opposites of feeling—impoverishes or contradicts any pat encapsulation. It takes time to come to terms with that experience, and writing that pretends efficiency by going immediately to the summary meaning or the hidden detail may help reading at the expense of discouraging seeing.

Chroniclers can dodge these problems by leaving the works to one side and concentrating on links to secondary literature and social data, but it's hard to accept that history's primary work is to nail quicksilver to lead. Of course, the only cure for the imprisonment of old words will be more and better words, provoked by better doubts; but confrontation with the material presence is a very good prod for getting to those questions. Certain rewards, and rewarding uncertainties, only come through periods of private silence in front of the art. They are what exhibitions, after the clatter of crates, budgets, and bargaining, should strive to provide. And accompanying essays, after wrestling with histories and issues, should similarly trust the art and the audience, and accept that an important aim, primary and final, is simply to direct attention back to the works themselves. Doubtless a lot of what went into Pollock's head, a lot that came out of his mouth, and a lot that has been and continues to be written about his pictures, embodies just the common cultural clutter of the time. The paintings do not. To be reminded of this, look at them.

Notes

Author's note: My account of Jackson Pollock's biography is dependent on the work of many scholars. Where the debt is specific, I acknowledge the source in footnotes. But much that is contained in this essay, and not specifically acknowledged, is drawn from the store of what has become general information about Pollock. That body of data is centered most obviously in the research of Francis V. O'Connor, as manifest particularly in the Chronology of the artist's life published in O'Connor and Eugene V. Thaw, *Jackson Pollock: A Catalogue Raisonné of Paintings, Drawings, and Other Works* (New Haven: Yale University Press, 1978; abbreviated below as OT). I have also profited enormously from the huge research effort of Stephen Naifeh and Gregory White Smith, in their *Jackson Pollock: An American Saga* (New York: Clarkson N. Potter, Inc., 1989; abbreviated below as NS), though I find myself frequently in disagreement with their assessments of Pollock's motivations and of his art. Constantly on my desk have also been B. H. Friedman's earlier biography *Jackson Pollock: Energy Made Visible* (New York: McGraw-Hill Book Company, 1972), as well as Ellen G. Landau's *Jackson Pollock* (New York: Harry N. Abrams, Inc., 1989). From Jeffrey Potter's *To a Violent Grave: An Oral Biography of Jackson Pollock* (New York: G. P. Putnam's Sons, 1985, and reprint ed. Wainscott, N.Y.: Pushcart Press, 1987) I have learned far more than the individual quotations included here. It states the obvious to say that my account would have been impossible without these sources, and I express my general debt to these authors, and my appreciative gratitude for their work, in advance of more specific citations.

In respect for all that I have learned from his work as a scholar and curator, and in gratitude for his generous support, this essay is dedicated to William Rubin.

1. There has been considerable debate about the level of wealth Pollock achieved through his work. Years after his death, his friend the architect and sculptor Tony Smith recalled, "The financial pinch must have been terrible. Especially when you realize how generous the Pollocks were.

I think Jackson started to drink again, in 1950 or so, just out of despair. Despair at his plight. He had done so much, and so little had come out of it. At about that time he gave me a sketchbook to draw on while going to New York on the train. He had figured out his income tax on the cover; the whole income was only $2,600 or something like that." Smith, quoted in Francine du Plessix and Cleve Gray, "Who Was Jackson Pollock?," *Art in America* (New York) 55 no. 3 (May–June 1967): 54. (In the same article, p. 58, Pollock's close friend the artist Alfonso Ossorio testifies to the dire financial circumstances of the Pollock–Lee Krasner household.) Deirdre Robson, in "The Market for Abstract Expressionism: The Time Lag Between Critical and Commercial Acceptance," *Archives of American Art Journal* (Washington, D.C.) 25 no. 3 (1985): 20, explains that "the highest price paid for a Pollock before 1947 was $740 in 1945," and that during his tenure at Art of This Century, "Pollock's sales never equalled the value of his stipend from Guggenheim." At Betty Parsons's, she goes on, "Pollock's prices rose to $250–$3,000 by 1950," but these figures were asking prices, not selling prices; "Pollock rarely got more than $900 for any work sold in the years he was at Parsons's." Robson also notes that inflation was a factor in the rise of Pollock's asking prices. Market success for Abstract Expressionist artists did not come until soon after Pollock's death.

NS, p. 557, notes that Pollock gave Dan Miller, owner of the Springs General Store, a painting to pay off the grocery bill; see also Ossorio in "Who Was Jackson Pollock?," p. 58. The authors go on, however (pp. 623–27), to describe what they see as Pollock's "indulgences and extravagances" in the face of poverty, and his and Krasner's "pretense of poverty" for patrons. They note that by the end of the 1949–50 season, Pollock's dealer Betty Parsons had sent checks to the Pollocks totaling $3,174.89 on sales of $4,750. In June, the total jumped to $4,741.55 (including payment from The Museum of Modern Art for its purchase of *Number 1A, 1948*), and in July to $5,841.55 (including the final payment for the mural commissioned for the Geller house

being built by Marcel Breuer; plate 173). By the end of the summer, the total had reached $6,508.23. Naifeh and Smith argue that "at a time when the average blue-collar worker earned $2,800 in a year and the average white-collar worker only $3,500, and the mortgage payment on the Fireplace Road house was only about $20 a month, $6,500 was a solid, even bourgeois, annual income, and gross sales of over $10,000 put Jackson among the most profitable artists in America—certainly the most profitable avant-garde artist. . . . Nevertheless, Jackson continued to plead poverty and badger Parsons to raise his prices" (p. 624). Friedman, who knew the artist in his final years, argues in *Jackson Pollock: Energy Made Visible*, p. 199, that "if one deducts dealers' commissions and routine working and living expenses, Pollock had a meager income at the end of his life. In the early fifties he could barely survive."

2. There has long been a dispute about the proper descriptive term for the paintings Pollock made by pouring, dripping, drizzling, and flinging liquid enamel onto canvases laid out on the floor. The standard early references were to "drip" paintings. When later it was argued that "dripping" seemed too passive and episodic in its implications, and that "pouring" more accurately captured the fluid continuity of Pollock's drawing with paint, a protest also arose that, by calling the process "pouring," one implicitly favored the connection between Pollock and later artists such as Helen Frankenthaler and Morris Louis. Both labels—"drip paintings" and "poured paintings"—have been in widespread use in the literature for years; neither seems wholly satisfactory, but neither is likely to be removed from familiar usage. Both will be used, interchangeably, throughout this essay. See OT, 2:vii, for a discussion of the definitions of "drip" and "pour," and their preference for the term "pouring technique" for Pollock. O'Connor later cited with approbation Lawrence Alloway's descriptions of Pollock's painting process during 1951–52 as involving "the fall and flow of liquid" and "applied in a continuous stream." O'Connor felt these characterizations "re-inforce my own preference for the semantic aptness of

the verb 'to pour' rather than the vulgar word 'to drip' to characterize the essential dynamics of Pollock's famous technique." See O'Connor, "Jackson Pollock: The Black Pourings 1951–53," in *Jackson Pollock: The Black Pourings 1951–53*, exh. cat. (Boston: The Institute of Contemporary Art, 1980), p. 6, citing Alloway, "Pollock's Black Paintings," *Arts Magazine* (New York) 43 no. 7 (May 1969): 41. William Rubin also favors "poured" in his essay "Jackson Pollock and the Modern Tradition [Part I]," *Artforum* (New York) 5 no. 6 (February 1967): 19; in a recent conversation with the author, however, he suggested that "poured and spattered" more properly evokes Pollock's mixture of continuous line and discontinuous droplets. However apposite such a double term may be, the need for a convenient one-word label will likely continue to favor a pithier if less complete characterization.

3. Leo Steinberg, "Month in Review: Fifteen years of Jackson Pollock . . . , " *Arts Magazine* (New York) 30 no. 3 (December 1955): 43–44, 46.

4. Already in 1967, reflecting on the Pollock retrospective at The Museum of Modern Art, Henry Seldis observed, "Much of Pollock that seemed so savagely violent when we first encountered it twenty years ago and that led to an enormous, often spurious myth surrounding the man and his work, now emerges, little more than ten years after his death, as a gutsy lyricism that is not without a sense of celebration along with echoes of pain and frustration." Seldis, "Jackson Pollock's Influence upon American Paintings," *Los Angeles Times*, April 9, 1967, Calendar section, p. 34.

5. The literature on the mythic element in Pollock's reputation is extensive. See for example the several sources cited by E. A. Carmean, Jr., in his essay "Jackson Pollock: Classic Paintings of 1950," in Carmean and Eliza E. Rathbone, with Thomas B. Hess, *American Art at Mid-Century—The Subjects of the Artist*, exh. cat. (Washington, D.C.: National Gallery of Art, 1978), note 137, p. 152. See also Brian O'Doherty, "Jackson Pollock's Myth," in O'Doherty, ed., *American Masters: The Voice and the Myth* (New York: Random House, 1973), pp. 82–111; and Barbara Rose, "Hans Namuth's Photographs and

the Jackson Pollock Myth. Part One: Media Impact and the Failure of Criticism," and " . . . Part Two: 'Number 29, 1950,'" both in *Arts Magazine* (New York) 53 no. 7 (March 1979): pp. 112–16 and 117–19 respectively. More recently see also Mary Lee Corlett, "Jackson Pollock: American Culture, the Media and the Myth," *Rutgers Art Review* (New Brunswick) 8 (1987): 71–106, and Michael Brenson, "Divining the Legacy of Jackson Pollock," *New York Times*, December 13, 1987, pp. 47, 53.

6. For the classic treatment of legends of the artist as misfit, see Rudolph and Margot Wittkower, *Born under Saturn: The Character and Conduct of Artists. A Documented History from Antiquity to the French Revolution* (New York: Random House, 1963). See also Johannes A. Gaertner, "Myth and Pattern in the Lives of Artists," *Art Journal* (New York) 30 no. 1 (Fall 1970): 27–30.

7. Hess, "Jackson Pollock 1912–56," *Artnews* (New York) 55 no. 5 (September 1956): 44–45, 57.

8. On the relationship between the New York School painters and the press, see Bradford R. Collins, "*Life* Magazine and the Abstract Expressionists, 1948–51: A Historiographic Study of a Late Bohemian Enterprise," *The Art Bulletin* (New York) 73 no. 2 (June 1991): 283–308.

9. On the Namuth photos and their impact, see especially Barbara Rose, "Hans Namuth's Photographs and the Jackson Pollock Myth. Part One: Media Impact and the Failure of Criticism," and " . . . Part Two: 'Number 29, 1950.'" Those essays first appeared in Namuth, *L'Atelier de Jackson Pollock*, ed. Rose, with essays by Rose, Namuth, Rosalind Krauss, et al. (Paris: Macula/Pierre Brochet, 1978), republished in English as *Pollock Painting* (New York: Agrinde Publications Ltd., 1980); the same book also contains O'Connor's essay "Hans Namuth's Photographs of Jackson Pollock as Art Historical Documentation," which appears as well in *Art Journal* (New York) 39 no. 1 (Fall 1979): 48–49.

10. Some who knew Pollock acknowledged his self-conscious relationship to his own "image" or "myth." See for example Hess's remark in "Pollock: The art of a myth," *Artnews* (New York) 62 no. 9 (January 1964): "Always attracted to

mythologies, Pollock willed himself into myth. Where an artist like Franz Kline would laugh off the Franz-Kline jokes and the adulation, Pollock took himself very seriously as a public lion. In this sense, he kept wanting to be bigger than his life-size. But his myth gave a balance to his nature. It answered a positive 'YES' to a crowd of whispering 'no's' and 'why's'; it was an approach to unity" (p. 63).

11. "Young Man From Wyoming," *The Art Digest* (New York) 18 no. 3 (November 1, 1943): 11.

12. An extensive literature tells the story of Buffalo Bill, and of the town of Cody; see, among others, Nellie Snyder Yost, *Buffalo Bill: His Family, Friends, Fame, Failures, and Fortunes* (Chicago: Sage/Swallow Press Books, 1979).

13. On Charles Pollock's early dandyism, see NS, pp. 75–77, including a photograph on p. 77.

14. Reuben Kadish (one of the young Pollock's closest friends), quoted in Friedman, *Jackson Pollock: Energy Made Visible*, pp. 10–11.

15. Jackson Pollock, letter to Charles and Frank Pollock, October 22, 1929. In OT, 4:207, D6. Quotations of Pollock in this essay selectively preserve the eccentricities of his writing.

16. Charles Pollock, letter to Jackson Pollock, quoted in NS, pp. 142–43. The letter is undated, but the content suggests that it is the correspondence that comes immediately prior to, and provokes, Pollock's letter of October 22, 1929.

17. Jackson Pollock, letter to Charles and Frank Pollock, October 22, 1929, OT, 4:207, D6.

18. Jackson Pollock, letter to Charles Pollock, January 31, 1930. In OT, 4:208–9, D7.

19. For a picturesque and apparently speculative account of Pollock's early contact with alcohol, see NS, pp. 117 and 819, which quotes Charles Pollock: "Jackson had been drinking since he was fifteen. He started on the North Rim of the Grand Canyon." See also OT, 4:205, and Friedman, *Jackson Pollock: Energy Made Visible*, pp. 7–8.

20. Whitney Darrow, quoted in Potter, *To a Violent Grave*, p. 45. Later a celebrated cartoonist for *The New Yorker*, Darrow was a close friend of Pollock's in the 1930s.

21. Jackson Pollock, letter to LeRoy Pol-

lock, February 1932. In OT, 4:212, D12.

22. On February 3, 1933, Pollock wrote to his father, "I have joined a class in stone carving in the mornings." See NS, p. 239; the letter is published in OT, 4:215, D16. In February of 1933 he also enrolled in Robert Laurent's "modeling" class and in March he wrote to his family, "I think I wrote that I am devoting all my time to sculpture now—cutting in stone during the day and modeling at night—it holds my interest deeply—I like it better than painting—drawing tho is the essence of all." Letter to Stella, Sande, and Marvin Jay Pollock, March 25, 1933, in ibid., 4:216–17, D19.

23. Pollock stated emphatically in 1944, "The only American master who interests me is Ryder." See "Jackson Pollock," *Arts & Architecture* (Los Angeles) 61 no. 2 (February 1944): 14.

24. See NS, p. 228.

25. In 1944, though he still remained friendly with Benton, Pollock was quoted as saying, "My work with Benton was important as something against which to react very strongly, later on; in this, it was better to have worked with him than with a less resistant personality who would have provided a much less strong opposition." See "Jackson Pollock," *Arts & Architecture*, p. 14.

26. See, for example, Stephen Polcari, "Jackson Pollock and Thomas Hart Benton," *Arts Magazine* (New York) 53 no. 7 (March 1979): 124. Arguing for the influence of Benton's "poles" on Pollock's work, Polcari identifies *Blue Poles* as the most obvious example. He also cites a letter from Benton to O'Connor in which Benton himself links Pollock's work to his own conception of poles. This letter is printed in OT, 2:196. O'Connor himself also notes two Pollock drawings with poles—OT vol. 3, no. 845, and vol. 4, no. 1014.

27. Benton, "Mechanics of Form Organization in Painting, Part IV," *The Arts* (New York) 11 no. 2 (February 1927): 96.

28. Benton, "Mechanics of Form Organization in Painting, Part II," *The Arts* (New York) 10 no. 6 (December 1926): 342.

29. See Katharine Baetjer, Lisa Mintz Messinger, and Nan Rosenthal, *The Jackson Pollock Sketchbooks in The Metropolitan

Museum of Art. exh. cat. for the exhibition *Jackson Pollock: Early Sketchbooks and Drawings* (New York: The Metropolitan Museum of Art, 1997). This valuable study of the sketchbooks, accompanying a set of superb facsimile reproductions, not only identifies numerous sources for drawings in the books but locates sound evidence for dating the books later than O'Connor and Thaw had done.

30. On Sande working with David Alfaro Siqueiros in Los Angeles, see NS, pp. 260–61. On the mural Philip Guston made in Mexico, and his connections with Siqueiros and Pollock, see Messinger, "Pollock Studies the Mexican Muralists and the Surrealists: Sketchbook III," in Baetjer, Messinger, and Rosenthal, *The Jackson Pollock Sketchbooks*, p. 69. On Guston see also James Oles, *South of the Border: Mexico in the American Imagination, 1914–1947*, trans. Marta Ferragut (Washington, D.C., and London: Smithsonian Institution Press, 1993), pp. 197–201.

31. Some sense of Pollock's youthful political notions, and specifically of his contempt for the art market, can be gleaned from a letter he wrote to his father on February 3, 1933 (little more than a month before LeRoy Pollock died). Consoling his father about being "laid up," Pollock says, "And for heck sake don't worry about money—no one has it. This system is on the rocks so no need try to pay rent and all the rest of the hokum that goes with the price system. Curious enough the artists are having it better now than before. They are getting more aid—the pot bellied financiers are turning to art as an escape from the some what blunt and forceful reality of today. Fat women, lean women, short and tall come with their dogs to lose themselves in the emotional junk of the artist—unfortunately thats the kind of stuff they want—they don't have to think when they look at it. Stuff that has significance is to near reality—it bothers them—tells them something—possibly it is just a matter of time—maybe not—when there will be a demand—for the real stuff—after all that isn't my worry—mine is to produce it." In OT, 4:215, D16.

32. On Siqueiros's workshop see Laurance P. Hurlburt, "The Siqueiros Experimental

Workshop: New York, 1936," *Art Journal* (New York) 35 no. 3 (Spring 1976): 237–46; Hurlburt, *The Mexican Muralists in the United States* (Albuquerque: University of New Mexico Press, 1989), pp. 220–31; Alvaro Medina, "About Pollock and Siqueiros," *Art Nexus* (Bogotá and Miami/Surfside) no. 19 (January/March 1996): 42–43; Axel Horn, "Jackson Pollock—The Hollow and the Bump," *The Carleton Miscellany* (Northfield, Minn.) 7 no. 3 (Summer 1966): 80–87; Jürgen Harten, *Siqueiros/Pollock, Pollock/Siqueiros*, exh. cat. ([Cologne]: DuMont, for the Kunsthalle Düsseldorf, 1995); and Shifra M. Goldman, "Siqueiros and Three Early Murals in Los Angeles," *Art Journal* (New York) 33 no. 4 (Summer 1974): 321–27.

33. Messinger makes this comparison in "Pollock Studies the Mexican Muralists and the Surrealists," p. 69.

34. According to Kadish; see NS, p. 219. On the Orozco *Prometheus*, see David W. Scott, "Orozco's *Prometheus*," *College Art Journal* (New York) XVII no. 1 (Fall 1957): 2–18.

35. He was initially paid $103.40, then $95.44, per month. See OT, 4:219.

36. Sanford Pollock, letter to Charles Pollock, July 27, 1937. In OT, 4:222, D27.

37. Sanford Pollock, letter to Charles Pollock, July 1941. In ibid., p. 226, D40.

38. Two women to whom Pollock was attracted in his youth found him passive, idealistic, and naïve in his proposals of marriage. One naïve relationship in Los Angeles is recounted in Deborah Solomon, *Jackson Pollock: A Biography* (New York: Simon and Schuster, 1987), pp. 46–47; see also NS, p. 154. NS also describes the other, better-known infatuation, with a folk singer named Becky Tarwater (pp. 305–6). Testimonies on the other side, from both early and late in Pollock's life, are legion. Audrey Flack describes being approached by Jackson in the Cedar Tavern: "All I wanted to do was talk art with him. . . . This huge man tried to grab me, physically grab me—pulled my behind—and burped in my face. He wanted to kiss me, but I looked at his face . . . and I realized that this man whom everybody adored, idolized, was a sick man." Quoted in Potter, *To a Violent Grave*, p. 210. Frank Pollock's wife Marie, in ibid., p. 41, tells of Jackson

drinking too much, then being physically abusive to her woman friend; when Marie tried to intervene, he threatened her with a hatchet, saying, "You're a nice girl, Marie, and I like you. I would hate to have to chop your head off." Charles Pollock's wife Elizabeth, in ibid., p. 49, tells of Jackson at a party suddenly roaring at a "particularly bright, unmarried woman in her late thirties": "You are one goddamned ugly bitch!" She also describes an incident when Jackson tried to force himself on a young girl and abused her when she resisted. Eleanor Ward, in ibid., p. 209, describes Jackson coming to her gallery drunk and telling the collector Kay Ordway, "What you need is a good fuck." Elaine de Kooning, in ibid., p. 122: "When he was drinking again he would say to women, 'You're a fucking whore'; it was just his little reflex. He started to say it to me, 'You're a—,' then just caught himself."

39. The artist Steve Wheeler recalls, "As early as the forties, rumors of Jackson's 'affair' with his teacher's wife were circulating in the art world—most of them started by Jackson himself." Pollock's brother Frank recalls a conversation in 1954: "'He told me right outside the door to his studio that he had had an affair with Rita. I was kind of shocked, but then Sande came over and confirmed it.'" Though Friedman does not describe such an affair in his own biography of Pollock, Naifeh and Smith quote him as saying, "He said it just this way: 'I used to fuck her.' Period." All quoted in NS, p. 211.

40. Becky Tarwater remembers Pollock seeing a woman leading a tiny dog on a leash. She recalls, "This infuriated him. He walked over to the woman and started to kick the dog. He was infuriated that somebody could be so infatuated with a dog. I was terrified the police would come." Quoted in ibid., p. 305. In Potter, *To a Violent Grave*, p. 53, Elizabeth Pollock remembers, "Jackson wrecked a sleazy nightclub, mauled a cop, spent the night in jail and had to be sprung the next day by the husband of a fellow worker on the *New York World*. . . . Jackson acted proud of the affair." Manuel Tolegian, in ibid., pp. 47–48, recalls another incident: "The Italians on Bleecker Street were having a candle mass. . . . [Pollock] went right up

79

to the altar and knocked everything down: candles, lights, all those things. The cops came and I had to go to the police station with him. They put him away but didn't keep him for more than a couple of hours." And Krasner told du Plessix and Gray, "One morning before we were married Sandy [Pollock's brother Sande] knocked on my door and asked 'Did Jackson spend the night here last night?' I answered, 'No, why?' 'Because he's in Bellevue Hospital and our mother has arrived in New York. Will you go with me and get him?' We went and there he was in the Bellevue ward. He looked awful. He had been drinking for days." Quoted in "Who Was Jackson Pollock," p. 49.

41. In Potter, *To a Violent Grave*, p. 46, Elizabeth Pollock remembers, "Jackson was a taker, not a giver, who rarely—the truth is I remember no incident at all—proffered a helping hand either in the flesh or in the spirit. He was filled with demons." And p. 44: "He feared me terribly and was shifty-eyed. . . . Although highly courteous, all he had, I guess, was his good looks and discontent." In NS p. 213: "'Outside, he could be very charming and lovely in his manners, but once he was in our house, he was sulky and lazy.'"

42. Benton, *An Artist in America* (fourth rev. ed. Columbia and London: University of Missouri Press, 1983), p. 332.

43. On Helen Marot, see especially Michael Leja, *Reframing Abstract Expressionism: Subjectivity and Painting in the 1940s* (New Haven and London: Yale University Press, 1993), pp. 143–47.

44. The eighty-three images now known as the "psychoanalytic drawings" were published in 1970 in C. L. Wysuph, *Jackson Pollock: Psychoanalytic Drawings* (New York: Horizon Press). They had remained in the files of one of Pollock's analysts, Dr. Joseph Henderson, for thirty years. When exhibited at the Whitney Museum of American Art, New York, concurrently with the publication of Wysuph's book, they were the subject of intense scrutiny. Krasner argued that their exposure in the public domain represented a breach of ethics, and filed a lawsuit against Henderson for violating his patient's privacy; she lost the case in 1977. See Grace Glueck,

"Pollock Exhibition Stirs Controversy: Widow Assails Monograph," and Hilton Kramer, "Pollock Exhibition Stirs Controversy: Drawings Done in Analysis," both in *New York Times*, October 16, 1970, p. 48. The drawings then took on an art-historical life of their own when various scholars turned their attention toward Jungian iconography. See Judith Wolfe, "Jungian Aspects of Jackson Pollock's Imagery," *Artforum* (New York) 11 no. 3 (November 1972): 65–73; David Freke, "Jackson Pollock: a symbolic self-portrait," *Studio International* (London) 184 no. 950 (December 1972): 217–21; Betsy Carter, "Jackson Pollock's drawings under analysis," *Artnews* (New York) 76 no. 2 (February 1977): 58–60; Elizabeth L. Langhorne, *A Jungian Interpretation of Jackson Pollock's Art through 1946* (Ph.D. diss., University of Pennsylvania, 1977) (Ann Arbor: UMI, 1979); Charles F. Stuckey, "Another Side of Jackson Pollock," *Art in America* (New York) 65 no. 6 (November–December 1977): 80–91; Langhorne, "Jackson Pollock's 'The Moon Woman Cuts the Circle,'" *Arts Magazine* (New York) 53 no. 7 (March 1979): 128–37; Hélène Lassalle, "Jackson Pollock: 'La Femme-lune coupe le cercle,' ou Pollock et Jung," *Cahiers du Musée National d'Art Moderne* (Paris) no. 4 (April–June 1980): 288–98; and Langhorne, "Pollock, Picasso and the Primitive," *Art History* (Oxford) 12 no. 1 (March 1989): 66–92. See also Rubin's rebuttal to this approach, in "Pollock as Jungian Illustrator: The Limits of Psychological Criticism [Part I]" and " . . . Part II," *Art in America* (New York) 67 nos. 7 (November 1979): 104–23, and 8 (December 1979): 72–91, respectively. The drawings have recently been reinvestigated in Claude Cernuschi, *Jackson Pollock: "Psychoanalytic" Drawings*, exh. cat. (Durham: Duke University Press, in association with the Duke University Museum of Art, 1992).

45. I have written elsewhere on the broader background to the question of Jung versus Freud, and on the relations between the thinking on the unconscious and other strains of artistic and intellectual life in the later 1930s and '40s. See Kirk Varnedoe, "Abstract Expressionism," in Rubin, ed., *"Primitivism" in 20th Century Art: Affinity of the Tribal and the Modern*, exh. cat. (New York: The

Museum of Modern Art, 1984), 2:616–18.

46. Leja has explored in depth the connections between Pollock's thinking, as recorded in his words and as indicated by the books in his library, and a broader range of "modern man" literature. See his *Reframing Abstract Expressionism*, especially chapter 4, "Narcissus in Chaos: Subjectivity, Ideology, Modern Man & Woman," pp. 203–74.

47. Donald E. Gordon examines this question in depth in "Pollock's 'Bird,' or How Jung Did Not Offer Much Help in Myth-Making," *Art in America* (New York) 68 no. 8 (October 1980): 44. Here Henderson is quoted as saying, in a questionnaire he filled out for Gordon, "My treatment was supportive and I did not consciously discuss Jung or Jungian theories with him." And Pollock's other Jungian analyst, Dr. Violet Staub de Laszlo, responded to the same questionnaire, "We rarely discussed abstract concepts . . . since I wished to avoid intellectualization."

48. Henderson has made it clear that he never sought to cure Pollock's alcoholism: "I wonder why I neglected to find out, study or analyze his personal problems in the first year of his work. . . . I wonder why I did not seem to try to cure his alcoholism. . . . I have decided that it is because his unconscious drawings brought me strongly into a state of counter-transference to the symbolic material he produced." Henderson, in an unpublished paper quoted in Wysuph, *Jackson Pollock: Psychoanalytic Drawings*, p. 14.

49. Pollock's lone comment on psychology, in an interview eight weeks before his death, was the anodyne statement, "We're all of us influenced by Freud, I guess. I've been a Jungian for a long time." Quoted in Selden Rodman, "Jackson Pollock," *Conversations with Artists* (New York: The Devin-Adair Co., 1957), p. 82.

50. Gordon argues this point in somewhat different terms: "The service that Henderson and de Laszlo performed for Pollock was that they *encouraged* him to accept the babblings and doodlings of his unconscious psyche as a part of his personal identity and ineluctable fate as an artist. Thus they saved a severely fragmented mind from taking refuge in psychosis and inevitable breakdown. In so

doing, they did not cure him. But they did help him lay the foundation for a kind of spontaneous *freedom* in artistic expression that would stand him in good stead in the years to come." Gordon, "Pollock's 'Bird,'" p. 44.

51. A week before her death (on June 3, 1940), Marot called Henderson after a long and tempestuous session with Pollock, and said, "I don't know but it seems to me we have a genius on our hands." See NS, pp. 359 and 852, citing a lecture by Henderson, "Jackson Pollock: A Psychological Commentary."

52. Greenberg, "'American-Type' Painting," *Partisan Review* (New York) 22 (Spring 1955): 186.

53. Hess, "Pollock: The art of a myth," p. 63.

54. In a dialogue of 1966 between the artists Peter Busa and Matta, Busa remarked, "Pollock was a natural painter. He could swim in it and come out creating the most beautifully organized lyrical effects. Pollock had the most articulate understanding of his means. While lavish and extravagant in spirit, he utilized the most economical means of color to get at a special kind of lyricism. He could make that magical nothingness everything. He gave painting an organism of existing, a canvas pulsating with the heart of a new-born creature." Matta responded, "He was very concerned with paint," and Busa continued, "He was what you might call anal-erotic about it. He could play with paint. He could make a painting called *Shimmering Substance* [plate 112] like you would make a mud-pie. He was a natural painter." Quoted in Sidney Simon, "Concerning the Beginnings of the New York School: 1939–1943," *Art International* (Lugano) 11 no. 6 (Summer 1967): 20.

55. Writing in 1964, Max Kozloff rendered a harsh assessment of the problems plaguing Pollock's work of the early 1940s: "The mechanism whereby an artist intuits the strength and duration of his touch, the load of paint on his brush proper to his emotion, went berserk in Pollock. It is as if the friction the canvas itself offered the path of his hand, sent him into a rage. The resulting oily turbulences, and hectic topographies of pigment are of an incomparably strangled brutishness. At every recognition of these

failings, Pollock would try to extricate himself by redoubling his furor, which only emphasized them the more." Kozloff, "Art," *The Nation* (New York) 148 no. 7 (February 10, 1964): 152.

56. Sande Pollock, in an unpublished interview with Kathleen Shorthall of *Life*, November 2, 1959, quoted in O'Connor, "The Genesis of Jackson Pollock: 1912 to 1943" (Ph.D. diss., Johns Hopkins University, 1965), p. 28.

57. Jackson Pollock, letter to Charles Pollock, n.d. [1940]. In OT, 4:225, D38.

58. Sanford Pollock (McCoy), letter to Charles Pollock, May 1940. In ibid., p. 224, D36.

59. Sanford Pollock (McCoy), letter to Charles Pollock, July 1941. In ibid., p. 226, D40.

60. On John Graham see Eleanor Green, *John Graham, Artist and Avatar*, exh. cat. (Washington, D.C.: The Phillips Collection, 1987); Anne Carnegie Edgerton, "Symbolism and Transformation in the Art of John Graham," *Arts Magazine* (New York) 60.2 no. 7 (March 1986): 60–68; Jacob Kainen, "Remembering John Graham," *Arts Magazine* (New York) 61 no. 3 (November 1986): 25–31; Paul Brach, "John Graham: Brilliant Amateur?," *Art in America* (New York) 75 no. 12 (December 1987): 130–37; Hilton Kramer, "Masked Man: Looking Back to the Strange Fictions of John Graham," *Art and Antiques* (New York), September 1988, pp. 129–31; and Carl Goldstein, "The Return to the Renaissance: John Graham and the Influence of Peter Agostini," *Arts Magazine* (New York) 63 no. 4 (December 1988): 70–75. On Graham and Pollock specifically, see Langhorne, "Pollock, Picasso and the Primitive," *Art History* (Oxford) 12 no. 1 (March 1989): 66–92.

61. Graham, "Primitive Art and Picasso," *Magazine of Art* (New York) 30 no. 4 (April 1937): 236–39, 260.

62. Ossorio describes Pollock's reference volumes in his contribution to du Plessix and Gray, "Who Was Jackson Pollock?," p. 58: "He had fifteen volumes published by the Smithsonian on American anthropology—he once pulled it out from under his bed to show me." See also O'Connor and Thaw, "Jackson Pollock's Library," in OT, 4:192.

63. On the background and context of

this exhibition see Daniel Belgrad, *The Culture of Spontaneity: Improvisation and the Arts in Postwar America* (Chicago: at the University Press, 1998), pp. 46–56.

64. See the recollections of Kadish and Harold Lehman, cited in NS, p. 357. See also Landau, *Jackson Pollock*, p. 51, and Polcari, "Jackson Pollock," *Art Journal* (New York) 5 no. 1 (Spring 1991): 98–102. An argument has recently been made for an inspiration from a particular pre-Columbian object; see Suzette Doyon-Bernard, "Jackson Pollock: A Twentieth-Century Chavín Shaman," *American Art* (New York) 11 no. 3 (Fall 1997): 8–31.

65. See "Jackson Pollock," *Arts & Architecture*, p. 14. This "interview" was actually written with help from friends; Robert Motherwell later claimed to have contributed, as follows: "Pollock first began to talk a lot to me when he was asked, a year or two after I met him, by a California art magazine to produce a statement of his views. He obviously wanted to accept, but was shy about his lack of literary ability, like a diffident but proud Scots farmer. We finally hit on the scheme of my asking him leading questions, writing down his replies, and then deleting my questions, so that it appeared like a straight statement—though there is a brief passage in it on art and the unconscious that does come from me, with Pollock's acquiescence." Quoted in "Jackson Pollock: An Artists' Symposium, Part 1," *Artnews* (New York) 66 no. 2 (April 1967): 64.

66. See Irving Sandler, "More on Rubin on Pollock," *Art in America* (New York) 68 no. 8 (October 1980): 57–58.

67. My assertion here obviously runs counter to Greenberg's insistence that Pollock's work was grounded in Cubism (see below in this essay). Though he sometimes referred specifically to early Cubism (of c. 1912–15), Greenberg may have had in mind a broader definition, encompassing Picasso's work of the 1930s as well. Pollock's debt to this latter body of work is incontestable, but seems to me to be independent of connection to Analytic or Synthetic Cubism before 1920. For one painting that does seem to grapple with the structures of earlier Cubism—and that stands out as an oddity because of this connection—see *Untitled (Interior*

with Figures) (c. 1938–41), cat. no. 76 in OT.

68. According to NS, p. 298, Pollock and Krasner met at an Artists Union party around Christmas of 1936. In their lurid account of this meeting, Pollock cut in on the dance floor and "pulled her closer and began rubbing his body against hers. 'Do you like to fuck?' he whispered in a beer-soaked grumble. . . . Indignant, the woman slapped him hard across the face." But then, Krasner recalled, "He started to charm me. I was intrigued and liked him and we went home together." Naifeh and Smith note, "If anything happened there, its memory quickly disappeared in the alcoholic fog that obscured much of the thirties. Four years later when the woman reappeared in his life, Jackson had forgotten both the incident and her name—Lee Krasner." In support of this rendition they cite interviews with Friedman and Ron Gorchov. Having sketched the young Krasner as a knowing young denizen of the art world, they also express skepticism regarding the traditional story of her not recognizing Pollock's name on the list of artists Graham had selected.

69. For a fuller picture of Krasner, see Emily Wasserman, "Lee Krasner in Mid-Career," *Artforum* (New York) 6 no. 7 (March 1968): 38–43; Barbara Rose, "Lee Krasner/Jackson Pollock: A Working Relationship," in *Krasner/Pollock: A Working Relationship*, exh. cat. (East Hampton, N.Y.: Guild Hall Museum, 1981); Landau, "Lee Krasner: A Study of Her Early Career (1926–1949)" (Ph.D. diss., University of Delaware, 1981); Landau, "Lee Krasner's Early Career, Part One: 'Pushing in Different Directions'" and " . . . Part Two: The 1940s," *Arts Magazine* (New York) 56 nos. 2 (October 1981): 110–22, and 3 (November 1981): 80–89; Barbara Rose, *Lee Krasner: A Retrospective*, exh. cat. (Houston: The Museum of Fine Arts, and New York: The Museum of Modern Art, 1983); Landau, "Lee Krasner's Past Continuous," *Artnews* (New York) 83 no. 2 (February 1984): 68–76; Robert Hobbs, *Lee Krasner* (New York: Abbeville Press, 1993); and Anne Middleton Wagner, "Krasner's Fictions," *Three Artists (Three Women): Modernism and the Art of Hesse, Krasner and O'Keeffe* (Berkeley: University of California Press, 1996), pp. 105–90.

70. See Motherwell, quoted in Simon, "Concerning the Beginnings of the New York School," p. 22.

71. Landau, who interviewed Krasner extensively between November 1978 and February 1980 as part of her dissertation research, writes, "The only influence on Pollock to which Krasner will readily admit was to bring to him an awareness of Matisse." Landau, "Lee Krasner's Early Career, Part Two: The 1940s," p. 81. When Bruce Glaser asked Krasner which French painters she had been most interested in, she responded, "Matisse and Picasso." Quoted in Glaser, "Jackson Pollock: An Interview with Lee Krasner," *Arts Magazine* (New York) 41 no. 6 (April 1967): 37.

72. The story of Mondrian's approbation of the picture, and of Peggy Guggenheim's reaction, is told in Jimmy Ernst, *A Not-So-Still Life: A Memoir by Jimmy Ernst* (New York: St. Martin's Press/Marek, 1984), pp. 241–42.

73. Melvin Lader, "Howard Putzel: Proponent of Surrealism and Early Abstract Expressionism in America," *Arts Magazine* (New York) 56 no. 7 (March 1982): 85–96.

74. Gordon advances this reading in "Pollock's 'Bird,'" p. 50.

75. By Motherwell's account, "So Matta said to Baziotes, are there some guys on the WPA who are interested in modern art and not in all that social realist crap? Baziotes said there are very few. He named Pollock, [Willem] de Kooning, [Gerome] Kamrowski and Busa. . . . I asked Baziotes who he thought to be the most talented of his friends. Baziotes thought probably Pollock." Quoted in Simon, "Concerning the Beginnings of the New York School," p. 21.

76. Motherwell would later recall that Pollock listened intently to his exposition of the possibilities for a new art based on Surrealist principles, and would speculate that Pollock—already more "street-wise" and ambitious than he knew at the time—was intent on using him as a connection to Peggy Guggenheim. See ibid., pp. 21–22.

77. Carmean makes this point in "Jackson Pollock: Classic Paintings of 1950," p. 128.

78. See "Jackson Pollock," *Arts & Architecture*, p. 14.

79. See especially Rubin, "Jackson Pollock

and the Modern Tradition," parts III and IV, *Artforum* (New York) 5 no. 8 (April 1967): 18–31, and no. 9 (May 1967): 28–33, and Rubin, "Notes on Masson and Pollock," *Arts Magazine* (New York) 34 no. 2 (November 1959): 36–43.

80. This topic is examined more broadly in my essay "Abstract Expressionism," pp. 615–59.

81. On the long delay and swift execution of *Mural*, see NS, pp. 466–69.

One surprising piece of contrary evidence, previously unpublished, has been made available to The Museum of Modern Art by Jonathan Pollock, the son of Jackson's brother Frank. In a postcard to Frank and Marie dated "1-15.44," Pollock wrote, "I painted quite a large painting for Miss Guggenheim's house during the summer. 8 feet x 20 feet, it was grand fun." Directly contradicting all the witnesses (including Guggenheim, Krasner, and several others) who claim that the canvas remained bare until very late in 1943, this statement is an anomaly in need of further analysis and explanation.

82. On the history of the picture, see Stephen Foster, "Turning Points in Pollock's Early Imagery," *The University of Iowa Museum of Art Bulletin* (Iowa City) 1 no. 1 (Spring 1976): 25–37.

83. Carmean, in "Jackson Pollock: Classic Paintings of 1950," p. 145, relates *Gothic* to Picasso's early painting *Three Women* (1908). *Gothic* may have an even stronger affinity with the "rhythmic" Cubism of repeated arcs manifest in several figure-composition studies Picasso essayed at the time he was working on this larger masterwork.

84. See NS, pp. 112–13, for a description of the horse stampede, and p. 468 for an account of the making of *Mural* apparently based on what Pollock told Busa and Kadish: "Just after nightfall, Jackson began to paint. 'I had a vision,' he told a friend years later. 'It was a stampede.' . . . Eventually the stampede was joined by 'every animal in the American West,' according to Jackson's own account. 'Cows and horses and antelopes and buffaloes. *Everything* is charging across that goddamn surface.'"

85. See Joann Moser, "The Impact of Stanley William Hayter on Post-War American Art," *Archives of American Art*

Journal (Washington, D.C.) 18 no. 1 (1978): 2–11; Lois Fichner-Rathus, "Pollock at Atelier 17," *Print Collector's Newsletter* (New York) 13 no. 5 (November–December 1982): 162–65; and Piri Halasz, "Stanley William Hayter: Pollock's Other Master," *Arts Magazine* (New York) 59 no. 3 (November 1984): 73–75.

86. See OT, 1:98 and 4:233, D53. A holograph notation on the back of an Art of This Century catalogue reads: "Blue detail (mural) Black Dancer with three parts—84½ x 56." The dimensions are those for *Gothic*.

87. Guggenheim was urged to take Pollock on by James Johnson Sweeney as well as by Putzel. The contract called for a stipend of $150 per month, in return for exclusive rights to all paintings Pollock produced. See Peggy Guggenheim, *Out of This Century: Confessions of an Art Addict*, 1946 (reprint ed. New York: Universe Books, 1979), p. 315: "I gave him a contract for one year. I promised him $150 a month and a settlement at the end of the year, if I sold more than $2,700 worth, allowing one-third to the gallery. If I lost I was to get pictures in return."

Sweeney first visited Pollock's studio, acting on the advice of Herbert Matter, in the spring of 1942, and told Guggenheim that Pollock "was doing interesting work" (NS, p. 442). Guggenheim thought little of Pollock's work, however, until Mondrian's approval of *Stenographic Figure* for Guggenheim's "Spring Salon for Young Artists" (May 18–June 26, 1943); see note 72. After much planning, Putzel arranged for Guggenheim to visit Pollock's studio on June 23, 1943—a day that unfortunately found Pollock struggling to sober up after a friend's wedding. Before making any decisions, Guggenheim asked Marcel Duchamp to visit the studio; after he did, in early July, Guggenheim worked out the contract with Pollock. See ibid., pp. 449–51.

88. The staff situation at The Museum of Modern Art in the mid-1940s was unusual. Alfred H. Barr, Jr., the founding Director, was removed from his position in 1943, but remained with the Museum. In 1944 he was reappointed as Director of Research in the Department of Painting and Sculpture, and then later the same year as Chair of Modern Painting

and Sculpture. James Thrall Soby, who supported Pollock, was both a Trustee of the Museum and a collaborator with Barr on many Museum projects. James Johnson Sweeney held the post of Director, Department of Painting and Sculpture, from 1945 to 1946.

89. Krasner recalls this exchange in Barbara Rose, "A Conversation with Lee Krasner," n.d. (probably 1972), p. 10. It is quoted in Landau, "Lee Krasner: A Study of Her Early Career 1926–1949" (Ph.D. diss., University of Delaware, 1981), p. 210.

90. See, for example, Paul Hart, "The Essential Legacy of Clement Greenberg from the Era of Stalin and Hitler," Oxford Art Journal (Oxford) 11 no. 1 (1988): 84–86.

91. See Greenberg, "Art," The Nation (New York) 160 no. 14 (April 7, 1945): 397, and "Art," The Nation (New York) 162 no. 15 (April 13, 1946): 445. See also Kozloff, "The Critical Reception of Abstract-Expressionism," Arts Magazine (New York) 40 no. 2 (December 1965): 29, for a discussion of ugliness as a criterion in Greenberg's judgment of the new.

92. Greenberg, "Art," The Nation (New York) 162 no. 15 (April 13, 1946): 445.

93. Greenberg, "Art," The Nation (New York) 166 no. 4 (January 24, 1948): 108.

94. Greenberg, "'Feeling Is All,'" Partisan Review (New York) 19 no. 1 (January–February 1952): 100.

95. Greenberg, "Art," The Nation (New York) 166 no. 4 (January 24, 1948): 108.

96. Greenberg, "Art," The Nation (New York) 158 no. 10 (March 4, 1944): 288.

97. Greenberg, "Art," The Nation (New York) 164 no. 5 (February 1, 1947): 139.

98. Reprinted in OT, 4:238, D67. See also Greenberg, "Art Chronicle—The Situation at the Moment," Partisan Review (New York) 15 no. 1 (January 1948): 84, where he argues that Picasso's and Miró's best work of the 1930s and '40s had essentially been in graphics, and held this to prove that "their genius, if not their consciousness, recognizes the demise of the easel picture . . . [even if they] are too old now to want to venture on anything so unprecedented as a genre of painting located halfway between the easel and the mural."

99. Greenberg, "Art Chronicle—The Situation at the Moment," p. 82.

100. "Our difficulty in acknowledging and stating the dull horror of our lives has helped prevent the proper and energetic development of American art in the last two decades and more." Greenberg, "The Present Prospects of American Painting and Sculpture," Horizon (London) 16 no. 93–94 (October 1947): 23.

101. See the comparative discussion of the two critics in Kozloff, "The Critical Reception of Abstract Expressionism," pp. 27–33.

102. Rosenberg, "The American Action Painters," Artnews (New York) 51 no. 8 (December 1952): 22–23, 48–50. On Pollock's reaction to the article, see NS, p. 708.

103. See Greenberg, "How Art Writing Earns Its Bad Name," Encounter (London) XIX no. 6 (December, 1962): 67–71, and the ensuing exchange with Herbert Read in Encounter (London) XX no. 2 (February 1963): 92–93.

104. Greenberg, "'Feeling Is All,'" pp. 97–102.

105. Greenberg, "Art," The Nation (New York) 166 no. 4 (January 24, 1948): 108.

106. In Potter, To a Violent Grave, p. 163, Willem de Kooning recalls, "Sure, he called me 'nothing but a French painter.'" See also Pollock's remarks in Rodman, Conversations with Artists, p. 85: "Bill is a good painter but he's a French painter. I told him so, the last time I saw him, after his last show."

107. Greenberg, "Present Prospects of American Painting and Sculpture," p. 26.

108. "In many of the weaker canvases here . . . the use of aluminum runs the picture startlingly close to prettiness, in the two last producing an oily over-ripeness that begins to be disturbing." Greenberg, "Art," The Nation (New York) 166 no. 4 (January 24, 1948): 108.

109. Greenberg, "Present Prospects of American Painting and Sculpture," p. 23.

110. In his long article "'American-Type' Painting," Greenberg praised Clyfford Still warmly while holding back his discussion of Pollock until late in the essay. Pollock apparently took this as an affront. According to Harry Jackson, "When Clem wrote against him, Jack took it very badly . . . but any artist would." Quoted in Florence Rubenfeld, Clement Greenberg: A Life (New York: Scribner, 1997), p. 194. Greenberg subsequently wrote to the Pollocks, "I hear there's been a ruckus over my piece in Partisan. I hope that

you two, at least, read the piece carefully; I weighed every word." Letter to Krasner and Pollock, May 21, 1955, quoted in NS, p. 743. For an account of the impact of the article on Pollock and Krasner's life, specifically in the summer of 1955, see Rubenfeld, p. 194.

111. Greenberg, "Art," The Nation (New York) 168 no. 9 (February 19, 1949): 221.

112. Greenberg, "Art," The Nation (New York) 160 no. 14 (April 7, 1945): 397; "Art," The Nation (New York) 162 no. 15 (April 13, 1946): 445; and "Art," The Nation (New York) 168 no. 9 (February 19, 1949): 221.

113. Rosenberg chastised Bryan Robertson for implying, in his 1960 monograph on Pollock, that Greenberg's contribution "consisted merely in promoting Pollock's reputation, whereas there is no doubt that, for better or worse, Greenberg affected his work itself, shoring up the artist's arbitrariness with his own and pressing him onward." In "The Search for Jackson Pollock," Artnews (New York) 59 no. 10 (February 1961): 59.

114. Pollock said of moving to Long Island, "We wanted to get away from the wear and tear. Besides, I had an underneath confidence that I could begin to live on my painting. I'd had some wonderful notices. Also, somebody had bought one of my pictures." [Berton Roueché], "Unframed Space," The New Yorker 25 (August 5, 1950): 16; excerpted in OT, 4:248, D86.

115. In 1944, well before moving to Long Island, Pollock had stated, "I have a definite feeling for the West: the vast horizontality of the land, for instance; here only the Atlantic ocean gives you that." "Jackson Pollock," Arts & Architecture, p. 14.

116. The death of Krasner's father in 1945 led her to reverse her previous indifference to marriage: "Jackson and I had been living together for three years, and I gave him an ultimatum—either we get married or we split." Krasner, quoted in Glueck, "Scenes from a Marriage: Krasner and Pollock," Artnews (New York) 80 no. 10 (December 1981): 60. It has also been suggested that the marriage was concluded in anticipation of the move to East Hampton, where villagers might have objected to unmarried cohabitation.

117. Krasner, quoted in ibid.: "Not until 1949 when Betty Parsons . . . told us the

Museum of Modern Art had bought a second painting . . . did we call Dick Talmadge, the plumber up the road, and have heat and hot water put in."

118. Pollock, "My Painting," Possibilities (New York) no. 1 (Winter 1947–48): 79. The journal was edited by Motherwell and Rosenberg.

119. Rubin, "Jackson Pollock and the Modern Tradition," parts I–IV.

120. Rubin, in "Jackson Pollock and the Modern Tradition, Part IV," p. 30, says that "[Max] Ernst told the French critic Françoise Choay that Pollock discovered the technique through his pictures." He also cites Patrick Waldberg, Max Ernst (Paris: J. J. Pauvert, 1958), p. 388, who says Pollock learned of the technique from Ernst, and "later used this technique, called 'dripping,' most systematically."

121. In his "Jackson Pollock and the Modern Tradition" articles, Rubin carefully reviews precedents for a technique of pouring and dripping in modern painting, ranging from Ernst, Joan Miró, and Hans Hoffmann to Janet Sobel—less known but, for Pollock, closer to hand. For a consideration of the models these artists may have provided, see, in addition to Rubin's articles (particularly Part III, pp. 29–30, and Part IV, pp. 28–33), Landau, Jackson Pollock, p. 193 (for a discussion of the possible influence of Sobel on Pollock), and Jeffrey Wechsler, "Abstract Expressionism: Other Dimensions," in Abstract Expressionism: Other Dimensions. An Introduction to Small-Scale Painterly Abstraction in America, 1940–1965, exh. cat. (New Brunswick: The Jane Voorhees Zimmerli Art Museum, Rutgers University, 1989), pp. 102–4.

Another less-known artist discussed by Wechsler in this respect is Knud Merrild. In a letter dated October 9, 1943, to Dorothy Miller, curator at The Museum of Modern Art, Merrild said of his own recent work, "I have developed a new tecnic [sic] (in the sense that other 20th Century painters' inventions are new) in the field of painting. I call my new tecnic FLUX.—I use the paint in liquid form so that it flows or runs together. It can be absolutely automatic. The paint flows in 3 dimentions [sic] by itself, for hours, do [sic] to various weights in pigment, and finally settles in a pattern created by its

own flux. In drying, these pictures take on various textural qualities, such as glass, intestines, or the hide of an elephant, etc. . . . I have now found a way to more or less control the flux tecnic. Some of the pictures I am sending Valentin are controlled to a pre-meditated vision, but still with the characteristics of the flux." My thanks to Anna Indych for bringing this letter (in the Museum Collection files, Department of Painting and Sculpture, The Museum of Modern Art) to my attention.

Finally, the more one compares Pollock's work to that of Sobel, Merrild, et al., the more one becomes aware of how little the technique in itself determined, autonomously, the look of Pollock's paintings, and how much these paintings result from a system of myriad decisions and inflections that were uniquely Pollock's own.

122. Carmean, in "Jackson Pollock: Classic Paintings of 1950," p. 128, makes the same point: Masson's "doodle was then changed into recognizable images, often suggested by the abstract, random patterns. In Pollock's 1943–45 work the opposite took place: the poured lines are on top and function with previously established patterns or areas."

123. See Bernice Rose, Jackson Pollock: Works on Paper, exh. cat. (New York: The Museum of Modern Art, published in association with The Drawing Society, Inc., 1969), especially p. 90. Carmean, in "Jackson Pollock: Classic Paintings of 1950," p. 137, suggests that some of these drawings be redated to the autumn of 1950.

124. It has often been noted that the titles of several of Pollock's major works—e.g., Autumn Rhythm—refer to nature or natural phenomena. Though Pollock's titles were given after the paintings were complete, and often at the suggestion of others, the references to landscape and sky in the late 1940s seem as meaningful as earlier recurrent themes, such as the "moon woman." See the discussion of these titles in Carmean, "Jackson Pollock: Classic Paintings of 1950," pp. 147–50. See also Ellen Johnson, "Jackson Pollock and Nature," Studio International (London) 158 no. 956 (June 1973): 257–62.

125. The x-rays, and Coddington's analy-

sis of their implications, will feature in a study of Pollock's materials and methods, co-authored with Carol Mancusi-Ungaro, that will appear in a volume of Pollock studies to be published by The Museum of Modern Art in 1999.

126. "I think that at certain moments of despair and frustration, he would violently cross out his Picasso images, and, at certain moments, some of them took on a beauty of their own. Part of the beauty of Pollock's work is the sense that underneath his beautiful surface there is a sea of swarming eels, lobsters, and sharks. And I think, at a certain moment (it was perfectly natural), he realized that he didn't have to make the Picasso thing at all, but could *directly* do the crossing out or dripping, or what have you." Motherwell, quoted in Simon, "Concerning the Beginnings of the New York School," p. 23.

127. Asked in 1950 whether he worked with a preconceived image in mind, Pollock at first said, "Well, not exactly—no . . . ," but then allowed, "I do have a general notion of what I'm about and what the results will be." Pollock, in an interview with William Wright, 1950, broadcast on radio station WERI, Westerly, R.I., 1951. In OT, 4:251, D87.

128. The most notorious instance of substantive reworking after a picture was "complete" is *Out of the Web: Number 7, 1949* (plates 154 and 155; OT 169). Several photographs show this painting in the studio before sections were cut out of it. It is also clear that some of the first poured abstractions, notably *Galaxy* (1947, plates 114 and 115, OT 169), were created by working over already "finished" paintings. Conservation study of Pollock's paintings (in connection with the 1998 Museum of Modern Art exhibition) points to the frequency with which Pollock reworked—sometimes by new campaigns of pouring, sometimes by detailed "fine tuning"—not only canvases that had dried, but canvases that had been stretched. Fuller presentation of this material will be made in the study by Coddington and Mancusi-Ungaro, in the volume of Pollock studies to be published by the Museum in 1999.

129. See Friedman, "An Interview with Lee Krasner," in *Jackson Pollock: Black and*

White, exh. cat. (New York: Marlborough-Gerson Gallery, 1969), p. 8.

130. See Steinberg, "Other Criteria," *Other Criteria: Confrontations with Twentieth-Century Art* (London, Oxford, and New York: Oxford University Press, 1972), specifically pp. 57–61.

131. Michael Fried, *Three American Painters: Kenneth Noland, Jules Olitski, Frank Stella,* exh. cat. (Cambridge: The President and Fellows of Harvard College, 1965), p. 14.

132. See Barr, "Gorky, Pollock, de Kooning," in *XXV Biennale de Venezia,* exh. cat. (Venice: Alfieri Editore, 1950), p. 383–85.

133. "Pollock made the remark about 'veiling' in reference to *There Were Seven in Eight,* and it doesn't necessarily apply to other paintings—certainly not to such pictures as *Autumn Rhythm, One,* etc." Krasner, quoted in Rubin, "Pollock as Jungian Illustrator, Part II," p. 86.

134. Pollock, quoted in NS, p. 591. The original source is Dorothy Seiberling's notes from her interview with Pollock and Krasner on July 18, 1949, at the Time-Life Building, New York.

135. See note 25 above.

136. As early as 1947, Greenberg insisted, "For all its Gothic quality, Pollock's art is still an attempt to cope with urban life; it dwells entirely in the lonely jungle of immediate sensations, impulse, and notions, therefore is positivist, concrete." Greenberg, "Present Prospects of American Painting and Sculpture," p. 26. Rubin developed this line of argument in far greater depth in his 1967 analysis of Pollock's relation to the modern tradition: "What I mean here has to do with their common confrontation of the flux, rhythm, and complexities of modern life, especially in great urban centers. . . . Only modern painters can have confronted the metropolis; none have better understood it than the Impressionists and Pollock. By this I do not mean that Pollock was a painter of the city in the literal manner of Impressionism. Pollock specifically rejected such suggestions." Rubin, "Jackson Pollock and the Modern Tradition, Part II," *Artforum* (New York) 5 no. 7 (March 1967): 29. See also Rubin, "Pollock Was No Accident," *The New York Times Magazine,* January 27, 1974, p. 35. Carmean further extended this analogy, in empha-

sizing the urban nature of Pollock's work, in "Jackson Pollock: Classic Paintings of 1950," pp. 150–51. And Rudolf Arnheim, speaking of the "evenness of the pattern" and texture in work like Pollock's, states, "In the texture patterns we recognize the portrait of a life situation in which social, economical, political, and psychological forces have become so complex that at superficial inspection nothing predictable seems to remain but the meaningless routine of daily activities, the undirected milling of anonymous crowds." See his "Accident and the Necessity of Art," *Journal of Aesthetics and Art Criticism* (Baltimore) 16 no. 1 (September 1957): 30. In response to Arnheim, Rubin states, "Anarchic variety might be produced by a series of random accidents, but if these accidents were sufficiently multiplied over a large enough surface, as Rudolph Arnheim has pointed out, they would produce an inert and boring order. The virtues of Pollock's classic pictures are due in part to his having introduced such great variety in their local sub-units while still making these subunits cohere in an organically unified whole." Rubin, "Jackson Pollock and the Modern Tradition [Part I]," p. 19. Rubin more fully addresses Arnheim's theory in "Jackson Pollock and the Modern Tradition, Part II," pp. 30–31.

137. Tony Smith recalled, "One of the things that possessed Jackson was his feeling for the land. . . . he identified with the land. . . . I never heard anyone mention it, but I think that his feeling for the land had something to do with his painting canvases on the floor. I don't recall if I had ever thought of this before seeing Hans Namuth's film. When he was shown painting on glass, seen from below and through the glass, it seemed that the glass was the earth, that he was distributing flowers over it, that it was spring. . . . I don't think that Jackson painted on the floor just for its hard surface, or for the large area, or the freedom of movement, or so that the drips wouldn't run. There was something else, a strong bond with the elements. The earth was always there." Quoted in du Plessix and Gray, "Who Was Jackson Pollock?," pp. 52–53. Finally Rubin, describing the elaboration of color in Pollock's poured pictures, makes the

following parenthetical remark: "In a marvelous image, Pollock described this elaboration and enrichment of the canvas on the ground before him as 'gardening' the picture." See Rubin, "Pollock as Jungian Illustrator [Part I]," p. 113.

138. NS, p. 541. An earlier mention of this connection lies in Patsy Southgate's recollection: "The reason he put his canvas on the floor, he said, came out of his childhood. The thing he had really liked then was standing beside his father on a flat rock pissing. He was really tickled, you know, when he watched and said to himself, 'When I grow up, am I ever going to do that!' This theory says 'Now I'm going to show Dad!'" Southgate, quoted in Potter, *To a Violent Grave,* p. 88.

139. See Yve-Alain Bois and Krauss, *L'Informe: Mode d'emploi* (Paris: Editions du Centre Georges Pompidou, 1996), published in English as *Formless: A User's Guide* (New York: Zone Books, 1997), especially pp. 28–29, 93–103, 123–24, and 126–27. See also Krauss, *The Optical Unconscious* (Cambridge, Mass.: The MIT Press, 1993), pp. 243–308, 321–29.

140. On the notion of "abject" art, see Jack Ben-Levi, Craig Houser, Leslie C. Jones, and Simon Taylor, *Abject Art: Repulsion and Desire in American Art. Selections from the Permanent Collection,* exh. cat. (New York: Whitney Museum of American Art, 1993), especially pp. 8–9.

141. Pollock, quoted in NS, p. 541. The original source is an unpublished manuscript by Frank A. Seixas, "Jackson Pollock: An Appreciation."

142. See, for example, Steinberg, "Picasso's Endgame," *October* (Cambridge, Mass.) 74 (Fall 1995): 105–22.

143. For a personal view of the spermatic connotations of Pollock's work, see Halasz, "Abstract Painting in General; Friedel Dzubas in Particular," *Arts Magazine* (New York) 58 no. 1 (September 1983): 76–83.

144. Pollock, in the interview with Wright, in OT, 4:249, D87.

145. The fragment of notes for the Wright interview appears in ibid., p. 253, D90.

146. Pollock, in the interview with Wright, ibid., p. 251.

147. In 1945, when Pollock renegotiated his contract with Guggenheim, his monthly stipend was doubled, to $300 monthly. (When he moved to Long

Island, Guggenheim also loaned him $2,000 for the down payment on the house in The Springs; to repay the loan, $50 was to be deducted from the stipend each month.) In return for this support, Pollock was to give Guggenheim his total output as an artist, with the exception of one painting a year that he could keep for himself. Of this contract Guggenheim writes, "We did not sell many Pollock paintings. . . . I never sold one for more than $1,000 and when I left America in 1947, not one gallery would take over my contract. I offered it to them all, and in the end Betty, of the Betty Parsons Gallery, said she would give Pollock a show, but that was all she could do. Pollock himself paid the expenses of it out of one painting Bill Davis bought." In Guggenheim, *Out of This Century,* pp. 316–17.

148. See note 1 above.

149. See Robson, "The Market for Abstract Expressionism," pp. 20–21.

150. Ibid., p. 21.

151. See NS, p. 624. This effort led to the Geller commission mentioned in note 1 above.

152. See Edward W. Hults, quoted in Potter, *To a Violent Grave,* p. 107.

153. See Helen Harrison's brochure "Ideal Museum for the Paintings of Jackson Pollock 1949/1995" (East Hampton, N.Y.: Pollock-Krasner House and Study Center, 1998); [Arthur Drexler], "Unframed space; a museum for Jackson Pollock's paintings," *Interiors* (New York) 109 no. 6 (January 1950): 90–91; and Peter Blake, *No Place like Utopia: Modern Architecture and the Company We Kept* (New York: Alfred A. Knopf, 1993), pp. 109–14, 116–18.

154. See Serge Guilbaut, "The Frightening Freedom of the Brush: The Boston Institute of Contemporary Art and Modern Art," in *Dissent: The Issue of Modern Art in Boston,* exh. cat. (Boston: The Institute of Contemporary Art, 1985), pp. 52–93.

155. On George Dondero see Jane de Hart Mathews, "Art and Politics in Cold War America," *The American Historical Review* (Washington, D.C.) 81 no. 4 (October 1976): 762–87. The numerous attacks on modern art that Dondero delivered in the House during the late 1940s and early 1950s are reprinted passim in the *Congressional Record* for those years.

156. See Collins, "*Life* Magazine and the

Abstract Expressionists."

157. Russell W. Davenport, "A *Life* Round Table on Modern Art," *Life* (New York) 25 no. 2 (October 11, 1948): 62.

158. For an account of the *Life* staff's bickering over the magazine's Pollock coverage, see NS, pp. 593–95.

159. See ibid., p. 591, quoting Seiberling's notes from her interview with Pollock and Krasner at the Time-Life Building.

160. This phrase of Pollock's was recalled by the painter Grace Hartigan, in conversation with the author. Hartigan's painting *The King Is Dead* (1950) refers to the "death" of Picasso, "dethroned" by Pollock. See Robert Saltonstall Mattison, *Grace Hartigan: a painter's world* (New York: Hudson Hills Press, 1990), p. 16.

161. Leo Castelli, quoted in Potter, *To a Violent Grave*, p. 184.

162. Parsons, quoted in du Plessix and Gray, "Who Was Jackson Pollock?," p. 55.

163. Tony Smith, in ibid., p. 53: "A while after Clem Greenberg had been quoted about Jackson in *Life* magazine, . . . we were in the kitchen looking out the window. The Model A was in the driveway. Jackson asked if I had seen the article, and then he asked if I didn't think he should have a better car. I didn't have any car, and I said, 'The Model A's a good car. What the hell kind of car do you want?' 'Oh, I don't know, maybe a Cadillac or something. . . . ' Well, he did get a Cadillac, a convertible."

164. NS, pp. 579 and 881, contends that Pollock was not entirely "dry," but only comparatively under control and partially sedated, during that two-year period. For the disagreement on the date of Namuth's last shoot, see ibid., p. 888.

165. Krasner remembers, "One night we were having ten or twelve people for dinner. Jackson and Hans Namuth were at one end of the table. I don't know what the argument was about, but I heard loud voices and suddenly Jackson overturned the whole table with twelve roast beef dinners. It was a mess. I said, 'Coffee will be served in the living room.' Everyone filed out and Jackson went off without any trouble. Jeffrey Potter and I cleaned up." Quoted in du Plessix and Gray, "Who Was Jackson Pollock?," p. 50. The story is also recounted by Namuth in "Photographing Pollock," *Pollock Painting*.

166. See for example Peter Fuller's contention that the unhappy endings of the lives of several of the Abstract Expressionist painters form a symptomatic pattern, in "American Painting since the Last War," *Art Monthly* (London) no. 27 (June 1979): 9. In a similar vein, see John Berger, "The Arts and Entertainment: The Battle," *The New Statesman and Nation* (London) LI no. 1298 (January 21, 1956): 71: "These works, in their creation and their appeal, are a full expression of the suicidal despair of those who are completely trapped within their own dead subjectivity. . . . Behind these works is the same motive of revenge against subjective fears as there is behind the political policy of clinging to the 'protection' of the H-Bomb." Quoted by Patrick Heron in "The Americans at the Tate Gallery," *Arts Magazine* (New York) 30 no. 6 (March 1956): 15.

167. See, for example, Hess, "Pollock: The art of a myth," p. 40: "'Jack' never treated Pollock the Great Painter with irony or at a distance."

168. See NS, pp. 652–53, citing the authors' interview with Buffie Johnson.

169. See Kim Levin, Introduction, *Energy Plan for the Western Man: Joseph Beuys in America* (New York: Four Walls Eight Windows, 1990), p. 4: "And what American artists interested him? Jackson Pollock. . . . "

170. Jacques Michel, "Jackson Pollock au Centre Pompidou: La fureur et le bruit," *Le Monde* (Paris), February 4, 1982, "Arts et Spectacles" section, p. 14.

171. Pollock, letter to Ossorio, n.d. [January 6, 1951]. In OT, 4:257, D93.

172. Pollock, letter to Ossorio, n.d. [sometime between January 23 and January 29, 1951]. In ibid., 4:257, D94.

173. See NS, pp. 659–61, 670. Pollock began treatment with Ruth Fox, a psychiatrist specializing in the treatment of alcoholism, in March 1951 and continued through the summer: "Fox prescribed Antabuse, a brand of disulfiram, a new drug that, when taken in combination with alcohol, caused nausea and vomiting—chemistry to fight chemistry" (p. 661).

174. On Mark Grant, his therapies, and his interest in art-dealing, see ibid., pp. 674–75, 680–81.

175. For a discussion of Ralph Klein's therapy, see ibid., pp. 768–69.

176. In "Jackson Pollock: Classic Paintings of 1950," p. 137, Carmean argues that these drawings should be redated to the autumn of 1950, when Tony Smith apparently gave Pollock a block of Japanese paper, or rice paper. But while it may be true that several of the drawings were done before the New Year, it does not necessarily follow, as Carmean would have it, that the first of these drawings should be seen as parallel to or synchronous with the paintings of early autumn 1950. It could be argued, to the contrary, that Pollock more likely began work on the drawings when the studio had been emptied out for the Parsons show in November, and continued on them when he moved into Ossorio's apartment in New York. My thanks to Bernice Rose for her help in the dating of these works; for the most focused and revealing analysis of the drawings, see her *Jackson Pollock: Works on Paper*.

177. Pollock, letter to Ossorio and Ted Dragon, June 7, 1951. In OT, 4:261, D99.

178. On the connections between the imagery of the 1951 paintings and earlier work by Pollock, see especially O'Connor, "Jackson Pollock: The Black Pourings," pp. 9–25.

179. Carmean, "The Church Project: Pollock's Passion Themes," *Art in America* (New York) 70 no. 6 (Summer 1982): 110–22.

180. For a vehement rebuttal of Carmean's proposal that we see the 1951 paintings as based on religious themes connected with the church project, see Krauss, "Contra Carmean: The Abstract Pollock," *Art in America* (New York) 70 no. 6 (Summer 1982): 123–31, 155.

181. According to Coddington and Mancusi-Ungaro, the canvas for *Echo* (plate 210) was presized with Rivit glue, so that the paint does not soak into it. See their essay on Pollock's methods and materials in the volume of Pollock studies to be published by the Museum in 1999.

182. Greenberg, in "Jackson Pollock's New Style," *Harper's Bazaar* (New York) 85 no. 2,883 (February 1952): 174, writes, "The more explicit structure of the new work reveals much that was implicit in the preceding phase and should convince any one that this artist is much, much more than a grandiose decorator." And in "'Feeling Is All,'" p. 102, he writes, "Pictures 'Fourteen' and 'Twenty-five' in the recent show represent high classical art."

183. In February 1951, Pollock wrote to Ossorio, "There is an enormous amount of interest and excitement for modern painting there [Chicago]—it's too damned bad Betty doesn't know how to get at it." In OT, 4:258, D95. On around August 6, 1951, he wrote again: "Betty sailed last Sat. August 4. . . . As usual there was no time to *plan* or discuss things." In ibid., p. 262, D101. And on March 30, 1952: "I have offers by two good galleries here—but I don't plan to make any final decision [sic] until you are back. . . . There is no change with Betty—haven't seen her since you left. This getting settled in a new gallery isn't easy to solve personally." In ibid., p. 267, D103.

184. "I remember saying this to Lee . . . don't you think that the market for Pollock after these one-man exhibitions is fairly well saturated? I remember her comment very well. She said, 'Sidney, the surface hasn't even been scratched.' And how right she was." Sidney Janis, interviewed by Paul Cummings, Part I, April 25, 1972, pp. 140–41. Archives of American Art, Smithsonian Institution, Washington, D.C.

185. OT 2:193–97 gives several accounts of the creation of *Blue Poles*, and a bibliography. See also Stanley P. Friedman, "Loopholes in 'Blue Poles,'" *New York Magazine* 6 no. 44 (October 29, 1973): 48–51, and Solomon, *Jackson Pollock: A Biography*, pp. 234–36. Friedman quotes numerous sources on the subject, including Tony Smith in a 1964 interview: "I started *Blue Poles*. Barney Newman also worked on it" (p. 48).

186. See NS, pp. 704–13.

187. See Greenberg, "'American-Type' Painting," pp. 179–96.

188. [Alexander Eliot], "The Champ," *Time* (New York) 66 no. 25 (December 19, 1955): 64–67.

189. See, for example, Landau, *Jackson Pollock*, pp. 217–18, and NS, pp. 728–29. Pollock told his homeopathic doctor, Elizabeth Wright Hubbard, that the head was a portrait of himself "when I'm not sober"; see O'Connor, "Jackson Pollock: The Black Pourings," p. 20. For O'Connor

himself, in ibid., "The head with a crescent in the complex of *Portrait and a Dream* resembles, to those who know her, Pollock's wife, Lee Krasner." See also Krasner's interview with B. H. Friedman in *Jackson Pollock: Black and White*, p. 8, where she recalls that Pollock once "described the upper right-hand corner of the left panel as the 'dark side of the moon.'"

190. According to Robson, "The Market for Abstract Expressionism," p. 22, "In 1957 . . . Pollock's *Autumn Rhythm* was sold to the Metropolitan Museum of Art for $30,000—a painting that the Museum of Modern Art had been reluctant to buy for $8,000 before the artist's death." As her source, however, Robson cites Cummings's interview with Janis, where Janis says that Barr had a reserve on *Autumn Rhythm* for $6,000 before Pollock's death. After he died, Janis, at Krasner's request, offered Barr first refusal on the painting, at $30,000; Barr did not respond, and the Metropolitan bought *Autumn Rhythm* at that price. Janis, interviewed by Cummings, Part II, August 1, 1972, pp. 374–75. It is unclear, then, what Robson's source is for the $8,000 figure.

191. See Fried, *Three American Painters*.

192. Allan Kaprow, "The legacy of Jackson Pollock," *Artnews* (New York) 57 no. 6 (October 1958): 24–26, 55–57.

193. Barbara Rose, "Hans Namuth's Photographs and the Jackson Pollock Myth: Part One," *Artforum* (New York) 6 no. 8 (April 1968): 33–35.

194. On the range of performance work that followed Pollock, see Paul Schimmel, "Leap into the Void: Performance and the Object," *Out of Actions: Between Performance and the Object, 1949–1979*, exh. cat. (Los Angeles: The Museum of Contemporary Art, 1998).

195. "I tried for something which, if it is like Pollock, is a kind of negative Pollockism." Frank Stella, quoted in Rubin, *Frank Stella*, exh. cat. (New York: The Museum of Modern Art, 1970), p. 29. The quotation is based on a conversation between Rubin and the artist, taped in June and September of 1969 and subsequently edited by the artist.

196. Don[ald] Judd, "Jackson Pollock," *Arts Magazine* (New York) 41 no. 6 (April 1967): 34.

197. Robert Morris, "Anti Form," *Artforum* (New York) 6 no. 8 (April 1968): 33–35.

198. See, for example, "Fling, Dribble and Drip: Young sculptors pour their art all over the floor," *Life* (New York) 68 no. 7 (February 27, 1970): 62–66.

199. Berger, "The White Cell," *The New Statesman* (London) LVI no. 1445 (November 22, 1958): 722–23.

200. Kozloff, "Art," *The Nation* (New York) 148 no. 7 (February 10, 1964): 151.

201. Kozloff, "American Painting during the Cold War," *Artforum* (New York) 11 no. 9 (May 1973): 43–54.

202. Fuller, "American Painting since the Last War," p. 9. Two key articles in this eruption of politicized readings of Abstract Expressionism and its critical fortunes are Eva Cockcroft, "Abstract Expressionism, Weapon of the Cold War," *Artforum* (New York) 12 no. 10 (June 1974): 39–41, and David and Cecile Shapiro, "Abstract Expressionism: The Politics of Apolitical Painting," *Prospects* (New York) no. 3 (1977): 175–214. Both are reprinted in Francis Frascina, ed., *Pollock and After: The Critical Debate* (New York: Harper and Row, 1985); see Frascina's comments in his introduction to them, pp. 91–106. The locus classicus of this argument is now Guilbaut's *How New York Stole the Idea of Modern Art: Abstract Expressionism, Freedom, and the Cold War*, trans. Arthur Goldhammer (Chicago: at the University Press, 1983). For a more recent overview, focusing on the critiques of the ostensible role of The Museum of Modern Art in strategically promoting New York School painting, and considering the 1970s political context in which the early articles were written, see Michael Kimmelman, "Revisiting the Revisionists: The Modern, Its Critics, and the Cold War," in *The Museum of Modern Art at Mid-Century: At Home and Abroad, Studies in Modern Art* no. 4 (New York: The Museum of Modern Art, 1994): 38–55.

203. For discussions of the ways in which the peace movement in Europe was manipulated by European Communist parties, and ultimately by the Soviet Union, as an anti-American strategy, see, among others, Dominique Desanti, *Les Staliniens: Une Expérience politique 1944–1956* (Paris: Arthéme Fayard, 1975), pp. 94–125; Annie Kriegel, "Lutte pour la paix et mouvement de paix dans la stratégie et la structure du mouvement communiste internationale,"

in Francis Conte and Jean-Louis Martres, eds., *L'Union Soviétique dans les relations internationales* (Paris: Economica, 1982), p. 226; Kriegel, *Ce que j'ai cru comprendre* (Paris: Robert Laffont, 1991), p. 497; Tony Judt, *Past Imperfect: French Intellectuals, 1944–1956* (Berkeley, Los Angeles, and London: University of California Press, 1992), pp. 222–26; and Ariane Chebel d'Apollonia, *Histoire politique des intellectuels en France, 1944–1954* (Paris: Editions Complexe, 1991), 2:174–85. My acquaintance with this subject derives from my reading of the doctoral thesis of Gertje Utley, "Picasso and Communism" (Institute of Fine Arts, New York University, 1996), soon to be published in revised form by Yale University Press. I am indebted to Dr. Utley for the references cited here.

204. There has never been a convincing argument that Abstract Expressionist painting itself was either shaped or "corrupted" by this or any other post facto attempt to use it for one purpose or another. Consciously or unconsciously, many advocates of Abstract Expressionism may have grafted Cold War ideologies onto the discussion of Pollock and his cohorts in a given period; but this hardly makes the paintings "reflect" or embody such ideologies, either in their genesis or in their effect. To the contrary, Meyer Schapiro and numerous other authors long ago pointed out how the formation of Pollock and other New York School artists in the 1940s involved a liberatingly "un-American" overthrow of cultural hierarchies, for example in the assimilation of tribal sources and rejection of nationalistic or Eurocentric viewpoints. On the receiving end too, the message could not be controlled as some may have desired; unconventional art, let loose in the world, has a way of producing unexpected results. Hence aspects of Pollock's work wound up being embraced for specifically antiimperialist use in Third World countries like Nicaragua. On this latter point especially, and for a broader treatment of the question of Abstract Expressionism's influence abroad—still from a leftist perspective, but critical of the reductive simplifications of Guilbaut—see David Craven, "Abstract Expressionism and Third World Art: A

Post-Colonial Approach to 'American' Art," *Oxford Art Journal* (Oxford) 14 no. 1 (1991): 44–66.

205. Fuller, "American Painting since the Last War," p. 8.

206. Pollock said, "The idea of an isolated American painting, so popular in this country during the 'thirties, seems absurd to me, just as the idea of creating a purely American mathematics or physics would seem absurd. . . . And in another sense, the problem doesn't exist at all; or, if it did, would solve itself: an American is an American and his painting would naturally be qualified by that fact, whether he wills it or not. But the basic problems of contemporary painting are independent of any one country." In "Jackson Pollock," *Arts & Architecture*, p. 14.

207. Pollock wrote to a friend and fellow painter in 1946, "Everyone is going or gone to Paris. With the old shit (that you can't paint in America) have an idea they will all be back." Pollock, letter to Louis Bunce, n.d. (postmarked June 2, 1946), pp. 2–3. In the Louis Bunce Papers, Archives of American Art, and quoted in Paul Karlstrom, "Jackson Pollock and Louis Bunce," *Archives of American Art Journal* (Washington, D.C.) 24 no. 2 (1984): 26. Dr. Raphael Gribitz (cited in Potter, *To a Violent Grave*, p. 115) recalled that "when I talked about Paris he resented it: 'It's *here*,' was his answer to 'Why don't you go to Paris, see other people? What the hell are you staying here for?' But 'It's here,' he'd say, 'it's not in Paris. It used to be with Benton, but now it's with me.'"

208. "This [Cowboy] myth, which Pollock was not above encouraging by wearing cowboy boots while at home in Long Island and threatening occasionally, when heavily loaded, to 'bust up' a saloon, was particularly popular among European critics. For the French especially, the American national genius is often taken to be that of a kind of Noble Savage inhabiting a 'real America' which begins somewhere west of the Mississippi." Rubin, "Pollock Was No Accident," pp. 35–40, 46–49. See also Claudio Savonuzzi, "Polemica su Pollock cow-boy della pitura," *Il Resto del Carlino* (Bologna), March 21, 1958; Jean Rollin, "Eclaboussures et peinture au lasso au Musée d'art

moderne," *L'Humanité* (Paris), February 2, 1959; and Jean-Paul Crespelle, "Pollock: Peintre-Cowboy," *Le Journal du Dimanche* (Paris), October 7, 1979. Greenberg's contrary insistence on Pollock's filiation to European modern art is discussed in the section of this essay on Greenberg, above; Rubin's most extensive refutation of the "cowboy" image is his four-part article "Jackson Pollock and the Modern Tradition," of 1967.

209. On Jean Dubuffet's reception in America see Aruna d'Souza, "*I think your work looks a lot like Dubuffet*: Dubuffet and America, 1946–1962," *Oxford Art Journal* (Oxford) 20 no. 2 (1997): 61–73.

210. See Rubin, "Jackson Pollock and the Modern Tradition, Part II," pp. 28–37.

211. Rubin's work on Pollock's connections to Europe is most fully summarized in "Jackson Pollock and the Modern Tradition." Robert Rosenblum published his article "The Abstract Sublime" in *Artnews* (New York) 59 no. 10 (February 1961): 38–41, 56–57. He developed this line of thinking more broadly in *Modern Painting and the Northern Romantic Tradition: Friedrich to Rothko* (New York: Harper and Row, 1975), and again, now focusing on American art, in his essay "The Primal American Scene," in Kynaston McShine, ed., *The Natural Paradise: Painting in America 1800–1950*, exh. cat. (New York: The Museum of Modern Art, 1976), pp. 13–37.

212. See note 136 above. Rubin also writes, in "Jackson Pollock and the Modern Tradition [Part I]," p. 14, "Pollock's art . . . developed amid, and reflected, the rhythms, fluxes, convergences and confrontations of a metropolitan urban environment. It was, like all other serious painting of our time, firmly rooted in European traditions. The acuity with which Pollock grasped the nature, the feel, of life in the great city in which he lived derived precisely from his having come to it from outside. Much in the new American painting is no more imaginable without New York than Impressionism is without Paris. . . . If we are to subscribe to the environmental reasoning by which the 'wide open spaces' inform the scale and size of Pollock's painting, then we must keep in mind that the New York environment is also a monumental one." Pollock himself had said in 1944, in "Jack-

son Pollock," *Arts & Architecture*, p. 14, "Living is keener, more demanding, more intense in New York than in the West; the stimulating influences are more rewarding." Hess made the same point in "Pollock: The art of a myth," p. 63: "He [Pollock] was a hometown boy, and his home was the cosmopolitan New York scene. His wide open spaces fitted the studios of MacDougal Alley and its Long Island suburbs."

213. Greenberg, "Avant-Garde and Kitsch," *Partisan Review* (New York) VI no. 9 (Fall 1939): 34–49.

214. Claes Oldenburg has said, "Pollock's paint immediately suggested city subjects, the walls, the stores, the taxicabs. . . . I used that kind of paint to entangle the objects in my surroundings. . . . The vinyl I now use is still paint, the objects dissolving now in paint. Pollock is a paint-legend because, unlike Picasso, he turned the Sapolin loose." Quoted in "Jackson Pollock: An Artists' Symposium, Part 2," *Artnews* (New York) 66 no. 3 (May 1967): 26 and 66.

215. Schapiro, "Race, Nationality, and Art," *Art Front* (New York) 2 no. 4 (March 1936): 10–12.

216. See Ann Gibson, "Abstract Expressionism's Evasion of Language," *Art Journal* (New York) 47 no. 3 (Fall 1988): 208–14.

217. Lamenting Pollock's self-enclosure, Berger said, "Having the ability to speak, he acted dumb. (Here a little like James Dean.)" "The White Cell," p. 722. Writers have also often compared Pollock to Marlon Brando, in terms of both actors' image as brooding, internally disturbed American antiheroes. See for example Landau, *Jackson Pollock*, pp. 14–18. Motherwell remarked of Pollock, "He was so involved with his uncontrollable neuroses and demons that I occasionally see him like Marlon Brando in scenes from *A Streetcar Named Desire*—only Brando was much more controlled than Pollock." Quoted in Potter, *To a Violent Grave*, p. 70. For a sample of the journalistic linkage between Abstract Expressionism and Brando as a personification of the "Beat Generation," see Robert Brustein, "The Cult of Unthink," *Horizon* (New York) 1 no. 1 (September 1958): 38–44.

Pollock's studio,
fall 1950.

Pollock at Work | The Films and Photographs of Hans Namuth

Pepe Karmel

By November 1949, Jackson Pollock's work had appeared in eight solo exhibitions and twenty-five group shows, including the Venice Biennale. Beginning in 1943, Pollock's shows had won respectful attention from mainstream periodicals like *The New Yorker* and *The Art Digest*, and strikingly favorable reviews in small-circulation, left-leaning journals like *The Nation* and *The New Republic*. He first attracted the attention of the mass media in December 1947, when *Time* magazine incredulously reported the opinion of *The Nation*'s art critic, Clement Greenberg, that Pollock was one of America's three best artists. *Vogue* magazine introduced Pollock to its fashionable readers in its April 1948 issue. *Life* featured Pollock's work twice in 1948, and then, in August 1949, ran a feature with the incendiary headline, "Jackson Pollock: Is he the greatest living painter in the United States?"[1]

A reasonably attentive follower of the art scene, then, would certainly have been aware of Pollock's work by November 1949, when his ninth solo show opened at the Betty Parsons Gallery. Nonetheless, when Alexey Brodovitch—photographer, designer, and art director for *Harper's Bazaar*—asked his students at The New School for Social Research if any of them had seen Pollock's work at Parsons, only one raised his hand.

That student was a German émigré named Hans Namuth.[2]

As a teenager growing up in the grimy industrial city of Essen (where he was born in 1915), Namuth was drawn to theater and radical politics. His hopes of becoming a theater director were shattered in July 1933, when he was arrested for distributing anti-Hitler leaflets. His father, a member of the Nazi *Sturm Abteilung*, got him out of jail, and then provided him with a passport and a one-way ticket out of the country. Namuth never saw his father again.[3]

Namuth arrived in Paris in September 1933. He was not yet nineteen. Living on the Left Bank, he quickly became part of a talented refugee community that included such figures as the photographer André Friedmann, later to become famous as Robert Capa. More important to Namuth, however, was his friendship with Georg Reisner, a young German-Jewish refugee who was taking courses in photography.

Namuth spent the summer of 1935 herding goats on a collective farm run by Quakers in the Pyrenees. An ill-fated love affair led him south through Italy and Greece, then left him stranded in Athens in the summer of 1935. There he received a letter from Reisner, who had started a successful photography studio in Majorca, providing portraits for affluent beach-goers. Namuth accepted Reisner's invitation to join him there. By the winter of 1935, when the two young men returned to Paris, they had become a team, selling photo stories to the European picture press.

In July 1936, the pair went to Barcelona to cover the Worker's Olympiad, organized to protest and offer an alternative to the Nazi-dominated Olympics in Berlin. No sooner had they arrived than the Spanish Civil War broke out. Accredited by the Republican government as French press photographers, Namuth and Reisner remained to cover the struggle raging across Spain. Their photographs, published in magazines like *Vu*

All still photographs of Jackson Pollock's studio are by Hans Namuth. Film frames are from the black and white film by Hans Namuth, the color film by Hans Namuth and Paul Falkenberg, or the color outtakes by Hans Namuth.

and *Paris-Soir*, ranged from close-ups of farmers to weary soldiers crouching in the rubble of bombarded cities.[4] Allied with the anarchists of the POUM (Partido Obrero de Unificación Marxista), Namuth and Reisner found themselves in danger from the Stalinist faction that came to dominate the Republican government, and by March 1937 they were forced to return to France. There history caught up with them again. In 1939, Reisner was interned by the French government; in 1940, despairing of escape, he killed himself. Namuth too was interned for a time before joining the French Foreign Legion. Demobilized in 1940, he escaped to the United States, where he joined the American army and served in military intelligence.

By the time the war ended, Namuth was married—to Carmen Herrera, the daughter of a Guatemalan diplomat—and had a child on the way. His wife's brother insisted that he would never be able to support his family as a photographer, and got him a job with a company trying to market waterproof paper. But Namuth converted his bathroom into a darkroom and continued making pictures. In 1947, he and his wife visited the remote Guatemalan village of Todos Santos Cuchumatan, where they became friendly with the anthropologist Maud Oakes, who was studying Mayan elements in the religious practices of the local Indians. Namuth's photographs provided striking illustrations for her book *The Two Crosses of Todos Santos*, published in 1951.[5]

Back in New York, Namuth began attending the weekly seminars held by Alexey Brodovitch, an important influence on many photographers and designers of the postwar era. Born in Russia, the son of a psychiatrist and a painter, Brodovitch had fought with the White Army against the Bolsheviks and then escaped to Paris, where he became a successful graphic designer. In 1930 he emigrated again, accepting a position as head of the Department of Advertising Design at the Pennsylvania Museum School of Industrial Art. In 1934, he was hired by Carmel Snow, the editor of *Harper's Bazaar*, to assist in the magazine's transformation from a stodgy journal of the old-money aristocracy to a handbook for a new elite based on wit, style, and self-made success. Snow had already hired the Hungarian photographer Martin Munkacsi, who brought the new look of 35-mm. action photography to fashion pages hitherto dominated by static portraits of socialites. To create a visual context for this new kind of photograph, Brodovitch eliminated the ruled borders around pictures, juxtaposed large and small images and fonts, and floated text and image against expanses of blank white paper.[6]

Throughout his career at *Harper's Bazaar*, Brodovitch continued to teach, holding a biweekly or monthly workshop known as the "Design Laboratory." While the workshop covered all aspects of design, its most illustrious alumni were photographers, including Richard Avedon, Bruce Davidson, Art Kane, Irving Penn, Bert Stern, and Garry Winogrand as well as Namuth. Brodovitch's own photographs, published in his 1945 book *Ballet*, used blur, repetition, and asymmetrical composition to provide a vivid image of a troupe in motion, rather than capturing the images of individual dancers. His students were to make even more effective use of these devices; Avedon in particular revolutionized fashion photography with a style based on Brodovitch's teachings. As the photography critic Andy Grundberg has noted, "Under the designer's wing, Avedon developed a repertory of stylistic effects that included blurred motion, activity frozen in mid-stride, out-of-focus faces, incongruous subject matter, and a cinema verité look that resembled the 'available light' school of photojournalism."[7] Brodovitch rapidly made Avedon his leading protegé. And Avedon returned the favor by letting Brodovitch hold the Design Laboratory in his studio for three years, from 1947 through 1949.

This was the period during which Namuth participated in the Laboratory, where he heard Brodovitch describe Pollock as "one of the most important artists

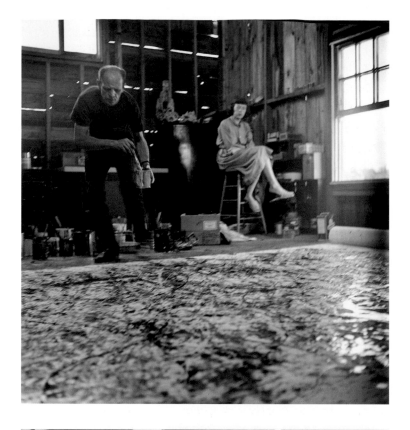

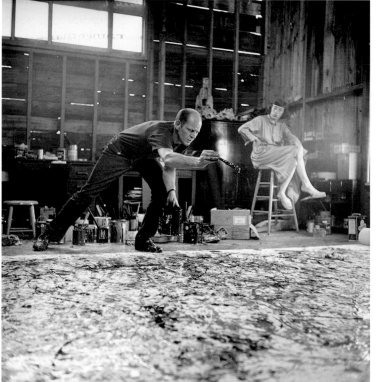

around today." Namuth had not in fact liked the paintings at the Betty Parsons Gallery, but Brodovitch's praise impelled him to return. "Again I found the pictures difficult, but after more visits I began to come to terms with them," he later recalled. "I wanted to meet the artist." The opportunity came several months later, on July 1, 1950, when Namuth encountered Pollock at the opening of a group show at the Guild Hall in East Hampton, Long Island, not far from the artist's studio in The Springs. Namuth explained that he was a student of Alexey Brodovitch's and a photographer for *Harper's Bazaar*, and asked if he could photograph the artist at work. It took some convincing, but Pollock finally agreed: "He promised he would start a new painting for me, and, perhaps, finish it while I was still around." They fixed a date for another weekend.[8]

When Namuth arrived at the studio, Pollock greeted him with the news that he had already finished the painting he was working on, and there was therefore nothing to photograph. Namuth asked at least to see the studio. Pollock and his wife, Lee Krasner, led the way to the barn behind their house. Namuth's description of his visit deserves to be quoted verbatim:

The large barn was filled with paintings. A dripping wet canvas covered the entire floor. Blinding shafts of sunlight hit the wet canvas, making its surface hard to see. There was complete silence. I looked aimlessly through the ground glass of my Rolleiflex and began to take a few pictures. Pollock looked at the painting. Then, unexpectedly, he picked up can and paintbrush and started to move around the canvas. It was as if he suddenly realized the painting was not finished. His movements, slow at first, gradually became faster and more dance-like as he flung black, white, and rust-colored paint onto the canvas [figs. 1 and 2]. . . . My photography session lasted as long as he kept painting, perhaps half an hour. In all that time, Pollock did not stop. How long could one keep up that level of physical activity? Finally, he said, "This is it." Later, Lee told me that until that moment she had been the only person who ever watched him paint.[9]

This was not literally true: Pollock had demonstrated his technique of dripping paint and sand for two Time-Life photographers, Arnold Newman and Martha

Figs. 1 and 2. Pollock at work on **One: Number 31, 1950** (plates 180 and 181).

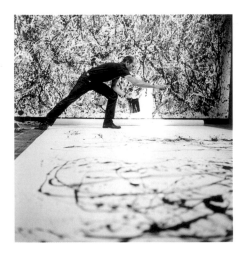

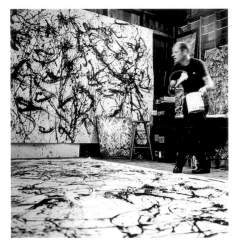

Figs. 3 and 4. At work on **Autumn Rhythm: Number 30, 1950** (plates 182 and 183).

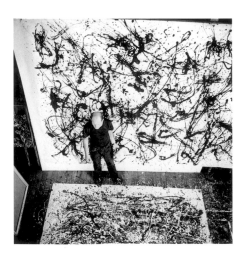

Fig. 5. At work on **One**.

Holmes, in the spring and summer of 1949.[10] But Namuth's half-hour with Pollock marked the beginning of an extraordinary collaboration, lasting from July through November of 1950.

Namuth took dozens of black-and-white photographs of Pollock working on two of his largest canvases—*One: Number 31, 1950* (plates 180 and 181; the painting Pollock reworked during that first visit) and *Autumn Rhythm: Number 30, 1950* (plates 182 and 183). He also filmed Pollock painting three additional pictures. Never before had a painter's activity been recorded in such detail. And never before had the activity of painting offered such a remarkable spectacle. Taking advantage of the premixed liquid paints that had only become available in recent decades,[11] Pollock would hoist a large can of paint in one hand and ladle it out with a thickly encrusted brush. Stepping forward and cantilevering his body over the canvas, or twisting counterclockwise like a tennis player preparing a ferocious backhand, he would move rapidly around the painting's perimeter, pausing only occasionally to contemplate the tangled web of lines, spots, and spatters that he had produced (figs. 3, 4, and 5).

"It was a great drama," Namuth reported, "the flame of explosion when the paint hit the canvas; the dance-like movement; the eyes tormented before knowing where to strike next; the tension; then the explosion again. . . ."[12] Shooting with available light, Namuth was forced to use long exposures, and the swiftness of Pollock's movements meant that his image was frequently blurred. Some of the photographs from the first session were also blurred by a defect in one of Namuth's cameras. He was initially troubled by these imperfections, but ultimately came to feel that they enhanced the pictures' visual excitement. In fact the use of blur to evoke motion was a central element in the visual style to which Namuth had been exposed in Brodovitch's Design Laboratory. His images of Pollock in motion recall the surging dancers in Brodo-

vitch's *Ballet*, as well as the running and skipping women in Avedon's contemporaneous fashion photographs.

It seems impossible, in retrospect, to distinguish the objective Pollock from the mythic Pollock who was, in a sense, created by Namuth's photographs. If Pollock appears as a kind of shaman, enacting enigmatic rituals in a sacred space, this is probably at least in part because Namuth had photographed actual shamans on his 1947 trip to Guatemala. If Pollock seems, at other moments, like a real-life version of Stanley Kowalski, it is not merely because he wears a proletarian T-shirt and jeans. Namuth, with his background in theater, would probably have seen Marlon Brando's searing performance in the original production of Tennessee Williams's *Streetcar Named Desire*, and would have recognized in Pollock another avatar of American sincerity, straining to express the inexpressible with strands of paint instead of mumbled words.[13]

Pollock himself is so hypnotically fascinating that it is hard to look at anything else in Namuth's photographs. Furthermore, the fact that Pollock worked on the floor made it difficult for Namuth to capture painter and painting in a single view. In the photographs taken from conventional eye level, the paintings in progress are distorted almost beyond recognition by extreme foreshortening, and the areas of canvas in the foreground are often out of focus. (The low light-levels in Pollock's studio dictated that Namuth use broad apertures, restricting his depth of field.) In order to shoot down toward the canvas, Namuth had to hold the camera over his head, climb atop a ladder, or stand on the roof of a shed adjoining the studio, leaning in through an aperture in the barn's south gable. At least once he clambered into the rafters of the barn roof.[14] This overhead viewpoint minimized the effects of foreshortening, although Namuth still could not get far enough away to capture huge canvases like *One* or *Autumn Rhythm* in a single frame.

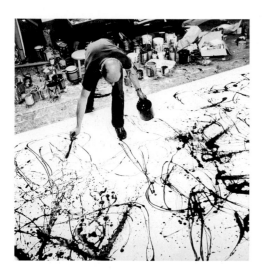

Fig. 6. At work on the bottom center of **Autumn Rhythm**.

The overhead view benefited the canvas but diminished Pollock, capturing his bald pate instead of his face (fig. 6). Bent over, with all four limbs extended toward the canvas, he seems to be scuttling around his picture like a spider around its web.

Namuth's main dissatisfaction with his still photographs, however, was simply that they were still. "To make a film was the next logical step," he concluded. "Pollock's method of painting suggested a moving picture—the dance around the canvas, the continuous movement, the drama." The first filming session was undertaken "at the end of summer, 1950"— by which Namuth seems to mean the end of August. The resulting five minutes and thirty-four seconds of film suffered from some of the same problems as the still photographs: half of the footage was shot from overhead, rendering the composition visible but the artist anonymous (fig. 32); the other half was shot from the floor, reversing the problem.[15]

Consulting his friend Paul Falkenberg, an experienced film editor, Namuth decided to undertake a more ambitious project: a longer film, shot in color. The available light in the barn studio would clearly be inadequate, and renting lights was too expensive, so Namuth and Pollock decided to shoot the film outdoors. Pollock would work on a long strip of red canvas, laid out on the concrete slab where the barn had stood before being moved to its new location, in the summer of 1946. Namuth writes that this initial filming took place over "five or six weekends during the months of September and October." But he remained dissatisfied with the results: "Somehow a main ingredient was missing. I realized that I wanted to show the artist at work with his face in full view, becoming part of the canvas, inside the canvas, so to speak." The solution he found was to have Pollock paint on a large sheet of glass mounted on supports, while Namuth filmed from underneath. This solved the problem of capturing artist and composition in a single shot, but imposed a new restriction: because the sup-

ports were low, Namuth was able to film Pollock at work on only a small section of the composition as a whole (figs. 56–58).[16] The finished film opens with brief excerpts from Pollock's work on the red canvas (now lost), continues with miscellaneous shots of other paintings in the studio and on view at the Betty Parsons Gallery, and concludes with the glass painting. Laconic narration by Pollock himself, and a dissonant cello solo written by Morton Feldman, lend a distinct period flavor.[17]

At first Namuth's photographs and film met with a lukewarm, even negative response. Edward Steichen, then head of the Department of Photography at The Museum of Modern Art, told Namuth flatly, "This is not the way to photograph an artist." Pictures of an artist at work could not reveal the fullness of his personality, Steichen insisted; one had to follow him through the course of a day—eating breakfast, talking to his wife, and so forth. Screened at MoMA and at a film festival in Woodstock, the film was panned by the *New York Times*.[18] Nonetheless, Namuth's pictures of Pollock began to attract attention.

Brodovitch published some of them in a 1951 issue of *Portfolio*, a short-lived journal devoted to graphic design. The same issue contained stories on French marbled papers, calligraphy, the sculptor Alexander Calder, and the illustrator Robert Osborn. Namuth's photographs of Pollock at work on *Autumn Rhythm* were published filmstrip style, and were followed by a page spread of details from two calligraphic drawings, reproduced as alternating negative and positive images, with the curving loops of paint silhouetted against a series of black and white bars. The "film stills" emphasized the drama of Pollock's movements, while the page spread of details stressed their repetitive, decorative quality.[19]

Namuth's photographs reached a broader audience with the publication of Robert Goodnough's article

"Pollock Paints a Picture," in the May 1951 issue of *Artnews*. The article included five of Namuth's pictures of Pollock working on *Autumn Rhythm*, along with a reproduction of the finished painting and a photograph by Rudolph Burckhardt of open paint cans on the floor of Pollock's studio. Frank O'Hara's 1959 monograph on Pollock reproduced a posed portrait by Namuth, but was otherwise illustrated exclusively with reproductions of Pollock's work. By contrast, Dorothy Seiberling's 1959 feature on Pollock in *Life* magazine included both posed portraits of him and a series of color photographs of him painting outdoors, made by Namuth during the shooting of his color film. Similarly, Bryan Robertson's big coffee-table book of 1960 opened with a portfolio of Namuth's photographs of Pollock at work. Though Robertson's text was widely criticized, the superb tipped-in plates—printed in five colors to reproduce the metallic sheen of Pollock's aluminum paint—made his book an indispensable reference.[20]

From the 1960s on, no reader on Pollock could fail to absorb Namuth's dramatic portrait of the artist in action. Beginning in 1967, when MoMA organized a major retrospective of Pollock's work, Namuth's photographs became virtually obligatory illustrations for both scholarly and popular writings about him. Indeed it has been suggested by Barbara Rose that over the decades, "Namuth's photographs and film affected a far larger audience than the paintings had." Relatively few people saw Pollock's paintings first-hand, and they lost much of their impact in reproduction. In contrast, the photographs remained effective even at small scale. What stuck in people's minds was less Pollock's work than Namuth's images of him making it.[21]

Insofar as this is true, it must also be said that the effect of Namuth's photographs was determined largely by the texts that accompanied or interpreted them. The ideas that would shape the reception of the photographs had already appeared in print before Namuth set foot in Pollock's studio. In a statement published in the winter of 1947–48 in the journal *Possibilities*, edited by Robert Motherwell and Harold Rosenberg, Pollock had announced, "When I am *in* my painting, I'm not aware of what I'm doing. It is only after a sort of 'get acquainted period' that I see what I have been about." In her 1949 *Life* article on Pollock, Dorothy Seiberling quoted this statement, then added, "Once in a while, a lifelike image appears in the painting by mistake. But Pollock cheerfully rubs it out because the picture must retain 'a life of its own.'" Pollock's original explanation, recorded in Seiberling's notes, was more emphatic: "I try to stay away from any recognizable image; if it creeps in, I try to do away with it. . . . I don't let the image carry the painting. . . . It's extra cargo—and unnecessary." (But, he added, "recognizable images are always there in the end.")[22]

When Namuth's photographs appeared in the Brodovitch journal *Portfolio* in 1951, they were accompanied by a brief text cobbled together from these earlier sources. The anonymous author stressed the idea that Pollock worked virtually unconsciously:

The conscious part of his mind, he says, plays no part in the creation of his work. It is relegated to the duties of a watchdog; when the unconscious sinfully produces a representational image, the conscience cries alarm and Pollock wrenches himself back to reality and obliterates the offending form. According to Pollock, he has no idea at all what the painting looks like while he is in the process of creating it.[23]

This description transforms what at first seems like Surrealist automatism into something odder and more surprising: Pollock rejects not only conventional representation but representational images emerging from the unconscious, which the Surrealists would have welcomed. Since he also rejects the rational mensuration of geometric abstraction, Namuth's photographs would seem—by a process of elimination—to document the creation of a new kind of irrational abstraction.

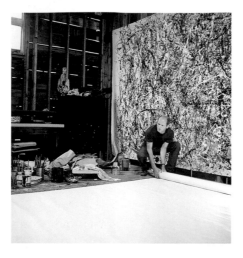 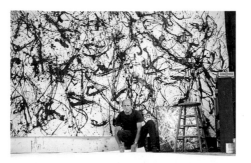 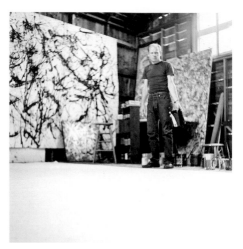

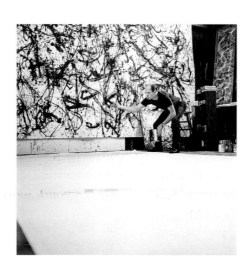 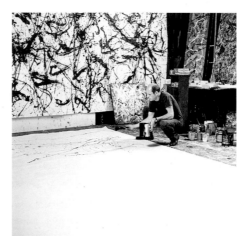 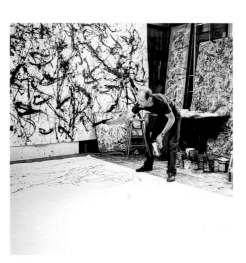

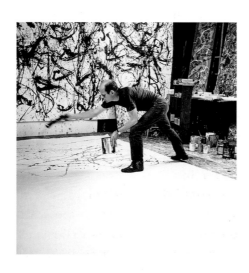 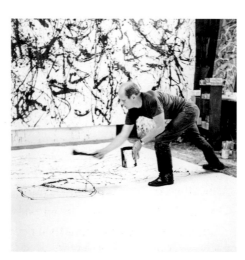

Figs. 7–14. Beginning work on **Autumn Rhythm**. On the east wall of the studio, hiding the window visible in fig. 1, hangs **One**. Below it, what will be the left edge of the new picture is still attached to the roll of canvas. **Number 32, 1950** (plates 178 and 179) hangs on the west wall, above the right edge of **Autumn Rhythm**, where Pollock begins painting.

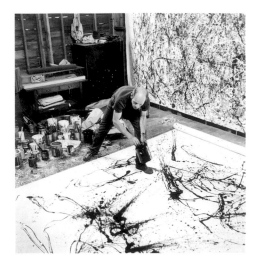 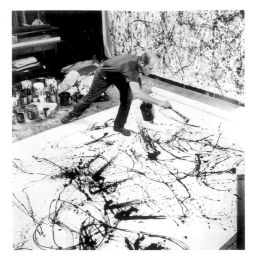 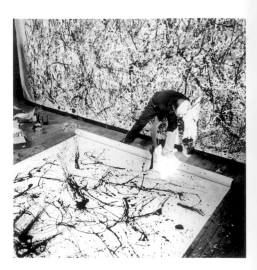

Figs. 15–17. Elaborating the leftmost section of **Autumn Rhythm**.

Goodnough's *Artnews* essay places Pollock among those artists (not yet known as Abstract Expressionists) who are "not concerned with representing a preconceived idea, but rather with being involved in an experience of paint and canvas, directly, without interference from the suggested forms and colors of existing objects." Is painting, under these circumstances, Goodnough asks, an "act of automatism"?

Pollock says that it is not. He feels that his methods may be automatic at the start but that they quickly step beyond that, becoming concerned with deeper and more involved emotions which carry the painting on to completion according to their degree of strength and purity. . . . Starting automatically, almost as a ritual dance might begin, the graceful rhythms of his movements seem to determine to a large extent the way the paint is applied, but . . . he is working toward something objective, something which in the end may exist independently of himself.[24]

Goodnough's article is full of troubling inaccuracies and inconsistencies. He refers to the painting as *Number 4, 1950* when its original title was *Number 30, 1950*. (It was subsequently renamed *Autumn Rhythm*.) He says that it was begun in June when the account of Namuth (who was present) makes clear that it cannot have been started before July. He describes the application of aluminum paint although the canvas shows no trace of it. On the other hand, many pas-

sages of Goodnough's article seem to be based on conversations with Pollock, so that the text may, overall, give an accurate idea of how Pollock wished his painting process to be understood.

The impression that Goodnough is describing firsthand experience presumably derives from his study of Namuth's photographs—not just the five reproduced in the article, but the considerably more numerous images that remained unpublished at the time. The sentences in which Goodnough describes the beginning stages of Pollock's work on the picture correspond with remarkable precision to Namuth's pictures:

The canvas, 9 by 17 feet, was laid out flat, occupying most of the floor of the studio and Pollock stood gazing at it for some time, puffing at a cigarette [figs. 7, 8, and 9]. After a while he took a can of black enamel . . . and a stubby brush which he dipped into the paint and then began to move his arm rhythmically about, letting the paint fall in a variety of movements on the surface [fig. 10]. At times he would crouch, holding the brush close to the canvas [fig. 11], and again he would stand [fig. 12] and move around it or step on it to reach to the middle [figs. 13 and 14]. Within a half hour the entire surface had taken on an activity of weaving rhythms. Pools of black, tiny streams and elongated forms seemed to become transformed and began to take on the appearance of an image [fig. 15]. As he continued, still with black, going back over former areas, rhythms were intensified with counteracting movements [figs.

94

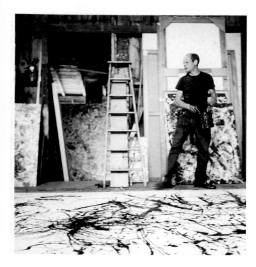

Fig. 18. Standing at the upper edge and toward the right of **Autumn Rhythm**.

16 and 17]. After some time, he decided to stop to consider what had been done [fig. 18].[25]

How long, exactly, had Pollock been working when he decided to stop? Goodnough does not say, but the caption to the "filmstrip" page spread in *Portfolio* may offer a provisional answer: "The unusual painting technique of Jackson Pollock begins . . . when the clean canvas is tacked to the painter's studio floor, and ends . . . some two hours later as Pollock stands erect, completely exhausted."[26]

The canvas was allowed to dry overnight, and was then "nailed to a wall of the studio for a period of study and concentration." Pollock may have followed this procedure with other paintings, but it would have been virtually impossible for him to nail *Autumn Rhythm* to the wall, since (as E. A. Carmean, Jr., has pointed out) it remained attached to a large, heavy roll of canvas.[27] Goodnough continues, "It was about two weeks before Pollock felt close enough to the work to go ahead again. This was a time of 'getting acquainted' with the painting, of thinking about it and getting used to it so that he might tell what needed to be done to increase its strength. . . . In the meantime other paintings were started."

Goodnough's description of Pollock's later campaigns of work on *Autumn Rhythm* (understanding by "campaign" each address of the canvas with a new can of paint) are notably less precise than his description of its beginning. He describes Pollock selecting a light reddish brown color and applying it "in rhythms and drops that fell on uncovered areas of canvas and over the black." Then, he says, Pollock added some aluminum paint, "to hold the other colors on the same plane as the canvas" and "to add a sense of mystery and adornment." After this the painting was again allowed to dry and hung back on the wall. The third and last campaign of work on the painting was "slow and deliberate. The design had become exceedingly complex and had to be brought to a state of complete organization." Goodnough does not specify the colors

Pollock used at this stage, except to say that "a few movements in white paint constituted the final act and the picture was hung on the wall; then the artist decided there was nothing more he could do with it."[28]

Goodnough's description of these second and third campaigns is difficult to reconcile with the evidence of either the painting or Namuth's photographs, which suggest a different and more complex series of paint layers. It is true that the "light reddish brown" paint described by Goodnough seems, in the finished painting, to lie on top of the initial layer of black and below the final strokes of white. But several pictures show white going down on top of what appears to be the initial black design (fig. 19), *before* the first application of the "light reddish brown" paint—which is actually more like a tan. Conversely, the photographs of Pollock working with what seems to be a can of tan paint show the painting at a later, denser stage of development (fig. 20). Several layers of black seem to have alternated with the lighter colors (fig. 21), and these were followed by at least one more application of white paint (fig. 22) corresponding to Goodnough's "final act." Work on *Autumn Rhythm* extended over at least two days, but it is highly unlikely, as Carmean argues, that Pollock suspended it on the wall between campaigns.[29] Furthermore, no aluminum paint is evident in the finished painting.

These inaccuracies or inconsistencies, however, did not affect the historical impact of Goodnough's article. Instead of analyzing his text in light of Namuth's photographs, subsequent artists and critics saw Namuth's photographs in light of what Goodnough had written. What remained fixed in the collective consciousness, so to speak, was the image of Pollock executing a kind of "ritual dance."

According to Goodnough, Pollock and his peers "are not concerned with representing a preconceived idea, but rather with being involved in an experience of paint and canvas, directly, without interference from the suggested forms and colors of existing objects." 95

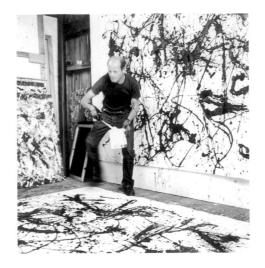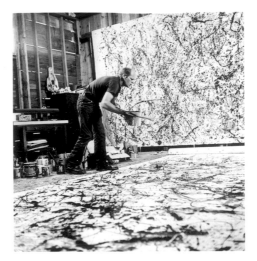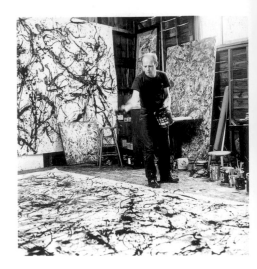

Figs. 19–21. Working at the upper right corner of **Autumn Rhythm**; at the left end of the lower edge; and at the right end of the lower edge.

Pollock in particular, Goodnough writes, insists that his painting "does not depend on reference to any object or tactile surface, but exists 'on its own.'"[30] He does not use sketches, for none of his movements is guided by the goal of creating a predetermined image; rather, the image emerges from the action of the "ritual dance," its movements determining the "weaving rhythms" of the paint falling to the canvas. As it develops, the picture begins to coalesce into a composition: "pools of black, tiny streams and elongated forms" are "transformed" and start to "take on the appearance of an image." This image is purely abstract, and its dominant characteristic is unity. "My paintings do not have a center, but depend on the same amount of interest throughout," Pollock tells Goodnough, who explains that the linear composition is designed "to carry the same intensity to the edges of the canvas." Similarly, the colors "have been applied so that one is not concerned with them as separate areas: the browns, blacks, silver and white move within one another to achieve an integrated whole in which one is aware of color rather than colors."[31] Representation, which inevitably divides the visual field between figure and ground, is obviously incompatible with this goal. Hence the repressive process

described in *Life* and *Portfolio*: when the unconscious produces a representational image, it must be repressed to maintain the unity of the composition.

Less than a year after the publication of Goodnough's article, *Artnews* published Harold Rosenberg's now famous essay "The American Action Painters." Many different sources have been suggested for this essay—Pollock himself supposedly said that its key ideas came from a "half-drunken" conversation he had with Rosenberg on a train ride between East Hampton and New York. It has also been suggested that "Rosenberg was not talking about painting at all; he was describing Namuth's photographs of Pollock."[32] There may be some truth to both these interpretations. More precisely, it might be said that Rosenberg is describing Namuth's photographs as interpreted by Goodnough.

Goodnough states that Pollock and his peers "are not concerned with representing a preconceived idea, but rather with being involved in an experience of paint and canvas, directly, without interference from the suggested forms and colors of existing objects"; Rosenberg boils this down to "The painter no longer approached his easel with an image in his mind." Goodnough says that "no sketches are used"

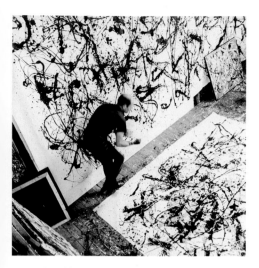

Fig. 22. At the right edge of **Autumn Rhythm**.

in Pollock's working process; Rosenberg cites an anonymous "leader" of the new movement as denouncing another painter as "not modern. . . . He works from sketches. That makes him Renaissance." Goodnough writes that "Pollock depends on the intensity of the moment of starting to paint to determine the release of his emotions and the direction the picture will take . . . the graceful rhythms of his movements seem to determine to a large extent the way the paint is applied"; Rosenberg declares that "what was to go on the canvas was not a picture but an event."[33] Similarly, Namuth's description in *Portfolio* of Pollock's working process as a drama, explosions alternating with periods of tension, seems to echo in Rosenberg's declaration that "since the painter has become an actor, the spectator has to think in a vocabulary of action: its inception, duration, direction—psychic state, concentration and relaxation of the will, passivity, alert waiting."[34]

Swathed in rhetoric—Rosenberg's, Goodnough's, his own—Namuth's photographs were increasingly restricted to illustrating a handful of ideas about Pollock's working process: his trancelike state, his rhythmic movements, the seemingly random quality of his compositions. To speak of the influence of the photographs, therefore, is to speak of the influence of these ideas.

At the risk of oversimplification, it might be said that Pollock criticism of the 1950s and '60s was dominated by the battle between the "action painting" theories of Harold Rosenberg and the "formalism" of Clement Greenberg; that the late 1960s, the '70s, and the '80s saw the emergence of new critical approaches rooted in Jungian analysis and in social history; and that the 1990s have yielded a new fusion of formalism and psychoanalysis rooted in the "deviant" Surrealism of the 1930s.[35] Throughout all these changes of critical opinion, however, the 1950s reading of Namuth's

photographs has persisted virtually unchanged.

The influence of these photographs has been most obvious in the critical and artistic tradition stemming from Goodnough and Rosenberg. The key text here is Allan Kaprow's essay "The Legacy of Jackson Pollock," published in *Artnews* in 1958 (and, ironically, illustrated not with Namuth's pictures but with Burckhardt's posed photographs of Pollock pretending to work on *Number 32, 1950*). For Kaprow, Pollock was important because he had "destroyed painting." By deciding to work on the floor, where it was difficult or impossible for him to see the whole of his composition, he had liberated himself from traditional ideas of composition, based on the relationship of part and whole. His "automatic" approach to pouring paint bordered on "ritual . . . which *happens* to use paint as one of its materials." Nor did his paintings conform to conventional ideas of composition, with a "beginning, middle and end"; rather, "anywhere is everywhere and you can dip in and out when and where you can . . . the confines of the rectangular field were ignored in lieu of an experience of a continuum going in all directions simultaneously, *beyond* the literal dimensions of any work." When Pollock's mural-scale paintings were hung together, "they ceased to become paintings and became *environments*." (The locus classicus for such environments, Kaprow might have added, was Pollock's own well-documented studio.) Pollock's "destruction" of the conventions deriving from Renaissance painting seemed to Kaprow to mark "a return to the point where art was more actively involved in ritual, magic and life" than it had been in several hundred years. Kaprow concludes, "Pollock, as I see him, left us at the point where we must become preoccupied with and even dazzled by the space and objects of our everyday life, either our bodies, clothes, rooms, or, if need be, the vastness of Forty-Second Street."[36]

Following his own prescription, Kaprow launched into the creation of a series of happenings, installations, and environments that treated the real world as

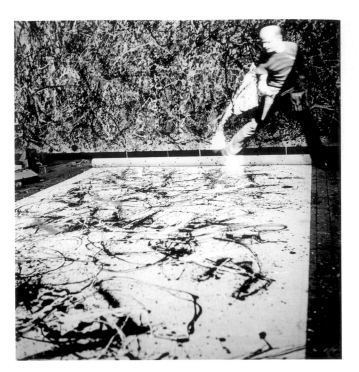

Fig. 23. Pollock at work on the left edge of **Autumn Rhythm**.

Fig. 24. Allan Kaprow. **Yard**. 1961. Photograph: Ken Heyman.

a canvas for action. Deliberately transient, these works found permanence only in the form of documentary photographs. To record his 1961 "environment" *Yard*, for example, Kaprow had himself (and his son) photographed wading in a sea of used tires (fig. 24). The overlapping curves of the tires provide a witty sculptural equivalent for Pollock's intertwining lines of paint. Similarly, the photograph's elevated viewpoint, placing Kaprow near the bottom of the field of tires, recalls pictures by Namuth where Pollock seems almost to vanish into the visual turmoil of the canvases surrounding him (fig. 23).

MoMA's Pollock retrospective of 1967 provoked a new wave of interest in him among contemporary artists. Minimalist sculptors who had hitherto embraced strict geometric forms soon began creating three-dimensional equivalents to Pollock's painterly chaos. The influence was more than a matter of formal resemblance: Namuth's photographs, reproduced in numerous reviews and articles,[37] fostered the idea of translating "action painting" into what might have been called "action sculpture." Fifteen years earlier, Rosenberg had written that a painter like Pollock "approached his easel . . . with material in his hand to do something to that other piece of material in front of him. The image would be the result of this encounter."[38] Now sculptors like Robert Morris, Eva Hesse, Barry Le Va, Bruce Nauman, and Richard Serra began "doing things" to a range of non-art materials like felt, glass, rubber, and lead. Documentary photography played an increasingly large role in their work, because the results of their encounters with materials were often intelligible only in light of the action that had produced them. Works like Serra's 1968 *Splashing* and 1969 *Casting* made sense as "sculptures" only if one knew that the artist had produced them by throwing a ladleful of molten lead into the juncture between floor and wall. Serra's gesture, captured by the art-world photographer Gianfranco Gorgoni, unmistakably echoed Namuth's photographs of Pollock

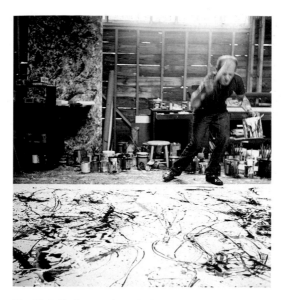

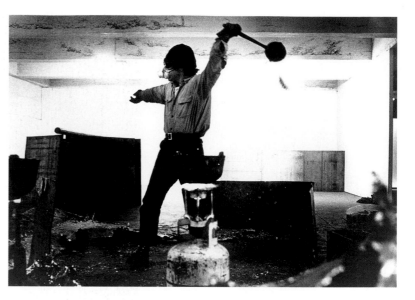

Fig. 25. Pollock at work on the bottom center of **Autumn Rhythm**.

Fig. 26. Richard Serra throwing molten lead for **Castings**, at the Castelli warehouse, New York, 1969. Photograph: Gianfranco Gorgoni, New York.

raising his arm to cast paint down toward the canvas (figs. 25 and 26). It might be further argued that Serra's interest in the intersection of floor and wall was in part inspired by the photographs showing Pollock's canvases occupying both of these surfaces, and virtually meeting at their juncture (fig. 23).[39]

Rosenberg's rhetoric encouraged artists and critics to focus on Pollock's actions rather than on the images resulting from them. Meanwhile other critics of the 1950s and '60s, equally struck by the athletic freedom of Pollock's paint-handling, struggled to explain how significant images could emerge from seemingly random swirls and splatters. Anton Ehrenzweig suggested in 1956 that the new "doodling" school—of which Pollock was the leading representative—was merely the most recent manifestation of a broader tendency in modern art, according to which "execution determines design instead of design determining execution." The modern artist's readiness to incorporate "accidental effects," Ehrenzweig argued, was a method for allowing "unconscious phantasy" to express itself through the work of art. In effect, the artist's "random" application of paint was the visual equivalent of the flow of free associations in psychoanalysis. (Ehrenzweig was evidently unaware of the idea, expressed in *Life* and *Portfolio*, that when Pollock's unconscious produced a representational image, he promptly tried to obliterate it.) Ehrenzweig's analysis offered a way to reconcile the seemingly contradictory ideas of self-expression and randomness. The artist, he wrote, "does not experience any accident cropping up during his work as a disruption of his design or a failure of skill; from the outset he keeps his design flexible, ready to be moulded by any happy effect that his not fully controlled technique might bring along."[40]

Rudolph Arnheim, the author of the influential treatise *Art and Visual Perception*, responded to Ehrenzweig in a 1957 essay analyzing the increasingly important role of accident in Western art from the Renaissance onward. "The Renaissance play with costumes, perspectives, lights, and groupings is rich in accidental features," Arnheim pointed out, compared to "the simple, schematic figures" of Byzantine art. In the

99

nineteenth century the Impressionists had introduced a new kind of seemingly accidental composition, in which "people walk past each other in the street, dancers hurry crisscross without any evidence of choreography, holiday-makers are spread irregularly over a lawn." Such images provided a symbol for "the atomization of society in an age of individualism," even though their random figures were fitted into "compelling, neatly defined visual patterns."[41] In the twentieth century, Arnheim argued, accident was employed "as a compositional principle," but genuine randomness turned out not to yield the same dramatic effect as simulated randomness. The statistical aggregation of accidents was merely monotonous. The viewer perceived an overall "texture" instead of "individual structural relationships." For Arnheim this was a grave error: "Lack of diversity, that is, the fact that the same thing happens all through the picture, seriously limits the importance of the content that can be conveyed."[42]

Arnheim also rejected the idea that the relaxation of conscious control would "open automatically the resources of wisdom that, according to the romantic version of psychoanalysis, hide in the treasure house of the unconscious." Distinguishing between several kinds of unconscious action—motivational strivings, cognitive processes, acquired skills, aimless doodling, and truly chance operations (such as the throwing of dice)—Arnheim argued that the relaxation of conscious control usually released several different kinds of unconscious activity, with a "fairly disorganized result." This was not a way to make great art. Nor was it, in Arnheim's opinion, the way Pollock worked. The "evenness of the pattern" throughout his pictures suggested that "something more than laissez-faire" was in play: "Only by careful supervision throughout the work will the artist obtain the perfect homogeneity of the texture, and such control must be guided by a definite image of what he is trying to accomplish." Arnheim continued,

This image is clearly the visual embodiment of a maximum of accident. . . . We recognize the portrait of a life situation in which social, economical, political, and psychological forces have become so complex that at superficial inspection nothing predictable seems to remain but the meaningless routine of daily activities, the undirected milling of anonymous crowds.[43]

Despite his obvious lack of sympathy for Pollock, Arnheim greatly broadened the interpretation of "action painting," weaving together its formal appearance, the technique that produced it, and its social significance.

The long enmity between Greenberg and Rosenberg—culminating in Greenberg's 1962 *Encounter* essay "How Art Writing Earns Its Bad Name"—tended, at least in the public mind, to reduce their positions to polar opposites: if Rosenberg's position was reduced to the slogan of "action painting," Greenberg was identified with a kind of mandarin formalism that could not possibly take into account the melodramatic paint-flinging recorded in Namuth's photographs. The reality was of course far more complex.

It is true that Greenberg wrote less about Pollock after 1947, when the drip technique emerged, than he had in the previous four years. And once Rosenberg had proclaimed the drip as Pollock's decisive innovation, there was little incentive for Greenberg to venture onto his opponent's territory. He preferred to point out that Pollock had proven himself a great painter before the appearance of the drip paintings, that the drip technique had been something of a common property among American painters in the early 1940s, and that a valid interpretation of Pollock's work could not possibly be staked on this one feature of it.[44]

This did not mean, however, that Greenberg had nothing to say about the drip style. What most impressed him when it first appeared was its "allover" quality—the sense that the picture was "knit together of a multiplicity of identical or similar elements," repeated "from one end of the canvas to the other" and apparently dispensing with "beginning,

middle, and ending." As Greenberg remarked, Pollock was one of a larger group of contemporary painters exploring the possibilities of allover composition, a group that also included Jean Dubuffet, Mark Tobey, and Janet Sobel, among others. "These painters," Greenberg wrote, "weave the work of art into a tight mesh whose principle of formal unity is contained and recapitulated in each thread, so that we find the essence of the whole work in every one of its parts."[45] At this point, in 1948, Greenberg was still interested in drawing connections between artistic and social developments, so he went on to comment,

This very uniformity, this dissolution of the picture into sheer texture, sheer sensation, into the accumulation of similar units of sensation, seems to answer something deep-seated in contemporary sensibility. It corresponds perhaps to the feeling that all hierarchical distinctions have been exhausted, that no area or order of experience is either intrinsically or relatively superior to any other.[46]

This analysis of allover composition sidestepped the issues raised by the drip technique itself. It was not until the 1960s that Greenberg confronted the argument that Pollock's technique rendered his compositions inherently random and accidental, a notion to which the critic responded, in 1961, that "Pollock learned to control flung and dribbled paint almost as well as he could a brush; if accidents played any part, they were happy accidents, selected accidents, as with any painter who sets store by the effects of rapid execution."[47] In 1967 he extended his argument:

Pollock wrests aesthetic order from the look of accident— but only from the look of it. His strongest "all-over" paintings tend sometimes to be concentric in their patterning; often the concentricity is that of several interlocking or overlapping concentric patterns (as in the marvellous *Cathedral* of 1947 [plates 120 and 121]). In other cases the patterning consists of a rhythm of loopings that may or may not be counterpointed by a "system" of fainter straight lines. At the same time there is an oscillating movement between different planes in shallow depth and the literal surface plane—a movement reminiscent of Cézanne and Analytical Cubism.

True, all this is hard to discern at first. The seeming haphazardness of Pollock's execution, with its mazy trickling, dribbling, whipping, blotching, and staining of paint, appears to threaten to swallow up and extinguish every element of order. But this is more a matter of connotation than of actual effect. The strength of the art itself lies in the tension (to use an indispensable jargon word) between the connotations of haphazardness and the felt and actual aesthetic order, to which every detail of execution contributes. Order supervenes at the last moment, as it were, but all the more triumphantly because of that.[48]

Curiously, both Greenberg's admirers and his critics have tended to ignore what he actually wrote about Pollock. Discussion of "Greenbergian formalism" has focused instead on broader theoretical essays like "Towards a Newer Laocoon" (1940) and "Modernist Painting" (1960)—neither of which contains a single word about Jackson Pollock. Here Greenberg laid out a theory that was a peculiar compound of Immanuel Kant, Walter Pater, and Irving Babbitt, arguing that the essence of modernism was the necessity for each art to demonstrate its uniqueness. This meant, in practice, that each art had to stick to demonstrating whatever was most characteristic of its medium, and to give up anything that might be achieved in some other medium. Painting, being essentially flat, had to give up the attempt to represent three-dimensional form, since that was better handled by sculpture, while the task of telling stories was delegated to literature. Although Greenberg himself deployed his theory with considerable subtlety, in other hands it often became a caricature, reducing the history of modern art to a one-way evolution from illusionistic representation to abstract flatness.[49]

Greenbergian formalism, in this sense, entered the critical debate over Pollock not in Greenberg's own writings but in a 1965 essay by his disciple Michael Fried. Trying to define Pollock's accomplishment, Fried wrote that, in a painting such as *Number 1A, 1948* (plates 138 and 139),

there is only a pictorial field so homogenous, overall and devoid both of recognizable objects and of abstract shapes that I want to call it "optical," to distinguish it from the structured, essentially tactile pictorial field of previous modernist painting from Cubism to de Kooning and even Hans Hofmann. Pollock's 101

field is optical because it addresses itself to eyesight alone. The materiality of the pigment is rendered sheerly visual, and the result is a new kind of space.[50]

Pollock, then, represented America's arrival in the promised land of pure opticality—a territory subsequently explored by artists such as Helen Frankenthaler, Morris Louis, and Kenneth Noland. And it was indeed true, as Fried argued, that the stain technique employed by these artists derived from Pollock—yet it required a powerful effort of will for Fried to argue away the tactile quality of Pollock's paint surface, with its impasto, its handprints, and its collections of studio debris. He managed it by arguing that all of these elements were woven together and subsumed by Pollock's "continuous, all-over line," creating a "homogenous visual fabric which both invites the act of seeing on the part of the spectator and gives his eye nowhere to rest."[51]

Greenberg had suggested that the allover compositions of Pollock's drip paintings derived from Analytic Cubism (and from Impressionism before that). On this point Fried disagreed with his mentor, arguing that the formal issues at stake in the drip paintings could not be characterized in Cubist terms.[52] Pollock, Fried wrote, had wrought a genuine revolution in the nature of modern art, establishing that "the different elements in the painting—most important, line and color—could be made, for the first time in Western painting, to function as wholly autonomous pictorial elements" functioning solely within the picture plane, without reference to any three-dimensional reality.[53] Fried acknowledged that Pollock was an unlikely leader for this revolution, since he was strongly impelled toward figuration, which implied the presence of tactile forms. But Pollock's retrograde inclinations only made his achievement more impressive. Where classical modernism had regarded color as the bearer of optical sensation, Pollock, in his 1947–50 paintings, had invented an optical *line*—a line "freed at last from the job of describing contours and bounding

shapes." And when the compulsion to depict the human figure became too strong to resist, he had found a way to do the "impossible," evoking the human figure by "negating part of the visual field" (in *Untitled (Cut-Out)*, c. 1948–50, plate 148) rather than by drawing a contour around it.[54]

Two years after the publication of Fried's essay, the formalist interpretation found its most comprehensive statement in William Rubin's magisterial "Pollock and the Modern Tradition." Summarizing the key points from earlier interpretations, Rubin placed them within a greatly enriched historical context. For instance, where Ehrenzweig had noted a general tendency in modern art for accidental effects to unlock the expression of unconscious fantasy, Rubin suggested a specific precedent in Joan Miró's 1925 painting *The Birth of the World*. According to Rubin, Miró began by pouring washes of blue paint across the surface of the canvas, then "drew an incipient iconography out of the 'chaos' of the spilled washes."[55]

Rubin accepted Arnheim's argument that visual randomness could be read as an allusion to the complexity of modern life, but rejected his criticism that Pollock's work was merely a statistical aggregation of accidents, creating a texture rather than a composition. On the contrary, he insisted, Pollock incorporated accident in order to transcend it. His allover compositions were only superficially random or uniform; in fact he used a great variety of formal elements, creating an impression of uniformity by finding "common denominators" among them. "The precarious poise of an all-over, single image," Rubin concluded, "is achieved through the equally precarious balancing of virtually endless symmetries."[56]

Greenberg's brief suggestions that Pollock's allover compositions were in some sense extensions of Impressionism and Analytic Cubism were expanded by Rubin into in-depth discussions of Renoir, Monet, Cézanne, Picasso, Braque, Mondrian, and Miró in relation to Pollock and his contemporaries.[57]

The accumulation of sources and antecedents seemed to pose the question: what, if anything, was genuinely *new* about this work? Here Rubin called on Fried's analysis of Pollock's line: if the "criss-crossings, convergences, and puddlings of the linear skeins" in Pollock's work were able to fuse together into "scintillating painterly fields" like those of Impressionist painting, it was because he had reinvented the nature of line itself. Converting drawing into painting, he had created a kind of line that was not "the edge of a plane" but rather "an entity in itself," sitting flat on the surface of the canvas. Pollock was not (as Fried had suggested) the first painter to achieve pure opticality, but he was the first to do so using line instead of color.[58]

Rubin's reliance on Fried led him to embrace two assertions about which he seems to have had some misgivings. Even as he endorsed the idea of an optical line, "freed at last," as Fried had written, "from the job of describing contours and bounding shapes," Rubin could not help insisting that there was something tactile about Pollock's drawing. His lines still carried "the connotations of dissolved sculptural conceptions from which contouring has been liberated." In other words, Pollock's line felt as if it were describing a three-dimensional object, even though it wasn't.[59] To uphold the concept of the purely optical line, Rubin had to insist that Pollock's "classic" drip paintings of 1947–50 were inherently nonfigurative: "his linear webs were, in the radical nature of their all-over drawing, incompatible with literal representation."[60]

But exceptions and counterarguments kept coming to mind. "The drip line in itself was by no means incompatible with representation . . . nor . . . was all-overness. It was only the conjunction of the two that militated against it."[61] In Pollock's transitional paintings of 1946–47, "the dripping, pouring, and spattering . . . are still superimposed on the kind of totemic figuration that dominated Pollock's work until that time. . . . The frothy whites of *Galaxy* still have to accommodate themselves to the 'personages' below"[62]

(figs. 27 and 28). Thomas Hess, the influential critic and longtime editor of *Artnews*, had written in 1964 that there was still a subject in Pollock's "abstract" pictures, "but it disappeared beneath the interlacing drips and streamers. The 'literary' image was the secret at the heart of a labyrinth." The existence of these hidden images, Rubin noted, had been suggested to Hess by Pollock himself.[63]

It seemed to Rubin, however, that by late spring 1947 the figures hidden in Pollock's transitional work had been suppressed "in favor of a fabric now non-figurative even in its inception."[64] In many of the paintings of 1948–50, it was possible to make out quite clearly the first "layer" of the web, and there was no trace of "anthropomorphic" or "landscape-like" forms. Finally, Rubin insisted, the absence of figurative imagery could be "confirmed by reference to the photographs and motion pictures made by Hans Namuth."[65]

Rubin's essay represented the culmination of the formalist interpretation, but also its conclusion. In the thirty years that followed, there were only a handful of significant contributions to this topic. Carmean's 1978 essay "Jackson Pollock: Classic Paintings of 1950" supplemented Rubin's theoretical framework with meticulous descriptions of *Number 27, 1950, Number 32, 1950, One,* and *Autumn Rhythm* (plates 172, 178 and 179, 180 and 181, and 182 and 183), emphasizing the control evident in the weaving of Pollock's webs.[66] A pair of 1979 articles, one by Stephen Polcari, the other by Mark Roskill, explored the relationship among Pollock, his teacher Thomas Hart Benton, and Cubism. Benton himself, Polcari pointed out, had suggested to the Pollock scholar Francis V. O'Connor that the diagrams Benton used to indicate the rhythmic axes of complex compositions had probably been the source for the tilting poles of Pollock's *Blue Poles: Number 11, 1952* (fig. 29, plates 214 and 215). Expanding on this idea, Polcari argued that the combination of "curves, straight lines, and countercurves" evident in many of Pollock's works, 103

Fig. 27. Jackson Pollock. **The Little King**. c. 1946. Oil on canvas. 50 x 40 in. (127 x 101.6 cm). OT 144. Exhibited in 1946, but repainted the following year and retitled **Galaxy**.

Fig. 28. Jackson Pollock. **Galaxy**. 1947 (plates 114 and 115). Joslyn Art Museum, Omaha, Nebraska. Gift of Miss Peggy Guggenheim.

from early paintings like *Birth* (c. 1941, plate 38) through mature masterpieces like *One*, could be seen as a more radical, abstract application of Benton's principles. Roskill, meanwhile, pointed out the resemblance between Benton's organizational principles and the modes of Cubist composition that flourished during and after Benton's 1908–11 sojourn in France. A residue of Cubism might thus have been present in Benton's classes when Pollock attended them. But Polcari and Roskill's observations had little effect on the course of Pollock scholarship. The formalist approach seemed to have been exhausted, and there was little interest in adding details to the complex picture sketched by Rubin.[67]

Meanwhile new critical approaches were emerging

that took Pollock's formal achievement as a given and looked for other sources of meaning in his career. Critics and historians oriented toward social history began to explore his significance as an unwitting protagonist in America's struggle for cultural and political dominance in the postwar world.[68] The emergence, in 1970, of a cache of early drawings that Pollock had given to his Jungian analyst in 1939–40 inspired a completely different approach: a new generation of critics examined his early work for mythological symbols that might have aided him in dealing with his psychological problems.[69]

In 1979, Rubin (by then Director of the Department of Painting and Sculpture at MoMA) published a fiery polemic denouncing these critics for reducing

Fig. 29. Diagram published as fig. 23 of Thomas Hart Benton, "Mechanics of Form Organization in Painting," *The Arts* (New York), November 1926.

Pollock to a "Jungian illustrator."[70] The Jungian interpretations, he argued, were inconsistent with one another and with the pictures they purported to explain. They ignored the far more convincing Freudian interpretation of Pollock's work (which did not in fact exist—so Rubin sketched its outlines in a few scintillating pages).[71] The Jungian critics were interested only in symbols, not in the formal qualities of Pollock's pictures. They either had nothing to say about Pollock's most important work, the drip paintings of 1947–50, or, worse yet, they *did* have the temerity to say something about the drip paintings, suggesting that the mythological reading was relevant to them.

Rubin himself had noted the "totemic presences" lurking mysteriously in the interstices of the 1947 drip painting *Galaxy* (fig. 28). C. L. Wysuph, one of the earliest of the psychoanalytic critics (he published in 1970), suggested that even the "abstract" paintings of 1947–50 began with figures expressing Pollock's "innermost struggles," and that the subsequent webs of paint were added to obscure them. If critics such as Rosenberg had identified Pollock's figuration with conscious control and his abstraction with an abandonment to unconscious motor impulses, Wysuph suggested the reverse: Pollock's figures emerged automatically from his unconscious, while his abstract webs of lines were conscious attempts at camouflage.[72] This interpretation echoed Pollock's 1949 statement to *Life* that "lifelike" images sometimes appeared in his paintings, but that he deliberately wiped them out; Wysuph, however, seems to have been unaware

of this precedent, or of Ehrenzweig's psychoanalytic reading. Instead, he cited a remark reported by Lee Krasner in a 1969 interview: when she asked Pollock why he was painting a web of curving lines over the figures in his canvas *There Were Seven in Eight* (c. 1945, plate 74), he responded, "I choose to veil the image."[73]

Responding to Wysuph, Rubin scrupulously cited Krasner's declaration, in the same interview, that "I saw his paintings evolve. Many of them, many of the most abstract, began with more or less recognizable imagery—heads, parts of the body, fantastic creatures."[74] But Rubin insisted, as he had in 1967, that the process of veiling the image occurred only in the "transitional" works done before the summer of 1947. Driving home the point, he reported that he had asked Krasner to clarify her statement, and that she had declared, "Pollock made the remark about 'veiling' in reference to *There Were Seven in Eight*, and it doesn't necessarily apply to other paintings—certainly not to such pictures as *Autumn Rhythm, One*, etc."[75] Even after this "clarification," critics might reasonably have debated the original intent of Krasner's 1969 remarks. But Rubin's devastating critique of the Jungian approach had effectively eliminated public interest in Pollock's imagery, and most scholars who dared return to the topic of Pollock's "psychoanalytic drawings" were careful to exclude the drip paintings of 1947–50 from their arguments.[76]

Namuth's photographs had helped inspire the definition of Pollock's work as "action painting," its composition determined not by a preconceived idea but by the dancelike rhythms of the painter's movement. Ironically, the photographs played a similar role in "formalist" interpretations of the work: Namuth's photographs and films, documenting the pictures in their early stages, seemed to provide the definitive proof that there were no figurative images hiding beneath their abstract webs, and this absence of

figuration was crucial to the formalist interpretation. If there *were* figures in the drip paintings, the lines around them would have to be read as outlines, describing three-dimensional, tactile forms. They could no longer be read as examples of the optical line that Fried had perceived in Pollock's work—a line "freed at last from the job of describing contours and bounding shapes." And if this were so, then the pictorial field of Pollock's paintings could no longer be described as purely optical. It would instead be a mix of optical and tactile—different from earlier painting in detail but not in essence. More pragmatically, if Pollock's pictures of 1947–50 consisted of figures concealed by arabesques, they would represent not a revolutionary departure but an evolutionary development from similar earlier pictures by Picasso and André Masson.[77]

In fact it was not easy to tell from Namuth's photographs whether the early stages of *Autumn Rhythm* were figurative or not. Most of the photographs showed only a limited section of the canvas, and if they showed a broader expanse, much of it was out of focus. In the photographs of Pollock working on *One*, the painting was already at an advanced stage when Namuth began shooting, making it even harder to decipher what Pollock was adding to the canvas. Besides, out of Namuth's hundreds of photographs of Pollock at work, only a relatively small number had ever been published, and these were out of order. There was no easy way for scholars to see whether the corpus of Namuth's photographs as a whole might reveal more than was visible in individual images.

Namuth's films documented Pollock working on several additional pictures, but posed their own problems of interpretation. The finished color film by Namuth and Falkenberg contained only a fraction of the footage Namuth took of Pollock at work on the long red-canvas painting. Furthermore, the excerpts in the finished film all came from a late stage of Pollock's work on the canvas, when its surface had already grown dense. Meanwhile the footage of Pollock work-

ing on the second picture documented in the film, the painting on glass, showed only a small area of the overall composition (figs. 56–58), so that, as in the still photographs, it was hard to evaluate the nature of the larger configuration to which this area belonged.

As for Namuth's earlier film in black-and-white, it was never officially released. Scholars were occasionally able to see it, but it was not a document they could easily study or cite. And if they did see the film, it was hard for them to be sure exactly what it revealed. In any one shot, the constantly roving camera captured only a small section of the canvas. Ellen Landau, discussing the black-and-white film in her 1989 monograph on Pollock, stated that he "began by dripping a vaguely figurative image with black enamel," but that this configuration soon disappeared "under a blanket of interwoven skeins of multicolored paint." It was impossible to evaluate the claim about figuration from her book, however, since the film stills accompanying her text came from a later section of the film, after the figurative images—if they existed—had been obscured.[78] Furthermore, it was hard to judge the significance of Pollock's use of figurative imagery in this canvas, since the composition visible in the film could not be compared with the completed version. Namuth himself commented that "the painting he created during the black-and-white film was particularly beautiful; no one knows today where it is or what became of it. His wife later exclaimed as she saw the film, 'My God, where is that painting? It's lovely.' It is conceivable that he destroyed it or painted over it."[79]

Bit by bit in the course of recent years, it has become possible to resolve some of these problems. The photographer's son, Peter Namuth, has had the outtakes from the color film transferred to video, and visitors to the Pollock-Krasner House in The Springs have been able to study them in this form. The color and black-and-white films themselves have also been transferred to video. Advances in video technology have made it relatively easy to study the film footage

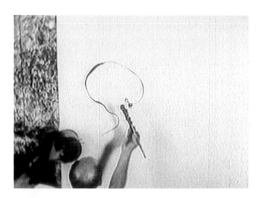

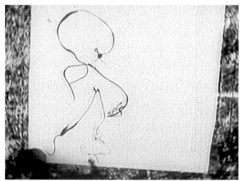

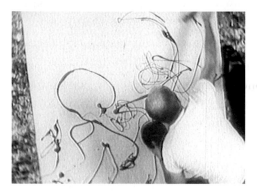

Figs. 30–32. Pollock drawing two figures at what will become the right end of **Number 27, 1950** (plate 172). Frames from Namuth's black-and-white film.

frame by frame, and to capture images from it. Peter Namuth has provided The Museum of Modern Art with contact sheets of *all* of his father's negatives of Pollock at work, making it possible to deduce the rough sequence in which they were taken, and clarifying countless details of Pollock's activity. Finally, advances in computer technology and software have made it possible to merge details from different photographs, assembling composite images that provide some sense of the overall appearance of *Autumn Rhythm* and *One* at earlier stages in their development.

As Landau implies, Namuth's black-and-white film provides the clearest image of how Pollock began a picture. Almost all of the black lines and splatters in the original composition were subsequently overpainted; a few details at the very edge of the composition remain visible, however, making it possible to identify the finished canvas as *Number 27, 1950* (plate 172), now in the collection of the Whitney Museum of American Art, New York. The film starts with a brief exterior shot of Pollock walking toward his studio in the barn. Once inside, Namuth seems to have mounted a ladder, so that he could capture both Pollock and the new, medium-format canvas that the artist was about to begin. We see Pollock's face silhouetted against *One*; then he puts his cigarette down on the edge of a stool, crouches at what will become the right edge of the canvas, and goes to work.

Watching from above, we see a hand extend a paint-clotted brush a few inches above the bare canvas (fig. 30). A black line appears on the white surface below it. As the brush moves through the air, the line swerves to the left, curves upward, and then loops to the right, forming a pumpkin-shaped ovoid. Narrow, then thick, then narrow again, it terminates in a pair of tiny blots connected by a stem: a miniature barbell with one end light and the other dark. Crouching over the canvas, Pollock is featureless, his bald cranium ringed by hair. His brush is wedged between thumb and forefinger like a chopstick. His left arm is

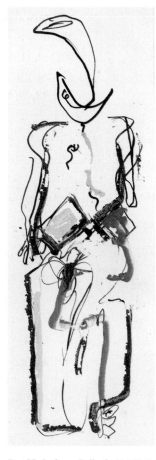

Fig. 33. Jackson Pollock. **Untitled**. c. 1942. Pen and black ink and gouache on paper. 11⅛ x 3¾ in. (28.3 x 9.5 cm). Private collection. OT 955.

crooked to support a can of black paint. His right forearm, holding the brush, casts a shadow on the white canvas.

In the following nine seconds, Pollock adds a series of lines describing the contours of a figure (fig. 31) unmistakably similar to the figures in earlier pictures such as *Untitled (Cut-Out)* (plate 148). One line curves upward on the left to form a shoulder, then turns down and right to make an arm, terminating in calligraphic fingers. A second line rises from the left corner of the canvas to describe a foot and leg. A third descends on the right, bending at the knee. A fourth is bent into a foot, shaped like a triangular shirt-hanger.

Moving right, Pollock begins a second figure, working upward this time instead of down (figs. 32 and 38). He inscribes an elongated version of the shirt-hanger foot, a horizontal crossbar with a spiral hook dangling from its end, a calligraphic doodle in place of the other foot. Curving parallel lines entwine a trapezoidal torso. Arcs stretch upward to compose a crescent head—a Picassoid motif that appears in numerous Pollock works of the early 1940s (fig. 33, plates 84 and 88).

Twenty seconds suffice to complete this second figure. Then there is a break in continuity: Pollock moves to the other end of the canvas, and Namuth, perched above him, must shift position to follow his

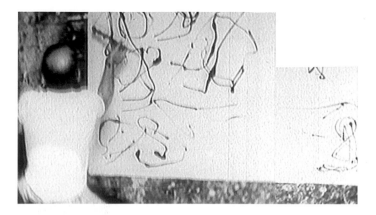

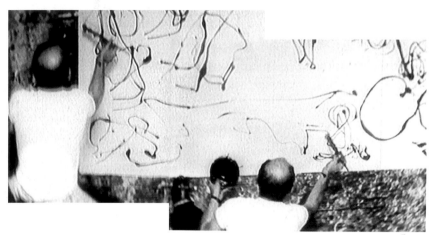

Figs. 34–35. Pollock drawing a she-wolf or dog at what will become the lower left corner of **Number 27, 1950**. Film-frame composites.

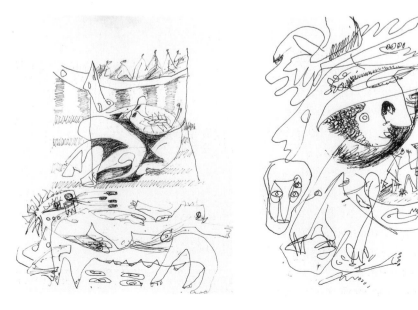

actions. It is not at first obvious how the newly visible area of the picture relates to the area where Pollock began work. On repeated viewing, however, it becomes apparent that he is completing a complex configuration at the far end of the canvas, in an empty space on the left side of what will become the picture's lower edge. Here Pollock adds a series of zigzagging curves. These seem at first glance random, but seen in the context of the surrounding forms, they begin to suggest the belly and teats of a female dog or wolf (figs. 34 and 35). Similar canines appear in many of Pollock's drawings and paintings of 1942–43, often in conjunction with a recumbent figure or a swarm of tiny stick figures (figs. 36 and 37, plates 47 and 67–69).[80]

By piecing together successive frames from the film, it is possible to assemble an overall view of the canvas (fig. 38). What this makes clear is that the dog or wolf is at a right angle to the original figures. The long crescent head of the second humanoid figure now seems to extend sideways, dangling like a jester's hat over the dog's hindquarters. "Up" and "down," at this stage in Pollock's working process, seem to be purely local terms, applying to particular areas but not to the canvas as a whole. Although drawn lines now cover the canvas, the composition is not really allover, at least not in the conventional sense of the word. Rather, it is divided into a series of self-contained configurations: the two figures at right, the dog at lower left, and what is probably another figure at upper left (in the picture's final, horizontal orientation). Pollock's compositional method in this instance is rather like that of his contemporary Adolph Gottlieb, or of the older, Uruguayan painter Joaquín Torres-García: he

Fig. 36. Jackson Pollock. **Untitled**. c. 1943–44. Ink on paper. 12⅞ x 10 in. (32.7 x 25.4 cm). Courtesy Joan T. Washburn Gallery, New York, and The Pollock-Krasner Foundation, Inc. OT 677.

Fig. 37. Jackson Pollock. **Untitled**. c. 1943. Ink on paper. 10½ x 9⅝ in. (26.7 x 24.5 cm) irregular. Courtesy Joan T. Washburn Gallery, New York, and The Pollock-Krasner Foundation, Inc. OT 679.

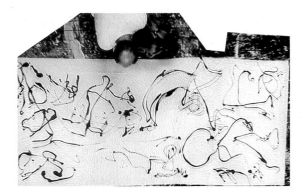

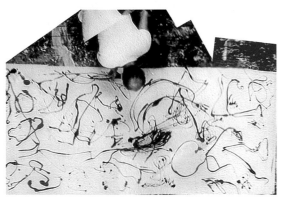

Figs. 38–39. Pollock completing the first layer of **Number 27, 1950**. Film-frame composites.

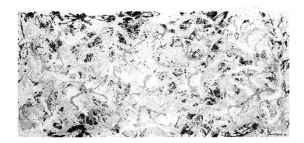

Fig. 40. Jackson Pollock. **Number 27, 1950** (plate 172). Whitney Museum of American Art, New York. Purchase.

divides the picture surface into a series of roughly rectangular areas and fills each one with an expressive pictograph. Similarly the picture, at this stage, is hardly optical in the sense defined by Greenberg and Fried; there is no flicker of interlacing lines. But neither is it conventionally illusionistic. Pollock's graphic forms lie flat in the picture plane, simultaneously tactile and optical.

Up to this point Pollock has worked primarily with single drawn lines, varying in width and accented with ovoid splotches. He now begins to vary the texture of his composition, filling an empty space near the center with a larger splotch built up by repeated passes of the brush, and forming a large horizontal "comma." A similar built-up splotch fills another empty area near the upper edge of the canvas (fig. 39). Namuth's camera pans rapidly from one end of the canvas to the other, and then there is a break in continuity.

Jumping ahead to the end of the story and comparing this stage of the picture with the finished canvas (fig. 40), it is evident that virtually nothing of the original composition remains visible. One can recognize some curves and a large dangling blot at the upper left corner, and some traces of the horizontal splotch added to fill in the space along the upper edge. By themselves, these would probably be insufficient to identify the canvas, for the original composition has been covered over with lines and splatters of aluminum, white, yellow, gray, and pink. Even before these colors were added, moreover, the original composition was heavily reworked with more black paint. It is some of these lines in black that confirm the identification of the canvas.

The next sequence of the film is devoted to this reworking with black. Descending to the floor, Namuth at first stands behind Pollock, at the edge of the canvas that will become the top in the finished picture. Then, to get a better view of Pollock at work, he moves

to the left end of the canvas (fig. 41). The initial lay-in of the canvas had been done with a brush held horizontal and moved smoothly along a linear path. Now, crouching low over the canvas, Pollock plunges his brush deeply into the can and discharges the paint with a rapid flick of the wrist.

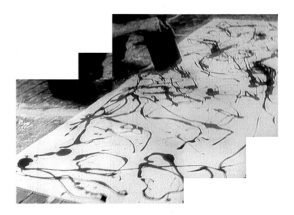

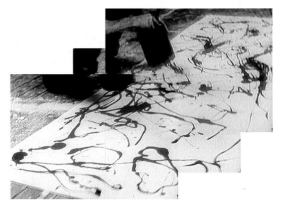

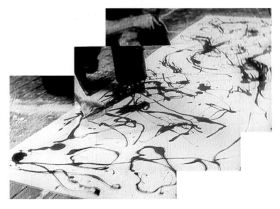

Figs. 41–43. Pollock throws down a series of splats at what will become the upper left corner of **Number 27, 1950**. Film-frame composites.

109

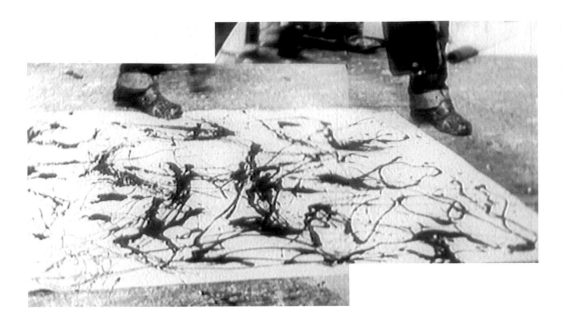

Fig. 44. At work on the left side of **Number 27, 1950**, seen from its top edge. Film-frame composite.

It descends onto the canvas to form an elongated blotch or splat. The uneven contours of these splats (in contrast to the smoother contours of the original lines) should not be taken to mean that there is any randomness in their placement: one splat bridges the axil between two diverging curves (fig. 42),[81] another is placed to extend a crossbar near the end of the longer of the two curves (fig. 43).

Namuth moves back to the top edge of the canvas as Pollock circles around to the bottom, standing now instead of crouching (fig. 44). A succession of splats has radically transformed the work's appearance, the even tracery of the original composition giving way to a varied texture of smooth lines alternating with irregular blotches. These blotches seem to have been applied strategically to accent existing details; their overall effect, however, is to diminish the legibility of the original composition. Instead of following the underlying contours, the viewer's eye jumps from splat to splat.

This is the point at which the painting is transformed from a collection of independent pictographs into a single allover composition, unified by a consistent rhythm of dark and light, thick and thin, extend-

ing across its surface. It also seems to be the point at which the original collection of "representational" images becomes an "abstract" composition. The painting at this stage resembles the all-black *Number 32, 1950* (plates 178 and 179), which Pollock had completed over the summer—and which is intermittently visible in Namuth's film, hanging on a wall in the background. Writing in 1967, Rubin cited *Number 32, 1950*, along with Namuth's photographs, as proof that the first layer of Pollock's drip paintings was already abstract.[82] Given the figurative base of *Number 27, 1950*, however, it seems possible or even likely that *Number 32, 1950*, as we see it today, is equally the product of at least two separate campaigns—that it began as a linear, figurative composition, which was subsequently veiled by additional lines and splats of black paint, applied in a regular rhythm across the surface.

Although Pollock is now standing instead of kneeling, and "throwing" paint instead of dripping it, his control over the placement of the strokes seems remarkably precise. He fills an empty space in the composition with a sideways stroke that seems to shoot outward from an existing cluster as if it had always been part of it (figs. 45 and 46). Not quite content with the result, he adds a second tilting stroke just below the first (fig. 47).

In the final sequence of the film, Pollock circles the canvas, using a broad brush to ladle large splats of white paint onto the surface (fig. 48). It is difficult to be sure, but he seems to be erasing much of the original, linear composition while leaving in place the larger and later array of broad rhythmic splotches, along with a miscellaneous tracery of ornamental lines. At this point the movie comes without warning to an end—perhaps Namuth simply ran out of film. But Pollock clearly continued to work on the canvas for some time. The yellow, white, pink, gray, and aluminum paints on the surface of the finished painting (fig. 40, plate 172), most of them applied more than once, must be the result of numerous additional

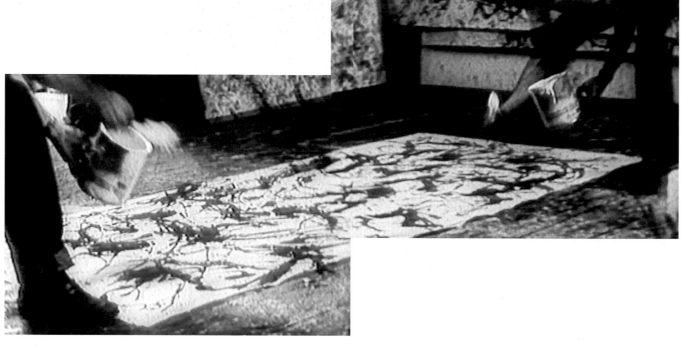

Fig. 48. Circling **Number 27, 1950** (seen from the lower left corner) and throwing down splats of white paint. Film-frame composite.

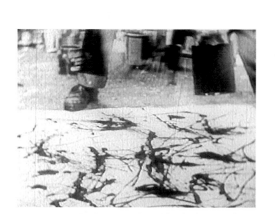

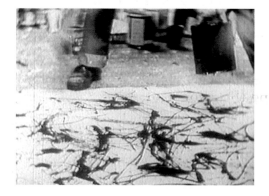

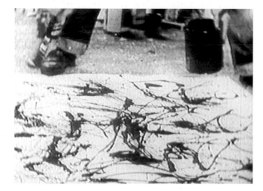

Figs. 45–47. Pollock adds radiating strokes to a cluster on the left side of **Number 27, 1950**, seen from its top edge. Film frames.

campaigns. A dramatic Namuth studio photograph shows the lower-right corner of the canvas, seen from the top edge (fig. 49). The aluminum paint shines brilliantly in the daylight from the window, with layers of white paint appearing as dull patches on top of it. The black structure of the first and second stages is still obvious beneath the interlacing curves of the lighter colors; by the time the picture is finished, though, the black will be visible only around the margins and in the narrow interstices between colors.[83]

The sequence of the color film describing the painting on glass—*Number 29, 1950* (plate 176)—reveals more about Pollock's technique than about his approach to composition. He begins the first version of the painting much as he did *Number 27, 1950*, dipping a long narrow brush into a can of black paint and "drawing" just above the surface. He starts with a pair of long

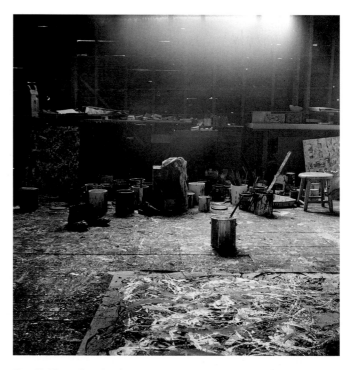

Fig. 49. The right side of **Number 27, 1950**, several layers later.

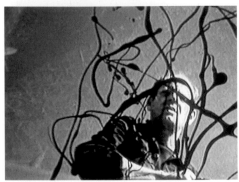

Figs. 50–53. Pollock at work on the first, ultimately erased version of the painting on glass. Frames from Namuth's color film.

curving lines and a self-contained loop (fig. 50), similar to the shapes with which he began the other canvas. They are probably part of a larger configuration, but since the camera captures only a fraction of the picture surface, it is impossible to tell whether this configuration is representational or not.

The first two lines are quickly enfolded within a more complex web, its lines often thicker and more imposing than the original ones (fig. 51). Even at this stage it would be impossible to distinguish earlier from later lines if we could not compare earlier and later film frames. Another notable feature at this stage is that the composition extends above, below, and to the right of the frame—but not to the left.

A few frames later the composition has undergone another transformation (fig. 52). On the one hand the entire picture surface is now covered by a tracery of fine lines. On the other, Pollock has reinforced several of the earlier lines, thickening them into major arteries. The division between painted and unpainted areas still persists as a distinction between denser and thinner areas of the web. Thick and thin lines continue to multiply, and the picture surface is soon covered by a clotted web that seems equally dense in all directions (fig. 53). This is where the first sequence ends.

In a voice-over, Pollock explains, "I lost contact with my first painting on glass, and I started another one." The script for Pollock's narration was cobbled together from written statements and interviews, and this remark in particular echoes the text that had appeared in *Possibilities* three years earlier: "It is only when I lose contact with the painting that the result is a mess."[84] But it is not altogether clear what Pollock means by "losing contact." This may be something that happens when a picture has been so heavily reworked that Pollock himself can no longer perceive or recall the original composition; or—since this must have happened quite often—it may be something more general, an inchoate sense that the painting is not "working." From what we can see of the first glass

painting, it had achieved precisely the homogeneity of texture that Arnheim attributed to Pollock's work in general. Perhaps this is what made Pollock feel he had lost contact with it.

Namuth records that he and Pollock could only afford one large sheet of glass (it cost $10[85]), so Pollock wiped away the first version and started again. He begins the second version in a radically different way, by arranging some coiled string and pieces of wire mesh atop the glass (fig. 54). These are supplemented with strips of colored glass and scattered pebbles, creating a rich and varied surface even before Pollock starts to paint (fig. 55).[86] Next he pours aluminum paint from a small can with a hole punched in its top, yielding a thin, threadlike line that forms a series of curlicues as his hand moves back and forth. This is the only documented instance of Pollock's pouring paint directly from a can rather than dripping or throwing it from a brush or stick.[87] It seems likely, however, that where similar threadlike curlicues appear in other paintings and drawings, they were produced by the same method.[88]

Pollock soon shifts to his more familiar technique of dripping paint from the end of a brush. The silver-colored pigment glows brightly as it falls in the sunlight, then turns to black as it hits the glass and is silhouetted against the blue sky. The camera pans to the left and then back to the right, coming to a halt with the orange glass strip in roughly the center of the frame (fig. 56). In this area at least, the composition seems to be built up from discrete clusters of interlaced lines. Pollock seems deliberately to be keeping the area around the glass strip clear, so that this strong rectangular element will contrast with the surrounding curvilinear forms. But there is nothing fixing the orange strip to the glass support. Knowing that the paint will act as glue, Pollock now "draws" a series of spiraling lines that begin at the center of the strip and circle outward until they connect with the "tails" of two lines emerging from a nearby cluster

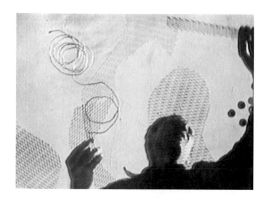

Fig. 58. Jackson Pollock. **Number 29, 1950** (plate 176), reversed left-to-right to show the painting as seen from underneath. The highlighted section corresponds to the area shown in figs. 56–57. National Gallery of Canada, Ottawa.

(fig. 57).[89] The spiraling lines of paint also provide a counterpart to the concentric coils of string with which Pollock began, now invisible to the left of the film frame.

The sequence of the color film dealing with the now-lost painting on red canvas (like the canvas used for *Number 13A, 1948: Arabesque*, *The Wooden Horse: Number 10A, 1948*, and *Number 2, 1949* [plates 145, 147, and 156]) contains sequences from what appear to be only the last two sessions of work on that picture. By that time the painting had reached a high degree of density; watching the film, it is almost impossible to keep track of where Pollock's rapidly launched strokes are landing. The almost inevitable effect is to reinforce the cliché that he is flinging paint at random. Namuth's outtakes, on the other hand, revealing the step-by-step evolution of the painting from bare canvas to complex web, offer a clear view of Pollock's combination of kinetic freedom and formal control.

As the outtakes begin, Pollock stands motionless near the right end of the canvas, his left hand grasping the rim of a can of black paint (fig. 59). The right end of the canvas (on the left in the film frame) is secured to the concrete slab with a piece of lumber. Pollock's movements, as he begins to paint, are far more rapid than his initial movements in the black-and-white film. He steps around to the right edge of the canvas and draws a brush from the paint can (fig. 60). Dripping paint from the brush, he extends his arm forward, palm down, and then rotates his wrist clockwise until his palm is facing upward, pulling the brush away from the canvas (fig. 61). The pictorial result of this movement is a hooklike curve, bending upward to the right and then down again, and terminating about a third of the way down the canvas.

Pollock adds another stroke, and then, stepping to his left, repeats the same motion: extending his arm, then rotating his wrist to complete the curve and terminate the flow of paint (figs. 62–64). He

113

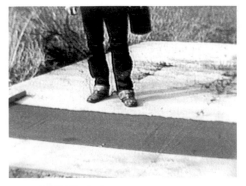

Figs. 59–61. Working on a lost red canvas, Pollock begins by drawing a curving line, rotating his wrist and finishing with his palm upward. Film frames.

Figs. 62–64. Pollock moves to his left and repeats the same stroke as in figs. 59–61. Film frames.

Fig. 65. Repeated strokes begin to form an extended, frieze-like composition. Film-frame composite.

leans to his left and executes the same motion a third time. If the sequential views are assembled into a single composite image, it becomes apparent that he is drawing a series of lambda-shaped marks along the length of the canvas (fig. 65). Less specifically figurative than the two surreal personages with which Pollock began *Number 27, 1950*, these forms seem somewhere on the border between pictographs and rhythmic abstract marks.

By the time Pollock has reached the left edge of the picture (held in place by a pair of bricks), the canvas is covered with a complex web of interlacing curves. Starting to work his way back toward the right edge, he accents the composition with a series of rapid splats (fig. 66). Despite this addition of denser, more emphatic strokes, the linear structure of the initial web remains fairly clear. The interlacing lines enclose a series of biomorphic shapes like those in *White Cockatoo: Number 24A, 1948* (plate 140) or *Summertime: Number 9A, 1948* (plate 146). The center of the composition is marked by two concentric circles touching the top edge of the canvas, with a symmetrical plume extending onto the concrete.

A close look at several frames in this sequence (figs. 67–69) underscores the fact that the splats are produced by a different hand motion than the initial curves. After taking the brush from the paint can, Pollock lifts his hand and bends the brush inward, toward his body; he then snaps his forearm downward, finishing with his palm down rather than up. It is the same gesture of wind-up and release visible in some of the still photographs of Pollock working on *Autumn Rhythm* (fig. 4).

The next sequence of outtakes (possibly shot on another day) shows Pollock adding a layer of aluminum paint to the initial black composition. He places his lines carefully, dripping them from a brush held close to the canvas (fig. 70), as in the early stages of *Number 27, 1950*. Moving in for a close-up, Namuth makes it clear how the new curves echo and elaborate

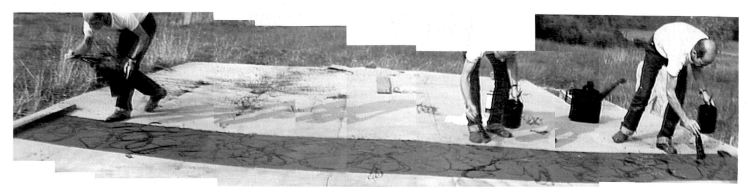

Fig. 66. Pollock accents the composition on the red canvas with a series of splats. Film-frame composite.

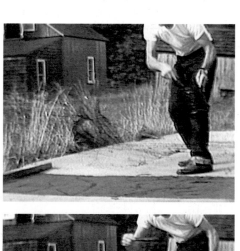

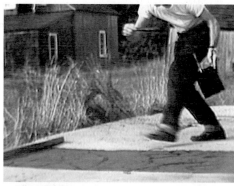

Figs. 67–69. Anatomy of a splat: Pollock snaps his hand downward, finishing with his palm down. Film frames.

Figs. 70–72. Switching to aluminum paint, Pollock retraces and elaborates the curves of the first, black layer. Film frames.

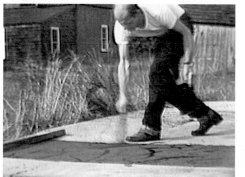

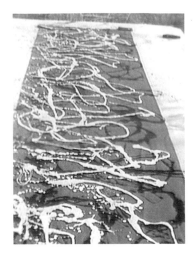

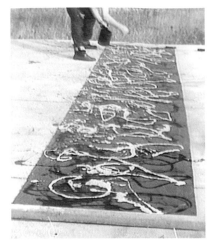

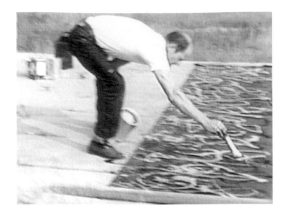

the original tracery of black lines (figs. 71 and 72). He then circles around to the right end of the canvas, executing a series of pans to create a sense of the composition as a whole (figs. 73 and 74). The seamless black web has been overscored with a series of silver forms, overlapping yet distinct. No two are exactly alike, but there is a family resemblance among them: the bottom of each form, on the left of the film frame, consists of a large circular shape. A long "neck" emerges from this, slanting to the right, and supporting a "head" composed of an inverted triangle with rounded corners.

The second pan shows Pollock elaborating the composition with strokes from a black can, but he soon returns to aluminum paint, casting a narrow diagonal splat into the empty space between one "head" and the next (fig. 75). He moves rapidly from one end of the canvas to the other. The regular diagonal accents that the composition now shows anticipate the rhythmic diagonals of *Blue Poles* (plates 214 and 215).

Several campaigns of work seem to have intervened between the conclusion of the aluminum layer and the beginning of the next phase Namuth records. Now, moving from his left to his right, Pollock lays down a series of simple white lines atop a complex multicolored surface (fig. 76). Each time he stops, he

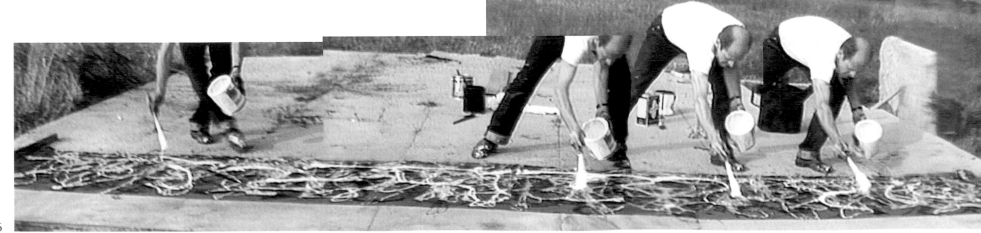

draws a line along the bottom edge of the canvas, then adds a curve (or, more rarely, a straight line) extending upward. He sometimes ornaments this stroke with one or two additional strokes branching from its apex. Returning to the left end of the canvas, Pollock proceeds to thicken and elaborate this new framework, repeating and extending his strokes with a forked brush that drips parallel strands of white paint (fig. 77).[90]

If the different campaigns recorded in these first outtakes were not all filmed on the same day, they were at least filmed under similar circumstances. In all of them Pollock is wearing a white T-shirt and dark jeans with broad turned-up cuffs. Behind him on the concrete slab is a large black watering can and a rectangular can that probably contains paint thinner. These are joined by additional cans of paint as Pollock continues to work. What appears to be a large white paving stone with a curved corner is propped upright at the left side of the concrete slab. The sunlight is diffuse, casting soft-edged shadows.

Once again, there is a significant time-lapse between the end of this sequence and the beginning of the next, which does appear in the edited version of the film (figs. 78–80). Pollock appears to be wearing a similar pair of jeans, but they are now topped by a denim windbreaker with the cuffs turned back. The paving stone is still propped up in the background; the black watering can remains too, but has fallen over. Even at the beginning of this sequence the sun already seems low in the sky, so that Pollock casts a long shadow onto the concrete slab behind him. By its conclusion, the entire foreground is in shadow (fig. 80), although glimpses of sunlit grass occasionally appear in the background.

The most significant differences appear in the canvas itself. At the

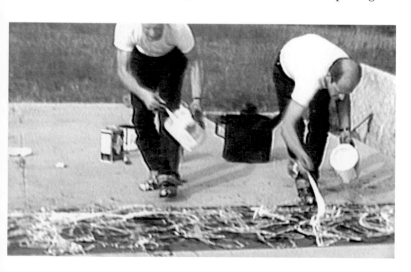

Fig. 77. He elaborates the new strokes with white paint and a forked brush. Film-frame composite.

beginning of the sequence a field of thick white splats extends over the surface, but the earlier linear composition of black and silver is still visible in the spaces between them (fig. 78). Pollock seems to have continued laying down splats of white paint until these spaces were all but filled (fig. 79). In effect, he has erased the original composition by overpainting, much as he erased the first glass painting by wiping it off. He now embarks upon a new composition, moving methodically across the canvas from his right to his left, laying down long arcs of black paint that seem more horizontal than vertical in orientation (fig. 80).

The fact that no trace survives of a finished painting corresponding to the picture in the film may suggest that, perhaps under the pressure of being filmed, Pollock "lost touch with the canvas," as he did with the first painting on glass. The expedient of creating a new "ground" (in this case a ground of white splats) and starting again with a new composition does not seem to have succeeded. Nonetheless, the film sequences showing Pollock at work on the red-canvas painting add significantly to our knowledge of his working method. Like the black-and-white film, they reveal the picture's evolution from bare canvas, through a stage of relatively legible figuration, and on into phases of abstract elaboration. In contrast to the earlier canvas painted indoors, however, the red canvas seems to have undergone at least two cycles of development, moving first from the definition of linear forms to the accumulation of a consistent allover texture, then back to the definition of linear forms and onward to a new texture a second time.

The development of *Number 27, 1950* in the black-and-white film made the progress from figuration to abstraction seem like a one-way street, the first layer of imagery providing the armature for successive layers of rhythmic strokes that finished by completely obscuring their figurative origin. It is difficult to say whether the first layer of the red-canvas painting should be described as figurative or as abstract. If we

117

successive film stills to obtain a panoramic view of the canvas Pollock is working on. It has always seemed impossible to do this with Namuth's photographs, for when working with a still camera he constantly changed position in response to Pollock's movements, so that it is rare for more than two or three shots in a row to be taken from the same vantage point.

Recent advances in digital imaging, however, offer a way to overcome these difficulties. It is now possible, in effect, to take a section of canvas that a photograph shows lying on the floor, at an angle to the

Figs. 78–80. Later stages of the lost red canvas: the surface of the composition grows increasingly dense, and is overscored with long arcs of black paint. Film frames (78, 79) and film-frame composite (80).

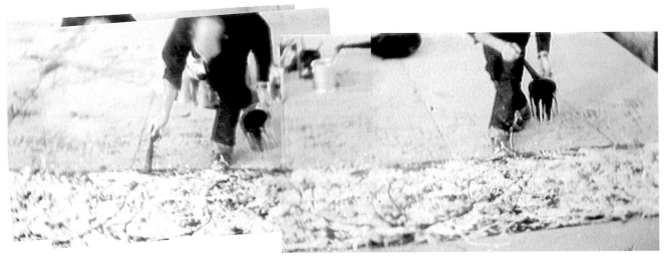

accept it as figurative, however, we will be compelled to describe other, later layers as being equally figurative. Rather than an evolution from figuration to abstraction, Pollock's working method seems, in this case, to involve an alternation between the two modes of image-making.

Namuth's films and their outtakes make it possible to see and study the actual sequence of Pollock's movements—a sequence that can only be guessed at from the still photographs. Because Namuth often filmed from a single point of view, panning rather than moving his camera, it is also relatively easy to combine

camera, and to flip it upward into the picture plane, undoing the distortions of foreshortening (see figs. 85 and 86, respectively showing a foreshortened and a "flattened" view of the left end of *Autumn Rhythm*). Furthermore, several of the "flattened" sections that are derived in this way can be combined to obtain an overall view of the painting at a given moment in its development. Conceptually simple, the process of perspective correction can be fiendishly difficult in practice, and it is not always possible to find a group of pictures revealing the totality of a painting's surface at a single moment in time. Furthermore, a reconstruction will inevitably end up combining sections from slightly different moments in the pic-

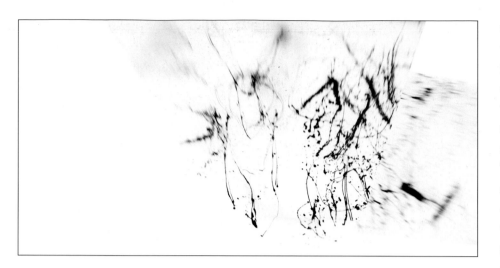

Fig. 81. **Autumn Rhythm** in an early state, after the completion of two configurations at right and center. Still-photograph composite.

from Namuth's photographs that Pollock began work at the right end of *Autumn Rhythm*, drawing a complex configuration of lines with a brush held anywhere from a few inches to a few feet above the canvas. The precision of Pollock's work at this point in the painting's development can be gauged by the way the dangling lines appearing at the lower left of this configuration in one photograph (fig. 11) are extended in the next photograph into a series of curves that merge seamlessly into the existing web (fig. 12). As in the early stages of *Number 27, 1950*, Pollock begins by working exclusively with a thin uninflected line. Once this linear configuration is in place, he proceeds to what we can now recognize as the usual second phase of his work, accenting the composition with a series of long thick splats, enlarged to match the larger scale of his canvas (figs. 13 and 14). This section of the painting—approximately the right third of the canvas—is thus brought to a certain degree of finish before Pollock begins working on the next section.

ture's development, producing an overall image that does not correspond exactly to the actual appearance of the painting at any one time. With these caveats, it is nonetheless possible to use Namuth's still photographs as the sources for photo-composites revealing several stages of Pollock's work on *Autumn Rhythm* and *One*.

Even without such manipulation, it is apparent

Once again, it is apparent from Namuth's unmanipulated photographs that when Pollock begins work on the second, central section of the painting, he does so by sketching a second configuration, separated from the first by at least a foot of bare canvas (fig. 83). A composite view assembled from four of Namuth's photographs provides a fuzzy but legible image of this state of the composition (figs. 81 and 88). This reveals that the configuration in the central section is constructed around a kind of wobbly circle (actually several concentric circles) with two oval loops extending upward from it. A third oval descends vertically through the center of the circle, while long dangling lines descend from either side.

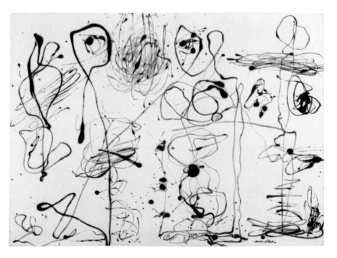

Fig. 82. Jackson Pollock. **Number 22A, 1948**. 1948. Enamel on gesso on paper mounted on fiberboard. 22½ x 30⅝ in. (57.1 x 77.8 cm). The Museum of Fine Arts, Houston. Purchase. OT 201.

119

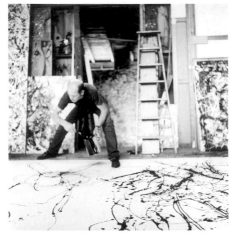

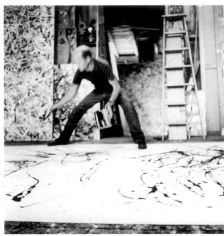

Figs. 83–84. Pollock adding large splats to the left of the central configuration in **Autumn Rhythm**, seen from the bottom of the canvas.

Although it is difficult to match the individual elements of this configuration with the elements of the human anatomy, this is probably a figure. In a drawing from 1948 that clearly represents three human figures (fig. 82), the abdomen of the central figure is represented by a similar wobbly circle, topped by two circles evoking breasts. The head of this figure is indicated by a deep curve that doubles back on itself to form two loops joined at the base, much like the loops at the top center of the central configuration in *Autumn Rhythm*. In another drawing from 1948 (plate 129), outstretched loops extending from the torso of a central figure seem to indicate outstretched arms. It seems reasonable, then, to read the circle in *Autumn Rhythm* as a torso, and the extended oval loops as either arms or the sides of a face. The dangling lines descending from the circle presumably represent legs. (There is a similar pair of dangling lines in the first configuration, at the right of the canvas.)

After laying in the initial elements of this central figure, Pollock adds a series of denser splats stacked along its left side (figs. 83 and 84). He then fills the empty space at the canvas's left with another figure, the most legible of the three (figs. 85 and 86). In fact it bears a striking resemblance to the leftmost figure in a silkscreen print that Pollock had executed a few years earlier (fig. 87, plate 58): both are constructed around a long diagonal tilting to the left, and this diagonal—or "pole"—seems to mark both the spinal column and the figure's left leg. The right leg juts out at an angle, with the foot pointing toward the corner of the image. Above, the right shoulder and arm emerge at a similar angle. In the painting, the left shoulder rises and then declines into the arm, merging with a series of curves enclosing the torso. This figure is overscored with a short vertical splat at the side of the head and two long diagonal splats over the area of the legs. Namuth's photographs also show Pollock covering the surface with a spray of black dots, and adding a tracery of long interlacing lines to fill

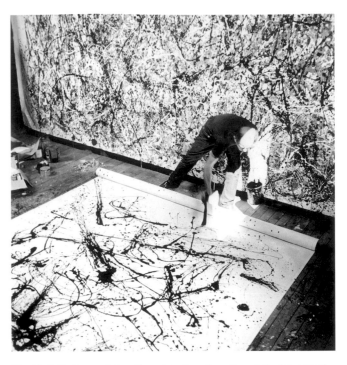

Fig. 85. Pollock completing the original configuration at the left end of **Autumn Rhythm**.

the empty space between the second and third figures (figs. 15 and 16).

Assuming that Pollock brought each of the figures in *Autumn Rhythm* to roughly the same state of finish by the end of his first working session, it is possible to assemble a photo-composite giving an overall view of the canvas at this moment in time (fig. 89). (Certain elements, unfortunately, are out of focus, or have to be supplied from earlier views.) The three original configurations are still easy to distinguish, despite the broadly speckled dots and irregularly distributed splats that tie together the composition as a whole. But this is not yet an allover composition in the sense defined by Greenberg—a picture that is "knit together of a multiplicity of identical or similar elements," that "repeats itself without strong variation from one end of the canvas to the other," and that "dispenses, apparently, with beginning, middle, and ending."[91] Although Pollock works with a limited vocabulary of lines, splats, and speckles, they are arranged into local

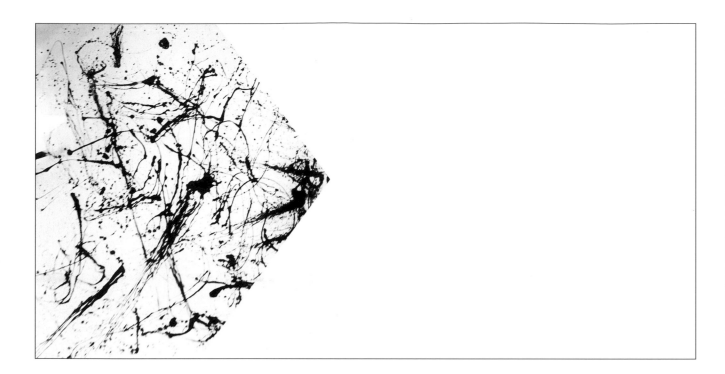

Fig. 86. The section of **Autumn Rhythm** visible in fig. 85, "flipped up" into the picture plane by digital processing.

Fig. 87. Jackson Pollock. **Untitled**. c. 1946 (variant of plate 58). Courtesy Joan T. Washburn Gallery, New York, and The Pollock-Krasner Foundation, Inc. OT supp. 36.

shapes and configurations that vary quite visibly from one area to another. The three original configurations provide the composition with a very definite beginning, middle, and end.

The middle configuration in particular is strongly marked by the circle on the central axis. As we have seen, a similar circle marks the center of the long painting on red canvas documented in Namuth's color film (fig. 66), and circles like these seem to play an important role in Pollock's compositional thinking. A circle placed at the center of a painting might serve as a hub around which larger patterns of concentric lines would pivot—as they do in paintings like *Reflection of the Big Dipper* (1947) and *Number 11A, 1948 (Black, White and Gray)* (plates 123 and 131). Hence Greenberg's observation that Pollock's allover paintings tend to be "concentric in their patterning" or based on "overlapping concentric patterns."[92] At this stage of *Autumn Rhythm*, however, the circle seems to operate in a more complex and subtle fash-

ion. Placed on the central axis of the painting (although above the horizontal midline), it suggests by its own symmetry that the larger composition will be disposed symmetrically around it, and the painting is indeed bilaterally balanced: the central configuration is flanked by two additional configurations of roughly similar size and density. But the internal structure of each configuration is different. Even the denser accents are placed asymmetrically: on the left, a column of splats is placed quite close to the central axis of the picture. Its nearest equivalent on the right is a large boomerang-shaped arrangement of splats, placed farther from the central axis and more isolated as an independent form. This arrangement of varying forms around a strongly marked central axis may be read either as a purely abstract mode of composition or as an allusion to archaic, frontal representations of the human figure.[93]

In the finished painting (fig. 91, plates 182 and 183), the underlying tension between symmetry and

Fig. 88. **Autumn Rhythm** in an early state, after the completion of the original configurations at right and center. Still-photograph composite.

Fig. 89. **Autumn Rhythm** in an intermediate state, after the completion of the configuration at the left end. Still-photograph composite.

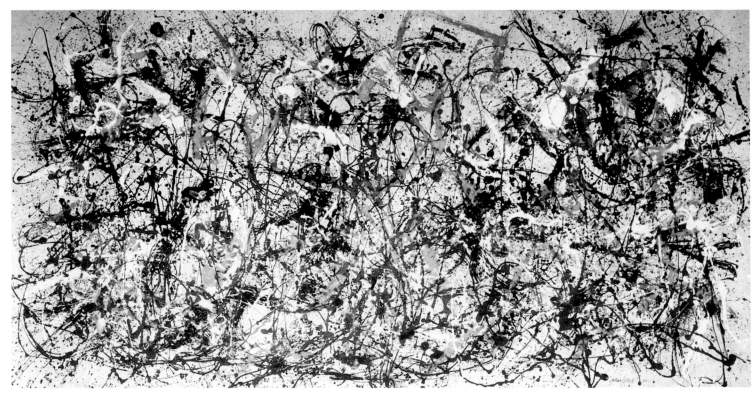

Fig. 90. **Autumn Rhythm** in a later state, after reworking with white, tan, and black. Still-photograph composite.

Fig. 91. **Autumn Rhythm** in its finished state (plates 182 and 183). The Metropolitan Museum of Art, New York. George A. Hearn Fund, 1957.

variation is largely hidden by the apparently uniform texture of the upper paint layers. As we have seen, Namuth's photographs suggest that Pollock repeatedly applied several different colors—principally white and tan, interspersed with black (figs. 19–22). He often placed broad strokes of white and tan directly atop earlier passages of black, breaking the lines of the original composition into discontinuous fragments. The superimposition of countless narrow black lines, looping in every direction, added to the sense of general confusion. The end result is a picture that finally corresponds to Greenberg's definition of an allover composition. By selecting photographs that seem to belong to an intermediate stage of the process, however, it is possible to assemble a composite that reveals how Pollock amplified and enriched his original composition before burying it (fig. 90).

He seems to have done this in three different ways. In some cases he simply reinforced existing forms with additional black lines or splats. This is particularly evident in the upper part of the left-hand figure, where the major lines have mostly become thicker and more insistent. In other cases he filled in vacant areas with linear networks. In the space at lower center, for instance, relatively empty in the first stage, he inscribed several pairs of horizontal, roughly parallel lines, echoing the paired lines higher up in this section of the painting, and giving the sense that its concentric organization extended over a far broader area than it actually did.

Most often, however, Pollock used existing structures as the basis for new forms, adding new contours with black paint and erasing unwanted lines with white and tan. At the end of the first stage (fig. 89), the upper part of the area between the left and central figures had been occupied by a kind of "X" of crossing lines. Pollock now reinforced the upper two arms of the "X," adding a small branch leading upward toward a large round splotch near the top of the canvas (fig. 90). At the top center of the canvas, the right-most of the two ascending ovals was largely overpainted with white and tan. A long arc ascending from the left was now extended past the tip of this obscured oval and made into the basis for a small horizontal lozenge. The resulting configuration looks something like a horse's neck and head. Another "X" shape, in the upper right corner, was reinforced and transformed by the addition of a fifth branch springing upward. (This shape—a kind of stick figure with outstretched arms—also appears in an unidentified canvas Pollock was working on in the summer of 1949; it can be seen in several unpublished photographs by Martha Holmes.)

This combination of reinforcement, elaboration, and erasure results in a complex, energetic composition. The three original configurations become increasingly difficult to distinguish, being overshadowed by features—such as the column of diagonal splats just to left of center—that originally seemed marginal or decorative. Yet their dominant lines remain clearly visible as coherent forms and groups of forms. It still required a good deal more work to transform this composition into an allover work in the Greenbergian sense.

Namuth's photographs of Pollock at work on *One* do not permit us to reconstruct the original composition of the painting, which was already far advanced when Namuth arrived. Indeed this was the work that Pollock initially described as finished, before picking up brush and paint can and resuming work as Namuth photographed. In the end Namuth seems to have recorded several distinct campaigns of work (figs. 1 and 2). Standing on the floor, he captured Pollock circling the canvas with cans of several different paint colors. He then ascended to the rafters and photographed three additional campaigns of black, tan, and white (fig. 5). Namuth recalled that the entire session lasted only half an hour, but this seems improbable: the photographs taken from overhead may have been made on the following day.

At first glance the photographs of Pollock working on *One* seem to offer little or no information about what he is actually doing to the canvas, for it is almost impossible to distinguish the strokes he has just laid down from the innumerable strokes that preceded them. Whether because of defects in Namuth's camera or because of its limited depth of field, the surface of the painting is badly blurred in almost all of the photographs taken from floor level. The photographs taken from the rafters, however, are more revealing. In an early campaign from this session (fig. 92), strong black lines stand out from the general multicolored texture, snaking from top to bottom of the canvas. In a later photograph (fig. 93), these lines have been obscured by a layer of white paint, laid down in sprays of narrow lines diverging from a single point. Such comparisons among the different campaigns suggest that Pollock was largely engaged in a kind of decorative elaboration of the existing composition.

Perched overhead, Namuth was able to photograph only the right end of the canvas, and a somewhat larger section of the lower edge. An overview of the entire painting during these campaigns cannot be assembled, then, but a composite view of this right-hand and lower portion can be managed, showing what seems to be the latest state that Namuth photographed (fig. 94). To the naked eye, the result does not seem all that different from the finished canvas (fig. 95, plates 180 and 181), but here the power of computer and software finds further uses: in a digital comparison of the photographic composite and the completed picture, the computer can be directed to suppress all the features they have in common (representing them as a middle-value gray) and to highlight all their differences. Dark lines present in the canvas but not in the photograph appear as black; lighter lines added to the canvas appear as white.

When the finished painting and the photo-composite are compared in this fashion, both black and

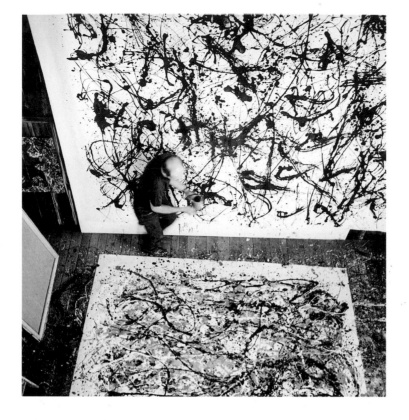

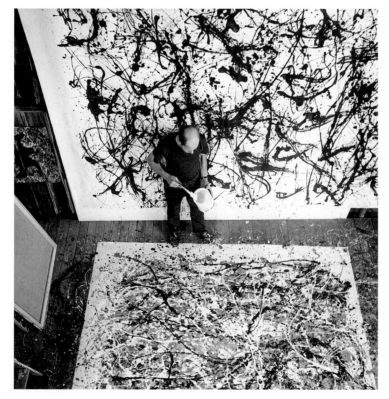

Fig. 92. The right end of **One**, in an intermediate state.

Fig. 93. The right end of **One** in a slightly later state, after the addition of white lines.

125

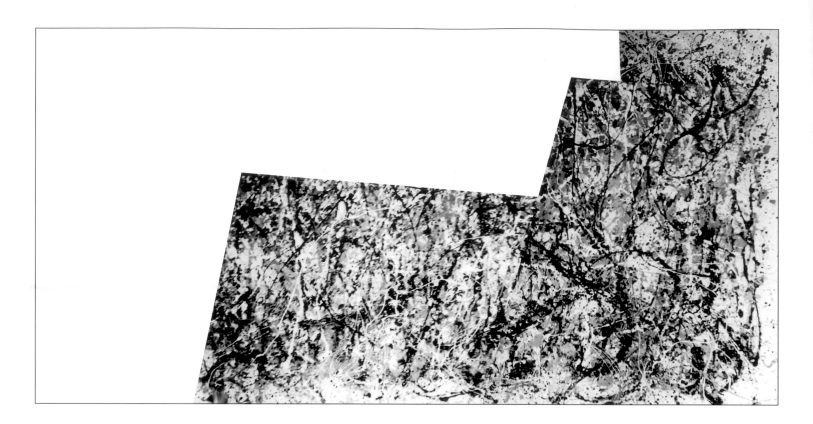

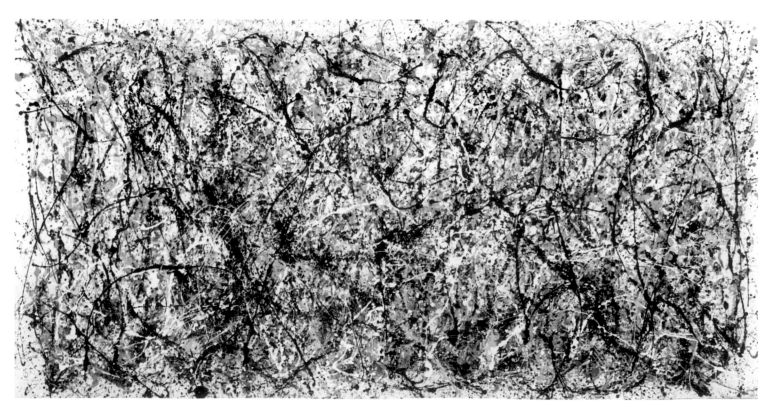

Fig. 94 (top). Part view of **One**, 1950, at a late stage in its development. Still-photograph composite.

Fig. 95 (bottom). **One** in its finished state (plates 180 and 181). The Museum of Modern Art, New York. Sidney and Harriet Janis Collection Fund (by exchange).

126

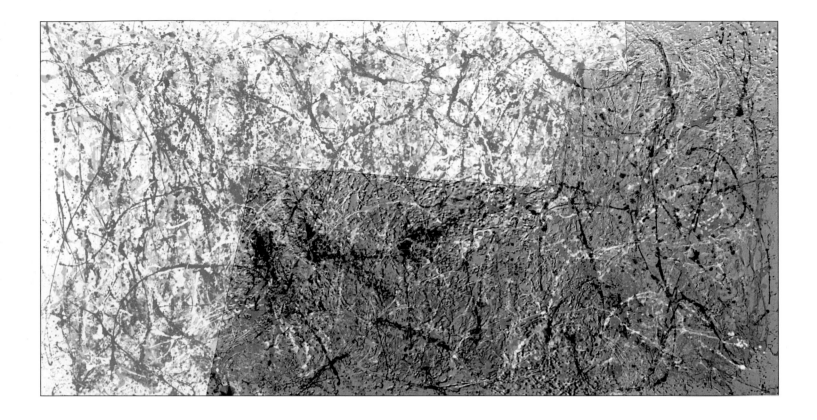

Fig. 96. Composite of figs. 94 and 95, highlighting features added to the painting between the last stage documented in Namuth's photographs and the finished canvas.

white lines appear in the area of overlap (fig. 96). The white lines arc across the surface of the canvas in what seems to be an abstract pattern of intersecting curves; the black lines are more regular and repetitive, forming a series of long verticals, each branching at the bottom or terminated by a crossbar. Further up along its stem, each vertical is traversed by another crossbar, either straight or curved. In the area where the overlap extends to the top of the canvas, the vertical stems are topped by large curves. They can be read, in other words, as oversized, curvilinear versions of the stick figures visible in many of Pollock's drawings (fig. 37). If this is true, it suggests that some of the black configurations visible in intermediate stages of Pollock's work on *One* (fig. 92) are also stick figures. This would reinforce an inference suggested by the film sequences showing Pollock at work on the red-canvas painting: apparently this is another case in which a Pollock picture did not evolve in one direc-

tion only, from figuration to abstraction. Rather, he seems to have alternated between the two modes of image-making. If the figurative images arising in the later stages are often hard to see, it is because they merge into the semiabstract, semirepresentational web beneath them.

This process of creating figures, obscuring them, and then overpainting them with new figures is evident not just in Pollock's drip paintings but throughout his oeuvre. Comparison between the finished version of the 1943 canvas *Guardians of the Secret* and the earlier state visible in a photograph of Pollock's 8th Street apartment (figs. 97 and 98, plates 66 and 67), for instance, reveals that the upper registers of the painting were originally occupied by a completely different set of heads. These seem to have been painted out and replaced with new versions; only a few details of the originals remain visible in the finished canvas. Similarly, the tall standing figure at left originally

127

extended into the central rectangle of the composition, and was "drawn" with a similar combination of dark lines on a light ground. While retaining this figure's linear armature, Pollock repainted it with more saturated colors, and added a dark vertical bar separating it from the light central panel. Many of his pictures from 1942–46 give evidence of similar reworking.

Donald E. Gordon noted another kind of revision in *Guardians of the Secret*: the central panel appears to be filled by abstract hieroglyphs, but if the painting is rotated 180 degrees— that is, if it is turned upside-down—it becomes apparent that many of these abstract forms are actually stick figures like those in Pollock's drawings (figs. 99 and 37).[94] A more obvious example of disguise-by-rotation appears in a later work, *Number 17, 1951* (fig. 100), which, rotated clockwise by 90 degrees, would appear to show a simple Picassoid head. The placement of Pollock's signature, however, makes it clear that he meant the composition to be seen as a horizontal, so that it seems at first glance like an "abstract" composition of interlacing curves and splotches—although its figurative origins are still evident.[95]

In fact several works from 1947–50, when Pollock's abstraction was apparently at its height, seem to contain figures concealed by rotation. As Michael Leja has noted, if *The Wooden Horse* of 1948 is turned counterclockwise to an upright position, it begins to look like a figure (fig. 101, plate 147).[96] Indeed it is a stick figure quite similar to those added in the later stages of Pollock's work on *One* (fig. 96):

Fig. 97. Pollock with **Guardians of the Secret**. 1943. Photograph: Reuben Kadish. Courtesy Estate of Reuben Kadish. Courtesy Jackson Pollock Papers, Archives of American Art, Smithsonian Institution, Washington, D.C.

the head, at upper left, is an open "U," while the feet are indicated by rounded triangles like the "wire hanger" foot of the first figure in *Number 27, 1950* (figs. 31 and 38). More speculatively, it might be suggested that if *Number 29, 1950*, the painting on glass, were rotated clockwise by ninety degrees, the result would be a bulbous figure rather like the Michelin tire man of advertising fame (fig. 102, plate 176). The concentric circles that appear at the far left when the work is oriented horizontally would then sit atop the composition's central axis, as they do in *Autumn Rhythm* and in the lost red-canvas painting documented in Namuth's film. In this instance they would represent the figure's head.

Examples like these, of course, do not answer the question of *why* Pollock veiled his figurative imagery. Wysuph suggests that he was reluctant to expose his figures because they "revealed his innermost struggles,

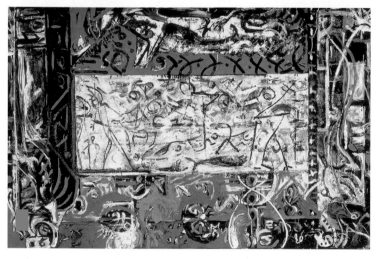

Fig. 98. Jackson Pollock. **Guardians of the Secret**. 1943 (plates 66 and 67). San Francisco Museum of Modern Art. Albert M. Bender Collection; Albert M. Bender Bequest Fund Purchase.

Fig. 99. **Guardians of the Secret** reproduced upside-down.

the most personal and perhaps most painful aspects of his life . . . he sought by camouflaging his imagery to disguise even inadvertent self-revelation."[97] But the painter of such images as *Untitled (Woman)* (c. 1935–38?, plate 3) and *Untitled [Naked Man with Knife]* (c. 1938–40, plate 36) does not seem to have been reluctant to expose his innermost struggles. Of course Pollock might have changed his mind, deciding to hide what he had previously flaunted. But, turning to his later work, it cannot be said that the rotation of a picture like *Number 17, 1951* (fig. 100) is very effective as camouflage. The anxious visage is clear enough to anyone who cares to see it.

Rather than describing the abstract webs of Pollock's 1947–50 work as veiling the painted figures, it might be more accurate to say that the figures are inserted to give form and rhythm to an abstract web that might otherwise tend toward monotony and homogeneity— the qualities attributed to Pollock's web by critics like Arnheim. What was distinctive in Pollock's allover drip paintings was neither their technique nor their appearance of allover abstraction, both of which could be found in the work of contemporaries like Hans Hofmann, Mark Tobey, Janet Sobel, and Knud Merrild.[98] It was, rather, the rhythmic energy that animated Pollock's work at every level, from the individual line to the overall composition. And this energy seems in large part to have resulted from the interaction between Pollock's figurative imagery and his allover, all-absorbing web.

Here it seems worth revisiting the topic of Pollock's indebtedness to Thomas Hart Benton, his teacher. Benton himself, we have seen, suggested a relationship between Pollock's late canvas *Blue Poles* (plates 214 and 215) and the structural principles diagrammed in his own 1926–27 article series "Mechanics of Form Organization in Painting" (fig. 29). Recent research by Nan Rosenthal and Katharine Baetjer has underscored the extent to which Pollock's early studies after old masters (plates 14 and 18) are modeled on Benton's teaching diagrams, but, as Polcari pointed out in his pioneering 1979 essay on Pollock and Benton, Pollock's indebtedness was not merely a matter of imitating diagrams. Benton had argued that the Renaissance study of anatomy went beyond mere illustration, and that "muscular shift and countershift" emerged in the Renaissance as a "determinant" for "the rhythmical structural arrangements" of art. Polcari argues that this idea liberated Pollock from a literal dependence on Benton's diagrams, and helped to inspire the "all-over rhythm" of paintings like *One* by encouraging him to create form through his own body movements. In this form, the argument leads back to the idea of "action painting," and thence to Namuth's photographs.[99]

Yet Namuth's photographs and films suggest a serious problem with what we might call the kinesthetic reading of Pollock's work—that is, the reading that sees Pollock's lines, spatters, and pools as signs evoking not conventional images but the dancelike movements that created them. The problem is that the kinesthetic sensation evoked by a given mark is often the exact opposite of the movement that actually produced it. Constantly changing direction, Pollock's lines give a sense of rapid, unpremeditated motion. But the films suggest that they were drawn in a controlled, deliberate fashion, with a brush or stick held at a more or less constant distance above the canvas (for example figs. 30–32 and 59–66). Meanwhile the denser pools of paint, with their rela-

129

Fig. 100. Jackson Pollock. **Number 17, 1951**. 1951. Watercolor and black and color inks on Howell paper. 17⅝ x 22⅛ in. (44.8 x 56.2 cm) irregular. Private collection, New York. OT 830.

Fig. 101. Jackson Pollock. **The Wooden Horse: Number 10A, 1948** (plate 147), rotated counter-clockwise by 90 degrees. Moderna Museet, Stockholm.

Fig. 102. Jackson Pollock. **Number 29, 1950** (plate 176), rotated clockwise by 90 degrees. National Gallery of Canada, Ottawa.

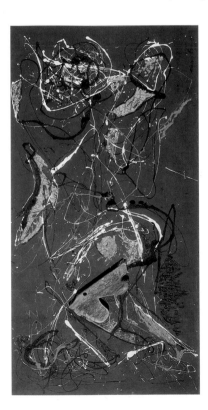

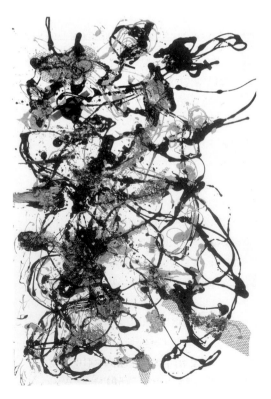

tive lack of directional emphasis, seem static in comparison to the lines; but the photographic evidence suggests that they were created by rapid flicks and flings of wrist and arm (figs. 41–43 and 67–69).

Of course the visual effect of a mark is *sometimes* consistent with the motion that produced it. Some of the short straight directional lines in the underpainting of *Number 27, 1950*, for example, seem to have been produced by rapid splats (figs. 45–47), and some of the much larger splats in *Autumn Rhythm* seem to have been produced by similar one-stroke gestures (figs. 83–84). But the even larger splat marks in the lower-left corner of this canvas (fig. 15) are in fact composed of many small strokes, like the linear blots we see Pollock creating at the end of the first stage of work on *Number 27, 1950* (fig. 39). In these instances Pollock seems deliberately to have imitated the look of a single rapid-fire gesture—one that would have been difficult or impossible to control at the scale he wanted.

The subtle idea of Benton as inspiration for an art of "muscular shift and countershift" may be less valuable, ultimately, than the crude, mechanistic idea of Benton's diagrams as a model for Pollock's paintings. Although the finished, allover version of a painting like *Autumn Rhythm* seems to have nothing in common with Benton's work, there is a distinct resemblance between the early states of the painting and some of the teacher's diagrams (figs. 29, 103, and 104). Discussing the problem of organizing a long horizontal composition, Benton wrote,

There seems to be a need in following lateral extensions of rhythmic sequences for new and distinct readjustments of the eye's exploring activity every few intervals. . . . There is no difficulty in following such compound vertical rhythms in an extended vertical progression but so great is the difficulty in adapting the eye and brain to their lateral extension that there has developed a practice (perhaps there was never any other) of orientating laterally extended rhythms about several poles. Vision then encounters, as it shifts sideways, distinct rhythmical sets which are joined on their fringes.[100]

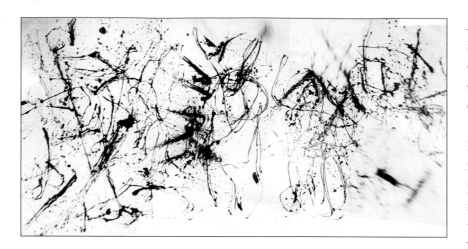

Fig. 103. **Autumn Rhythm** in an intermediate state, after the completion of the configuration at the left end. Still-photograph composite.

Fig. 104. Diagram published as fig. 24 of Thomas Hart Benton, "Mechanics of Form Organization in Painting," *The Arts* (New York), November 1926.

Autumn Rhythm seem to have been started in a similar fashion and then overpainted, but their initial rhythm continues to be felt even when the individual figures are no longer visible.[101]

Even if this account of Pollock's large-scale compositional procedures is correct, of course, it does not explain the seductive energy and vitality of the particular lines that create the local rhythms of his pictures. These are not bloodless, optical lines, "freed from the job of describing contours and bounding shapes," as Fried wrote; rather, as Rubin insists, "Pollock's drawing derives from a tradition in which space is not thought of as an autonomous void but in reciprocity with solids. Even though Pollock's space is drained of illusion, his articulation is informed by the optical vestiges of this Western spatial bipolarization." His lines still carry "the connotations of dissolved sculptural conceptions from which contouring has been liberated."[102]

Need it be said that the kind of space that exists "in reciprocity with solids" is precisely the illusionistic space of Renaissance art? From a distance, Pollock's webs seem to dissolve into the optical flicker of Impressionism. Up close, each line reasserts itself as a potential contour, or a sculptural shape in its own right. But Pollock breaks with earlier art in his refusal to let the eye rest for more than an instant: guided by the picture's hidden structure, it moves continuously from point to point across the surface. New contours emerge as old ones merge back into the web. Form comes momentarily into being and then dissolves.

Greenbergian formalism, with its reductive picture of modernism as a long march from realistic illusion to abstract flatness, can offer no explanation for the revolutionary impact of such pictures. But it is a

What is important, in other words, is the breakup of the composition into a series of self-contained configurations. It may be useful conceptually to think of these configurations as revolving around a series of central axes or poles, but the poles themselves are dispensable.

This certainly seems relevant to Pollock's compositional practice. At the risk of oversimplification, we might say that he has two ways of creating a horizontal image. One is to create a vertical composition—a figure—and to turn it sideways. The other is to do just what Benton says: to arrange a series of figures or figure groups into "distinct rhythmical sets which are joined on their fringes." There are numerous examples of Pollock composing in just this way (figs. 66 and 76, plates 125, 145, 146, and 156). Pictures like

Fig. 105. Jackson Pollock and Lee Krasner, photographed by Hans Namuth in their house in The Springs, Long Island, fall 1950.

Fig. 106. Hans Namuth, photographed by Jackson Pollock or Lee Krasner, fall 1950.

strange, parochial error to take Greenberg as a spokesman for modernism. We can place Pollock more accurately in historical perspective by seeing "flatness" not as modernism's conclusion but as its starting point. More precisely, modernism begins with two competing versions of flatness: on one hand the supposed flatness of optical sensation; on the other the flatness of the graphic sign.

Historically, optical flatness is linked to the idea of primordial sensation. The Impressionists strove to communicate the experience of the visual field prior to the recognition of particular objects. Analytic Cubism discovered a new structure for the visual field: the grid, which organized sensations on a planar surface, instead of structuring them in depth, as Renaissance perspective had done. Mondrian demonstrated that the Cubist grid could serve as an equivalent for optical experience in general, without specific reference to reality. The sign, by contrast, inhabits an explicitly artificial terrain. The Nabis were the first to insist that a picture was above all an arrangement of lines and colors on a plane surface. With Synthetic Cubism,

the picture became an arrangement of signs—some realistic, others arbitrary. In the 1920s and '30s, Miró and Picasso invented a new language of biomorphic signs, imbued with an emotive power beyond the range of Cubism. These signs, however, have little to do with ordinary visual sensation.

Coming to artistic maturity in the early 1940s, Pollock was drawn to an art of the sign rather than an art of primordial sensation. His early work derives with almost painful obviousness from Picasso and Miró (see, for example, plates 41 and 49), but, astonishingly, within a few years he had discovered a way to go beyond his masters. Pollock's achievement, in his pictures of 1947–50, was to transform graphic flatness into optical flatness—to show that by piling layer upon layer, sign upon sign, you could generate a pictorial sensation equivalent to that of the primordial visual field. The impact of this discovery is evident in Pollock's paintings. But only through the films and photographs of Hans Namuth can we understand the technique that made it possible.

Technical Note

The photographic research for this essay would not have been possible without the generous cooperation of Peter Namuth, who made available all of his father's negatives of Pollock at work, as well as videotapes of his films, including numerous outtakes. For research purposes, numerous archival prints were made by Lexington Labs from the original negatives; at the conclusion of the exhibition, these prints will be placed on deposit at the Pollock-Krasner House and Study Center, East Hampton, Long Island.

Greg Van Alstyne, Design Manager, New Media, in the Department of Graphics at The Museum of Modern Art, provided essential advice on the digital processing of details from Namuth's photographs and films. The still photographs were drum-scanned at LS Graphic, Inc., and composite images were created from them using Adobe Photoshop. Mary.Lynne Williams, Designer, Oven Digital, labored heroically at this complex, time-consuming, and mind-numbing task without losing her sense of humor. She was assisted by Christopher Eamon. I am also grateful to Henry O. Bar-Levav, President of Oven Digital, for allowing me to consume so many hours of his talented staff's time.

Betamax tapes of the Namuth films were provided by J&D Video Labs. Individual film frames were downloaded from a Sony PVW-265 DT Betacam deck, using a Video Port Professional capture card. The downloading was carried out by Bonnie Rimer, a conservation intern at The Museum of Modern Art, who also used Adobe Photoshop to assemble composites from them. This process would not have been possible without the advice and assistance of James Coddington, Chief Conservator, The Museum of Modern Art. I am also grateful to Burt Minkoff

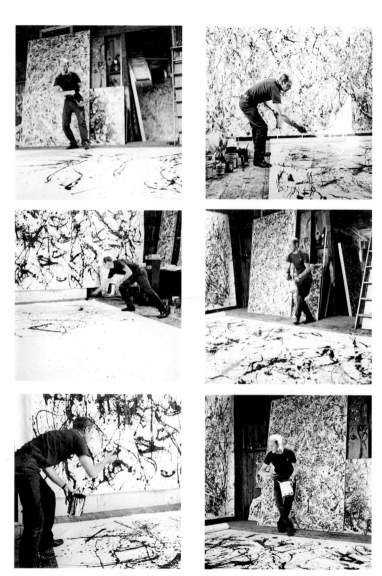

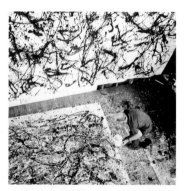

and Andrew Clayman, of Mediaworks, Inc., for assistance in conducting "test runs" of the video capture process.

The composite image in figs. 81 and 88 was assembled from sections of *Autumn Rhythm* visible in figs. 83, 84, 107, and 108. The composite in figs. 89 and 103 was assembled from figs. 6, 16, 17, 83, 84, 107, 108, and 109. Fig. 90 was assembled from figs. 18, 19, 22, 23, 25, 110, 111, and 112. The composite image of *One* in fig. 94 was assembled from figs. 5, 113, and 114.

Figs. 107–112 (the two left columns). Pollock at work on **Autumn Rhythm**.

Figs. 113–114 (the right column). Pollock at work on **One**.

133

Notes

1. See *The Art Digest* (New York) 21 no. 8 (January 15, 1947): 21; 22 no. 8 (January 15, 1948): 19. *Horizon* (London) no. 93–94 (October 1947): 20–30. *Life* (New York) 25 no. 2 (October 11, 1948): 56, 65; 27 (August 8, 1949): 42–45. *The Nation* (New York), May 29, 1943, p. 786; 27 no. 22 (November 27, 1943): 621; 158 no. 22 (May 27, 1944): 634; 160 no. 14 (April 7, 1945): 396–98; 162 no. 15 (April 13, 1946): 444–45; 163 no. 26 (December 28, 1946): 767; 164 (February 1, 1947): 137–39; 166 no. 2 (January 10, 1948): 515; 166 no. 4 (January 24, 1948): 107–8; 166 no. 5 (January 31, 1948): 139; and 168 no. 9 (February 19, 1949): 221–22. *The New Republic* (Washington, D.C.) 112 no. 6 (June 25, 1945): 871–72. *The New Yorker*, May 29, 1943, p. 49; November 20, 1943, pp. 95–98; January 17, 1948, pp. 56–57. *Partisan Review* (New Brunswick) 15 (January 1948): 81–84. *Time* (New York) 50 no. 22 (December 1, 1947): 55. *Vogue* (New York), April 1, 1948, pp. 142 and 172.

2. Hans Namuth, "Photographing Pollock," in Namuth, *Pollock Painting*, ed. Barbara Rose, with essays by Rose, Namuth, Rosalind Krauss et al. (New York: Agrinde Publications Ltd., 1980), n.p. Originally published as *L'Atelier de Jackson Pollock* (Paris: Macula/Pierre Brochet, 1978).

3. This and the following four paragraphs have been condensed from Pepe Karmel, "Hans Namuth: exils et découverts," *Art Press* (Paris) no. 127 (July–August, 1988): 10–13. The information in that article was based on an extended interview with Namuth in 1988.

4. The photographs are republished in Namuth and Georg Reisner, *Spanisches Tagebuch 1936: Fotografien und Texte aus den ersten Monaten des Bürgerkriegs*, ed. Diethart Krebs (Berlin: Nishen, 1986).

5. Maud Oakes, *The Two Crosses of Todos Santos: Survivals of Mayan Religious Ritual* (New York: Pantheon Books, 1951).

6. For this and the following two paragraphs, see Andy Grundberg, *Brodovitch* (New York: Harry N. Abrams, Inc., 1989), pp. 62–65, 75–81, 121–23, 152–53. On the technical origins of action photography see Gisèle Freund, *Photography and Society*, trans. Richard Dunn et al. (Boston: David R. Godine, 1980), pp. 127–29. First published as *Photographie et société* (Paris: Editions du Seuil, 1974).

7. Grundberg, *Brodovitch*, p. 121.

8. Namuth, "Photographing Pollock."

9. Ibid.

10. Martha Holmes took ten shots of Pollock at work. Two of these appear in anonymous [Dorothy Seiberling], "Jackson Pollock: Is he the greatest living painter in the United States?," *Life* (New York) 27 (August 8, 1949), p. 45; they are captioned "Pollock drools enamel paint on canvas" and "He applies sand to give enamel texture." In the summer of 1950, Rudolph Burckhardt took several photographs of Pollock *pretending* to paint, as well as photographs documenting the studio. One of these studio photographs appears in Robert Goodnough, "Pollock Paints a Picture," *Artnews* (New York) 50 no. 3 (May 1951), along with Namuth photographs of Pollock at work on *Autumn Rhythm*; two of Burckhardt's pictures of Pollock appear in Allan Kaprow, "The Legacy of Jackson Pollock," *Artnews* (New York) 57 no. 6 (October 1958).

11. Reviewing the 1967 retrospective, the artist Mel Bochner wrote, "It may or may not be pertinent that paint only began being manufactured in cans in quantity in the 'thirties.'" *Arts Magazine* (New York) 41 no. 7 (May 1967): 54. Bochner was familiar with the development of commercial paints because his father was a sign painter.

12. Namuth, quoted in a caption in "Jackson Pollock," *Portfolio: The Annual of the Graphic Arts* (Cincinnati) 2 no.1 (1951): n.p.

13. See Ellen G. Landau, *Jackson Pollock* (New York: Harry N. Abrams, Inc., 1989), pp. 15–17 and 238–39. In an interesting but plausible twist on this often invoked comparison, Landau suggests that the character of Stanley Kowalski may have been based in part on Pollock, whom Tennessee Williams had met in Provincetown in the summer of 1944.

14. Namuth writes in "Photographing Pollock," "All the still photographs had been done at ground level, although sometimes I climbed on a chair or held the Rolleiflex above my head." Yet the relatively distant vantage point in still photographs like fig. 5 seems identical to that in Namuth's black-and-white movie of Pollock from the end of the summer of 1950, which Namuth says was shot, in part, from what he called a "platform" or "hayloft" in the barn. There is, however, no evidence of

anything more substantial than bare rafters in the overhead space in Pollock's studio. Namuth's limited mobility may suggest he shot from the top of a ladder.

15. Namuth writes, in ibid., "One weekend I brought my wife's camera, an inexpensive Bell and Howell 'Turret.' As with the still photographs, I used available light and black-and-white film with a hand-held camera. Pollock started to work. I moved around him and then went up to a platform (a hayloft) to film from above." Actually it is only the early sequences of the film that are shot from overhead; Namuth descends to the floor for the later scenes.

16. As Krauss has noted, Paul Haesaerts's film *Visite à Picasso*, shot in 1949 and released in the spring of 1950, anticipated Namuth's idea of filming an artist painting on glass. Although Namuth may not have been aware of Haesaerts's film, Krauss adds, he almost certainly would have seen Gjon Mili's 1949 photos of Picasso drawing in space. See Krauss, *The Optical Unconscious* (Cambridge, Mass., and London: The MIT Press, 1993), pp. 301–2. Rose, in contrast, argues that Duchamp's *Large Glass* provided the most important precedent; see her "Hans Namuth's Photographs and the Jackson Pollock Myth. Part Two: 'Number 29, 1950,'" *Arts Magazine* (New York) 53 no. 7 (March 1979): 117–19. Reprinted in Namuth et al., *Pollock Painting*.

Namuth records that Pollock left the glass outside, exposed to the elements, for several weeks. Ultimately deciding that the painting was worth preserving, he brought it back into the studio and gave it the title *Number 29, 1950* (plate 176; now in the collection of the National Gallery of Canada, Ottawa). A short passage of film showing the painting held upright, with Accabonac Creek behind it, suggests that Pollock may have been interested in the interaction between the image and the natural backdrop. In this respect the painting seems comparable to the openwork sculptures, such as *Hudson River Landscape* and *Australia* (both 1951), that David Smith displayed and photographed against the Adirondack landscape around his studio in Bolton Landing, New York. See *David Smith: Photographs 1931–1965*, exh. cat., with an introduction by Krauss and an essay by Joan Pachner (New York: Matthew Marks Gallery, and San Francisco: Fraenkel

Gallery, 1998). *Number 29, 1950* can also be seen as a prototype for the mural-scale paintings on glass that Pollock planned to make as windows for Tony Smith's chapel project; see E. A. Carmean, Jr., "The Church Project: Pollock's Passion Themes," *Art in America* (New York) 70 no. 6 (Summer 1982): 110–22.

17. In "Photographing Pollock," Namuth describes part of the middle section of the film as a "simulated" scene showing Pollock's shadow flinging paint onto canvas, and comments that he has periodically considered deleting it from the movie. Outtakes of the film reveal that the paint-flinging figure in this scene is actually Namuth, not Pollock. On the question of the music for the film, see Steven Naifeh and Gregory White Smith, *Jackson Pollock: An American Saga* (New York: Clarkson N. Potter, Inc., 1989), p. 663.

18. Namuth, "Photographing Pollock."

19. The details selected by Alexey Brodovitch came from two paintings on paper, numbered 797 and 798 in Francis V. O'Connor and Eugene Victor Thaw, *Jackson Pollock: A Catalogue Raisonné of Paintings, Drawings, and Other Works* (New Haven: Yale University Press, 1978). Their publication in *Portfolio* is not included in the catalogue raisonné entries for these works, although it is suggested that 798 (also reproduced for a 1950 gallery announcement) belonged to Brodovitch, and was destroyed when his East Hampton house burned down, in 1956.

20. Goodnough, "Pollock Paints a Picture," pp. 38–41, 60–61; Frank O'Hara, *Jackson Pollock* (New York: George Braziller, Inc., 1959); Seiberling, "Baffling U.S. Art: What It Is About—Beginning of the Rebellious Career of Jackson Pollock," *Life* (New York), November 9, 1959, pp. 66–80; Seiberling, "The Varied Art of Four Pioneers, Part II," *Life* (New York), November 16, 1959, pp. 74–86; Bryan Robertson, *Jackson Pollock* (New York: Harry N. Abrams, Inc., 1960).

21. Rose, "Hans Namuth's Photographs and the Jackson Pollock Myth. Part One: Media Impact and the Failure of Criticism," *Arts Magazine* (New York) 53 no. 7 (March 1979): 112–16. Reprinted in Namuth et al., *Pollock Painting*. See also Carter Ratcliff, *Fate of a Gesture: Jackson Pollock and Postwar American Art* (New York: Farrar, Straus & Giroux, 1996).

22. *Possibilities* (New York) no. 1 (Winter 1947–48): 79, and anonymous [Seiberling], "Jackson Pollock: Is he the greatest living painter in the United States?," p. 45. Seiberling's notes are quoted in Naifeh and Smith, *Jackson Pollock: An American Saga*, p. 591.

23. "Jackson Pollock," *Portfolio*. Some articles in *Portfolio* are signed; others, like the Pollock text, were presumably written by the editors, George S. Rosenthal and Frank Zachary.

24. Goodnough, "Pollock Paints a Picture," p. 60.

25. Ibid., p. 40. Although this description seems to imply that Goodnough watched the creation of *Autumn Rhythm*, there is no record to suggest the presence of anyone but Pollock and Namuth in the studio.

26. "Jackson Pollock," *Portfolio*. Since the photos on the adjacent page spread show both early and late stages of *Autumn Rhythm*, the caption might be taken to indicate that the painting was completed in just two hours. This seems physically impossible, however, and since Goodnough offers an alternative, more plausible sequence for its completion, it seems more sensible to take the "two hours" as describing the duration of Pollock's initial campaign of work on the picture.

27. Since it would have been difficult for Pollock to raise the painting to the wall while it was still attached to the roll of canvas, it seems most likely that it remained on the floor throughout the period of Pollock's labor; see Carmean, "Jackson Pollock: Classic Paintings of 1950," in Carmean and Eliza E. Rathbone, with Thomas B. Hess, *American Art at Mid-Century: The Subjects of the Artist*, exh. cat. (Washington, D.C.: The National Gallery of Art, 1978), p. 135. It was only once the painting was completed that it was detached from the roll. In its finished state, it can be seen in Namuth's black-and-white film, hanging on the studio wall on top of *One: Number 31, 1950* while Pollock is working on what will become *Number 27, 1950*, now in the Whitney Museum of American Art, New York.

28. Goodnough, "Pollock Paints a Picture," pp. 40–41. On p. 40, Goodnough cites Pollock's denial that he works in stages, but everything in the article's narrative, as in Namuth's photographs, points to

the opposite conclusion.

29. Fig. 23, as well as a photograph not shown here (negative no. 158 in Namuth's numbering system), show *Autumn Rhythm* at what are clearly very different stages of development: the first before Pollock has even finished the initial black lay-in, the second when he has put down at least one layer each of white and of reddish brown. But in both pictures the sunlight from the high windows is falling on almost exactly the same section of *One: Number 31, 1950*, suspended on the wall in the background. It seems clear that the two photographs must have been taken at roughly the same time of day on two different days.

30. Goodnough, "Pollock Paints a Picture," pp. 40–41, 60.

31. Ibid., p. 60.

32. Harold Rosenberg, "The American Action Painters," *Artnews* (New York) 51 no. 8 (December 1952): 22–23, 48–50. For the story about Pollock and Rosenberg's conversation on the East Hampton train, see Clement Greenberg, "How Art Writing Earns Its Bad Name," *Encounter* (London) XIX no. 6 (December 1962): 67–71, reprinted in *Modernism with a Vengeance, 1957–1969*, vol. 4 of *Clement Greenberg: The Collected Essays and Criticism*, ed. John O'Brian (Chicago: at the University Press, 1993), p. 136. For the possibility of Rosenberg's dependence on Namuth, see Rose, "Hans Namuth's Photographs and the Jackson Pollock Myth. Part One," *Arts Magazine*, p. 112, and *Pollock Painting*.

33. All quotations from Goodnough, "Pollock Paints a Picture," p. 60, and Rosenberg, "The American Action Painters," p. 22. In their *Jackson Pollock: An American Saga*, pp. 704–8, Naifeh and Smith argue that Rosenberg's essay was meant simultaneously to appropriate Pollock's glamour and to deflate his reputation. This interpretation may be excessively Machiavellian, but Rosenberg's sarcastic description (p. 49) of "apocalyptic wallpaper" may in fact have been inspired by the reproduction of Pollock's work in *Portfolio*, a design magazine. Similarly, his bitter reference (p. 50) to the "use" of vanguard painting for "profit-making enterprises" by those who fail to buy it seems to have been provoked by *Vogue* magazine's use of paintings by Pollock and Mark Rothko as backdrops for fashion shoots. See, for

instance, the Cecil Beaton photographs of Pollock's work published in the anonymous feature "American Fashion: The New Soft Look," *Vogue* (New York), March 1, 1951, p. 157. A more benign view of this phenomenon was offered at the spring 1997 symposium on Pollock at The Museum of Modern Art, where it was suggested that Alexander Liberman (Brodovitch's counterpart at *Vogue*) was simply trying to help out struggling artists whom he admired.

34. Namuth, quoted in the caption in "Jackson Pollock," *Portfolio*, and Rosenberg, "The American Action Painters," p. 23. In *Jackson Pollock: An American Saga*, p. 704, Naifeh and Smith suggest that this passage of Rosenberg's text was inspired by Namuth's photographs; it seems to me likely that the influence of the photographs (which Rosenberg may have seen only in *Portfolio* and *Artnews*) was supplemented by the influence of Namuth's written comments.

35. See, for example, Krauss, *The Optical Unconscious*, pp. 243–93, and Yve-Alain Bois and Krauss, *L'In forme: Mode d'emploi*, exh. cat. (Paris: Editions du Centre Pompidou, 1996), published in English as *Formless: A User's Guide* (New York: Zone, 1997), especially pp. 28–29, 93–103, 123–24, and 126–27.

36. Kaprow, "The Legacy of Jackson Pollock," pp. 24–26, 55–57.

37. See, for instance, Vivien Raynor, "Jackson Pollock in Retrospect—'He Broke the Ice,'" *The New York Times Magazine*, April 2, 1967, p. 68, and Jack Kroll, "A Magic Life," *Newsweek* (New York), April 17, 1967, p. 96.

38. Rosenberg, "The American Action Painters," p. 22.

39. Krauss, one of the few critics to examine Namuth's pictures *as photographs*, focuses on this image of Pollock's studio as an all-encompassing environment. She writes, "In the field of Namuth's photographs Pollock is always sandwiched in between large stretches of canvas, some on the wall, some on the floor, on which the black and white skeins of line form an active, engulfing pattern which repeats itself in the linear drips and spatters of paint which appear on the floor of the studio as well. The photographs, then, recreate the space of all-over pattern in which the human figure can barely exist, or in

which its relationship to gravity, to a solid foundation, is made equivocal at best." Krauss, "Reading Photographs as Text," in Namuth et al., *Pollock Painting*. Krauss takes as the starting point for her discussion a 1977 article by Jean Clay, "Hans Namuth, critique d'art," *Macula* (Paris) no. 2 (1977): 24–35.

40. Anton Ehrenzweig, "The Modern Artist and the Creative Accident," *The Listener* (London), January 12, 1956, pp. 53–54. Ehrenzweig expanded on his ideas in a second essay of the same year, "The Mastering of Creative Anxiety," in *Art & Artist* (Berkeley and Los Angeles: University of California Press, 1956), pp. 33–52, and in a later book, *The Hidden Order of Art: A Study in the Psychology of Artistic Imagination* (Berkeley and Los Angeles: University of California Press, 1967), whose vocabulary of "differentiation" and "de-differentiation" was taken up in the Post-Minimalist criticism of artists such as Robert Morris and Robert Smithson.

41. Rudolph Arnheim, "Accident and the Necessity of Art," *Journal of Aesthetics and Art Criticism* 16 no. 1 (September 1957): 18–22.

42. Ibid., p. 30. Like Greenberg, Arnheim sees Cubism as a precursor to Pollock's allover pictures, since it dissolved form into small, overlapping units that tended to "fill evenly the entire surface within the picture frame" (p. 23).

43. Ibid., pp. 29–30.

44. Greenberg, "The Jackson Pollock Market Soars," *The New York Times Magazine*, April 16, 1961. Reprinted in *Modernism with a Vengeance*, p. 111.

45. Greenberg, "The Crisis of the Easel Picture," *Partisan Review* (New York), April 1948. Reprinted in revised form in Greenberg, *Art and Culture* (Boston: Beacon Press, 1961); reprinted in original form in *Arrogant Purpose, 1945–1949*, vol. 2 of *Clement Greenberg: The Collected Essays and Criticism*, ed. O'Brian, pp. 222–24.

46. Greenberg, "The Crisis of the Easel Picture," *Arrogant Purpose*, p. 224.

47. Greenberg, "The Jackson Pollock Market Soars," *Modernism with a Vengeance*, p. 111.

48. Greenberg, "Inspiration, Vision, Intuitive Decision," *Vogue* (New York), April 1, 1967. Reprinted in *Modernism with a Vengeance*, pp. 246–47.

49. Greenberg, "Towards a Newer Laocoon," *Partisan Review* (New York), July–August 1940, reprinted in *Perceptions and Judgments, 1939–1944*, vol. 1 of *Clement Greenberg: The Collected Essays and Criticism*, ed. O'Brian, pp. 28–38; and "Modernist Painting," first delivered as a "Forum Lecture" for the Voice of America in 1960, and often reprinted, for example in Charles Harrison and Paul Wood, eds., *Art in Theory 1900–1990: An Anthology of Changing Ideas* (Oxford and Cambridge: Blackwell, 1992), pp. 754–60.

The most extreme case of invoking Greenberg as a standard-bearer for Pollock while ignoring what he wrote about him is to be found in Francis Frascina's often cited anthology *Pollock and After: The Critical Debate* (New York: Harper and Row, 1985), which opens with two essays by Greenberg—"Avant-Garde and Kitsch" and "Towards a Newer Laocoon"—in which the name of Jackson Pollock does not appear. Since the remaining essays in the book are also virtually silent on the subject of Pollock's work, his name appears to have been invoked solely for the purpose of enticing readers to plod through a highly politicized critical "debate"—actually more of a tirade—on the political significance of formalist criticism.

50. Michael Fried, "Jackson Pollock," *Artforum* (San Francisco) 4 no. 1 (September 1965): 15. It should be said that this essay was published in a context of intense art-world politics. With the exhaustion of Abstract Expressionism, Minimalism and Pop art had gained grudging acceptance as the cutting edge of the American art scene. Profoundly opposed to both of these movements, Greenberg and Fried championed an alternative style of simplified geometric compositions and pure unmodulated colors. In the spring of 1965, while still a graduate student at Harvard, Fried presented three leading representatives of this style—Frank Stella, Kenneth Noland, and Jules Olitski—in an exhibition at the Fogg Art Museum, Cambridge, Mass., titled simply *Three American Painters*. (Fried's *Artforum* article on Pollock was in fact an excerpt from his catalogue introduction for this exhibition.) Later the same year, Greenberg curated a much larger exhibition, *Post-Painterly Abstraction*, at the Los Angeles County Museum. Unlike Fried's

exhibition, this was a critical fiasco, and led to a decline in Greenberg's power as a maker and breaker of artistic reputations. In 1967, Fried struck back against Minimalism with the fiery polemic "Art and Objecthood," in *Artforum* (New York) 5 no. 10 (Summer 1967): 12–23. But the battle was lost, and he abandoned the contemporary scene in favor of studies in eighteenth- and nineteenth-century art.

51. Fried, "Jackson Pollock," p. 14. Fried traces the technical evolution of the stain technique from Pollock to Helen Frankenthaler, Morris Louis, and Noland in his introduction to *Three American Painters*, exh. cat. (Cambridge, Mass.: Fogg Art Museum, 1965), pp. 3–53.

52. Fried, "Jackson Pollock," p. 14.

Greenberg's argument that Pollock's allover work derived from Cubism appeared as early as 1950, when he wrote that the art of Pollock, Willem de Kooning, and Arshile Gorky represented "the first genuine and compelled effort to impose Cubist order—the only order possible to ambitious painting in our time—on the experience of the post-Cubist, post-1930 world." See his "The European View of American Art," *The Nation* (New York), 1950, reprinted in *Affirmations and Refusals, 1950–1956*, vol. 3 of *Clement Greenberg: The Collected Essays and Criticism*, ed. O'Brian, p. 62. In the original version of "'American-Type' Painting," published in *Partisan Review* in 1955, Greenberg suggested that "Pollock remained close to Cubism until at least 1946," but that "he went beyond late Cubism in the end" (*Affirmations and Refusals*, p. 225). In the revised version of this essay published in *Art and Culture*, Greenberg inserted a new passage stating that "by means of his interlaced trickles and spatters, Pollock created an oscillation between an emphatic surface—further specified by highlights of aluminum paint—and an illusion of indeterminate but somehow definitely shallow space that reminds me of what Picasso and Braque arrived at thirty-odd years before, with the facet-planes of their Analytic Cubism. I do not think it exaggerated to say that Pollock's 1946–50 manner really took up Analytic Cubism from the point at which Picasso and Braque had left it" (p. 218). This is the passage that Fried cited

and to which he objected. A similar comment appeared in Greenberg's 1961 essay "The Jackson Pollock Market Soars," where he wrote that Pollock's allover paintings of 1947–50 "continue Braque's and Picasso's earlier, monochromatic Cubism of 1910–12, with its shutter-work of planes. . . . The interstitial spots and areas left by Pollock's webs of paint answer Picasso's and Braque's original facet-planes, and create an analogously ambiguous illusion of shallow depth" (*Modernism with a Vengeance*, p. 110). In *The Collected Essays*, Greenberg and his editor, O'Brian, went back to the original version of "'American-Type' Painting," omitting the passage on Analytic Cubism, but they retained the similar passage in "The Jackson Pollock Market Soars."

53. Fried, "Jackson Pollock," pp. 14–15. It was actually quite surprising that Fried should have chosen to characterize Pollock's revolutionary importance in these terms, and to insist that the autonomy of line and color marked a decisive step beyond Cubism. In a 1954 interview with Dora Vallier ("Braque, la peinture, et nous: propos de l'artiste recueillis," *Cahiers d'art* [Paris] 29 no. 1 [October 1954]: 17), Georges Braque had described the significance of *papier collé*, before World War I, in almost exactly the same terms: "*On est arrivé à dissocier nettement la couleur de la forme et à voir son indépendance par rapport à la forme, car c'était ça la grande affaire: la couleur agit simultanément avec la forme, mais n'a rien à faire avec elle*" ("We began to make a sharp distinction between color and form, and to perceive color's independence from form—indeed, that was the great revelation: color acts simultaneously with form, but has nothing to do with it").

54. Fried, "Jackson Pollock," pp. 15–16. Fried's insistence on the absolute novelty of Pollock's line also seems surprising, since the early paintings of Joan Miró, such as *The Hunter* of 1923–24, often include stick figures whose lines provide a conceptual indication of shapes without attempting to reproduce their contours. (So, of course, do the stick figures drawn by children.) Pollock would certainly have been familiar with *The Hunter*, which The Museum of Modern Art acquired in 1936.

55. William Rubin, "Jackson Pollock and the Modern Tradition, Part IV," *Artforum* (New York) 5 no. 9 (May 1967): 29.

56. Rubin, "Jackson Pollock and the Modern Tradition, Part II," *Artforum* (New York) 5 no. 7 (March 1967): 30, and "Jackson Pollock and the Modern Tradition [Part I]," *Artforum* (New York) 5 no. 6 (February 1967): 19–20. The kind of analysis Rubin calls for, locating the "common denominators" among Pollock's varied forms, is superbly demonstrated in Claude Cernuschi's reading of *Number 32, 1950* (plates 178 and 179) in his *Jackson Pollock: Meaning and Significance* (New York: HarperCollins, 1992), pp. 118–22.

57. Rubin, "Jackson Pollock and the Modern Tradition, Part II," and "Jackson Pollock and the Modern Tradition, Part III," *Artforum* (New York) 5 no. 8 (April 1967): 18–31.

58. Rubin, "Jackson Pollock and the Modern Tradition [Part I]," pp. 20–21. Rubin here credits Greenberg with having anticipated Fried in his definition of "a line which would no longer be the edge of a plane." Rubin's dissension from Fried on the novelty of Pollock's opticality is registered discreetly in Part III, p. 31, note 20. It is worth noting that Rubin's phrase "drawing into painting" was later adopted as the title for a traveling exhibition of Pollock's works on paper, organized by Bernice Rose for The Museum of Modern Art in 1979.

59. Rubin, "Jackson Pollock and the Modern Tradition, Part III," p. 29.

60. Ibid., p. 30.

61. Ibid., p. 31, note 31.

62. Rubin, "Jackson Pollock and the Modern Tradition, Part IV," p. 32. The present writer realized that *Galaxy* had been painted over *The Little King* in the course of preparing this catalogue. The same discovery is reported in the supplement to O'Connor and Thaw's catalogue raisonné, where it is credited to Richard J. Watkins of Eleonora Heights, Australia; see *Jackson Pollock: A Catalogue Raisonné of Paintings, Drawings and Other Works. Supplement Number One*, ed. O'Connor (New York: The Pollock-Krasner Foundation, Inc., 1995), p. 78.

63. Thomas Hess, "Pollock: The Art of a Myth," *Artnews* (New York) 62 no. 9 (January 1964): 64. Referred to but not cited in Rubin, "Jackson Pollock and the Modern Tradition, Part III," p. 31, note 31. Rubin himself provides the information that it was Pollock who had suggested to

Hess the existence of hidden images in his paintings of 1947–50; this source does not appear in Hess's article.

64. Rubin, "Jackson Pollock and the Modern Tradition, Part IV," p. 32.

65. Rubin, "Jackson Pollock and the Modern Tradition, Part III," p. 31, note 31.

66. Carmean, "Jackson Pollock: Classic Paintings of 1950." Matthew L. Rohn's *Visual Dynamics in Jackson Pollock's Abstractions* (Ann Arbor: UMI, 1987) contains insightful observations about several paintings, but is vitiated by an excessive dependence on Gestalt theory. Furthermore, Rohn often draws deductions about pictorial organization from surface features that seem to have been added at a late stage, elaborating the image but not defining its fundamental structure.

67. Stephen Polcari, "Jackson Pollock and Thomas Hart Benton," *Arts Magazine* (New York) 53 no. 7 (March 1979): 120–24, and Mark Roskill, "Jackson Pollock, Thomas Hart Benton, and Cubism: A Note," p. 144 of the same issue. According to Roskill, the art historian Robert Goldwater had years earlier observed that Benton's teachings, summarized in his articles, were relevant to Pollock. See also O'Connor, "The Genesis of Jackson Pollock: 1912 to 1943," *Artforum* (New York) 5 no. 9 (May 1967): 17.
The curious lack of response to Polcari's and Roskill's articles may be explained by two factors (in addition to the general sentiment among critics and art historians that formalism was an exhausted approach). First, there seemed to be little gain in explaining a great artist (Pollock) by reference to a mediocre one (Benton). Rubin, for example, responded to O'Connor's assertion of Benton's importance for Pollock by denouncing Benton's murals as "squirming forms in dirty colors staggering under the burden of anecdotal interruptions," and insisting that Benton's "mannered Grecoism is a far cry from the 'pneuma' of Pollock's mature lyricism." Rubin, letter to the editor, *Artforum* (New York) 5 no. 10 (Summer 1967): 5. Second, to the extent that the influence of Benton's teaching diagrams pointed to a link between Pollock and early Cubism (of 1907–9), it seemed to undercut Greenberg's and Rubin's thesis that Pollock was crucially influenced by Analytic Cubism (of 1910–11). Ironically, in the same year that

Polcari's and Roskill's articles appeared, Rubin himself published a pioneering essay, "Cézannisme and the Beginnings of Cubism," on the early Cubist pictures by Picasso and Braque that had obviously influenced Benton (in Rubin, ed., *Cézanne: The Late Work*, exh. cat.[New York: The Museum of Modern Art, 1977], pp. 151–202).

68. See, for example, Max Kozloff, "American Painting during the Cold War," *Artforum* (New York) 11 no. 9 (May 1973): 43–54; Eva Cockcroft, "Abstract Expressionism: Weapon of the Cold War," *Artforum* (New York) 12 no. 10 (June 1974): 39–41; Serge Guilbaut, *How New York Stole the Idea of Modern Art: Abstract Expressionism, Freedom and the Cold War*, trans. Arthur Goldhammer (Chicago: at the University Press, 1983); Frascina, ed., *Pollock and After: The Critical Debate*; T. J. Clark, "Jackson Pollock's Abstraction," in Guilbaut, ed., *Reconstructing Modernism: Art in New York, Paris, Montreal 1945–1964* (London and Cambridge: The MIT Press, 1990), pp. 172–243; Michael Leja, *Reframing Abstract Expressionism: Subjectivity and Painting in the 1940s* (New Haven and London: Yale University Press, 1993); Clark, "In Defense of Abstract Expressionism (On Vulgarity as a Reflection of Bourgeois Taste in the New York School Painters)," *October* (Cambridge, Mass.) no. 69 (Summer 1994): 22–48; and Michael Kimmelman, "Revisiting the Revisionists: The Modern, Its Critics and the Cold War," in *The Museum of Modern Art at Mid-Century: At Home and Abroad, Studies in Modern Art* no. 4 (New York: The Museum of Modern Art, 1994): 38–55.

69. Judith Wysuph, *Jackson Pollock: Psychoanalytic Drawings* (New York: Horizon Press, 1970); Judith Wolfe, "Jungian Aspects of Jackson Pollock's Imagery," *Artforum* (New York) 11 no. 3 (November 1972): 65–73; David Freke, "Jackson Pollock: A Symbolic Self-Portrait," *Studio International* (London) 184 no. 950 (December 1972): 217–21; Elizabeth L. Langhorne, *A Jungian Interpretation of Jackson Pollock's Art through 1946* (Ph.D. diss., University of Pennsylvania, 1977) (Ann Arbor: UMI, 1979); Charles F. Stuckey, "Another Side of Jackson Pollock," *Art in America* (New York) 65 no. 6 (November–December 1977): 80–91; Langhorne, "Jackson Pollock's 'The Moon Woman Cuts the Circle,'" *Arts Magazine*

(New York) 53 no. 7 (March 1979): 128–37; Hélène Lassalle, "Jackson Pollock: 'La Femme-lune coupe le cercle,' ou Pollock et Jung," *Cahiers de Musée National d'Art Moderne* (Paris) no. 4 (April–June 1980): 288–98; Langhorne, "Pollock, Picasso and the Primitive," *Art History* (London and Boston) 12 no. 1 (March 1989): 66–92; and Cernuschi, *Jackson Pollock, "Psychoanalytic" Drawings*, exh. cat. (Durham: Duke University Press, in association with the Duke University Museum of Art, 1992).

70. Rubin, "Pollock as Jungian Illustrator: The Limits of Psychological Criticism [Part I]," *Art in America* (New York) 67 no. 7 (November 1979): 104–23, and "Part II," *Art in America* (New York) 67 no. 8 (December 1979): 72–91.

71. Rubin, "Pollock as Jungian Illustrator [Part I]," pp. 117–20, and "Part II," pp. 88–90. Rubin's Freudian interpretation brilliantly integrated personal psychology with art history, arguing that Pollock's Oedipal conflicts emerged in his work as a long struggle to master and overcome the influence of Picasso, the inescapable father figure of modern art. A similar thesis was subsequently explored in Jonathan Weinberg, "Pollock and Picasso: The Rivalry and the 'Escape,'" *Arts Magazine* (New York) 61 no. 10 (Summer 1987): 42–48. Curiously, Weinberg seems to have been unaware of Rubin's earlier exploration of this topic.

72. Wysuph, *Jackson Pollock: Psychoanalytic Drawings*, pp. 20–23.

73. Lee Krasner, interviewed by B. H. Friedman in *Jackson Pollock: Black and White*, exh. cat. (New York: Marlborough-Gerson Gallery, 1969). Quoted in Wysuph, *Jackson Pollock: Psychoanalytic Drawings*, p. 22. Also quoted in Rubin, "Pollock as Jungian Illustrator, Part II," p. 83.

74. Krasner, interviewed by Friedman, in *Jackson Pollock: Black and White*, quoted in Rubin, "Pollock as Jungian Illustrator, Part II," p. 83.

75. Rubin, "Pollock as Jungian Illustrator, Part II," p. 86. Another of Pollock's remarks—"I'm very representational some of the time and a little all of the time" (see Selden Rodman, *Conversations with Artists* [New York: The Devin-Adair Co., 1957], p. 82)—Rubin discounts as applying only to the works from 1951–56 (p. 83).

76. Cernuschi, for instance, in *Jackson Pollock: Meaning and Significance*, cites the

hypothesis that Pollock "obscured or veiled pre-existing imagery by means of the abstract web," but then rejects it, agreeing with Rubin that "there is no direct visual evidence to suggest the poured paintings cover initial layers of figurative imagery." At the same time, Cernuschi does note the existence of several clearly figurative works from 1947–50, including plates 128, 148, 149, 151–53, and 155 in the present volume, and suggests that "the poured paintings may hide a latent figural presence . . . it would require very little, it seems, for Pollock to obliterate any representational layer, if such was his intention" (pp. 140–43). Perhaps Cernuschi, who also published the thoughtful exhibition catalogue *Jackson Pollock, "Psychoanalytic" Drawings*, would have been more sympathetic to the Wysuph hypothesis had it not been condemned by Rubin. Among recent scholars, Leja is exceptional in his willingness to reexamine the topic of Jungian imagery and in his insistence that figuration remains an important element of Pollock's work even in 1947–50; see his *Reframing Abstract Expressionism*, pp. 122–202 and 284–308. See also Wolfe, "Jungian Aspects of Jackson Pollock's Imagery," pp. 65–73.

77. Rubin identifies André Masson's work of the 1920s as an important antecedent for Pollock in his "Jackson Pollock and the Modern Tradition, Part III," pp. 24–26.

78. Landau, *Jackson Pollock*, p. 197. Similarly, O'Connor writes that "the short black and white film, which reveals Pollock's technique more explicitly than the color film, shows the artist beginning with a studied pouring out of an elegant black 'drawing' over the entire surface of a long, narrow ground. He then proceeds to develop this initial drawing, carefully countering its formal elements (some of which are suggestive of figures) with an ever more dense and complex interweaving of strands of paint." See O'Connor, "Hans Namuth's Photographs of Jackson Pollock as Art Historical Documentation," in Namuth et al., *Pollock Painting*. Here too it is difficult to evaluate O'Connor's analysis, since he provides no illustrations.

79. Namuth, "Photographing Pollock."

80. The similar creatures in Pollock's earlier work have been variously interpreted as avatars of Anubis, Hecate, the Terrible Mother, a father figure, the she-wolf who

suckled Romulus and Remus, a recollection of the dog in Picasso's *Three Musicians*, and a symbol of male aggression. See Rubin, "Pollock as Jungian Illustrator [Part I]," pp. 117–20 and note 61. Donald E. Gordon, in "Pollock's 'Bird,' or How Jung Did Not Offer Much Help in Myth-Making," *Art in America* (New York) 68 no. 8 (October 1980): 50, critiques Rubin's Freudian reading and adds his own interpretation of the "underdog" in *Guardians of the Secret* as a symbolic self-portrait.

81. On axil-filling as a decorative principle, see Alois Riegl, *Stilfragen*, 1893, published in English as *Problems of Style: Foundations for a History of Ornament*, trans. Evelyn Kain (Princeton: at the University Press, 1992), pp. 64–66.

82. Rubin, "Jackson Pollock and the Modern Tradition, Part III," p. 31, note 31: "In many of the paintings of 1948–50 we can make out quite clearly the first 'layer' of the web (*No. 32, 1950*, for example, is a single 'layer' picture); these contain none of the patently anthropomorphic and landscape-like morphologies that reappear in the black pictures of 1951."

83. The configuration of paint cans seen in the background of this photograph, and in other photographs taken at the same time, differs from the configuration visible in the film's glimpses of the same area. The photographs also show no trace of a large rectangular can of turpentine or paint thinner that appears in the film, near the lower-left corner of the painting; nor does the film show the paint-spattered shoes that figure so prominently in the photographs.

84. According to Namuth, "Photographing Pollock," the script for Pollock's narration was assembled by Pollock, Falkenberg, and himself from Pollock's writings and interviews. Indeed this is evident from the script itself (reprinted in *Pollock Painting*), which seems to be drawn mostly from the 1947–48 statement in *Possibilities* and from Pollock's 1951 radio interview with William Wright (also reprinted in *Pollock Painting*).

85. A sense of the value of $10 in the currency of the time might be derived from the fact that a few years earlier, before Pollock and Krasner bought the house in The Springs, it was offered to them at a monthly rent of $40.

86. Some of the materials used in *Number*

29, 1950, such as the strips of colored glass, also seem to have been employed in the 1948 *Untitled (Cut-Out Figure)* (plate 149), and, presumably, in its pendant, *Untitled (Cut-Out)* (plate 148).

87. In "Jackson Pollock and the Modern Tradition [Part I]," Rubin proposes that Pollock's basic painting technique, in the years 1947–50, was "to place a stick in the can of paint, and, by tilting the can, to let the pigment run down the stick onto the canvas" (p. 19). This technique would have allowed Pollock to "pour liquid paint in a continuous unbroken line virtually indefinitely," thus achieving a painterly equivalent to the uninterrupted pencil lines of the Surrealists' automatist drawings. The proposal is plausible, but there is no evidence in Namuth's photographs or films that Pollock actually worked this way. On the whole, it is more accurate to describe his paintings as "dripped" rather than "poured."

88. For example in *Number 20, 1948* (plate 134), or the tiny lines on the left side of *One: Number 31, 1950* (plate 180).

89. The use of enamel or duco paint (technically, pyroxylin lacquer) as an adhesive is discussed in José Gutierrez, *From Fresco to Plastics: New Materials for Easel and Mural Paintings* (Philadelphia, 1952, rev. ed. Ottawa: The National Gallery of Canada, 1959). Gutierrez, like Pollock, had participated in the New York workshop of 1936 in which David Siqueiros had taught adventurous uses of materials. He writes, "The materials most commonly used for building textures [with pyroxylin lacquer] are: marble dust, pebbles, sawdust, celite, sand, fiber, pieces of rope, wire, pieces of metal, cloth, anything usable to create the desired effect. Nothing will stop your using a horse shoe, or nails, as the pyroxylin lacquer will stick and harden any applied material." I am grateful to James Coddington, Chief Conservator, The Museum of Modern Art, for bringing this text to my attention.

90. At one point during this sequence, Pollock moves around to Namuth's side of the canvas and works on it from the upper edge (see frame 01:45.04.28). This suggests that if he mostly worked on the painting from the same, lower edge, it was because he wished to do so, not because he was forced to by the exigencies of filming.

91. Greenberg, "The Crisis of the Easel Picture," *Arrogant Purpose*, p. 222.

92. Greenberg, "Inspiration, Vision, Intuitive Decision," *Modernism with a Vengeance*, p. 246. Reading these forms for their representational rather than their compositional value, Leja notes the way Pollock's "gestural tendencies toward centrifugality produce spiraling forms evocative of eyes, breasts, vortexes" (*Reframing Abstract Expressionism*, p. 306).

93. The idea of frontality as a distinctive characteristic of archaic art was first broached by the Danish scholar Julius Lange in an article most easily consulted, in both French and German, in *Darstellung des Menschen in der älteren griechischen Kunst*, trans. Mathilde Mann (Strassburg: Heitz & Mündel, 1899). The initial publication was accompanied by a French translation, and Lange's ideas were publicized by French and German scholars such as Salmon Reinach, Henri Lechat, and Adolf Furtwängler.

94. Gordon, "Pollock's 'Bird,'" p. 50. The same observation also appears in Landau, *Jackson Pollock*, p. 127.

95. Another rotated head can be seen in O'Connor and Thaw, *Jackson Pollock: A Catalogue Raisonné*, cat. no. 839. This kind of rotation may be fairly typical of Pollock's work from 1951; although many of his pictures from that year are visibly figurative in origin, according to Krasner he worked on them from all sides, so that "there really was no absolute top or bottom." The question of vertical orientation was settled only at the last minute: whatever edge he signed became the bottom edge. Krasner, interviewed by Friedman, in *Jackson Pollock: Black and White*, p. 10.

96. Leja, *Reframing Abstract Expressionism*, p. 306. As supporting evidence Leja reproduces a Namuth photograph that shows the painting standing on the floor of Pollock's studio in this vertical orientation. It should be noted, however, that Namuth's photographs show numerous paintings stored vertically (presumably to save floor space) even though they were meant to be displayed horizontally.

The role of rotation as a means of disguising figuration is also discussed by Cernuschi in *Jackson Pollock: Meaning and Significance*, p. 143. Discussing a dripped drawing in which the interlaced lines fill

out the contours of a human figure (plate 151), Cernuschi comments that "to change its orientation (to place it upside down or on its side) and to add several additional layers of pigment would, in all likelihood, completely obscure all suggestions of figurative reference."

97. Wysuph, *Jackson Pollock: Psychoanalytic Drawings*, pp. 21–22.

98. For a discussion of the work of Mark Tobey and Janet Sobel in relation to Pollock, see Rubin, "Jackson Pollock and the Modern Tradition, Part III," pp. 27–30. For a discussion of the work of Sobel, Hans Hoffman, and Knud Merrild, see also Jeffrey Wechsler, *Abstract Expressionism: Other Dimensions. An Introduction to Small-Scale Painterly Abstraction in America, 1940–1965*, exh. cat. (New Brunswick, N.J.: Jane Voorhees Zimmerli Art Museum, Rutgers University, 1989), especially pp. 102–4.

99. Katherine Baetjer, Lisa Mintz Messinger, and Nan Rosenthal, *The Jackson Pollock Sketchbooks in The Metropolitan Museum of Art*, exh. cat. for the exhibition *Jackson Pollock: Early Sketchbooks and Drawings* (New York: The Metropolitan Museum of Art, 1997), and Polcari, "Jackson Pollock and Thomas Hart Benton," pp. 122–24.

100. Benton, "Mechanics of Form Organization in Painting [Part I]," *The Arts* (New York) X no. 5 (November 1926): 289.

101. See, however, Rubin's vigorous critique of the idea that Benton influenced Pollock in his letter to the editor, *Artforum*, June 1967.

102. Rubin, "Jackson Pollock and the Modern Tradition, Part III," p. 29.

Plates

Note In the captions for the plates, we have used Francis V. O'Connor and Eugene V. Thaw's *Jackson Pollock: A Catalogue Raisonné of Paintings, Drawings, and Other Works* (here abbreviated "OT") as our chief reference for titles, dates, mediums, and dimensions. Following their conventions, we have placed in parentheses titles that were not assigned by Pollock himself but have become accepted through general usage; descriptive titles assigned by O'Connor and Thaw we have placed in square brackets.

In a few cases, our research has suggested dates different from those in the catalogue raisonné; here the new dating is followed by the date given in OT, in parentheses. We have also revised descriptions of mediums and dimensions in cases where more precise information has been provided by the current owners of works. Because Pollock's use of industrial, non-traditional materials was well-known and influential, we have wherever possible noted his use of materials such as enamel and aluminum paint, nails, tacks, and pebbles. We do not distinguish, however, between nitrocellulose-based, pyroxylin enamels and oil-based, resinous enamels. Pollock appears to have used both types.

We have also tried to standardize descriptions of Pollock's supports, which play a significant role in the appearance of his work. He often used a resinous wood-fiber board such as Masonite, sometimes as a backing for canvas or paper, sometimes as a painting surface in its own right. Since we have been unable to determine when a board was manufactured by the Masonite Corporation and when it was not, we have used the term "fiberboard" to describe all supports of this type. Where a canvas or sheet of paper has been mounted on a support by someone other than Pollock, we omit that support from our medium description. We have employed the technical term "Japanese paper" for the highly absorbent sheets that Pollock often used for his drawings of 1950–51, and that have been variously described as "rice," "mulberry," or "Japan" paper. Because the gesso in Pollock's work often remains visible, playing an active role in his compositions, we have listed it as a medium where we know it is present, but it may also be a less visible and unrecorded element in other works.

Throughout the captions, dimensions are given in inches (or, when they include a measurement over six feet, in feet and inches), followed by centimeters in parentheses; unless otherwise noted, height precedes width. For drawings and prints, the dimensions correspond to the size of the support rather than to the size of the composition. With the exception of the detail of *Mural* (1943–44, plate 70), the full-page images of details from paintings have been reproduced at life-size.

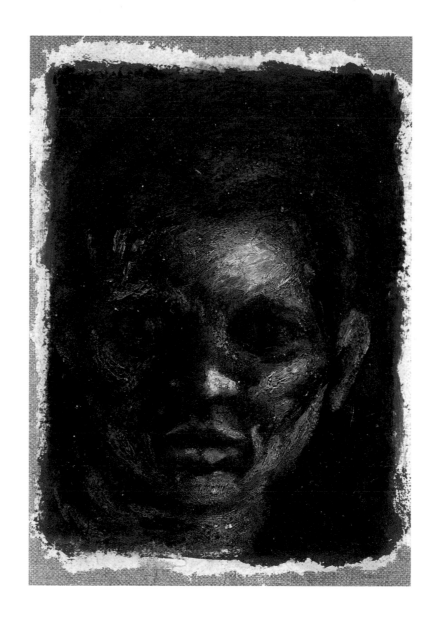

1. **Untitled (Self-Portrait)**. c. 1931–35? (OT: c. 1930–33)
Oil on gesso on canvas, mounted on fiberboard
7¼ × 5¼ in. (18.4 × 13.3 cm)
Courtesy Joan T. Washburn Gallery, New York,
and The Pollock-Krasner Foundation, Inc. OT 9

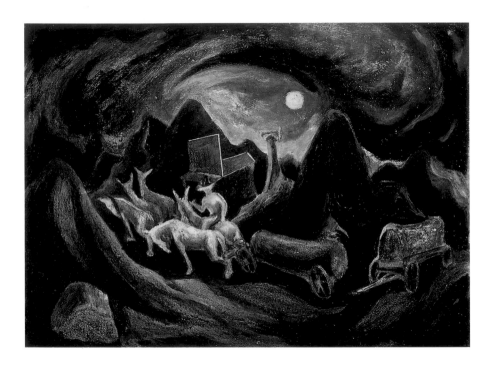

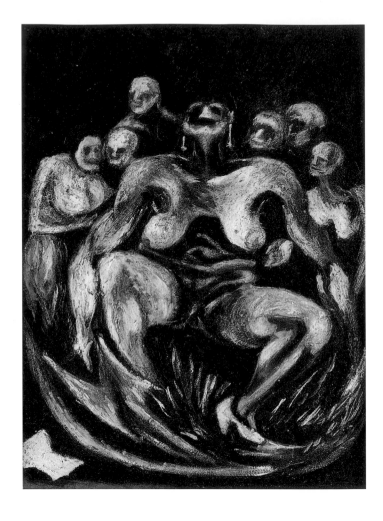

2. **Going West**. c. 1934–38
Oil on gesso on fiberboard
15⅛ × 20¾ in. (38.3 × 52.7 cm)
National Museum of American Art, Smithsonian Institution,
Washington, D.C. Gift of Thomas Hart Benton. OT 16

3. **Untitled (Woman)**. c. 1935–38? (OT: c. 1930–33)
Oil on fiberboard
14⅛ × 10½ in. (35.8 × 26.6 cm)
Nagashima Museum, Kagoshima City. OT 10

4. **Untitled [Composition with White Edge]**. c. 1934–38
Oil on wood panel
10⅝ × 16⅜ in. (27 × 41.6 cm)
Courtesy Joan T. Washburn Gallery, New York, and The Pollock-Krasner
Foundation, Inc. OT 34

5. **Seascape**. 1934
Oil on canvas
12 × 16 in. (30.4 × 40.6 cm)
Courtesy The Gerald Peters Gallery,
Santa Fe, New Mexico. OT 30

141

6. **Harbor and Lighthouse**. c. 1934–38
Watercolor on paper
18½ × 23 in. (47 × 58.4 cm)
Collection Mrs. Beatrice Cummings Mayer,
Chicago. OT 934

7. **Untitled (Sea-Landscape)**. 1936
Oil on canvas
24¼ × 30¼ in. (61.6 × 76.8 cm)
Collection Dr. David Abrahamsen. OT 26

142

8. **Untitled [Landscape with Steer]**. c. 1936–37
Lithograph
13⅞ × 18½ in. (35.2 × 47 cm)
Whereabouts unknown. OT 1064

9. **Untitled [Landscape with Steer]**. c. 1936–37
Airbrushed enamel over lithograph
13⅞ × 18½ in. (34.6 × 47.2 cm)
The Museum of Modern Art, New York. Gift of Lee Krasner Pollock. OT 1065

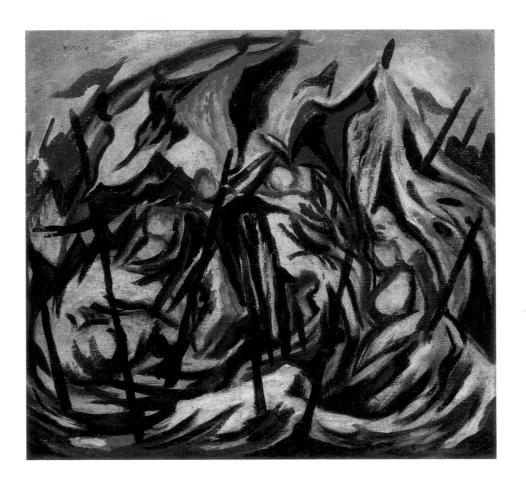

10. **Untitled [Composition with Figures and Banners]**. c. 1934–38
Oil on canvas
10⅝ × 11¾ in. (27 × 29.8 cm)
The Museum of Fine Arts, Houston. Museum purchase with funds
provided by the Brown Foundation Accessions Endowment Fund. OT 32

11. **Untitled [Overall Composition]**. c. 1934–38
Oil on canvas
15 × 20 in. (38.1 × 50.8 cm)
The Museum of Fine Arts, Houston. Museum
purchase with funds provided by the Brown
Foundation Accessions Endowment Fund. OT 33

12. **The Flame**. c. 1934–38
Oil on canvas, mounted on fiberboard
20½ × 30 in. (51.1 × 76.2 cm)
The Museum of Modern Art, New York.
Enid A. Haupt Fund. OT 31

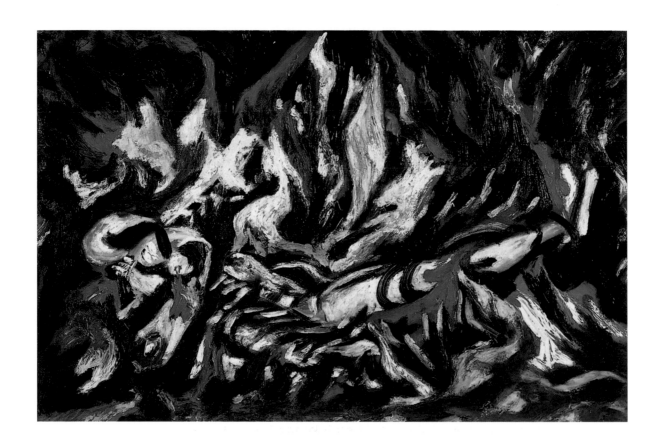

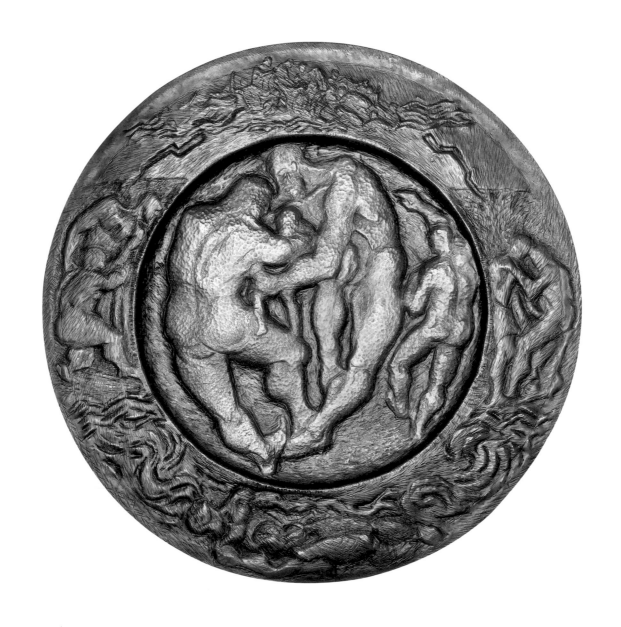

13. **Untitled**. 1938
Oxidized copper
18 in. (45.7 cm) diameter
Collection John P. Axelrod, Boston. OT 1046

14. **Untitled**. c. late 1937–39
Pencil and color pencil on paper
18 × 12 in. (45.7 × 30.5 cm)
The Metropolitan Museum of Art, New York.
Purchase, anonymous gift, 1990. OT 402r

15. **Untitled**. c. late 1937–39
Pencil and color pencil on paper
17 × 13¾ in. (43.2 × 34.9 cm)
The Metropolitan Museum of Art, New York.
Purchase, anonymous gift, 1990. OT 436r

16. **Untitled**. c. late 1937–39
Pencil and color pencil on paper
18 × 12 in. (45.7 × 30.5 cm)
The Metropolitan Museum of Art, New York.
Purchase, anonymous gift, 1990. OT 426r

17. **Untitled**. c. late 1937–39 [verso of plate 16]
Pencil and color pencil on paper
18 × 12 in. (45.7 × 30.5 cm)
The Metropolitan Museum of Art, New York.
Purchase, anonymous gift, 1990. OT 426v

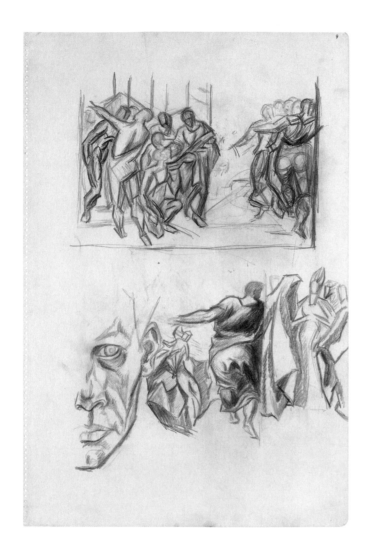

18. **Untitled**. c. late 1937–39
Pencil and color pencil on paper
18 × 12 in. (45.7 × 30.5 cm)
The Metropolitan Museum of Art, New York.
Purchase, anonymous gift, 1990. OT 410r

19. **Untitled**. c. 1938–41
Pencil and color pencil on paper
14⅛ × 11⅛ in. (35.9 × 28.3 cm)
The Metropolitan Museum of Art, New York.
Gift of Lee Krasner Pollock, 1982. OT 558

20. **Untitled**. c. 1938–41
Pencil and color pencil on paper
14¼ × 10 in. (36.2 × 25.4 cm)
The Metropolitan Museum of Art, New York.
Purchase, anonymous gift, 1990. OT 470r

21. **Untitled**. c. 1938–41
Pencil and color pencil on paper
14 × 11 in. (35.6 × 27.9 cm)
The Museum of Modern Art, New York.
Gift of Lee Krasner in memory of Jackson Pollock. OT 486

22. **Untitled**. c. 1938–41
Pencil and color pencil on paper
14¼ × 10 in. (36.2 × 25.4 cm)
The Metropolitan Museum of Art, New York.
Purchase, anonymous gift, 1990. OT 467r

23. **Untitled**. c. 1938–41
Pencil and color pencil on paper
14¼ × 10 in. (36.2 × 25.4 cm)
The Metropolitan Museum of Art, New York.
Purchase, anonymous gift, 1990. OT 475r

151

24–30. **Untitled (Panels A–G)**. c. 1934–38
Oil on fiberboard
Smallest 4⅝ × 7¹¹⁄₁₆ in. (11.7 × 19.8 cm), largest 7¾ × 6⅞ in. (19.7 × 17.5 cm)
Courtesy Joan T. Washburn Gallery, New York, and
The Pollock-Krasner Foundation, Inc. OT 37–40, 42–44

152

31. **Mask**. c. 1941
Oil on canvas
16¾ × 19 in. (42.5 × 48.3 cm)
The Museum of Modern Art, New York.
Enid A. Haupt Fund. OT 70

32. **Untitled (Circle)**. c. 1938–41
Oil on gesso on fiberboard
12¾ × 12 in. (32.2 × 30.5 cm)
The Museum of Modern Art, New York. Gift of
Lee Krasner in memory of Jackson Pollock. OT 64

153

33. **Bird**. c. 1938–41
Oil and sand on canvas
27¾ × 24¼ in. (70.5 × 61.6 cm)
The Museum of Modern Art, New York. Gift of
Lee Krasner in memory of Jackson Pollock. OT 72

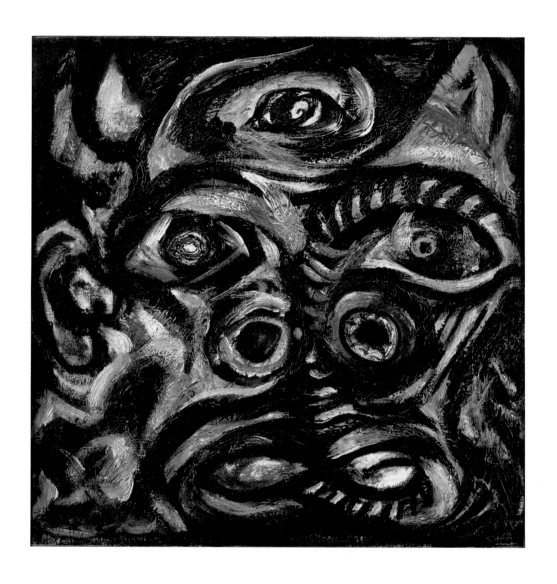

34. **Head**. c. 1938–41
Oil on canvas
16 × 15¾ in. (40.6 × 40 cm)
Sintra Museu de Arte Moderna, Sintra. Berardo Collection. OT 71

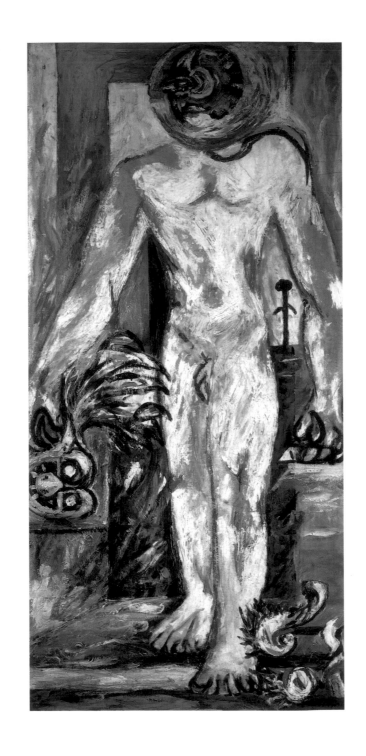

35. **Untitled [Naked Man]**. c. 1938–41
Oil on plywood
50 × 24 in. (127 × 60.9 cm)
Private collection, courtesy Robert Miller Gallery. OT 80

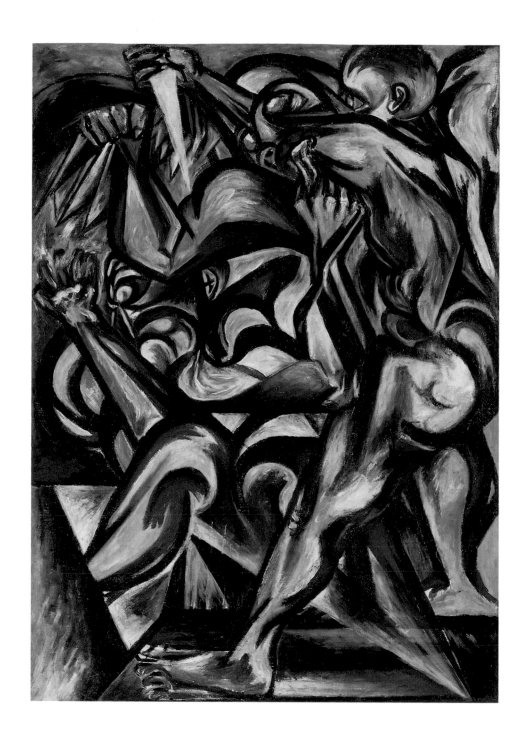

36. **Untitled [Naked Man with Knife]**. c. 1938–40 (OT: c. 1938–41)
Oil on canvas
50 × 36 in. (127 × 91.4 cm)
Tate Gallery, London. Presented by Frank Lloyd. OT 60

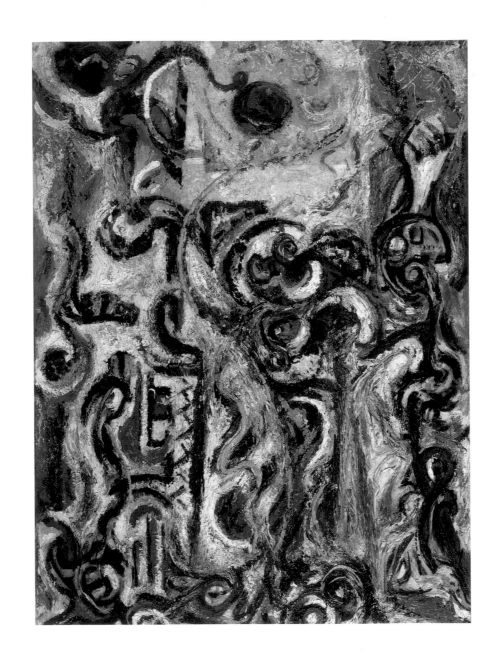

37. **The Mad Moon-Woman**. 1941
Oil on canvas
39½ × 29½ in. (100.3 × 74.9 cm)
Private collection. OT 84

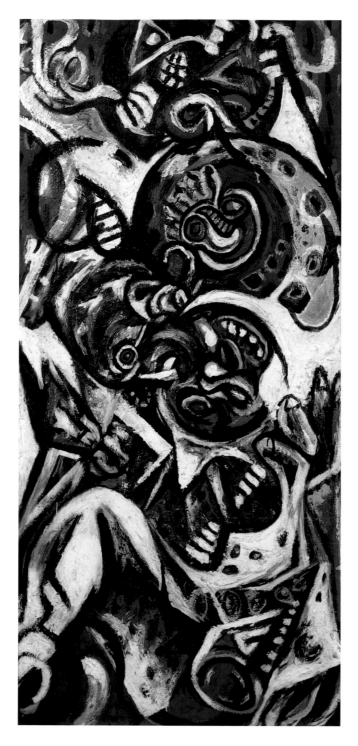

38. **Birth**. c. 1941 (OT: c. 1938–41)
Oil on canvas
45¹³⁄₁₆ × 21¹¹⁄₁₆ in. (116.4 × 55.1 cm)
Tate Gallery, London. Purchased 1985. OT 77

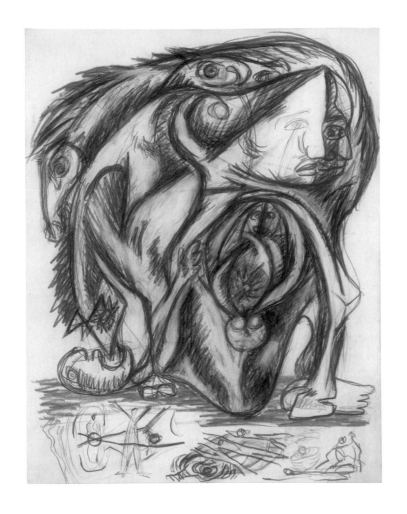

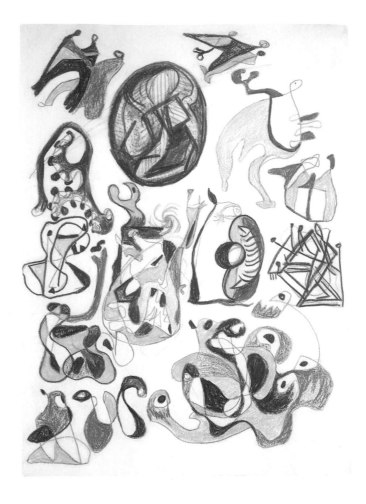

39. **Untitled**. c. 1939–40
Pencil and red pencil on paper
14 × 11 in. (35.5 × 27.9 cm)
Collection Leonard Nathanson, Nashville, Tennessee. OT 529

40. **Untitled**. c. 1939–42
Color crayon and pencil on paper
15¹⁄₁₆ × 11 in. (38.2 × 27.9 cm)
Collection Blake Byrne, Los Angeles. OT 626

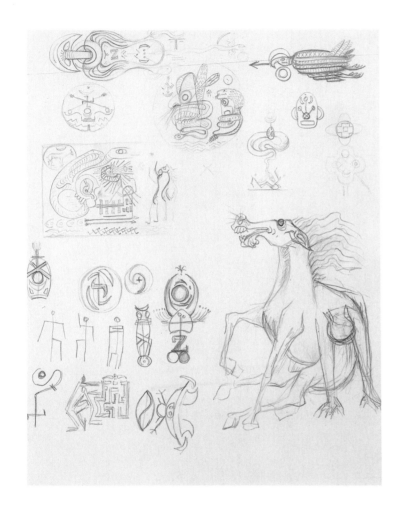

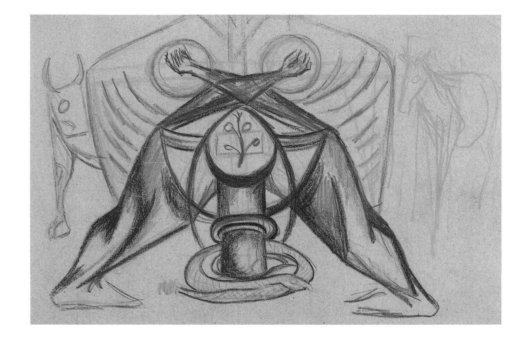

41. **Untitled**. c. 1939–40
Pencil on paper
14 × 11 in. (35.5 × 27.9 cm)
Museum of Art, Rhode Island School of Design, Providence. Gift
of Mr. and Mrs. Erwin Strasmich in memory of Ida Malloy. OT 521r

42. **Untitled**. c. 1939–40
Crayon and color pencil on gray paper
12¼ × 18¾ in. (31.1 × 47.6 cm)
Collection Phyllis and David Adelson. OT 555

161

43. **Untitled**. c. 1939–42 (signed and dated "38")
India ink and color pencil on paper
17⅞ × 13⅞ in. (45.4 × 35.2 cm)
The Metropolitan Museum of Art, New York.
Gift of Lee Krasner Pollock, 1982. OT 612r

44. **Untitled**. c. 1939–42 (signed and dated "38") [verso of plate 43]
India ink on paper
17⅞ × 13⅞ in. (45.4 × 35.2 cm)
The Metropolitan Museum of Art, New York. Gift of Lee Krasner Pollock, 1982. OT 612v

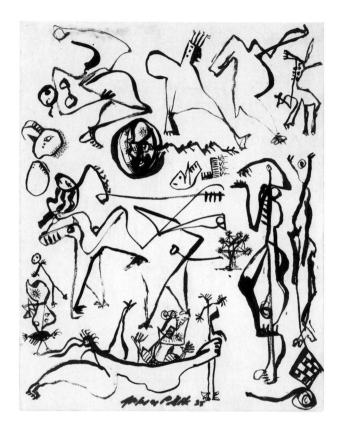

45. **Untitled**. c. 1939–42
India ink on paper
18 × 13⅞ in. (45.7 × 35.2 cm)
Whitney Museum of American Art, New York. Purchase, with
funds from the Julia B. Engel Purchase Fund and the Drawing
Committee. OT 603r

46. **Untitled**. c. 1939–42 (signed and dated "38")
India ink on paper
17⅜ × 13⅞ in. (44.8 × 35.2 cm)
The Metropolitan Museum of Art, New York. Gift of
Lee Krasner Pollock, 1982. OT 604

163

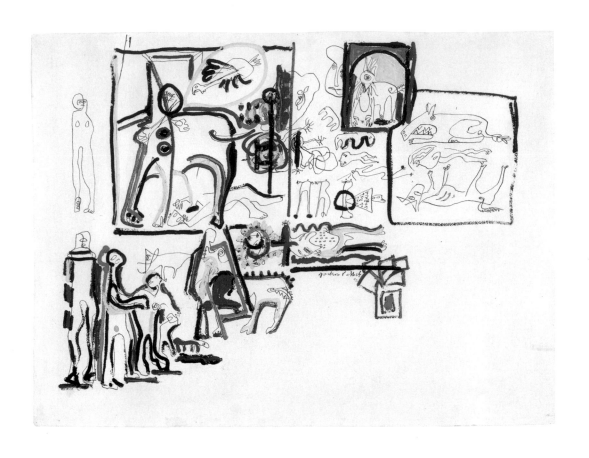

47. **Untitled (Animals and Figures)**. 1942
Oil, gouache, and ink on paper
22½ × 29⅞ in. (57.1 × 76 cm)
The Museum of Modern Art, New York.
Mr. and Mrs. Donald B. Straus Fund. OT 961

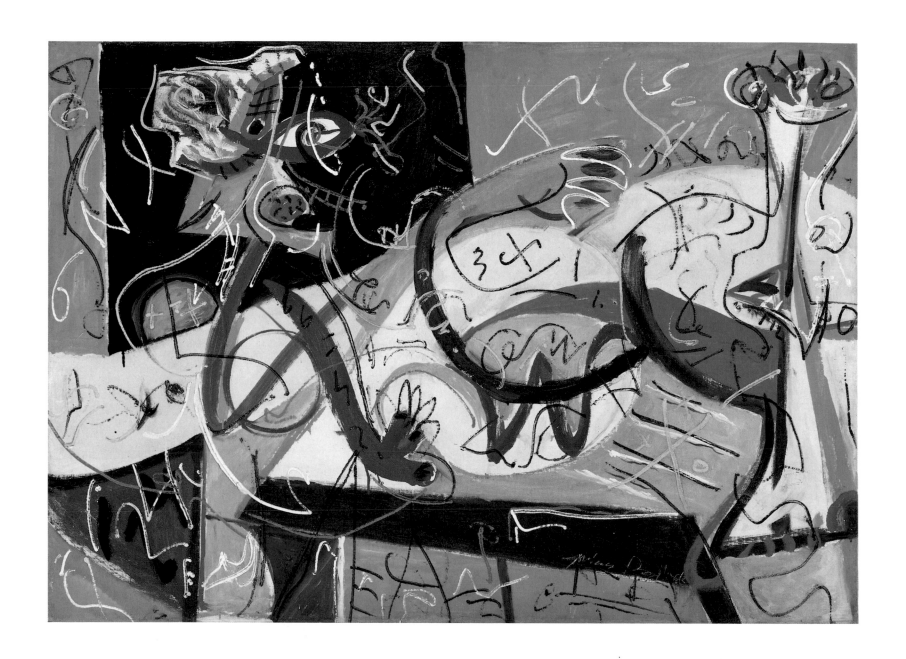

48. **Stenographic Figure**. c. 1942
Oil on linen
40 × 56 in. (101.6 × 142.2 cm)
The Museum of Modern Art, New York.
Mr. and Mrs. Walter Bareiss Fund. OT 88

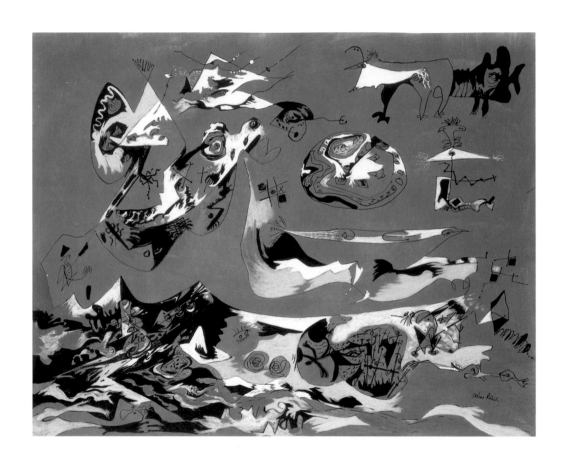

49. Untitled (Blue (Moby Dick)). c. 1943
Gouache and ink on fiberboard
18¾ × 23⅞ in. (48 × 60.5 cm)
Ohara Museum of Art, Kurashiki, Japan. OT 971

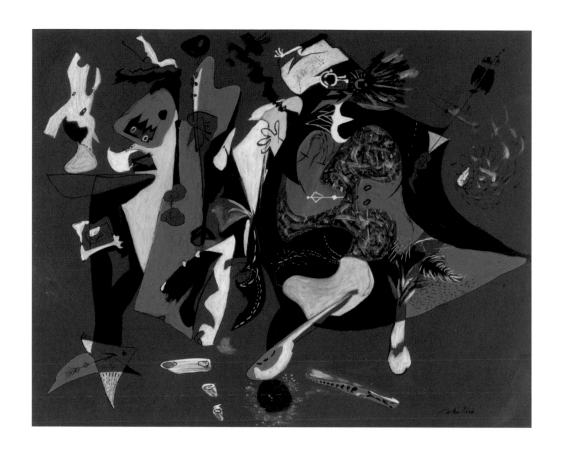

50. **Red and Blue**. c. 1943–46 (OT: c. 1943)
Gouache, tempera, and ink on fiberboard
19⅛ × 24 in. (48.6 × 61 cm)
Collection Charles H. Carpenter, Jr. OT 970

51. **Untitled**. c. 1940–43
Bone
6¼ × 3 in. (15.9 × 7.6 cm)
The Museum of Fine Arts, Houston. Museum purchase with funds provided
by Louisa Stude Sarofim in memory of Alice Pratt Brown. OT suppl. 29

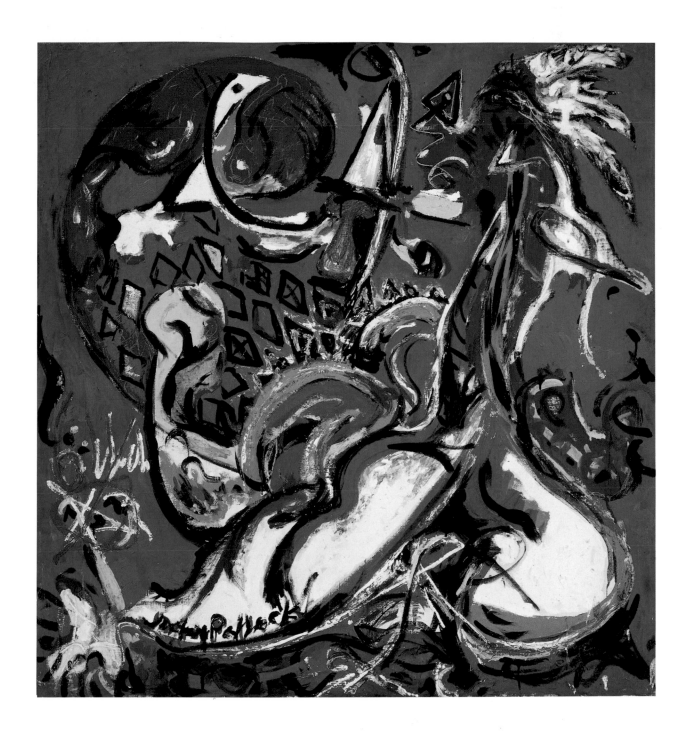

52. **The Moon-Woman Cuts the Circle**. c. 1943
Oil on canvas
43⅛ × 40¹⁵⁄₁₆ in. (109.5 × 104 cm)
Musée national d'art moderne, Centre de Création Industrielle, Centre Georges
Pompidou, Paris. Donated by Frank K. Lloyd, Paris, 1979. OT 90

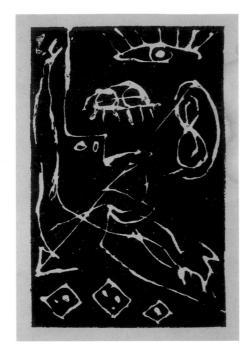

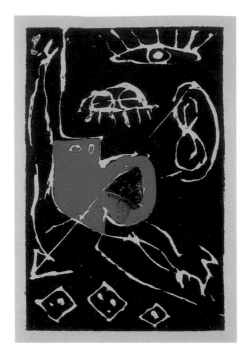

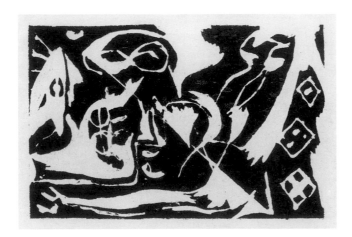

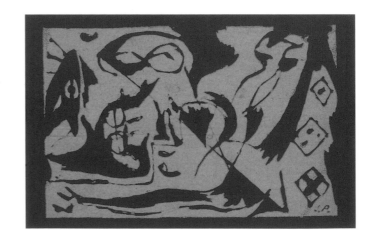

TOP LEFT
53. **Untitled**. c. 1943–44
Screenprint, printed in orange ink
on black paper
8½ × 5½ in. (21.5 × 14 cm)
The Museum of Modern Art, New York.
Acquired through the generosity of Agnes
Gund and Daniel Shapiro, in honor of Lily
Auchincloss. Variant of OT suppl. 32

TOP CENTER
54. **Untitled**. c. 1943–44
Screenprint, printed in green ink
on black paper
8½ × 5½ in. (21.5 × 14 cm)
The Museum of Modern Art, New York.
Acquired through the generosity of Agnes
Gund and Daniel Shapiro, in honor of Lily
Auchincloss. Variant of OT suppl. 33

TOP RIGHT
55. **Untitled**. c. 1943–44
Screenprint, printed in black and orange
inks on blue paper
8½ × 5½ in. (21.5 × 14 cm)
The Museum of Modern Art, New York.
Acquired through the generosity of Agnes
Gund and Daniel Shapiro, in honor of Lily
Auchincloss. Variant of OT suppl. 34

BOTTOM LEFT
56. **Untitled**. c. 1943–44
Screenprint, printed in black ink
on white paper
5½ × 8½ in. (14 × 21.5 cm)
The Museum of Modern Art, New York.
Purchased with funds given by John
Loring in memory of China Loring.
OT suppl. 31

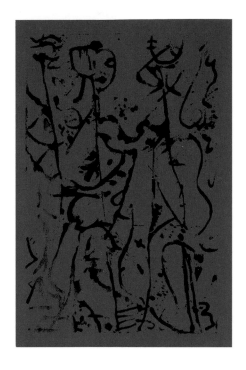

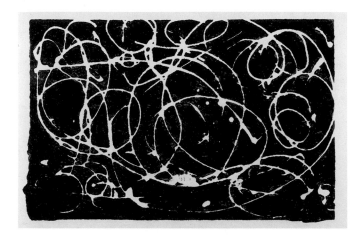

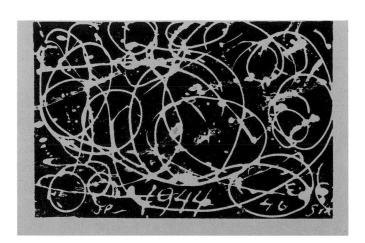

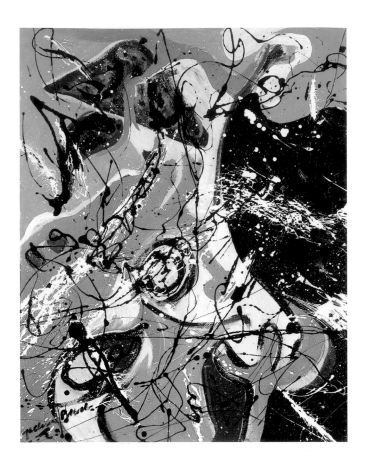

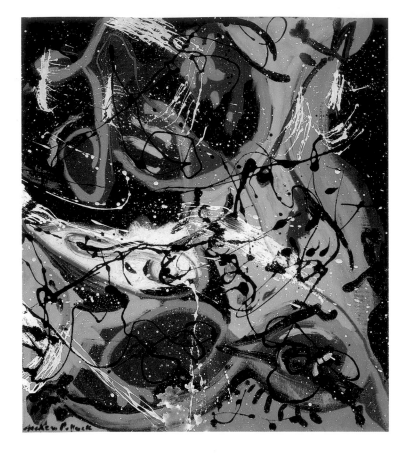

61. **Water Birds**. 1943
Oil on canvas
26⅛ × 21³⁄₁₆ in. (66.4 × 53.8 cm)
The Baltimore Museum of Art. Bequest of Saidie
A. May. OT 93

62. **Untitled [Composition with Pouring II]**. 1943
Oil and enamel on canvas
25⅛ × 22⅛ in. (63.8 × 56.2 cm)
Hirshhorn Museum and Sculpture Garden, Smithsonian Institution,
Washington, D.C. Gift of Joseph H. Hirshhorn, 1966. OT 94

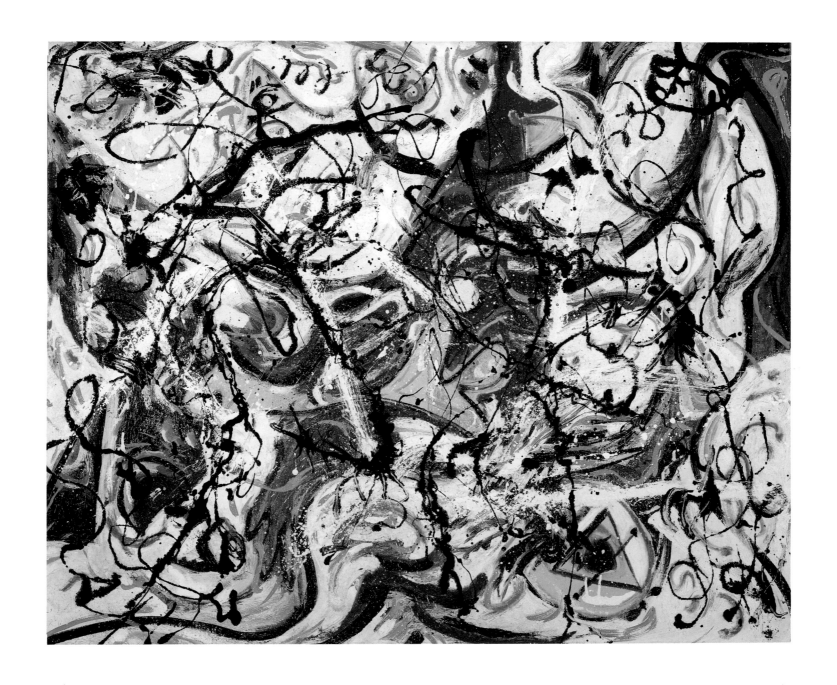

63. **Untitled [Composition with Pouring I]**. 1943
Oil on canvas
35¾ × 44¾ in. (90.8 × 113.6 cm)
Private collection. OT 92

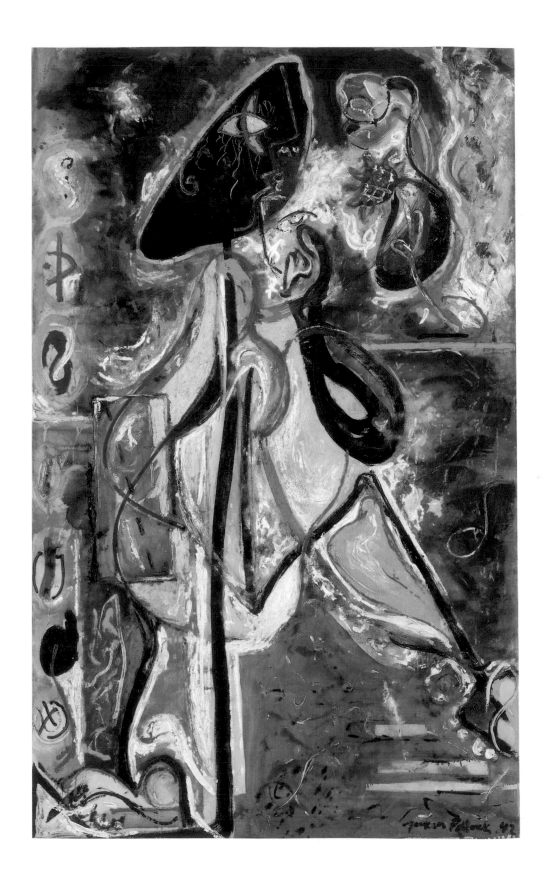

64. **The Moon Woman**. 1942
Oil on canvas
69 × 43⅛₆ in. (175.2 × 109.3 cm)
Peggy Guggenheim Collection, Venice. The Solomon R.
Guggenheim Foundation, New York. OT 86

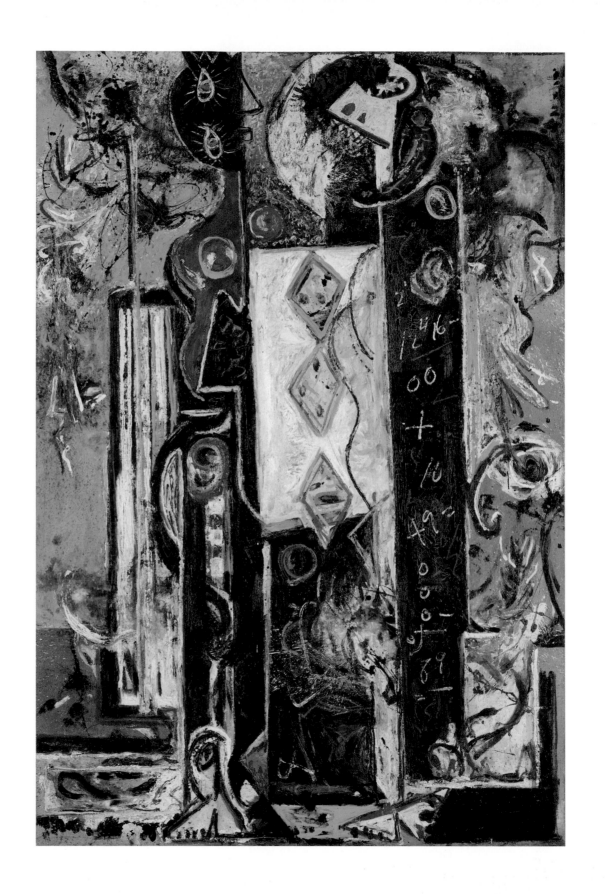

65. **Male and Female**. c. 1942
Oil on canvas
6 ft. 1 in. × 49 in. (184.4 × 124.5 cm)
Philadelphia Museum of Art.
Gift of Mr. and Mrs. H. Gates Lloyd. OT 87

175

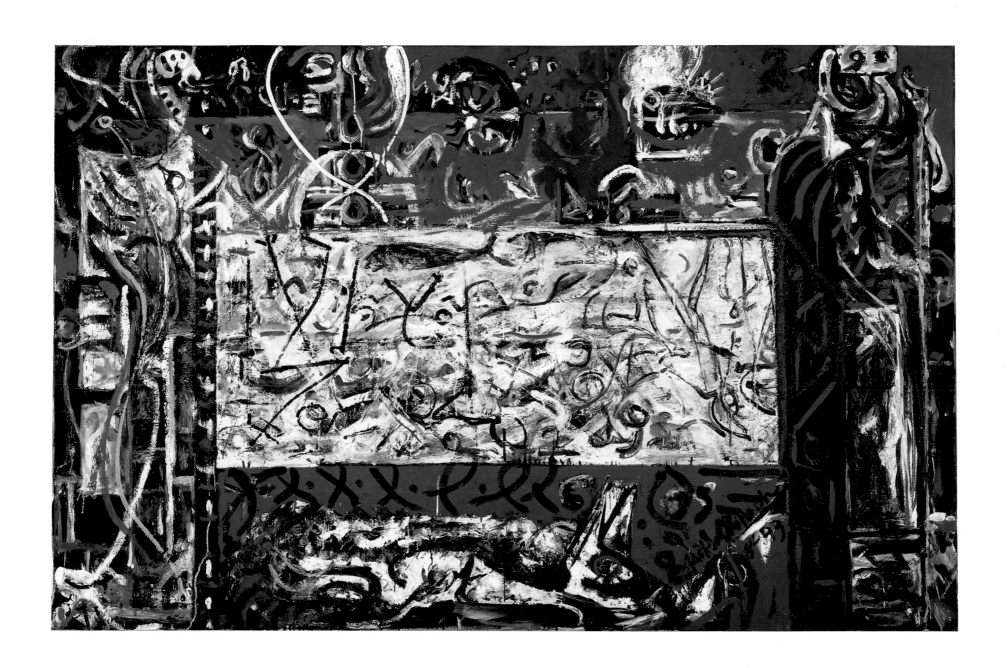

OPPOSITE (DETAIL) AND ABOVE

66 and 67. **Guardians of the Secret**. 1943
Oil on canvas
48⅜ in. × 6 ft. 3⅜ in. (122.9 × 191.5 cm)
San Francisco Museum of Modern Art. Albert M. Bender Collection;
Albert M. Bender Bequest Fund Purchase. OT 99

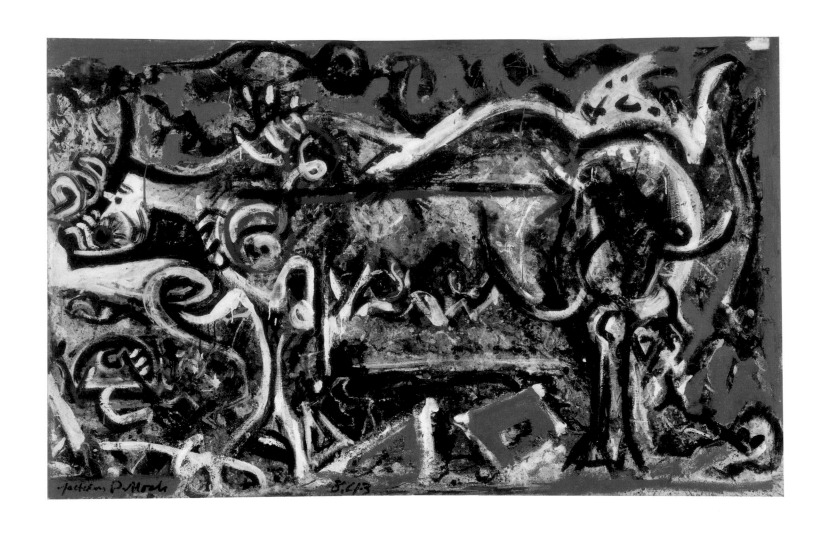

68. **The She-Wolf**. 1943
Oil, gouache, and plaster on canvas
41⅞ × 67 in. (106.4 × 170.2 cm)
The Museum of Modern Art, New York. Purchase. OT 98

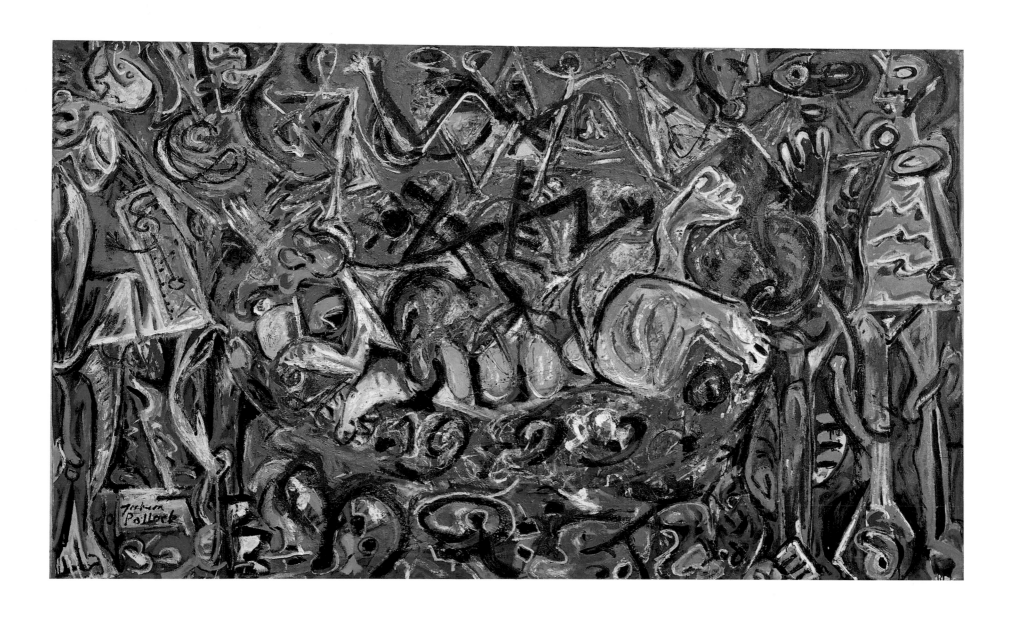

69. **Pasiphaë**. c. 1943
Oil on canvas
56⅛ in. × 8 ft. (142.5 × 243.8 cm)
The Metropolitan Museum of Art, New York. Purchase, Rogers, Fletcher,
and Harris Brisbane Dick Funds and Joseph Pulitzer Bequest, 1982. OT 101

OPPOSITE (DETAIL) AND ABOVE
70 and 71. **Mural**. 1943–44 (dated "1943") (OT: 1943)
Oil on canvas. 7 ft. 11¾ in. × 19 ft. 9½ in. (243.2 × 603.2 cm)
The University of Iowa Museum of Art, Iowa City. Gift of Peggy Guggenheim. OT 102

72. **Night Mist**. c. 1944–45
Oil on canvas
39 in. × 6 ft. ⅛ in. (99.1 × 183.2 cm)
Norton Museum of Art, West Palm Beach, Florida. OT 104

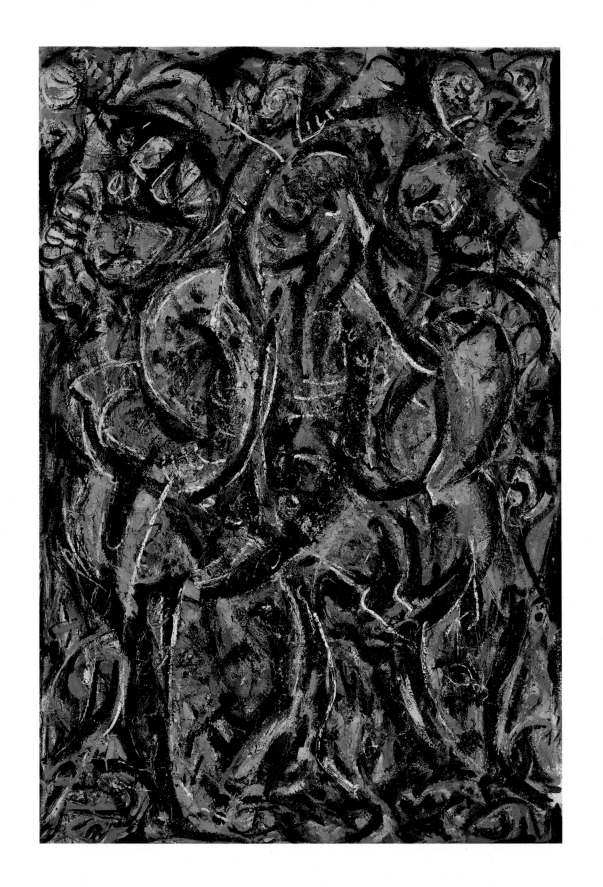

73. **Gothic**. 1944
Oil on canvas
7 ft. ⅜ in. × 56 in. (215.5 × 142.1 cm)
The Museum of Modern Art, New York.
Bequest of Lee Krasner. OT 103

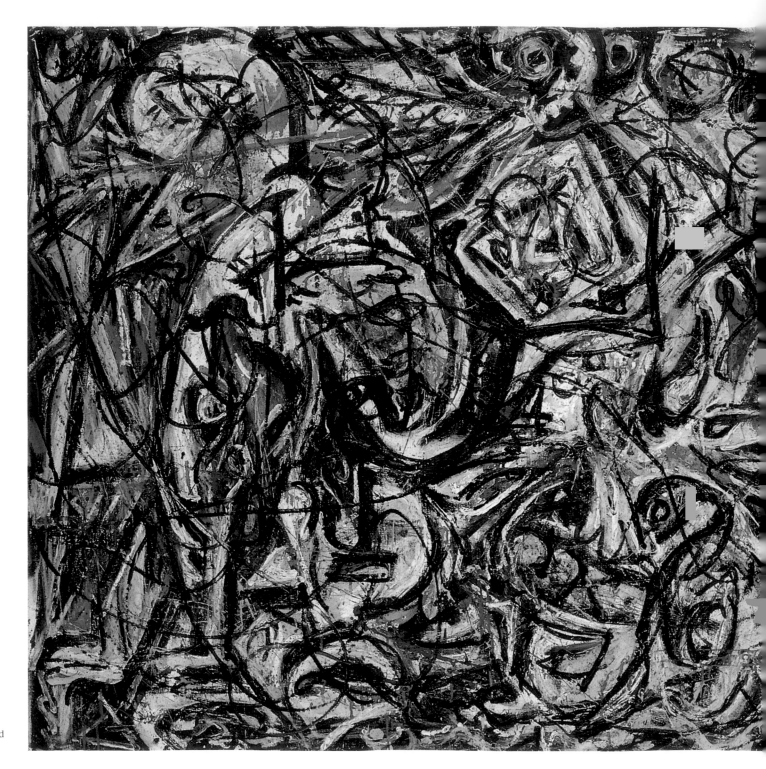

74. **There Were Seven in Eight**. c. 1945
Oil on canvas
43 in. × 8 ft. 6 in. (109.2 × 259.1 cm)
The Museum of Modern Art, New York. Mr. and
Mrs. Walter Bareiss Fund and purchase. OT 124

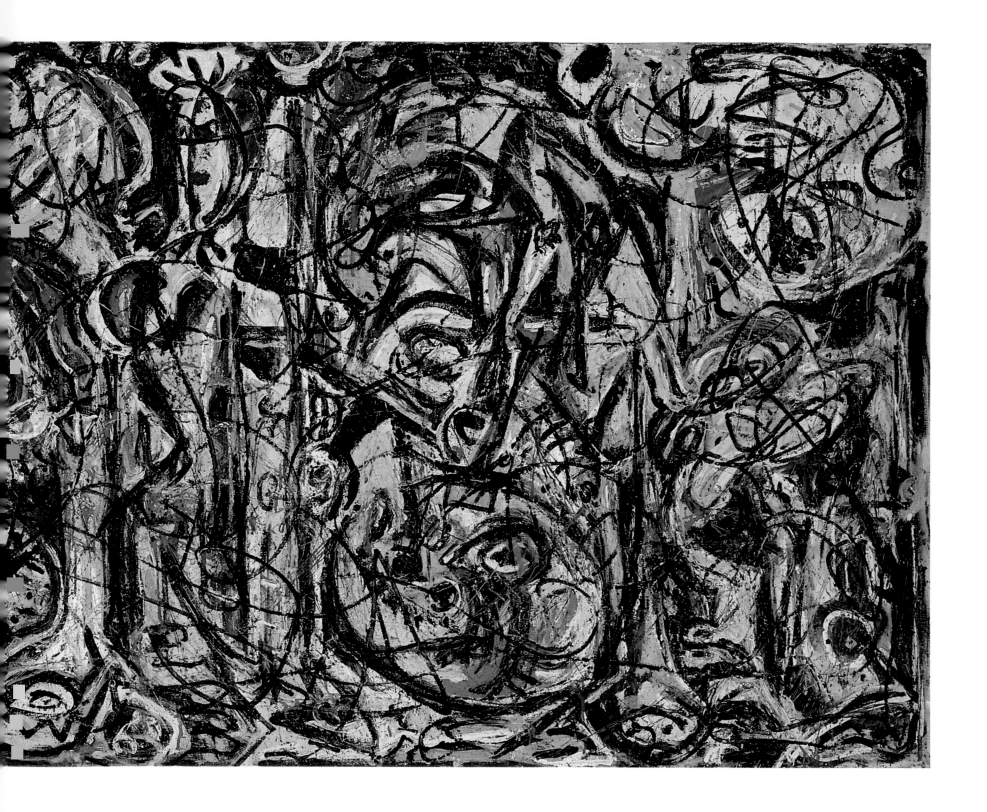

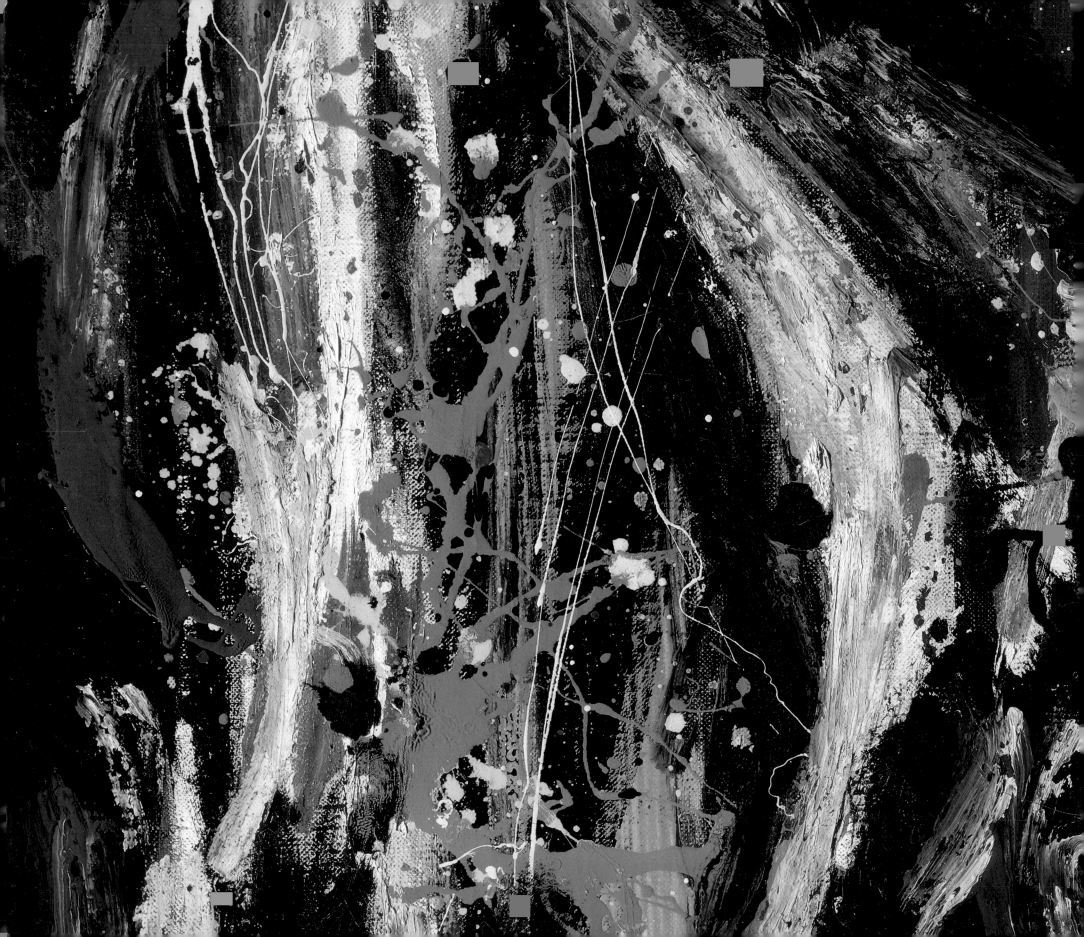

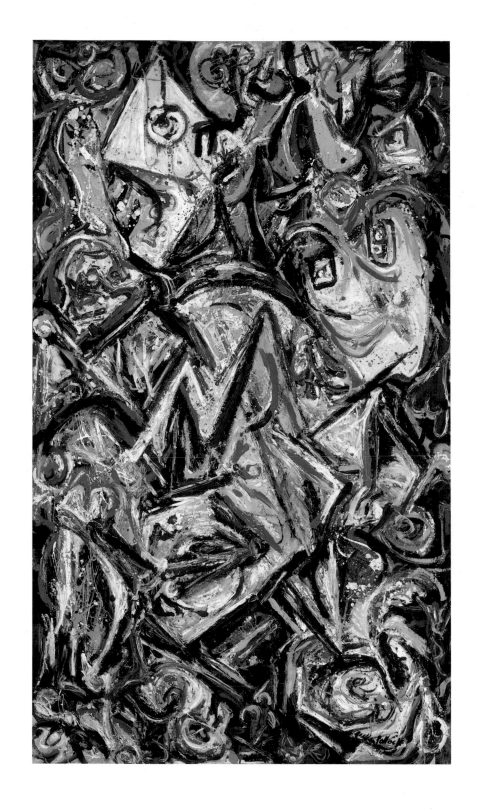

OPPOSITE (DETAIL) AND RIGHT
75 and 76. **Troubled Queen**. c. 1945
Oil and enamel on canvas
6 ft. 2⅛ in. × 43½ in. (188.3 × 110.5 cm)
Museum of Fine Arts, Boston. Charles H. Bayley Picture
and Painting Fund and gift of Mrs. Albert J. Beveridge and
Juliana Cheney Edwards Collection, by exchange. OT 128

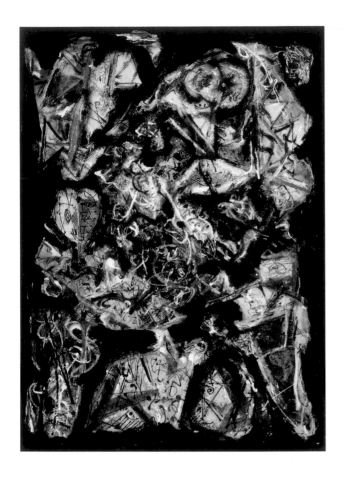

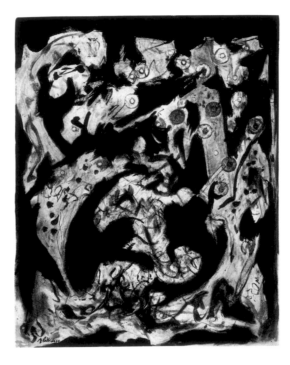

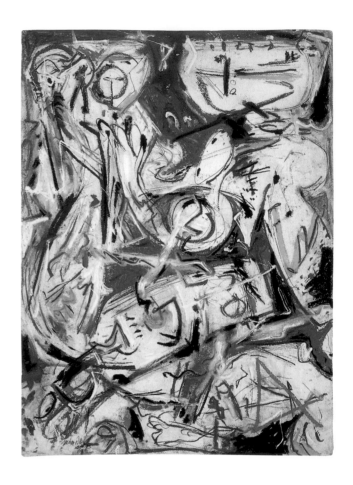

77. **Untitled**. c. 1944
Gouache and mixed mediums on paper
31¼ × 23 in. (79 3 × 58.4 cm)
Private collection, Toronto. OT 978

78. **Untitled**. 1944
India ink and watercolor on mulberry paper
12½ × 10⅛ in. (31.8 × 25.7 cm)
The Museum of Modern Art, New York.
The William S. Paley Collection. OT 977

79. **Untitled**. 1945
Pastel, gouache, and ink on paper
30⅜ × 22⅛ in. (77.7 × 56.9 cm)
The Museum of Modern Art, New York.
Blanchette Rockefeller Fund. OT 991

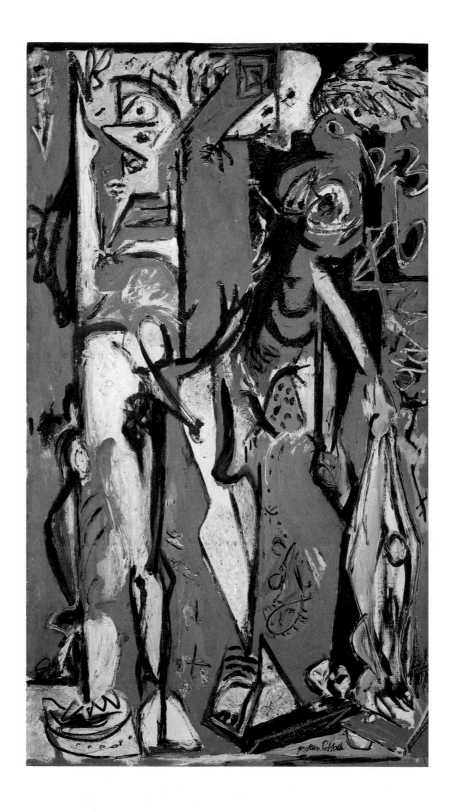

80. **Two**. 1943–45
Oil on canvas
6 ft. 4 in. × 43¼ in. (193 × 110 cm)
Peggy Guggenheim Collection, Venice. The Solomon R.
Guggenheim Foundation, New York. OT 123

189

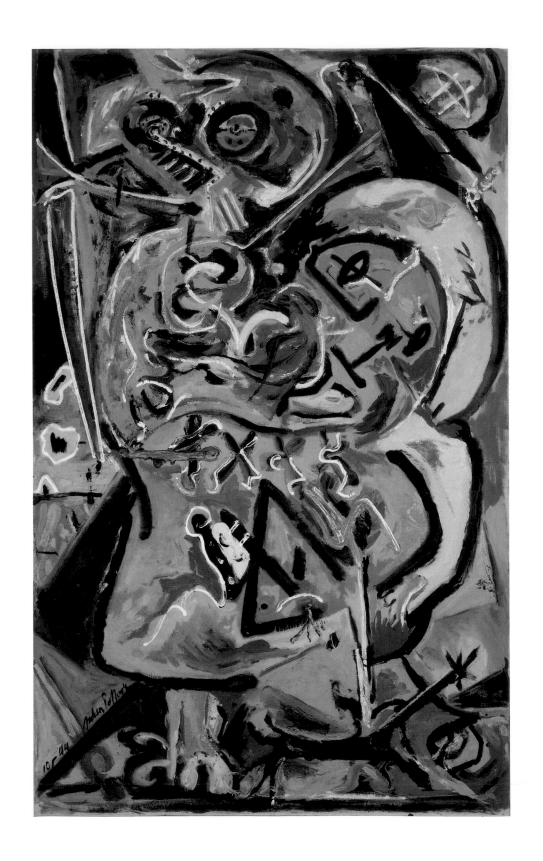

81. **Totem Lesson I**. 1944
Oil on canvas
70 × 44 in. (177.8 × 111.8 cm)
Collection Harry W. and Mary Margaret
Anderson. OT 121

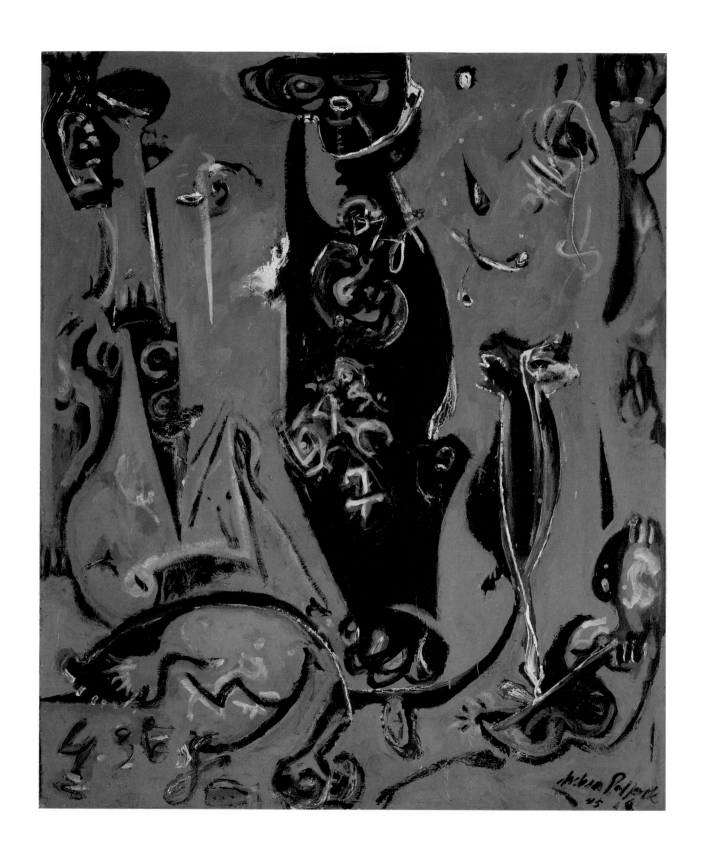

82. **Totem Lesson 2**. 1945
Oil on canvas
6 ft. × 60 in. (182.8 × 152.4 cm)
National Gallery of Australia,
Canberra. OT 122

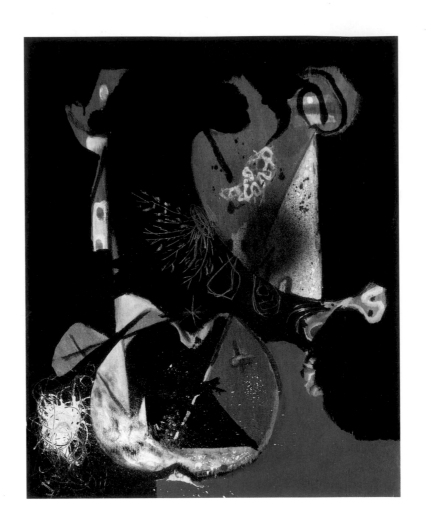

83. **Painting**. c. 1944
Gouache on plywood
23 × 18⅞ In. (58.4 × 47.8 cm)
The Museum of Modern Art, New York.
Gift of Monroe Wheeler. OT 976

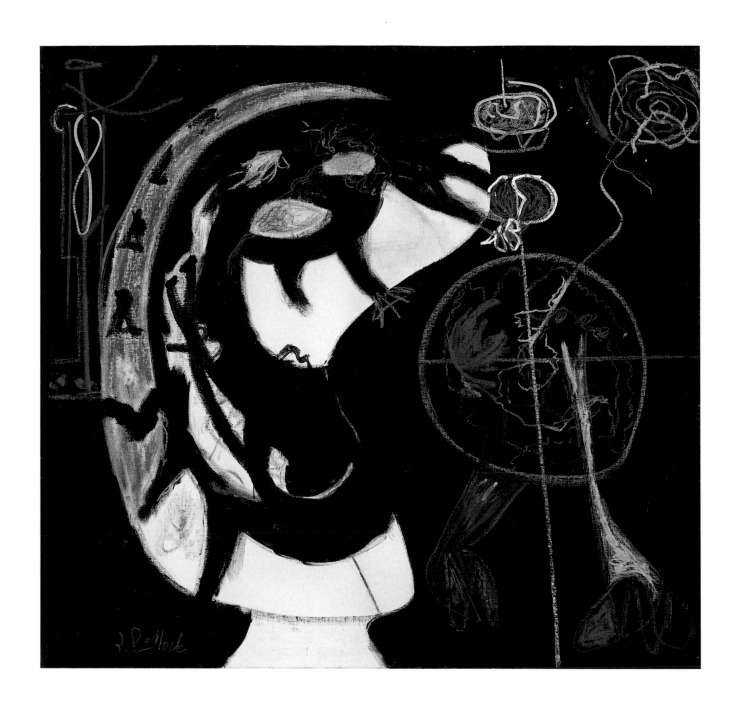

84. **Night Sounds**. c. 1944
Oil and pastel on canvas
43 × 46 in. (109.2 × 116.8 cm)
Private collection. OT 111

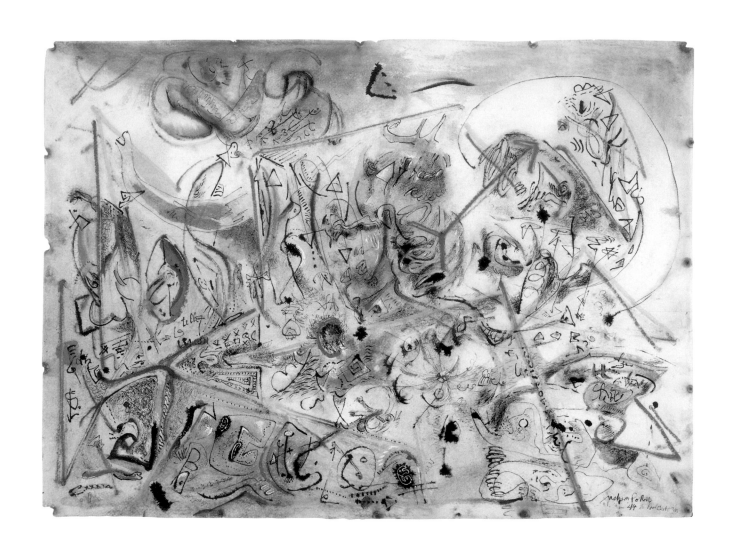

85. **Untitled**. 1944
Gouache, ink, and wash on paper
22½ × 30⅝ in. (57.1 × 77.8 cm)
Private collection. OT 723

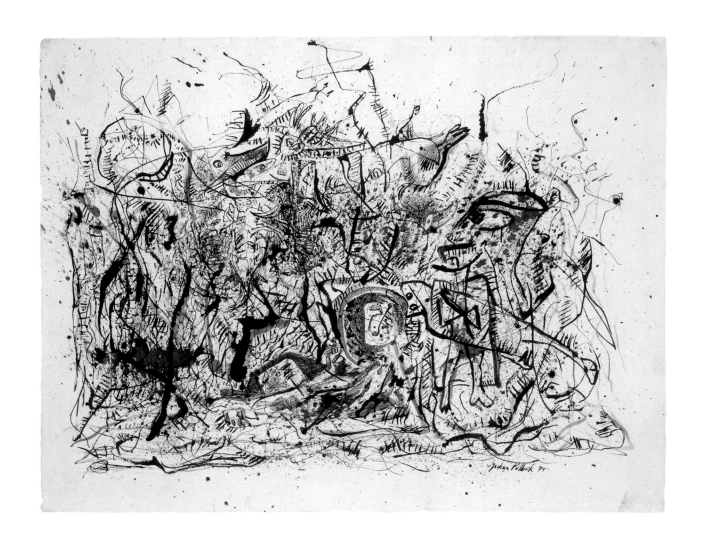

86. **Untitled**. 1944
Black and color ink on paper
18⅞ × 24⅞ in. (48 × 63.2 cm)
The Art Institute of Chicago. Ada Turnbull Hertle Fund and gifts of Mrs. Leigh B.
Block, Margaret Fisher, William H. Hartmann, and Joseph R. Shapiro. OT 724

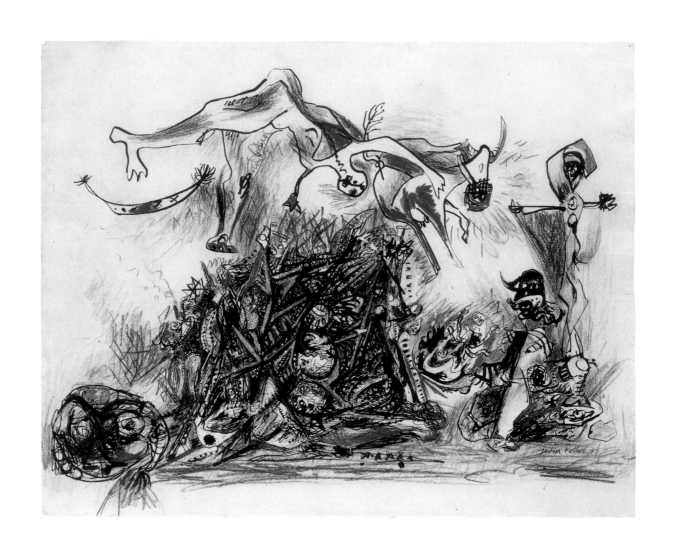

87. **War**. c. 1944–46 (dated "1947") (OT: 1947)
Ink and color pencil on paper
20⅝ × 26 in. (52.4 × 66 cm)
The Metropolitan Museum of Art, New York. Gift of Lee Krasner
Pollock, in memory of Jackson Pollock, 1982. OT 765

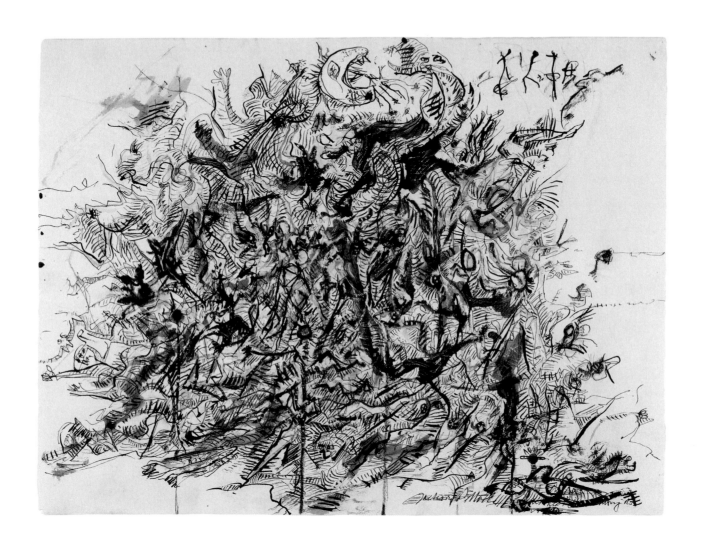

88. **Untitled**. c. 1945
Black and color ink, gouache, pastel, and wash on paper
18⅛ × 24¾ in. (46.6 × 62.8 cm)
Gecht Family Collection, Chicago. OT 726

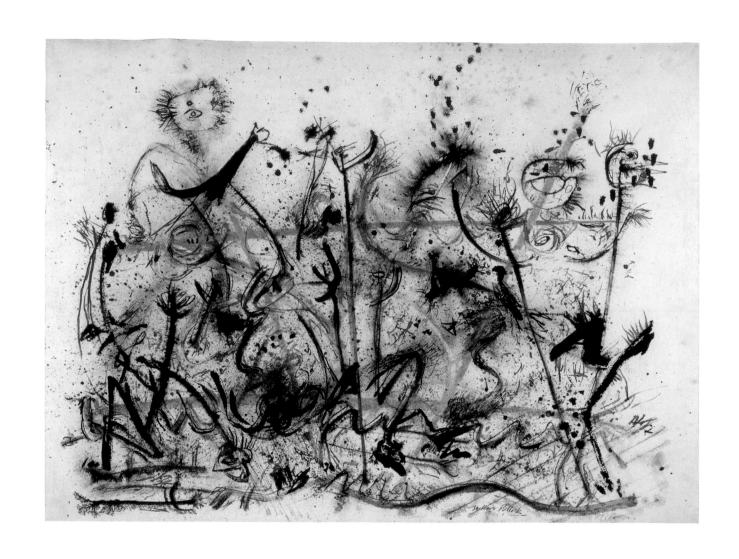

89. **Untitled**. c. 1946
Ink, pastel, and gouache on paper
19 × 26 in. (18.3 × 66 cm)
Collection Denise and Andrew Saul. OT 1014

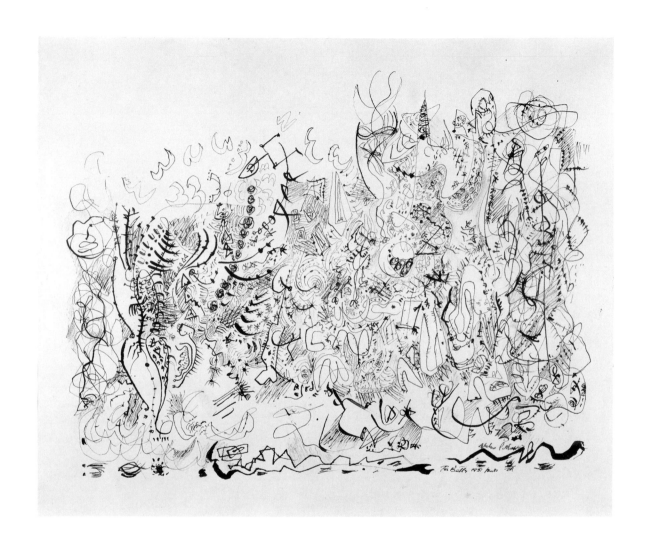

90. **Untitled**. 1947
Ink and crayon on paper
17¾ × 23¼ in. (45 × 59 cm)
Collection Charlotte and Duncan MacGuigan. OT 762

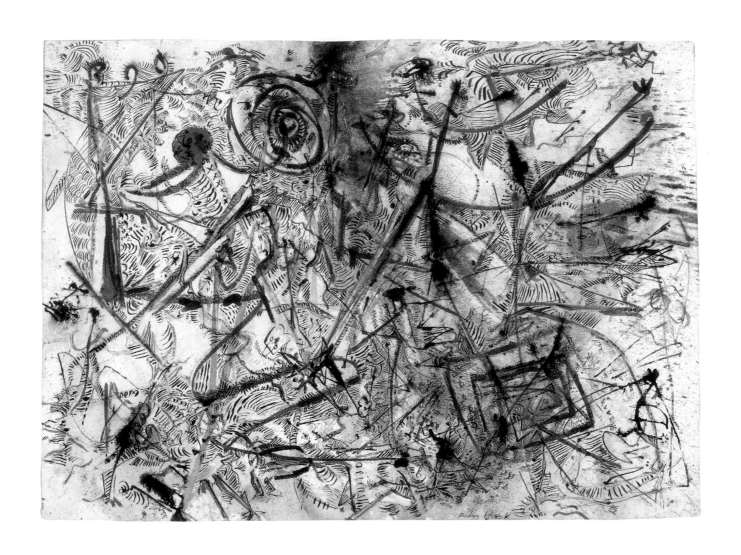

91. **Untitled [Drawing with Spirals]**. c. 1946
Brush, spatter, and black and color ink, pastel,
gouache, and wash on paper
22½ × 31 in. (57.2 × 78.8 cm)
Collection Mr. and Mrs. Bertram L. Wolstein. OT suppl. 20

200

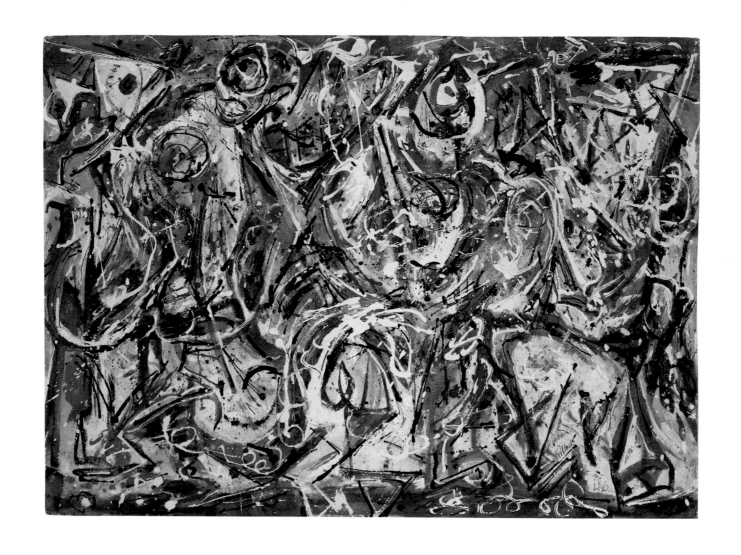

92. **Untitled**. 1946
Gouache on paper
22¼ × 32½ in. (56.5 × 82.6 cm)
Thyssen-Bornemisza Collection, Lugano. OT 1010

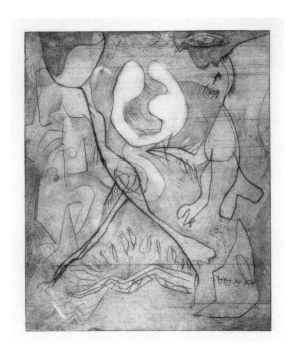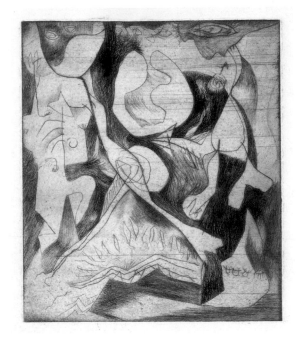

93. **Untitled**. 1944–45
Engraving
11⅞ × 9¹³⁄₁₆ in. (30.2 × 24.9 cm)
The Museum of Modern Art, New York.
Gift of Lee Krasner Pollock. OT 1069

94. **Untitled**. 1944–45
Engraving and drypoint
11⅜ × 9¹⁵⁄₁₆ in. (29.5 × 25.3 cm)
The Museum of Modern Art, New York.
Gift of Lee Krasner Pollock. OT 1070

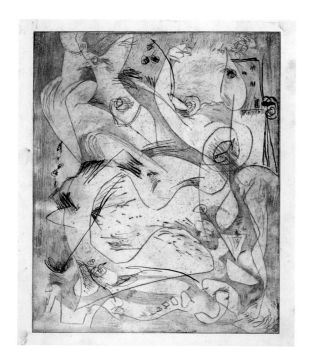

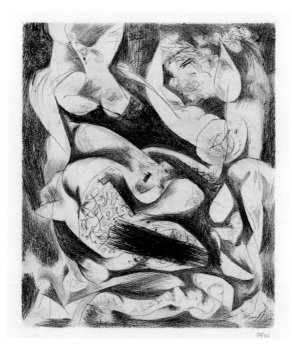

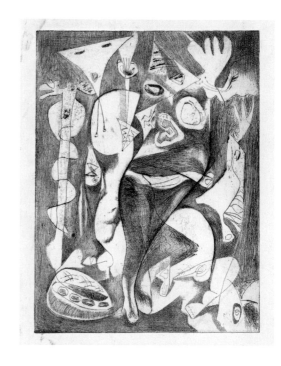

95. **Untitled**. 1944–45
Ink over engraving and drypoint
11⅞ × 9¹³⁄₁₆ in. (30.2 × 24.9 cm)
The Museum of Modern Art, New York.
Gift of Lee Krasner Pollock. OT 1072

96. **Untitled**. 1944–45 (printed posthumously, 1967)
Engraving and drypoint
11⅞ × 10 in. (30.2 × 25.4 cm)
The Museum of Modern Art, New York.
Gift of Lee Krasner Pollock. OT 1074

97. **Untitled**. 1944–45
Engraving and drypoint
11¹³⁄₁₆ × 8¹³⁄₁₆ in. (30 × 22.8 cm)
The Museum of Modern Art, New York.
Gift of Lee Krasner Pollock. OT 1083

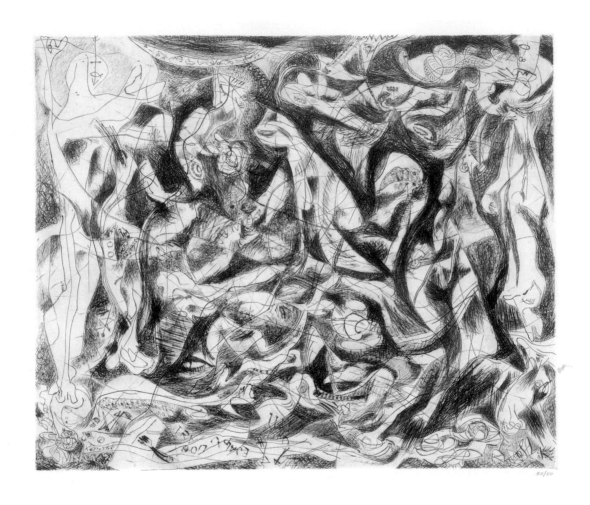

98. **Untitled**. 1944–45 (printed posthumously, 1967)
Engraving and drypoint
14¹¹⁄₁₆ × 17⅞ in. (37.3 × 45.8 cm)
The Museum of Modern Art, New York.
Gift of Lee Krasner Pollock. OT 1078

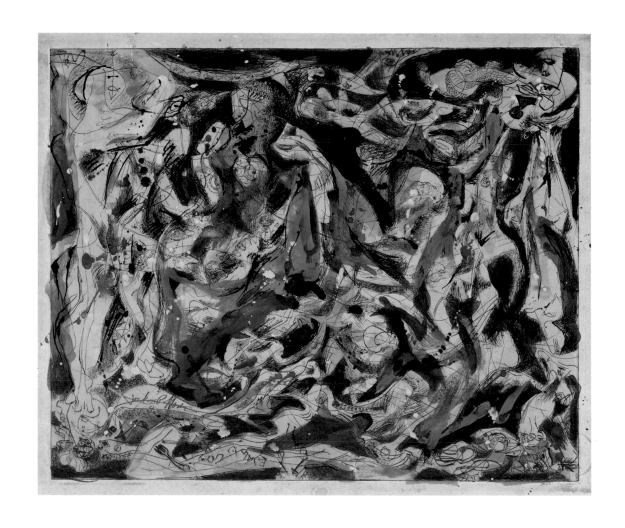

99. **Untitled**. c. 1945
Ink and gouache over engraving and drypoint
17¹¹⁄₁₆ × 21⅜ in. (44.9 × 54.3 cm) irregular
Collection The Guerrero Family. OT 989

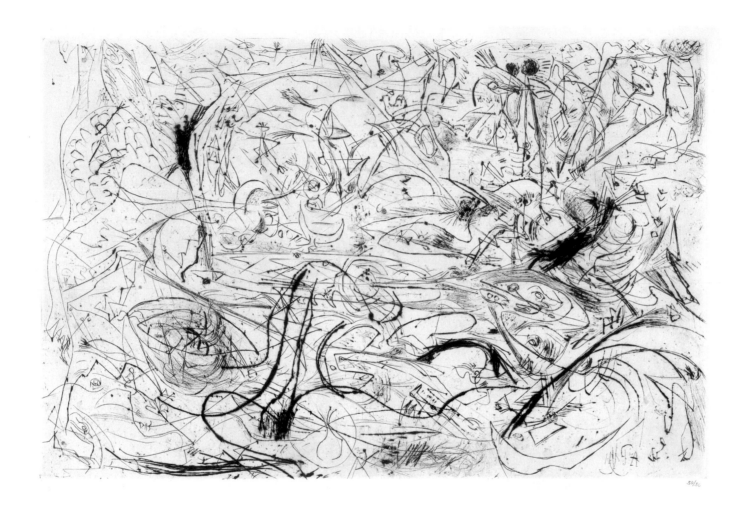

100. **Untitled**. 1944–45 (printed posthumously, 1967)
Engraving and drypoint
15¾ × 23¾ in. (40 × 60.3 cm)
The Museum of Modern Art, New York.
Gift of Lee Krasner Pollock. OT 1082

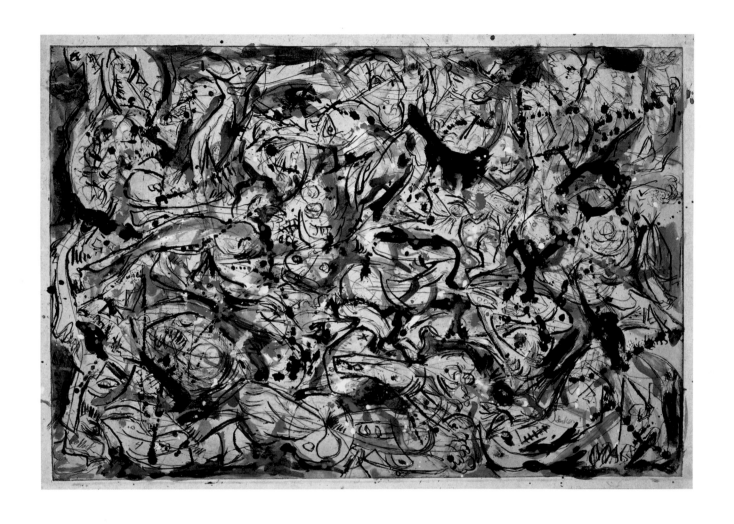

101. **Untitled**. c. 1945
Ink and gouache over engraving and drypoint
16 × 23½ in. (40.6 × 59.7 cm)
Private collection. OT 990

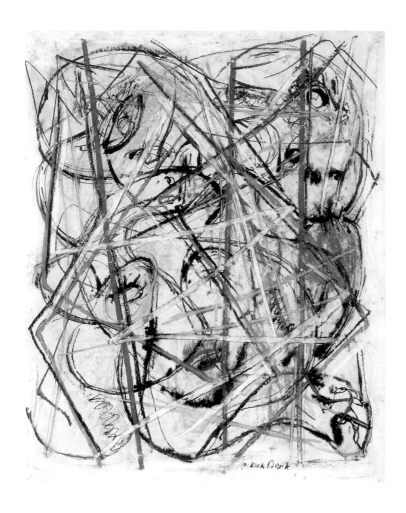

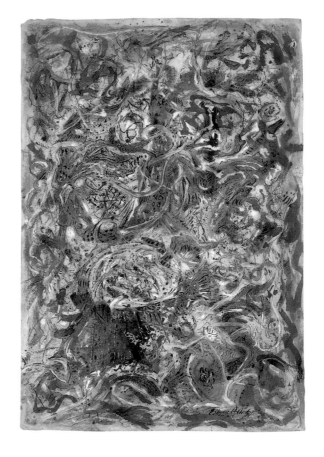

102. **Untitled**. c. 1945
Crayon, pastel, and gouache on paper
25⅝ × 20½ in. (65.1 × 52.1 cm)
Los Angeles County Museum of Art. Gift of Anna Bing Arnold and purchased with funds provided by Mr. William Inge, Dr. and Mrs. Kurt Wagner,
Graphic Arts Council Fund, and Museum Acquisition Fund. OT 1001

103. **Untitled (Pattern)**. c. 1945
Watercolor, ink, and gouache on paper
22½ × 15½ in. (57.1 × 39.4 cm)
Hirshhorn Museum and Sculpture Garden, Smithsonian
Institution, Washington, D.C. Gift of the Joseph H.
Hirshhorn Foundation, 1966. OT 993

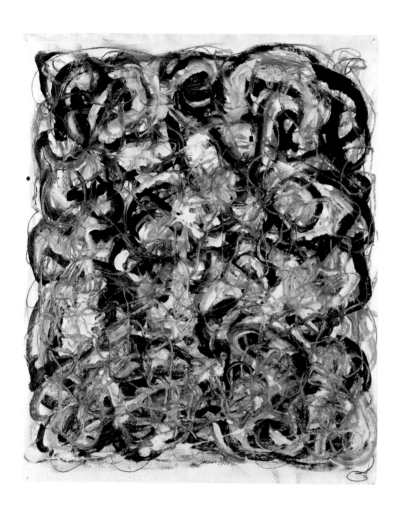

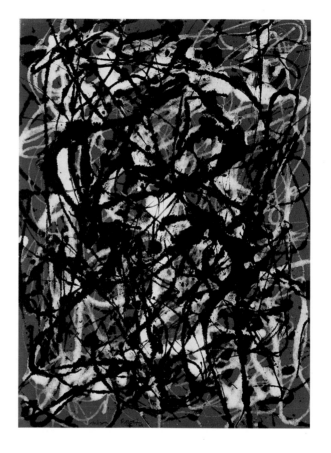

104. **Untitled**. c. 1945
Pastel and enamel on paper
25⁹⁄₁₆ × 20½ in. (65 × 52 cm)
Thyssen-Bornemisza Collection, Lugano. OT 994

105. **Free Form**. 1946
Oil on canvas
19¼ × 14 in. (48.9 × 35.5 cm)
The Museum of Modern Art, New York.
The Sidney and Harriet Janis Collection. OT 165

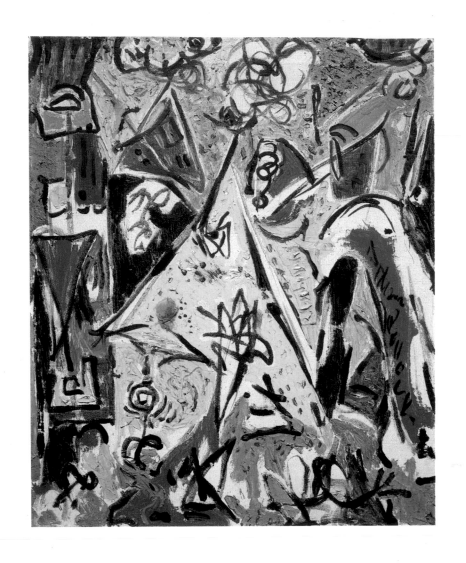

106. **Yellow Triangle** (Accabonac Creek Series). 1946
Oil on canvas
30 × 24 in. (76.2 × 60.9 cm)
Private collection, Los Angeles. OT 151

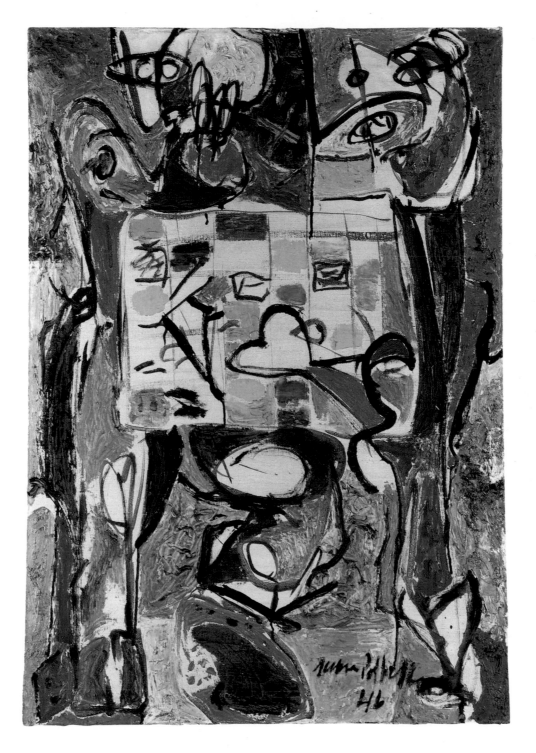

107. **The Tea Cup** (Accabonac Creek Series). 1946
Oil on canvas
40 × 28 in. (101.6 × 71.1 cm)
Collection Frieder Burda. OT 150

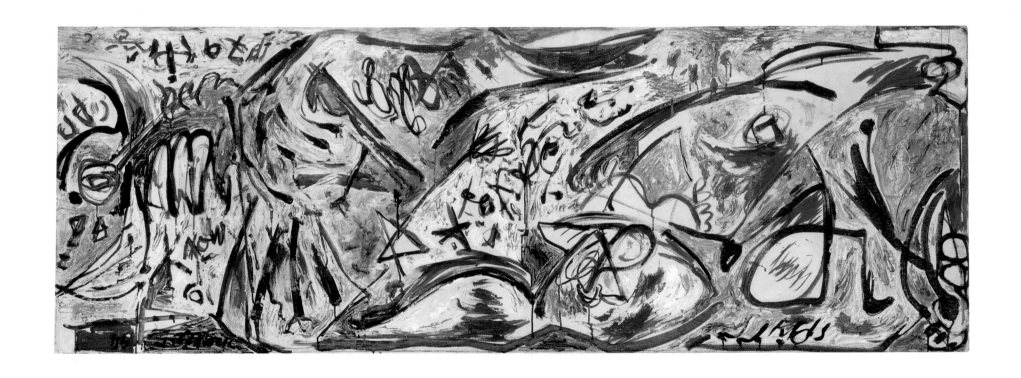

108. **The Water Bull** (Accabonac Creek Series). c. 1946
Oil on canvas
30⅛ × 6 ft. 11⅞ in. (76.5 × 213 cm)
Stedelijk Museum, Amsterdam. OT 149

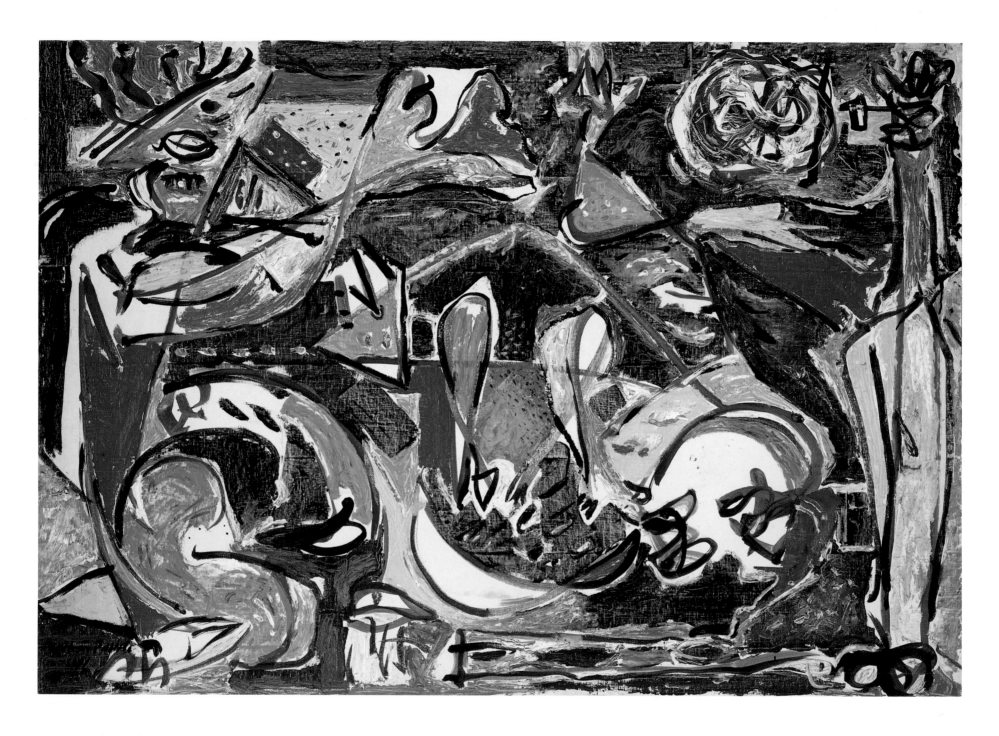

109. **The Key** (Accabonac Creek Series). 1946
Oil on canvas
59 in. × 7 ft. (149.8 × 213.3 cm)
The Art Institute of Chicago. Through prior gift
of Mr. and Mrs. Edward Morris. OT 156

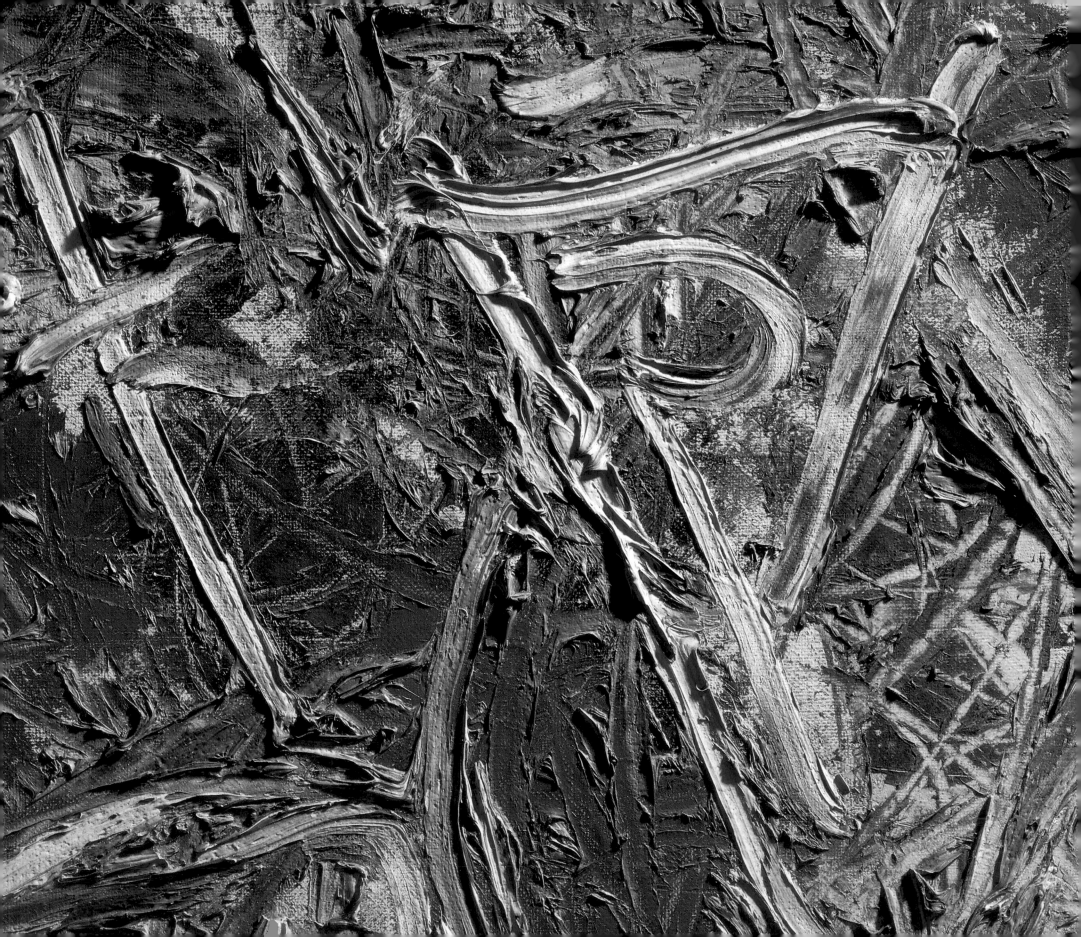

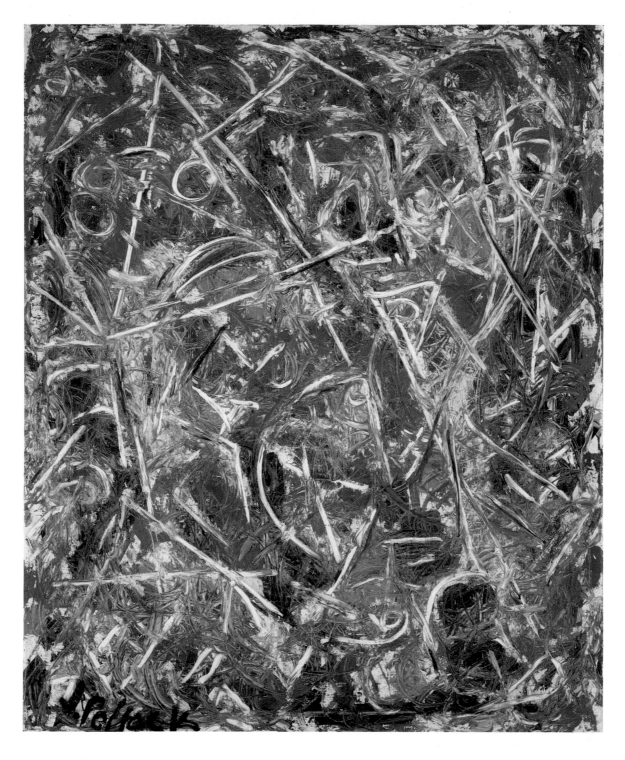

OPPOSITE (DETAIL) AND ABOVE
110 and 111. **Croaking Movement** (Sounds in the Grass Series). 1946
Oil on canvas
54 × 44⅛ in. (137 × 112.1 cm)
Peggy Guggenheim Collection, Venice. The Solomon R. Guggenheim Foundation, New York. OT 161

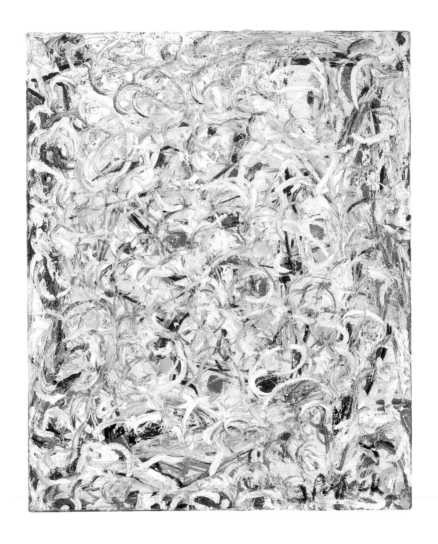

112. **Shimmering Substance** (Sounds in the Grass Series). 1946
Oil on canvas
30⅛ × 24¼ in. (76.3 × 61.6 cm)
The Museum of Modern Art, New York.
Mr. and Mrs. Albert Lewin and Mrs. Sam A. Lewisohn Funds. OT 164

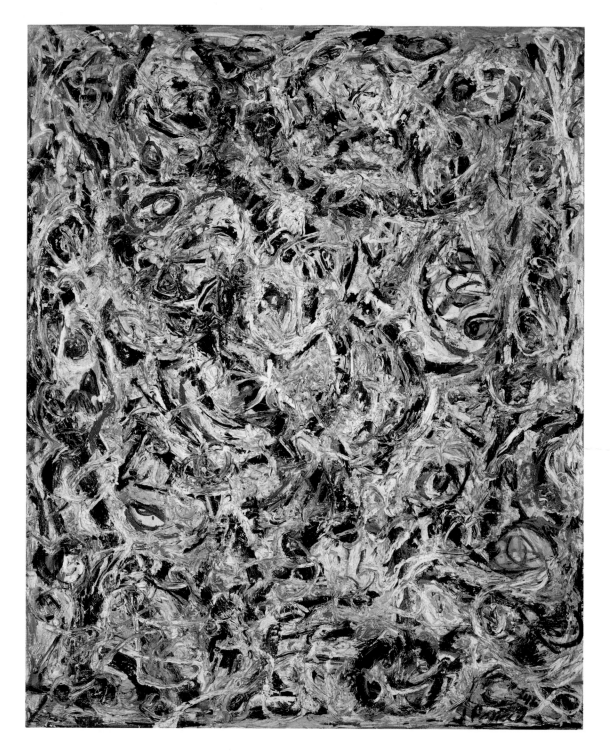

113. **Eyes in the Heat** (Sounds in the Grass Series). 1946
Oil on canvas
54 × 43 in. (137.2 × 109.2 cm)
Peggy Guggenheim Collection, Venice. The Solomon R.
Guggenheim Foundation, New York. OT 162

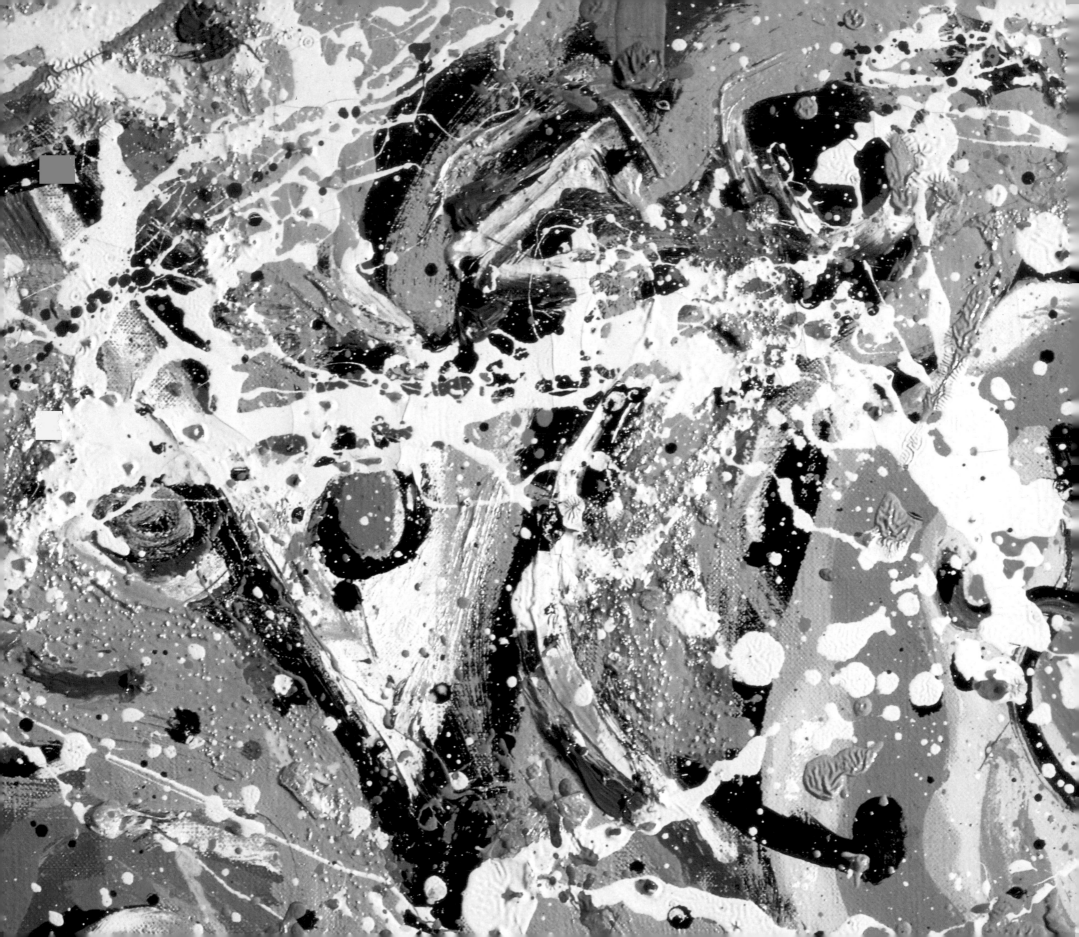

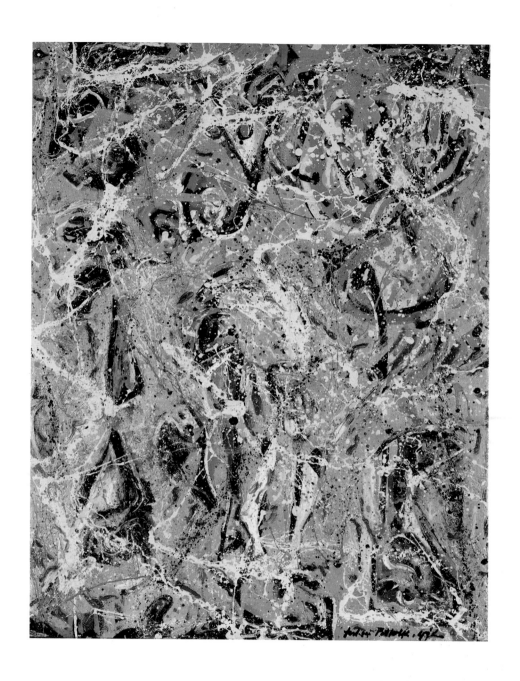

OPPOSITE (DETAIL) AND ABOVE
114 and 115. **Galaxy**. 1947
Oil, aluminum paint, and small gravel on canvas
43½ × 34 in. (110.4 × 86.3 cm)
Joslyn Art Museum, Omaha, Nebraska.
Gift of Miss Peggy Guggenheim. OT 169

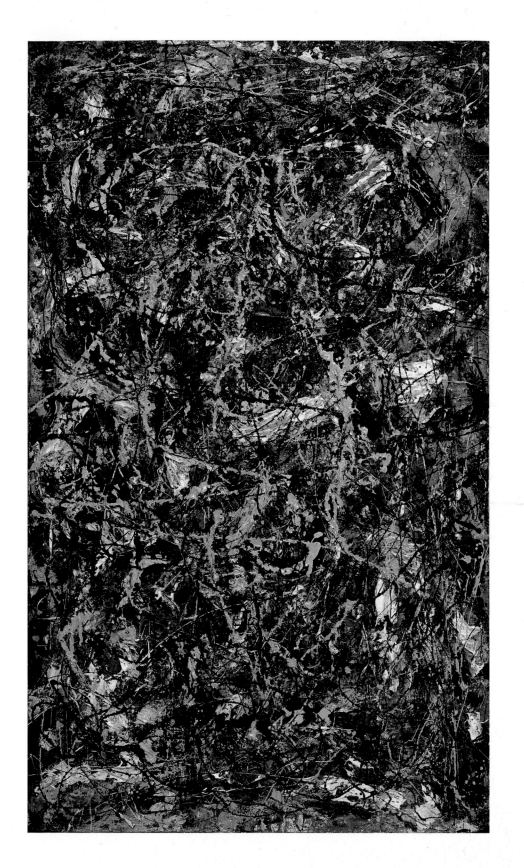

116 and 117. **Full Fathom Five**. 1947
Oil on canvas with nails, tacks, buttons,
key, coins, cigarettes, matches, etc.
50⅞ × 30⅛ in. (129.2 × 76.5 cm)
The Museum of Modern Art, New York.
Gift of Miss Peggy Guggenheim. OT 180

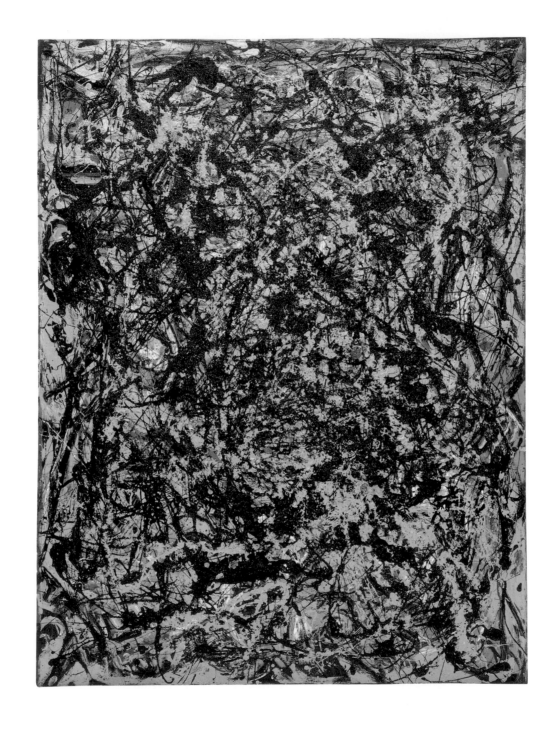

118. **Sea Change**. 1947
Collage of oil and small pebbles on canvas
55⅞ × 44⅛ in. (141.9 × 112.1 cm)
The Seattle Art Museum.
Gift of Miss Peggy Guggenheim. OT 177

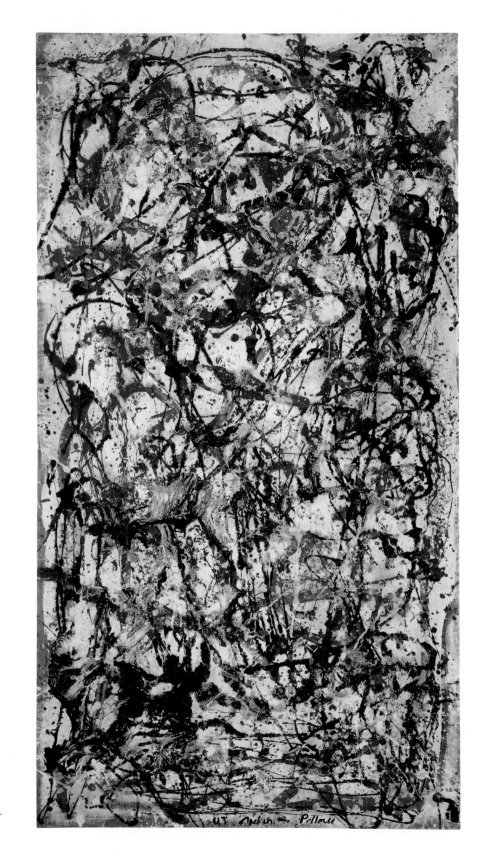

119. Enchanted Forest. 1947
Oil on canvas
7 ft. 3⅛ in. × 45⅛ in. (221.3 × 114.6 cm)
Peggy Guggenheim Collection, Venice. The Solomon R.
Guggenheim Foundation, New York. OT 173

223

120 and 121. **Cathedral**. 1947
Enamel and aluminum paint on canvas
71½ × 35¹⁄₁₆ in. (181.6 × 89 cm)
Dallas Museum of Art.
Gift of Mr. and Mrs. Bernard J. Reis. OT 184

225

122. **Phosphorescence**. 1947
Oil, enamel, and aluminum paint on canvas
44 × 28 in. (111.8 × 71.1 cm)
Addison Gallery of American Art, Phillips Academy, Andover,
Massachusetts. Gift of Mrs. Peggy Guggenheim. OT 183

123. **Reflection of the Big Dipper**. 1947
Oil on canvas
43¾ × 36³⁄₁₆ in. (111 × 92 cm)
Stedelijk Museum, Amsterdam. OT 175

126. **Alchemy**. 1947
Oil, enamel, aluminum paint, and
string on canvas
45⅛ in. × 7 ft. 3⅛ in. (114.6 × 221.3 cm)
Peggy Guggenheim Collection, Venice.
The Solomon R. Guggenheim
Foundation, New York. OT 179

OPPOSITE (DETAIL) AND ABOVE
124 and 125. **Lucifer**. 1947. Oil, enamel, and aluminum paint on canvas.
41 in. × 8 ft. 9½ in. (104.1 × 267.9 cm). Collection Harry W. and Mary Margaret Anderson. OT 185

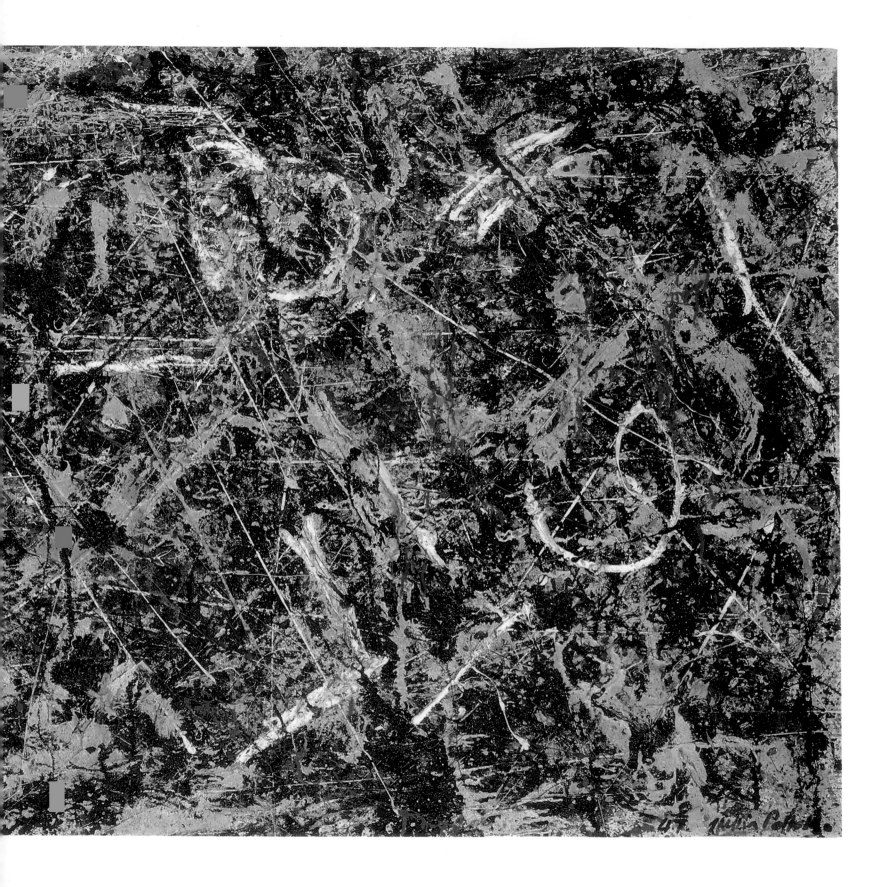

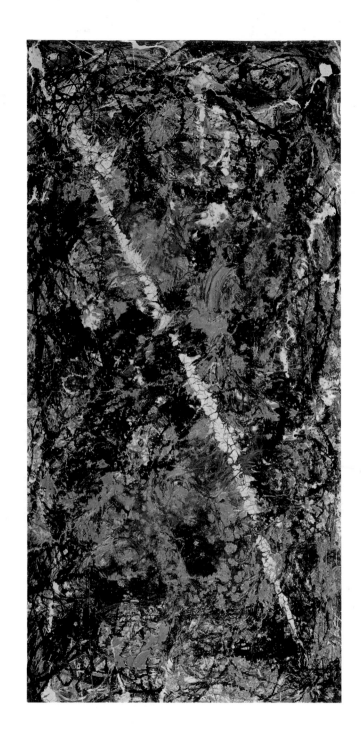

127. **Comet**. 1947
Oil on canvas
37⅛ × 17⅞ in. (94.3 × 45.4 cm)
Wilhelm-Hack-Museum, Ludwigshafen
am Rhein, Germany. OT 181

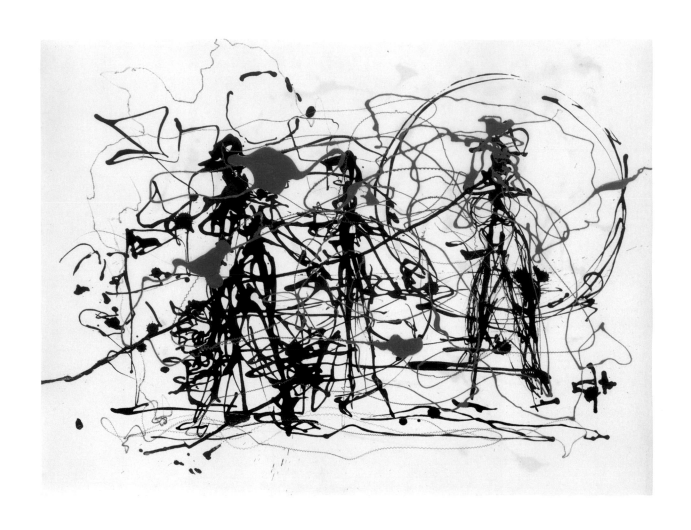

128. **Untitled**. c. 1948–49
Dripped ink and enamel on paper
22⅛ × 30 in. (56.8 × 76.2 cm)
The Metropolitan Museum of Art, New York.
Gift of Lee Krasner Pollock, 1982. OT 786

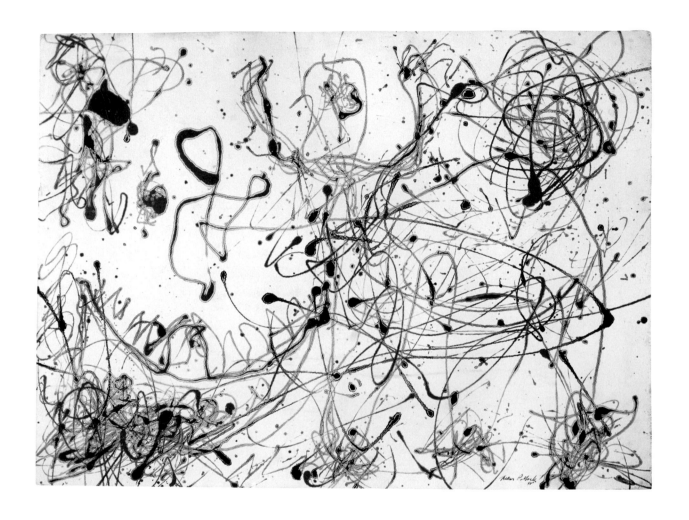

129. **Number 4, 1948: Gray and Red**. 1948
Oil and gesso on paper
22⅜ × 30⅞ in. (57.4 × 78.4 cm)
Estate of Frederick R. Weisman. OT 202

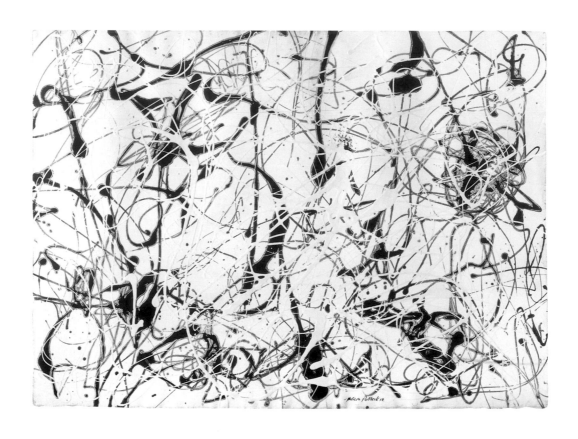

130. **Number 23, 1948**. 1948
Enamel on cardboard
22⅝ × 30⅞ in. (57.5 × 78.5 cm)
Tate Gallery, London. Presented by the Friends of the Tate Gallery (purchased out of
funds provided by Mr. and Mrs. H. J. Heinz II and H. J. Heinz Co., Ltd., 1960). OT 199

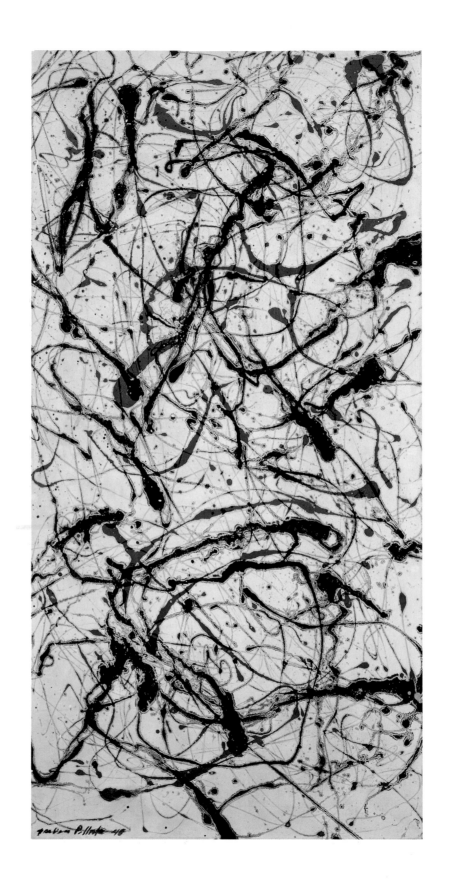

131. **Number IIA, 1948 (Black, White and Gray)**. 1948
Oil, enamel, and aluminum paint on canvas
66 × 33 in. (167.6 × 83.8 cm)
Private collection. OT 203

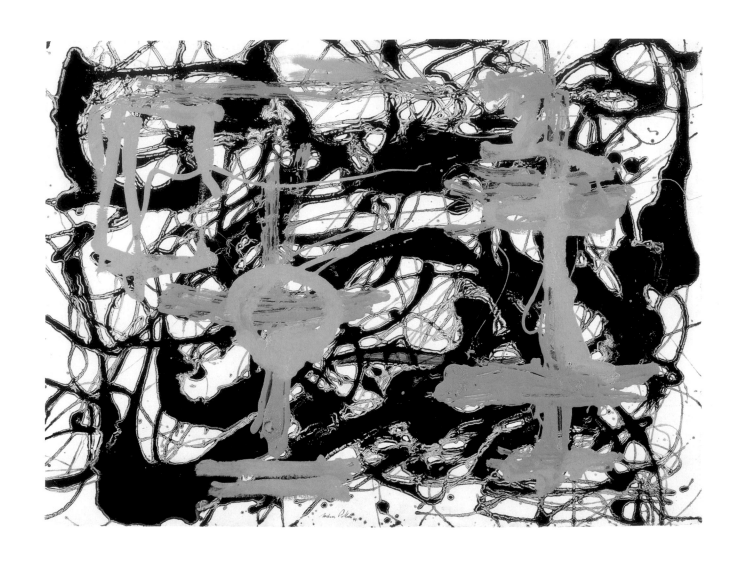

132. **Number 12A, 1948: Yellow, Gray, Black**. 1948
Enamel on gesso on paper
22½ × 30⅝ in. (57.2 × 77.8 cm)
Collection Mr. and Mrs. Stanley R. Gumberg, Pittsburgh. OT 200

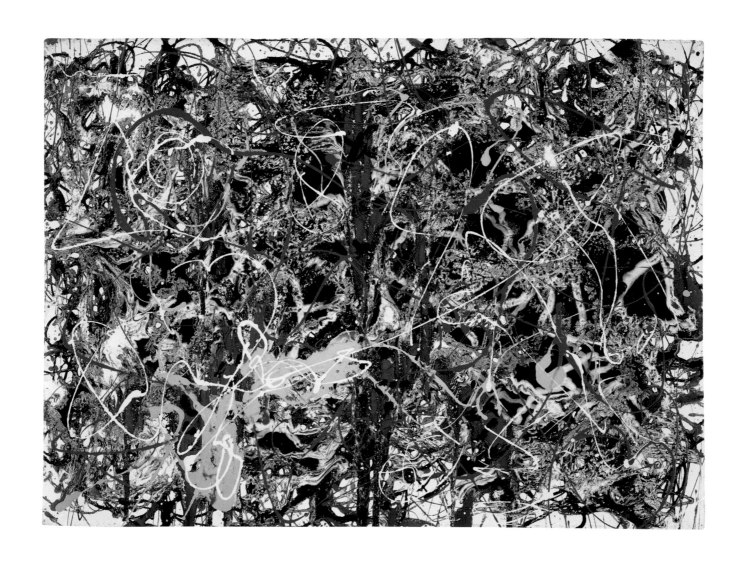

133. **Number 6, 1948: Blue, Red, Yellow**. 1948
Oil and enamel on paper, mounted on canvas
22½ × 30⅝ in. (57.2 × 77.8 cm)
Private collection. OT 209

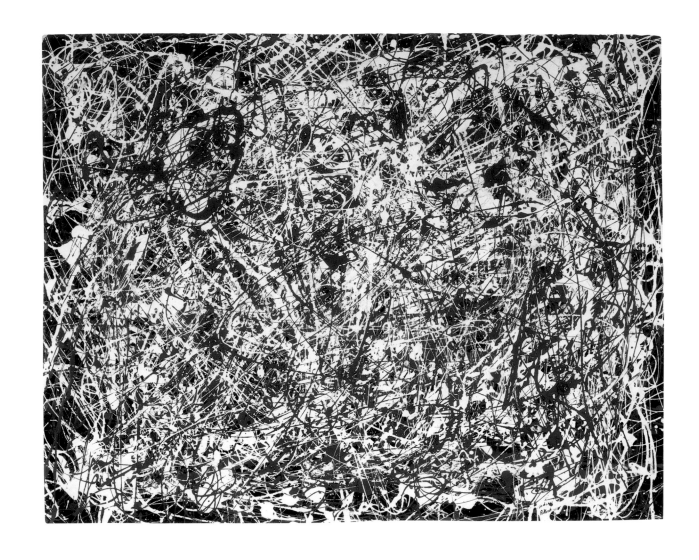

134. **Number 20, 1948**. 1948
Enamel on paper
20½ × 26 in. (52 × 66 cm)
Munson-Williams-Proctor Institute Museum of Art,
Utica, New York. Edward W. Root Bequest. OT 191

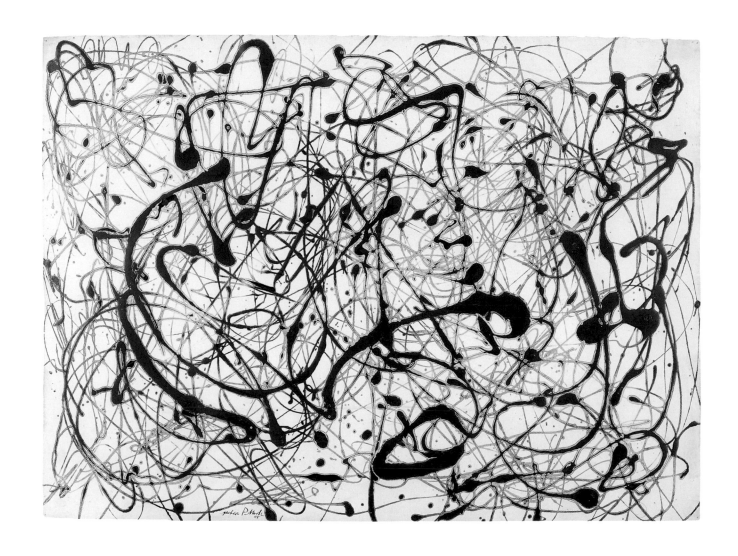

135. **Number 14, 1948**. 1948
Enamel on gesso on paper
22¾ × 31 in. (57.8 × 78.8 cm)
Yale University Art Gallery, New Haven, Connecticut.
The Katherine Ordway Collection. OT 204

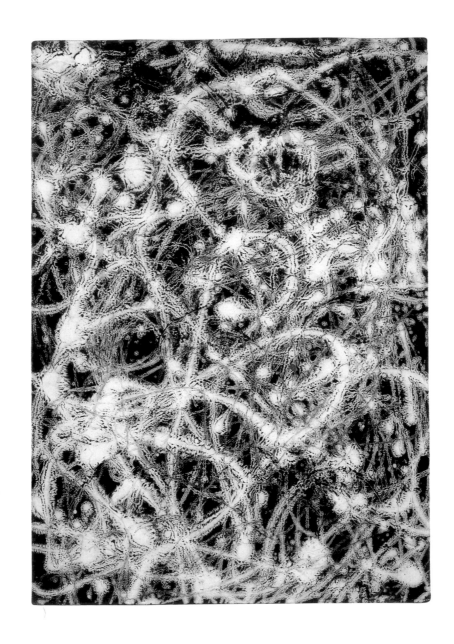

136. **Untitled (White on Black I)**. c. 1948
Oil on canvas
24⅛ × 17¼ in. (61.2 × 43.8 cm)
Private collection. OT 215

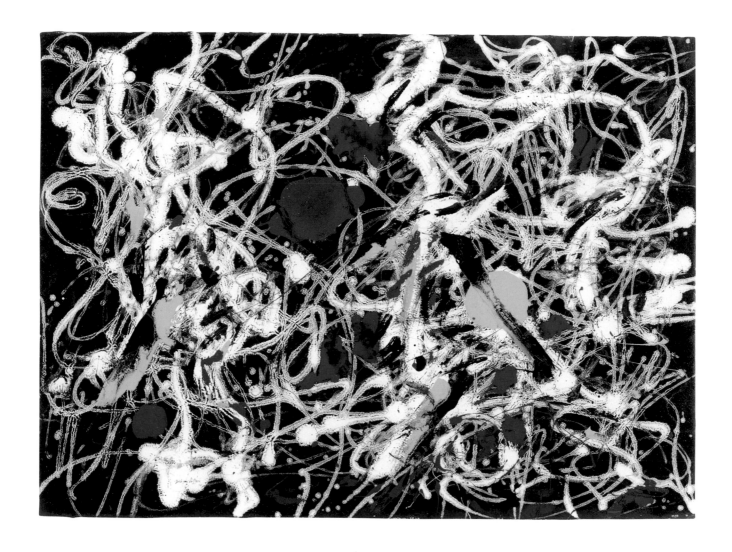

137. **Number 15, 1948: Red, Gray, White, Yellow**. 1948
Enamel on paper
22¼ × 30½ in. (56.5 × 77.5 cm)
Virginia Museum of Fine Arts, Richmond.
Gift of Mr. Arthur S. Brinkley, Jr. OT 196

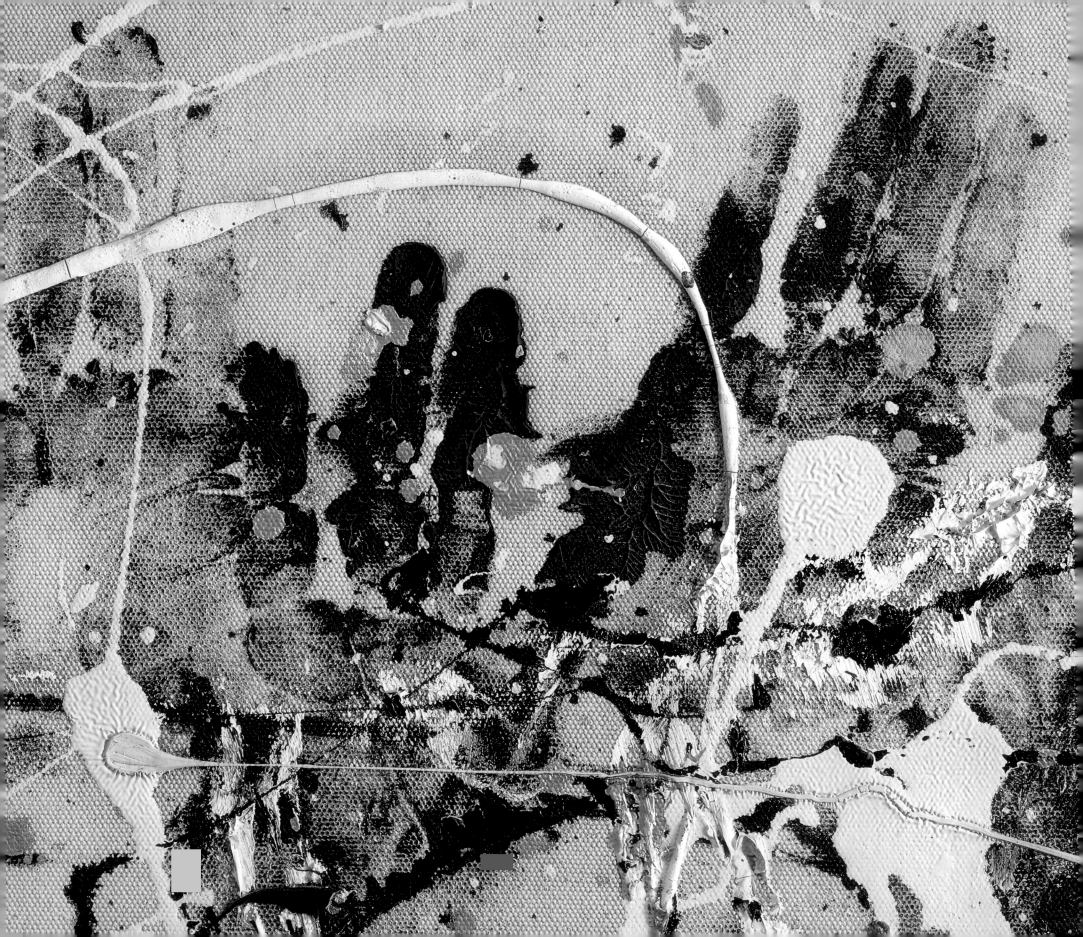

140. **White Cockatoo: Number 24A, 1948**. 1948
Enamel and oil on canvas
35 in. × 9 ft. 6 in. (88.9 × 289.5 cm)
Private collection. OT 194

243

OPPOSITE (DETAIL) AND RIGHT
138 and 139. **Number IA, 1948**. 1948
Oil and enamel on canvas
68 in. × 8 ft. 8 in. (172.7 × 264.2 cm)
The Museum of Modern Art, New York.
Purchase. OT 186

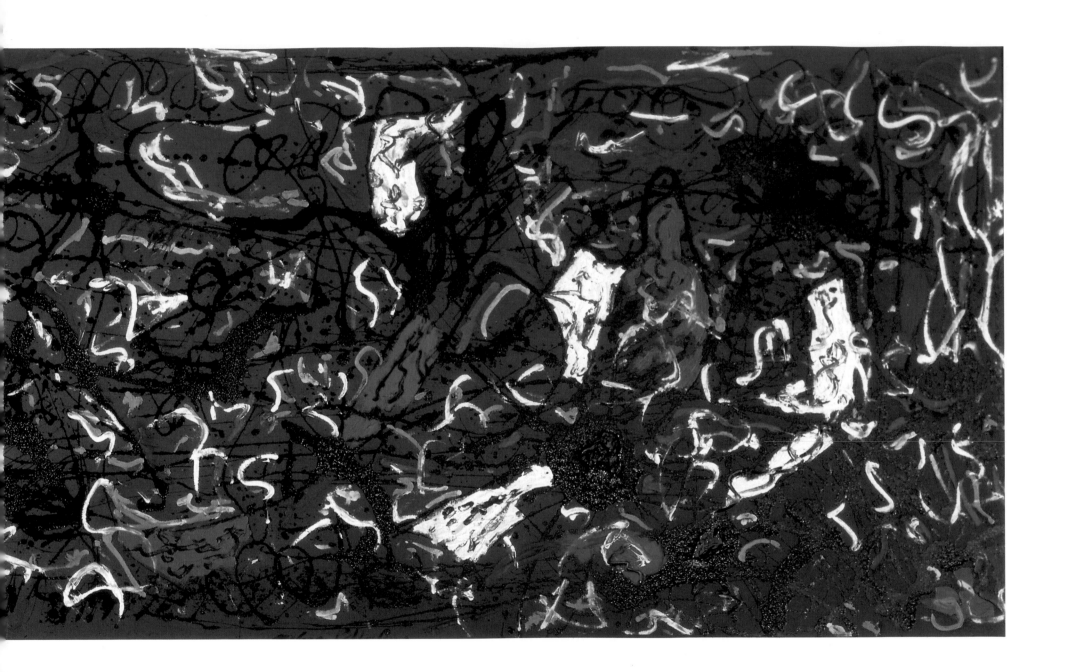

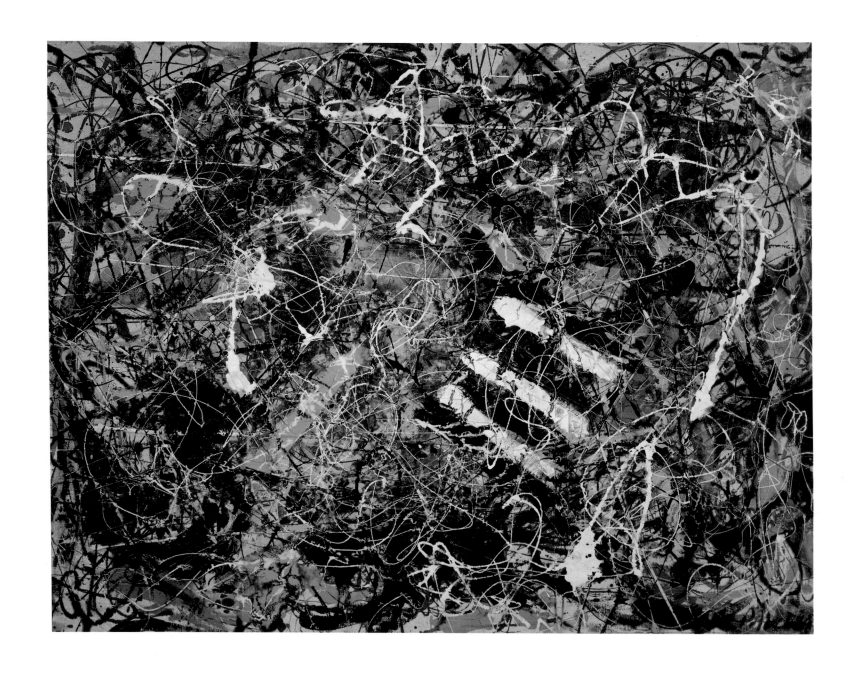

141. **Number 17A, 1948**. 1948
Oil on canvas
34¹⁄₁₆ × 44⅛ in. (86.5 × 112 cm)
Collection David Geffen, Los Angeles. OT 211

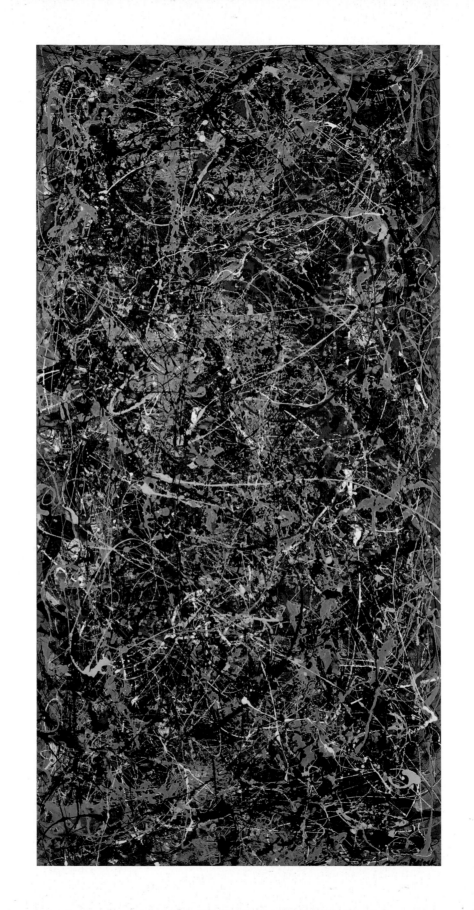

142 and 143. **Number 5, 1948**. 1948
Oil, enamel, and aluminum paint on fiberboard
96 in. × 48 in. (243.8 × 121.9 cm)
Collection David Geffen, Los Angeles. OT 188

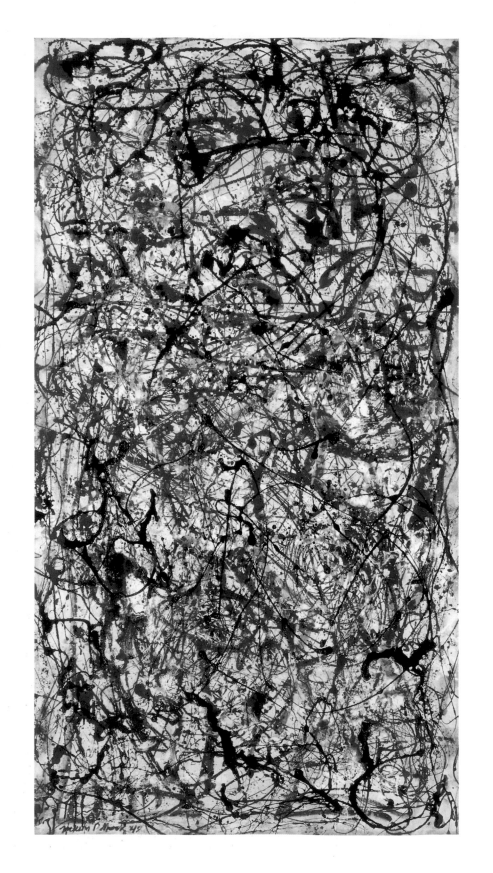

144. **Number 26A, I948: Black and White**. 1948
Enamel on canvas
6 ft. 9⅛ in. × 47⅞ in. (208 × 121.7 cm)
Musée national d'art moderne, Centre de Création
Industrielle, Centre Georges Pompidou, Paris. OT 187

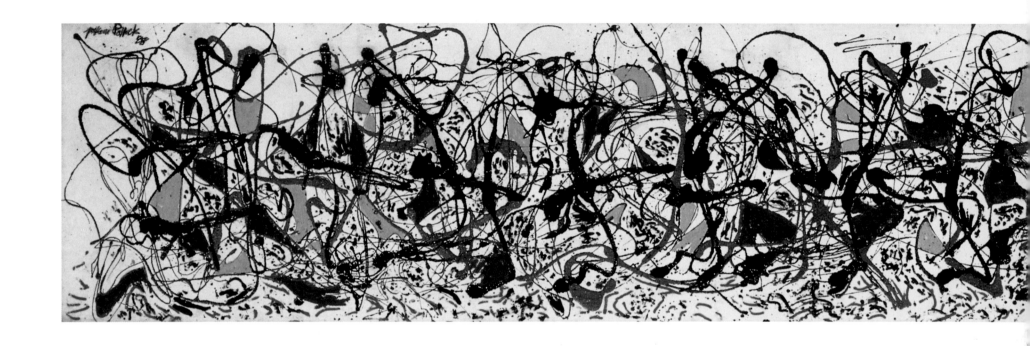

146. **Summertime: Number 9A, I948**. 1948
Oil and enamel on canvas
33¼ in. × 18 ft. 2 in. (84.5 × 549.5 cm)
Tate Gallery, London. Purchased 1988. OT 205

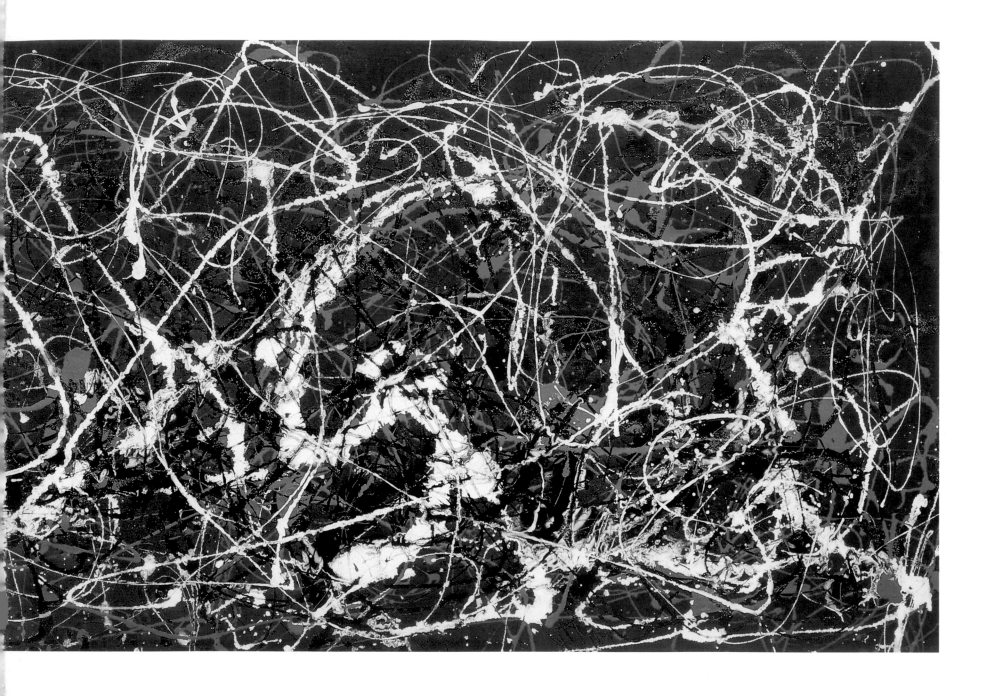

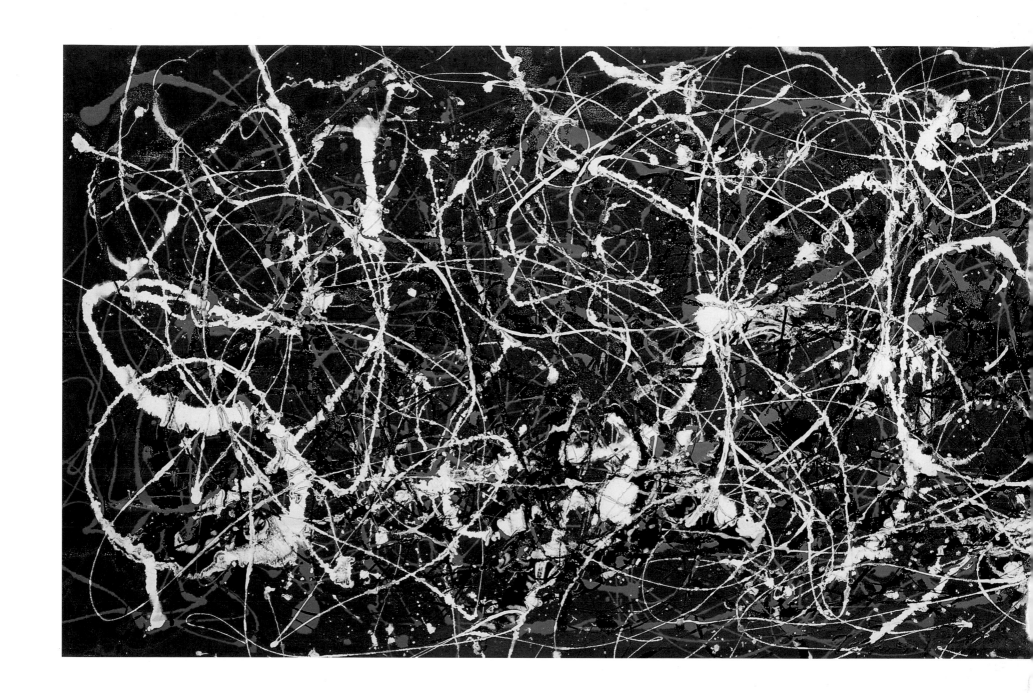

145. **Number 13A, 1948: Arabesque**. 1948
Oil and enamel on canvas
37¼ × 9 ft. 8½ in. (94.6 × 295.9 cm)
Yale University Art Gallery, New Haven, Connecticut.
Gift of Richard Brown Baker, B.A. 1935. OT 217

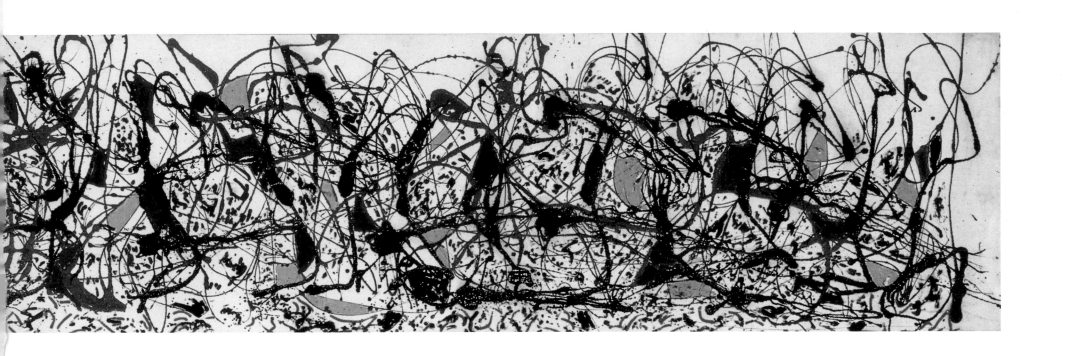

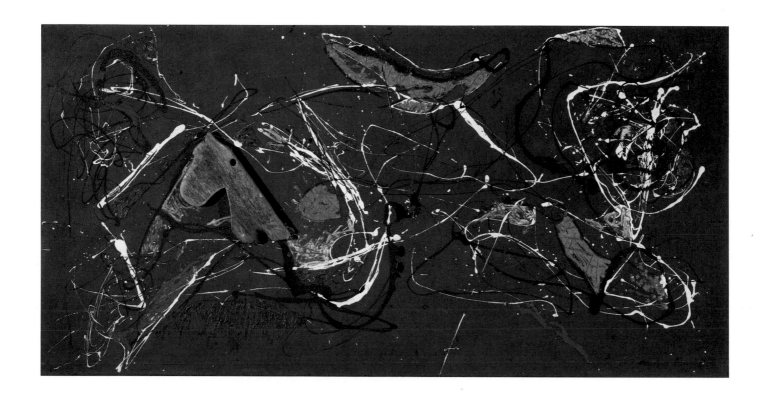

147. **The Wooden Horse: Number IOA, I948**. 1948
Oil, enamel, and wood hobbyhorse head on brown cotton
canvas, mounted on fiberboard
35½ in. × 6 ft. 3 in. (90.1 × 190.5 cm)
Moderna Museet, Stockholm. OT 207

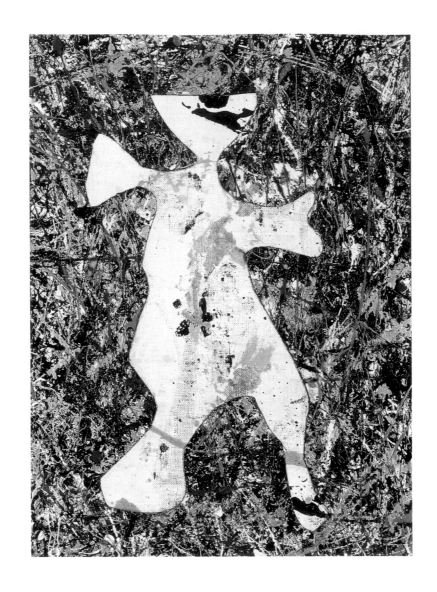

148. **Untitled (Cut-Out)**. c. 1948–50
Oil, enamel, aluminum paint, and
mixed mediums on cardboard and canvas
30½ × 23½ in. (77.3 × 57 cm)
Ohara Museum of Art, Kurashiki, Japan. OT 1030

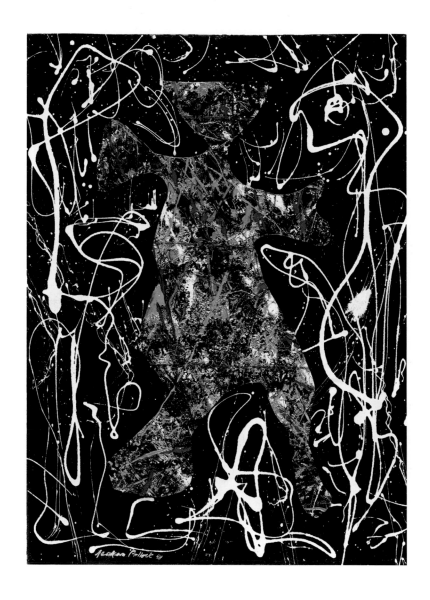

149. **Untitled (Cut-Out Figure)**. 1948
Enamel, aluminum, and oil paint, glass, and nails
on cardboard and paper, mounted on fiberboard
31 × 22⅝ in. (78.8 × 57.5 cm)
Private collection, Canada. OT 1031

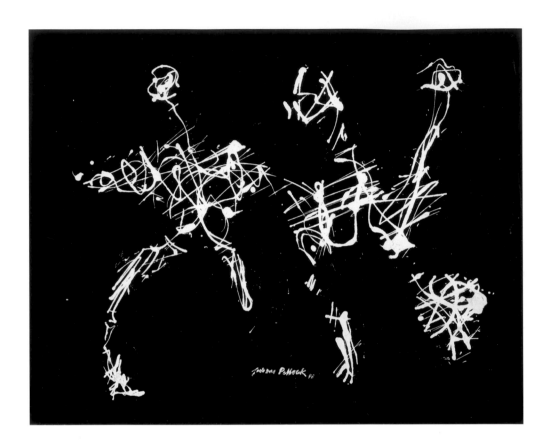

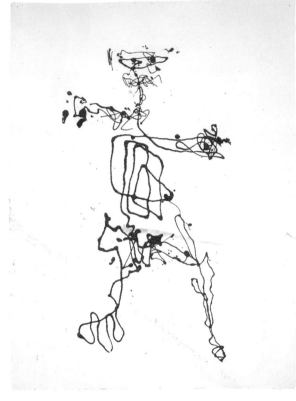

150. **Triad**. 1948
Oil and enamel on paper, mounted on fiberboard
20½ × 25¾ in. (52 × 65.4 cm)
Collection Art Enterprises, Ltd., Chicago. OT 198

151. **Figure**. 1948 (OT: c. 1948–49)
Enamel on paper
30⅞ × 22⅜ in. (78.5 × 57.5 cm)
Städelsches Kunstinstitut und Städtische
Galerie, Frankfurt. OT 783

254

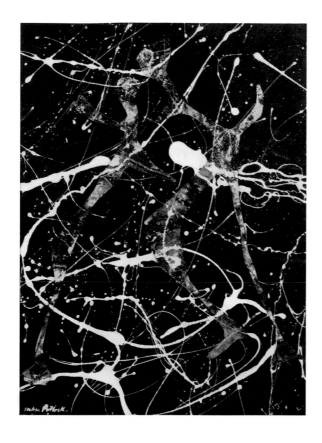

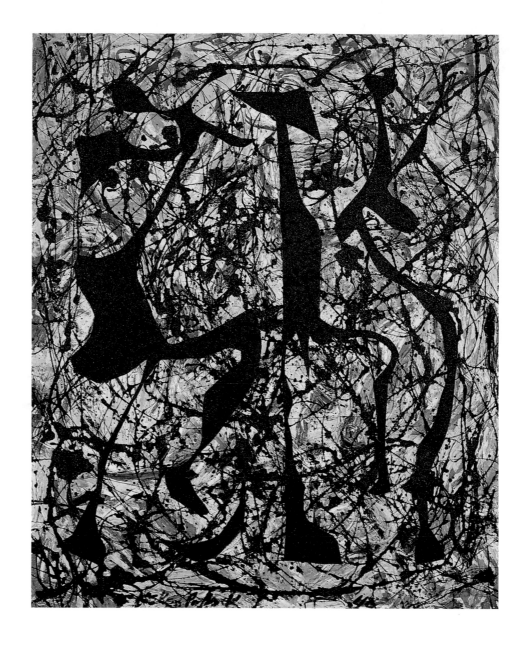

152. **Untitled**. c. 1948
Oil and enamel on canvas and paper,
mounted on fiberboard
31 × 23 in. (78.7 × 58.4 cm)
Private collection. OT 1033

153. **Untitled (Shadows: Number 2, 1948)**. 1948
Oil and paper cut-out on canvas
55¾ × 44 in. (136.5 × 111.8 cm)
Private collection. OT 1034

156. **Number 2, 1949**. 1949
Oil, enamel, and aluminum paint on canvas
38⅛ in. × 15 ft. 9½ in. (96.8 × 481.3 cm)
Munson-Williams-Proctor Institute Museum of Art, Utica, New York. OT 222

OPPOSITE (DETAIL) AND RIGHT
154 and 155. **Out of the Web: Number 7, 1949**. 1949
Oil and enamel on fiberboard
48 in. × 8 ft. (121.5 × 244 cm)
Staatsgalerie Stuttgart. OT 251

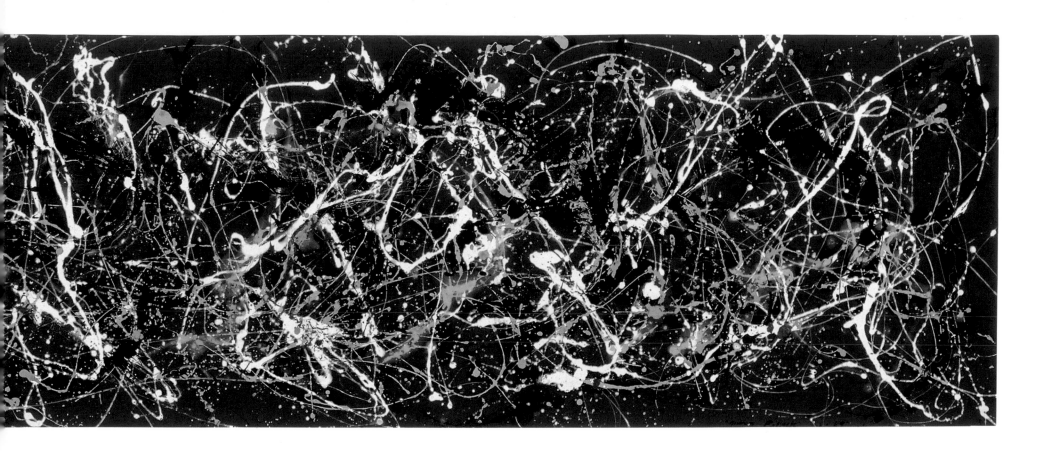

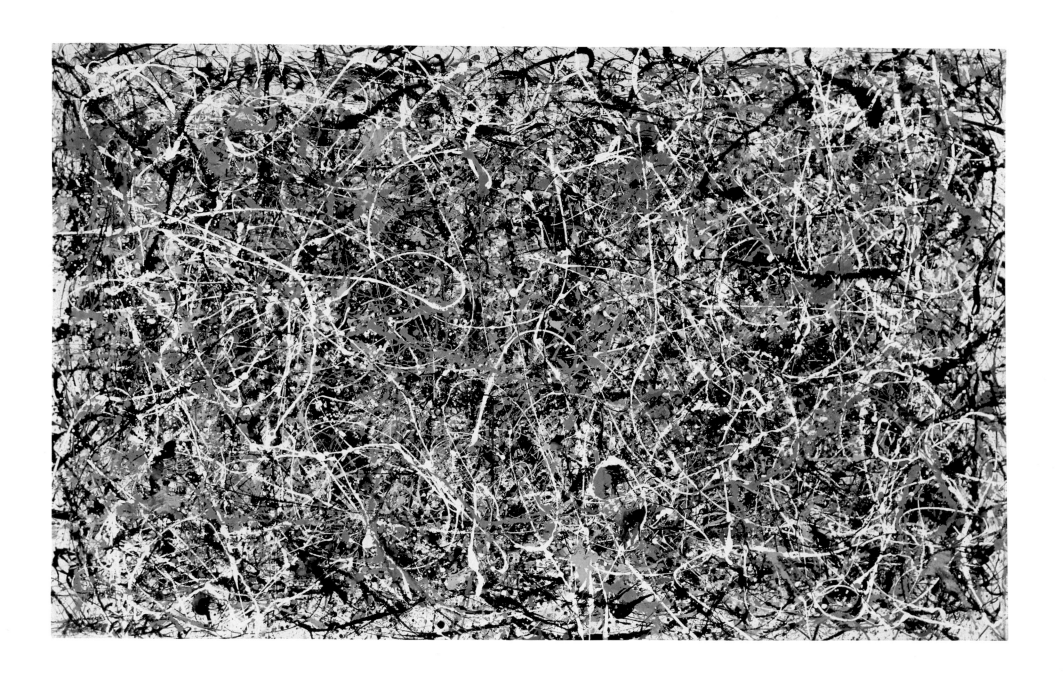

157. **Number 1, 1949**. 1949
Enamel and aluminum paint on canvas
63 in. × 8 ft. 6 in. (160 × 259 cm)
The Museum of Contemporary Art, Los Angeles. The Rita and Taft Schreiber Collection.
Given in loving memory of her husband, Taft Schreiber, by Rita Schreiber. OT 252

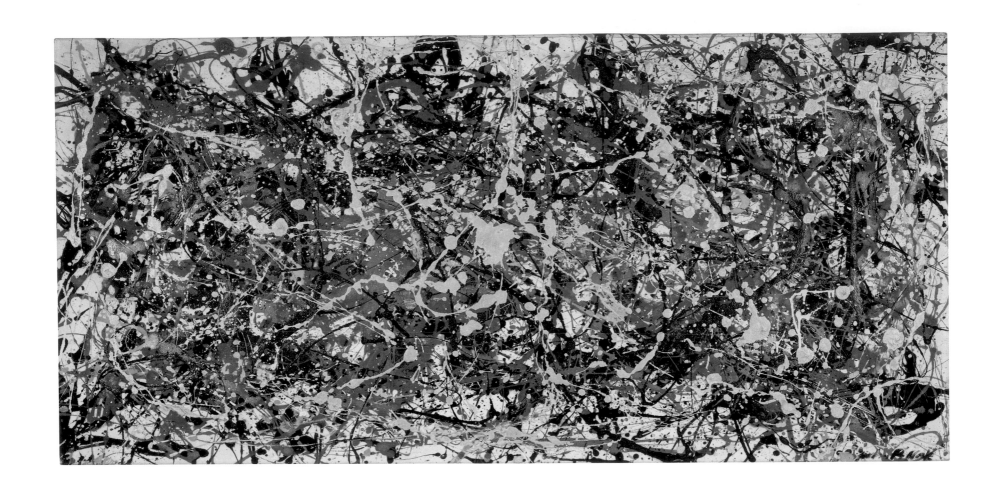

158. **Number 8, 1949**. 1949
Oil, enamel, and aluminum paint on canvas
34⅛ × 71¼ in. (86.6 × 180.9 cm)
Neuberger Museum of Art, Purchase College,
State University of New York. Gift of Roy R. Neuberger. OT 239

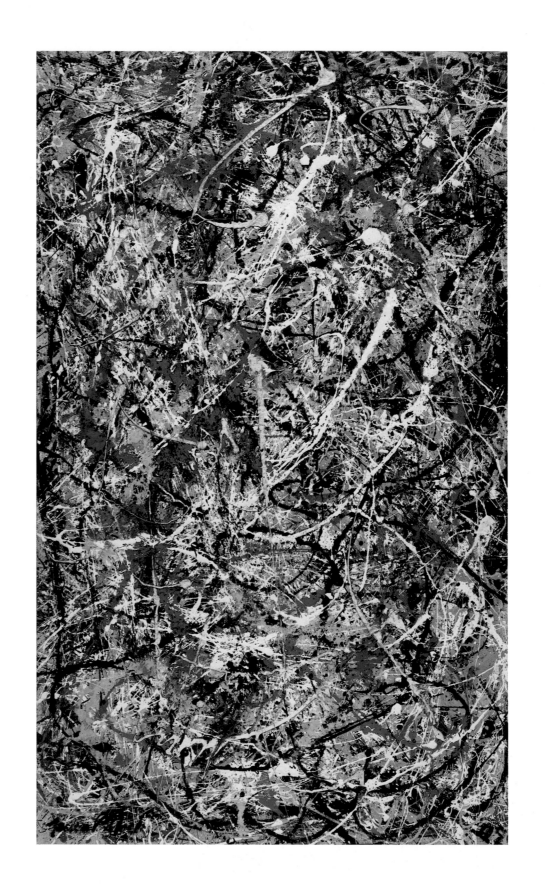

159. **Number 3, 1949: Tiger**. 1949
Oil, enamel, aluminum paint, string, and cigarette
fragment on canvas, mounted on fiberboard
62 × 37¼ in. (157.5 × 94.6 cm)
Hirshhorn Museum and Sculpture Garden,
Smithsonian Institution, Washington, D.C. Gift of
the Joseph H. Hirshhorn Foundation, 1972. OT 250

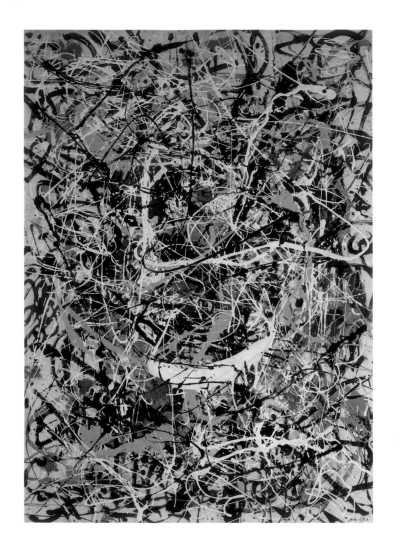

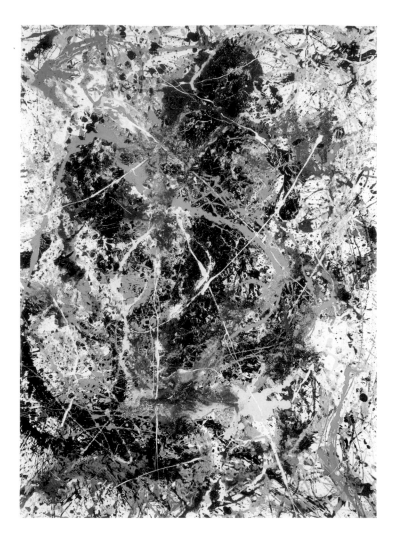

160. **Number 19, 1949**. 1949
Enamel on paper mounted on fiberboard
31 × 22⅝ in. (78.7 × 57.4 cm)
Private collection. OT 229

161. **Number 31, 1949**. 1949
Oil, enamel, and aluminum paint on gesso
on paper, mounted on fiberboard
30¼ × 22⅛ in. (76.8 × 56.1 cm)
Private collection. OT 242

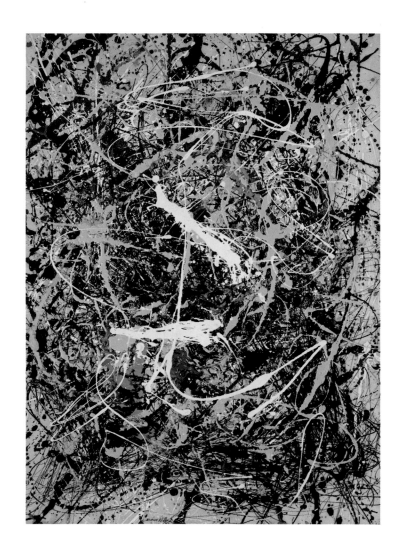

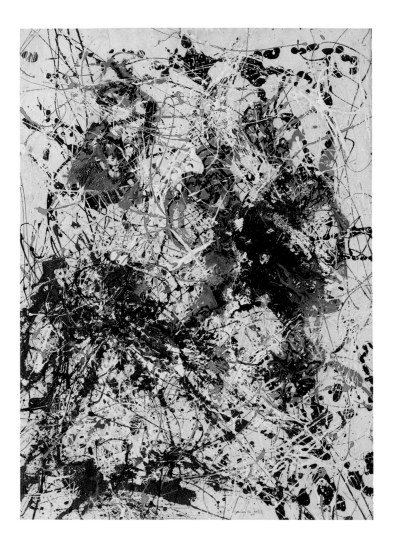

162. **Number 30, 1949: "Birds of Paradise."** 1949
Oil, enamel, and aluminum paint on paper,
mounted on fiberboard
30¾ × 22½ in. (78.1 × 57.1 cm)
Collection Adriana and Robert Mnuchin. OT 237

163. **Number 12, 1949**. 1949
Enamel on paper, mounted on fiberboard
31 × 22½ in. (78.8 × 57.1 cm)
The Museum of Modern Art, New York.
Gift of Edgar Kaufmann, Jr. OT 233

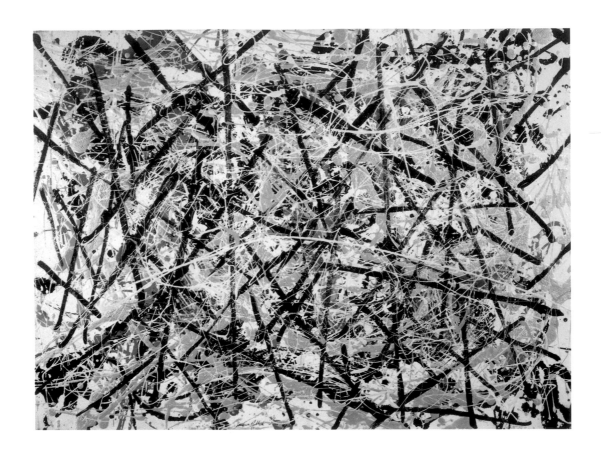

164. **Number 13, 1949**. 1949
Oil, enamel, and aluminum paint on gesso on
paper, mounted on fiberboard
22¾ × 30⅞ in. (57.7 × 78.4 cm)
Private collection. OT 231

OPPOSITE, LEFT
165. **Number 23, 1949**. 1949
Oil and enamel on canvas mounted
on fiberboard
26½ × 12⅛ in. (67.3 × 30.7 cm)
Collection Mr. and Mrs. Eugene V. Thaw. OT 223

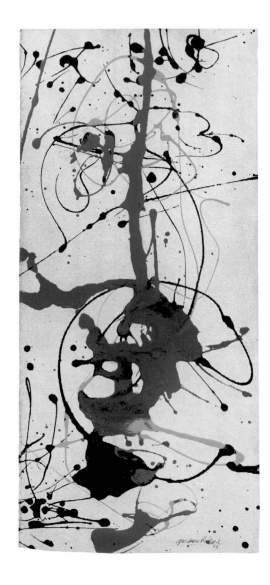

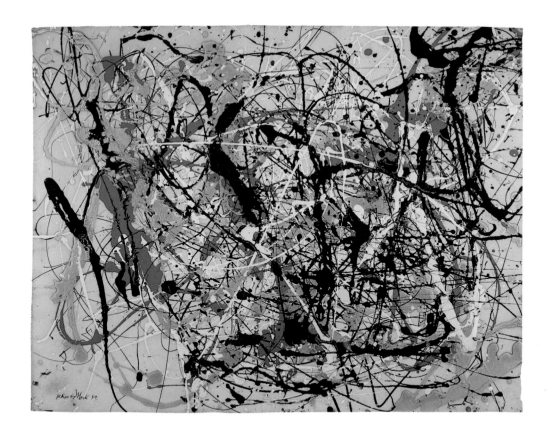

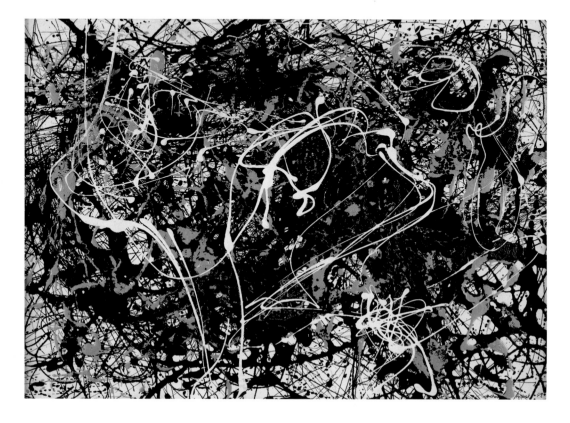

166. Number 17, 1949. 1949
Enamel and aluminum paint on paper,
mounted on fiberboard
22½ × 28½ in. (57.1 × 71.4 cm)
Private collection, New York. OT 243

BOTTOM RIGHT
167. Number 33, 1949. 1949
Enamel and aluminum paint on gesso
on paper, mounted on fiberboard
22½ × 31 in. (57.1 × 78.7 cm)
Private collection. OT 234

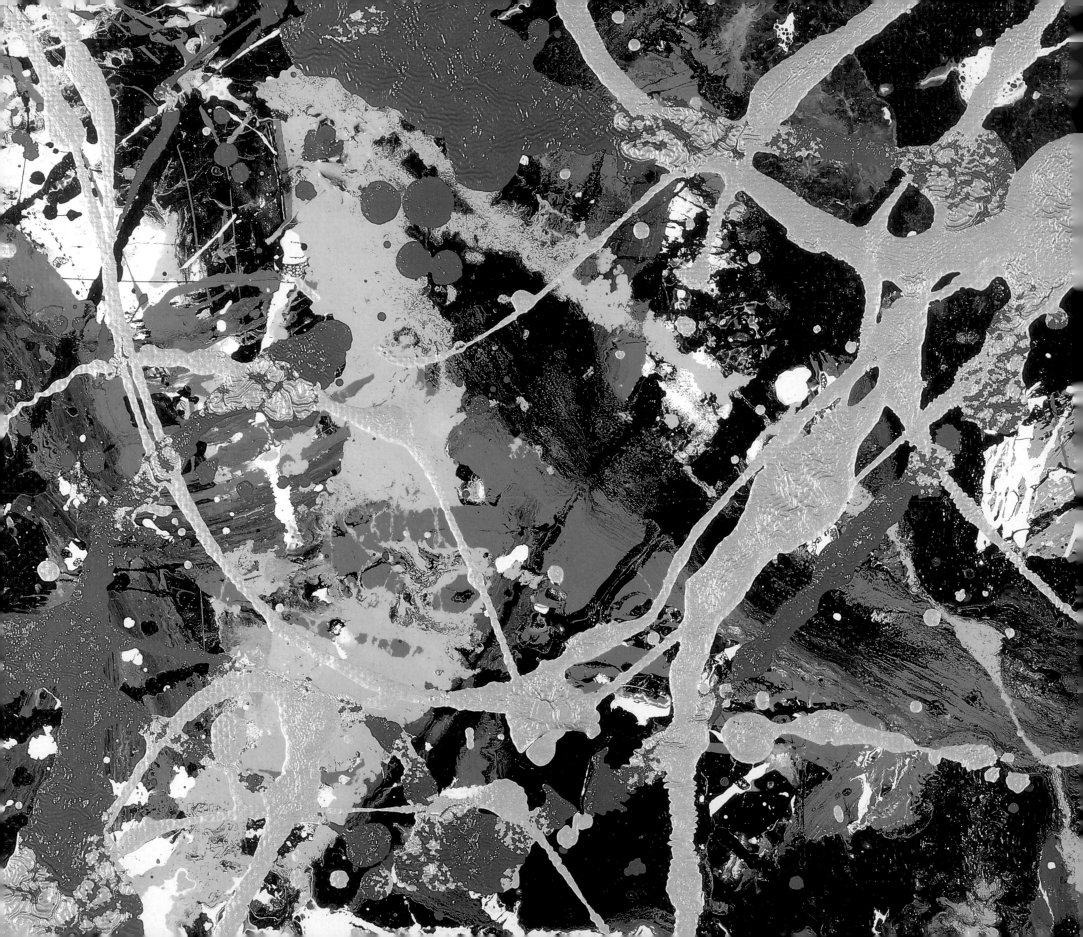

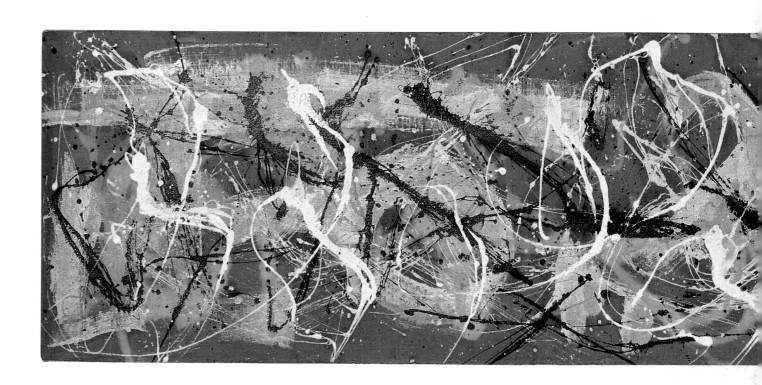

170. **Number 7, 1950**. 1950
Oil, enamel, and aluminum paint on canvas
23 in. × 9 ft. 1⅜ in. (58.5 × 277.8 cm)
The Museum of Modern Art, New York.
Gift of Sylvia Slifka in honor of William Rubin. OT 272

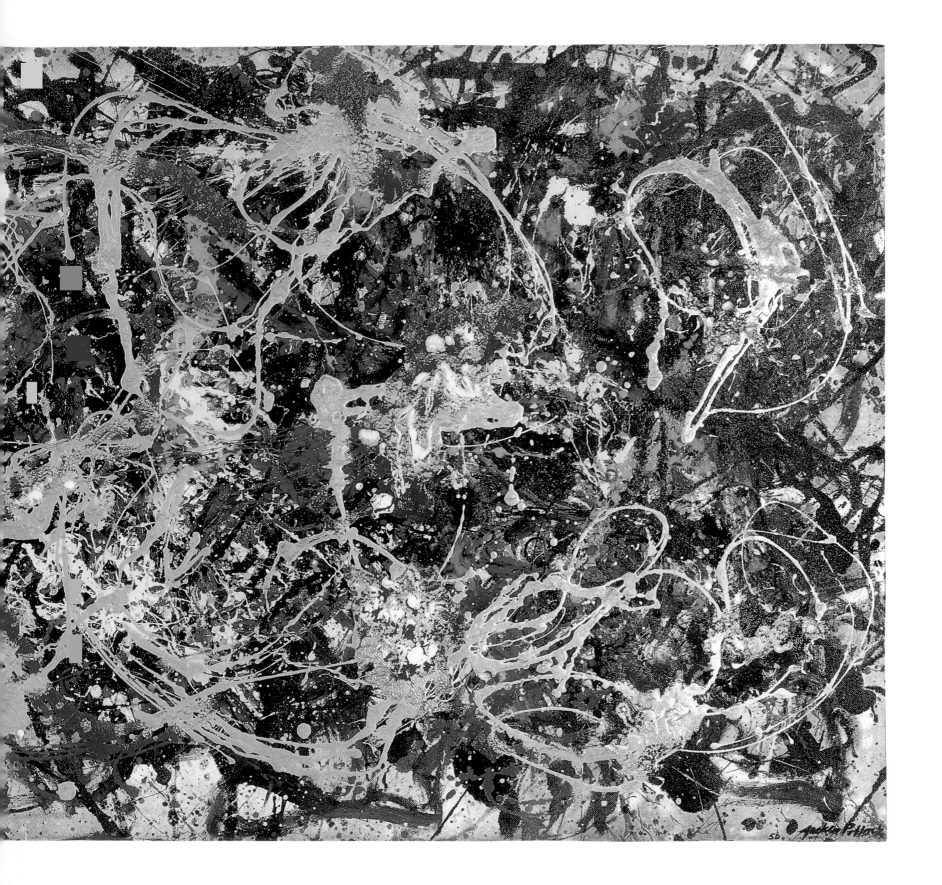

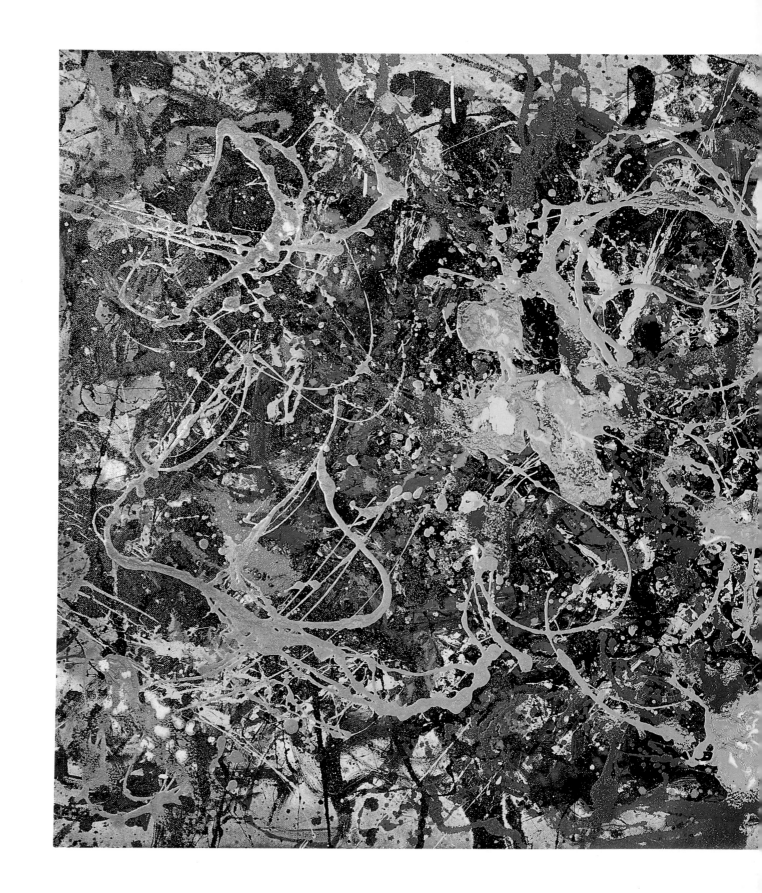

OPPOSITE (DETAIL) AND RIGHT
168 and 169. **Number 3, 1950**. 1950
Oil, enamel, and aluminum paint on fiberboard
48 in. × 8 ft. (121.9 × 243.8 cm)
Private collection. OT 269

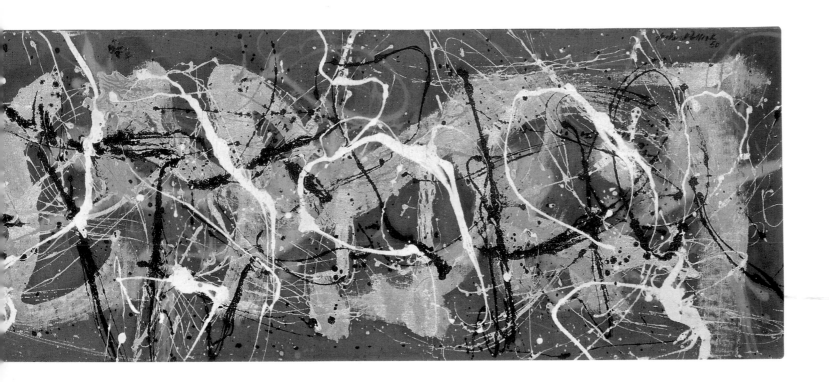

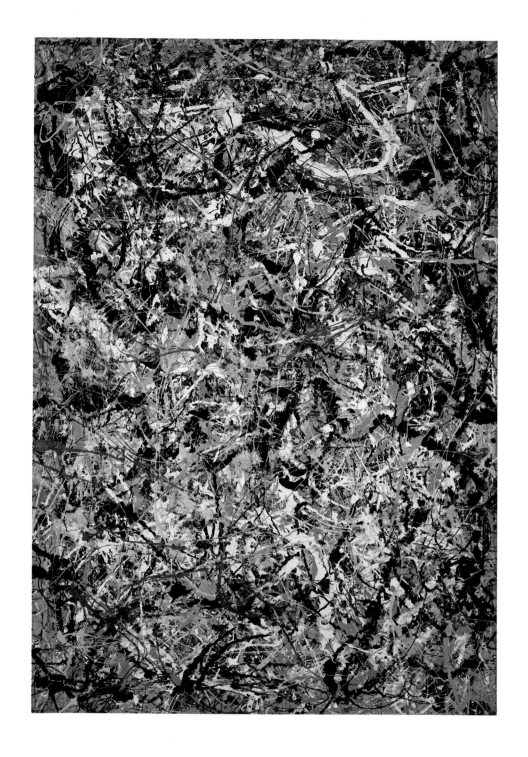

171. **Number 8, 1950**. 1950
Oil, enamel, and aluminum paint on canvas,
mounted on fiberboard
56⅛ × 39 in. (142.5 × 99 cm)
Collection David Geffen, Los Angeles. OT 265

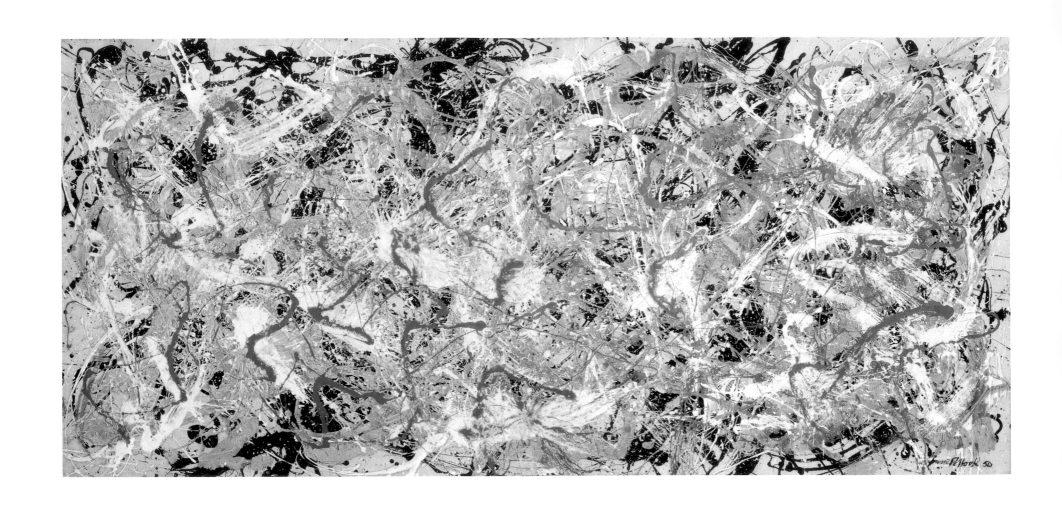

172. **Number 27, 1950**. 1950
Oil on canvas
49 in. × 8 ft. 10 in. (124.5 × 269.2 cm)
Whitney Museum of American Art, New York.
Purchase. OT 271

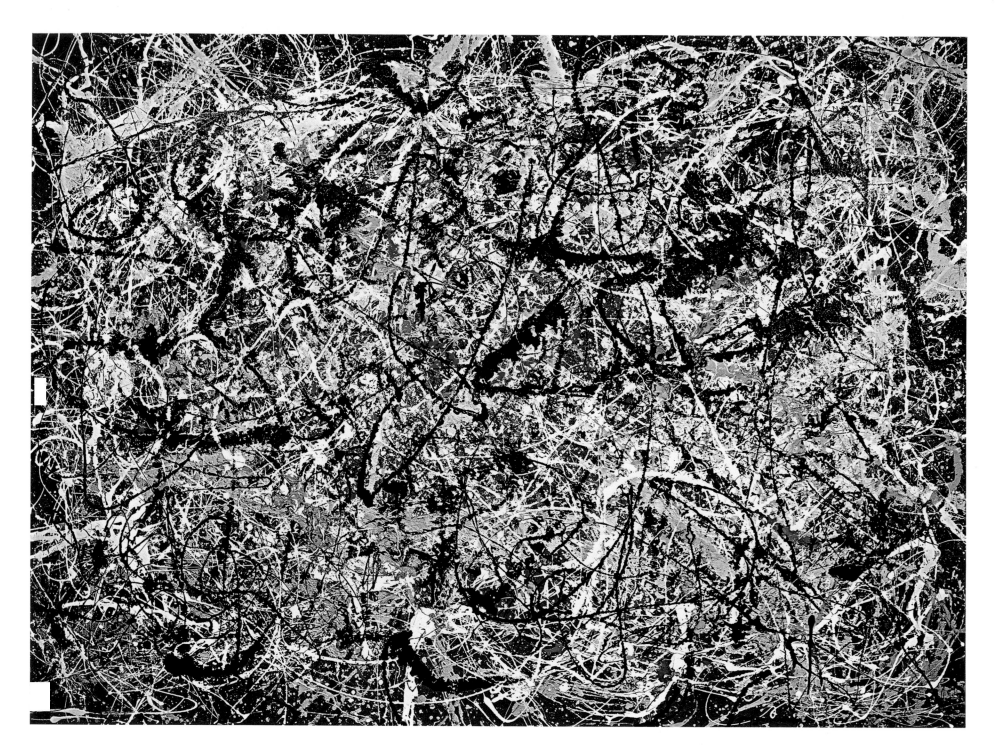

173. **Untitled (Mural)**. 1950
Oil, enamel, and aluminum paint
on canvas, mounted on wood
6 × 8 ft. (183 × 244 cm)
Teheran Museum of Art, Iran. OT 259

271

174 and 175. **Lavender Mist: Number 1, 1950**. 1950
Oil, enamel, and aluminum paint on canvas
7 ft. 3 in. × 9 ft. 10 in. (221 × 299.7 cm)
National Gallery of Art, Washington, D.C. Ailsa Mellon Bruce Fund. OT 264

176. **Number 29, 1950**. 1950
Enamel, oil, aluminum paint, wire lathe mesh,
string, colored glass, and pebbles on ¼-inch glass
48 in. × 6 ft. (121.9 × 182.9 cm)
National Gallery of Canada, Ottawa. OT 1036

177. **Number 28, 1950**. 1950
Oil, enamel, and aluminum paint on canvas
68 in. × 8 ft. 9 in. (172.7 × 266.7 cm)
Collection Muriel Kallis Newman, Chicago. OT 260

180 and 181. **One: Number 31, 1950**. 1950
Oil and enamel paint on canvas
8 ft. 10 in. × 17 ft. 5⅝ in. (269.5 × 530.8 cm)
The Museum of Modern Art, New York.
Sidney and Harriet Janis Collection Fund
(by exchange). OT 283

OPPOSITE (DETAIL) AND RIGHT
178 and 179. **Number 32, 1950**. 1950
Enamel on canvas
8 ft. 10 in. × 15 ft. (269 × 457.5 cm)
Kunstsammlung Nordrhein-Westfalen, Düsseldorf. OT 274

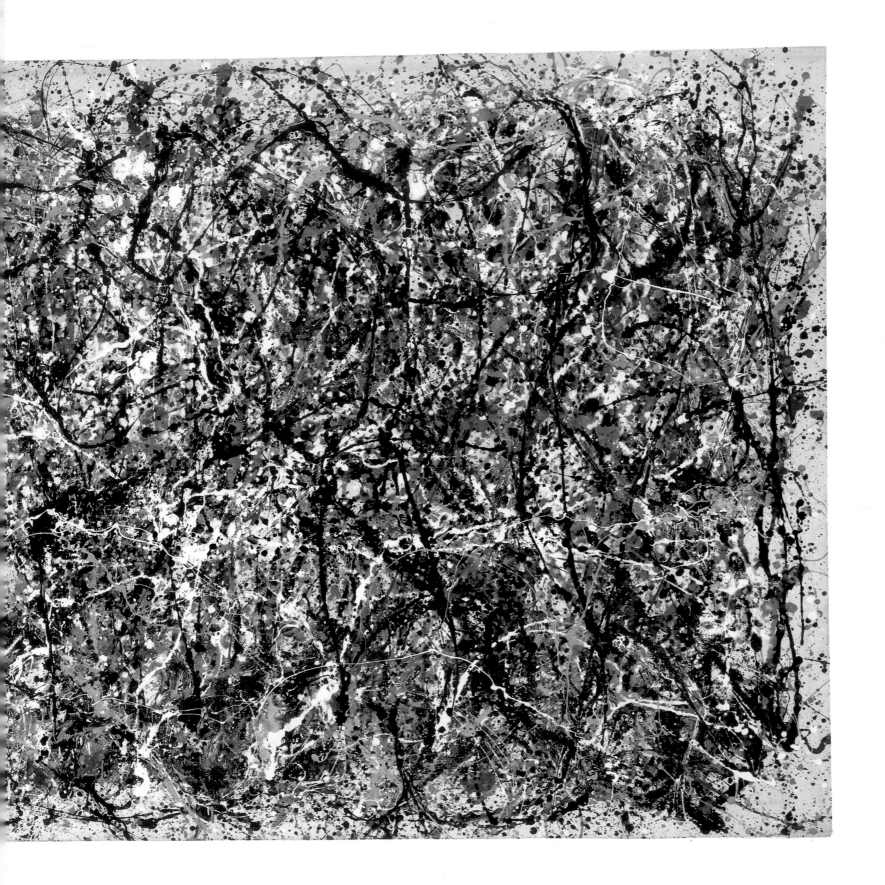

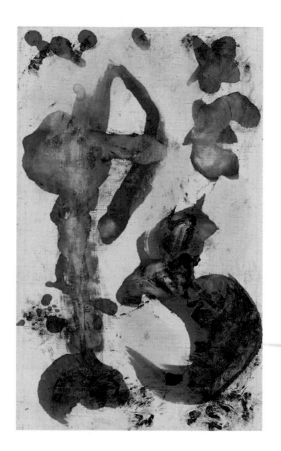

184–190. **Untitled [Red Painting I–7]**. c. 1950
Oil on canvas
Smallest 20 × 8 in. (50.8 × 20.3 cm),
largest 21 × 13 in. (53.3 × 33 cm)
Private collection, Berlin. OT 303–309

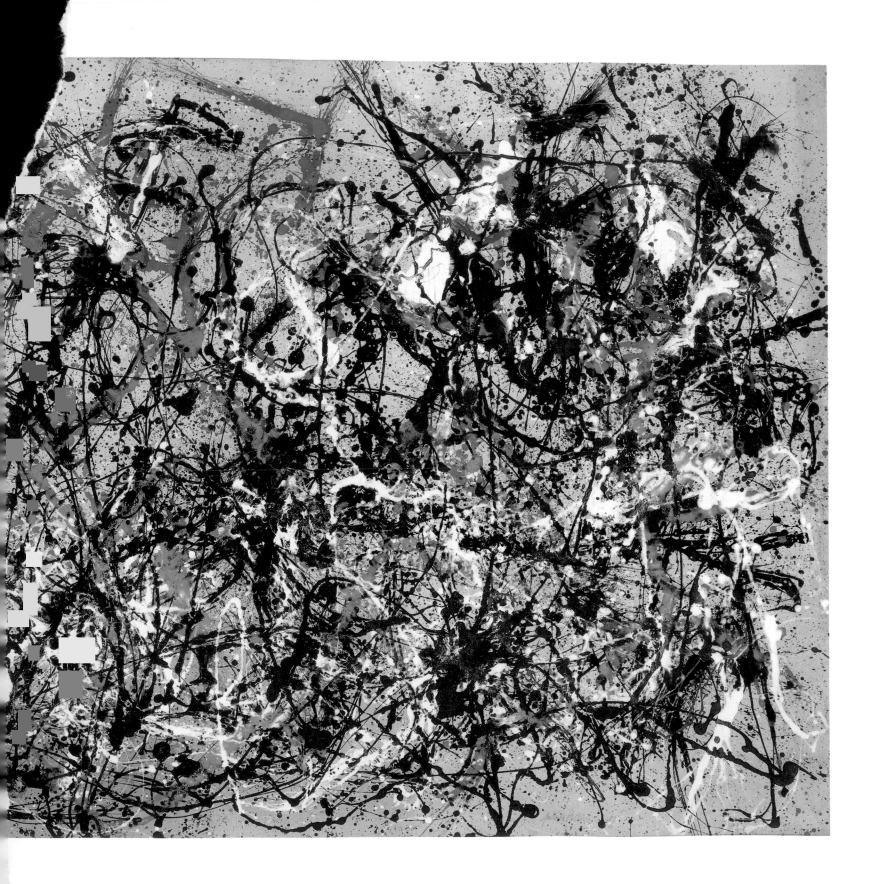

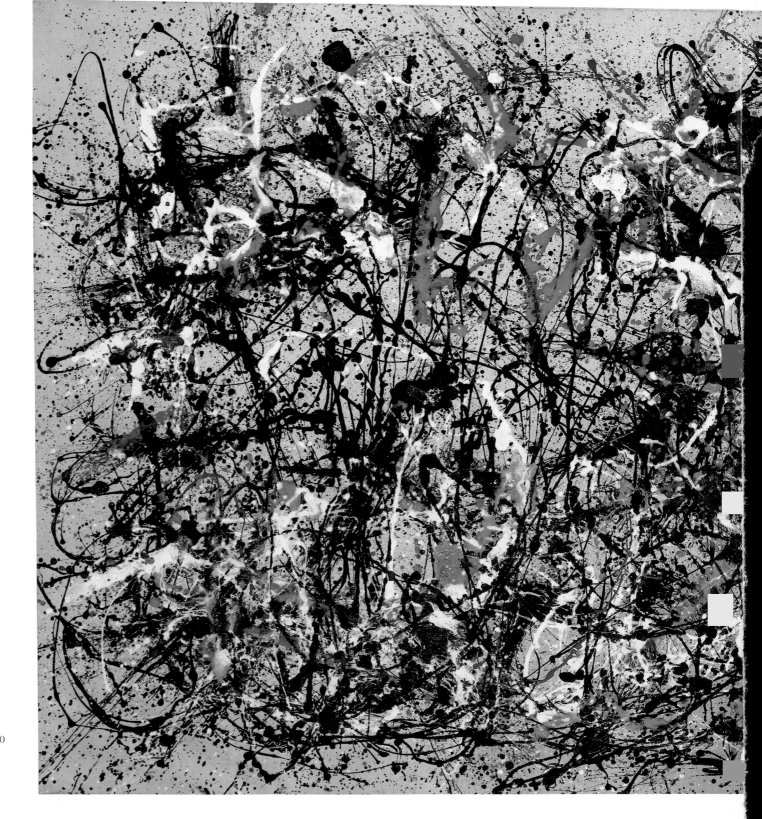

OPPOSITE (DETAIL) AND RIGHT
182 and 183. **Autumn Rhythm: Number 30, 1950**. 1950
Oil on canvas
8 ft. 9 in. × 17 ft. 3 in. (266.7 × 525.8 cm)
The Metropolitan Museum of Art, New York.
George A. Hearn Fund, 1957. OT 297

191. **Untitled**. c. 1951
Oil, ink, glue, and paper on canvas
50 × 35 in. (127 × 88.9 cm)
The Phillips Collection, Washington, D.C. OT 1040

192. **Untitled**. c. 1950–51
Screenprint, printed in black ink on red paper
8⅜ × 5½ in. (21.3 × 13.9 cm)
Courtesy Joan T. Washburn Gallery, New York, and
The Pollock-Krasner Foundation, Inc. OT suppl. 38

193. **Untitled**. c. 1950–51
Screenprint, printed in yellow ink on red paper
8½ × 5½ in. (21.6 × 13.9 cm)
Courtesy Joan T. Washburn Gallery, New York, and
The Pollock-Krasner Foundation, Inc. OT suppl. 39

194. **Untitled**. c. 1950–51
Screenprint, printed in black and yellow inks on red paper
8½ × 5¾ in. (21.6 × 14.6 cm)
Courtesy Joan T. Washburn Gallery, New York, and The
Pollock-Krasner Foundation, Inc. OT suppl. 40

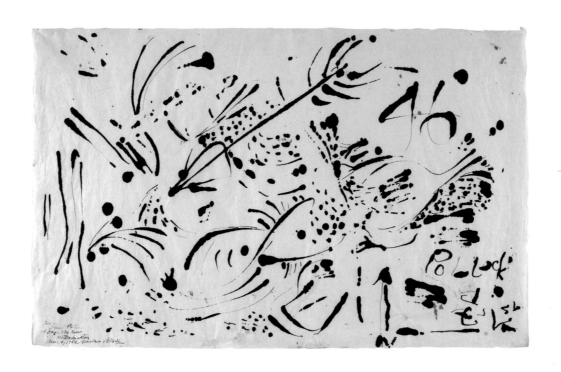

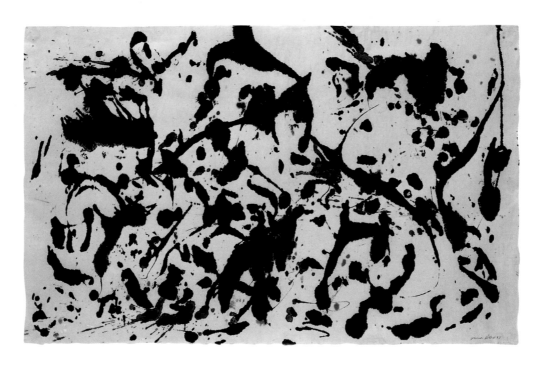

195. **Untitled**. c. 1951
Ink and watercolor on Japanese paper
25 × 39¼ in. (63.5 × 99.6 cm)
The Menil Collection, Houston. OT 812

BOTTOM
196. **Number 18, 1951**. 1951
Watercolor and ink on Japanese paper
24⅜ × 38¼ in. (61.9 × 97.2 cm)
Private collection. OT 826

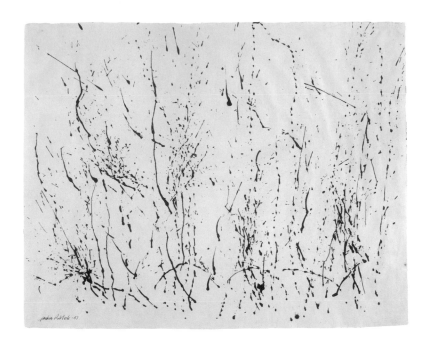

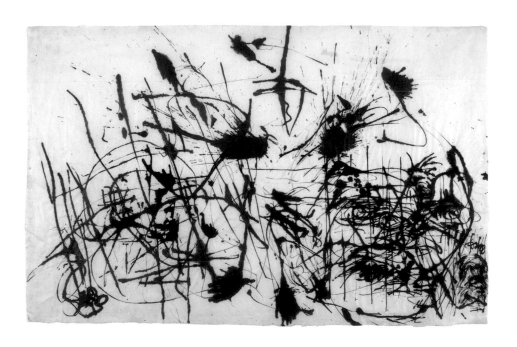

TOP
197. **Untitled**. 1951
Ink on Japanese paper
17½ × 22¼ in. (44.4 × 56.5 cm)
Private collection. OT 846

BOTTOM
198. **Untitled**. c. 1951
Black ink on Japanese paper
24¾ × 38¾ in. (62.9 × 98.4 cm)
Private collection. OT 821

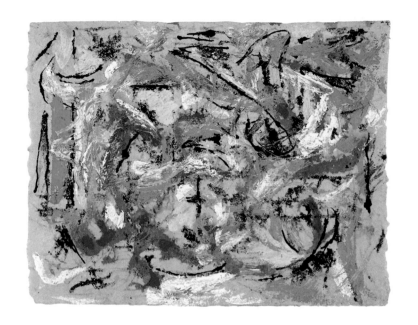

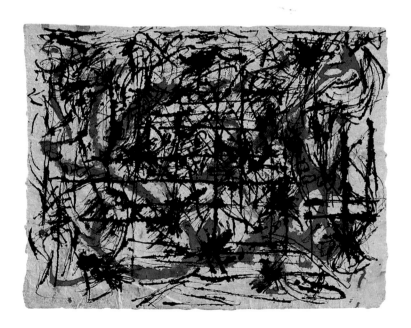

287

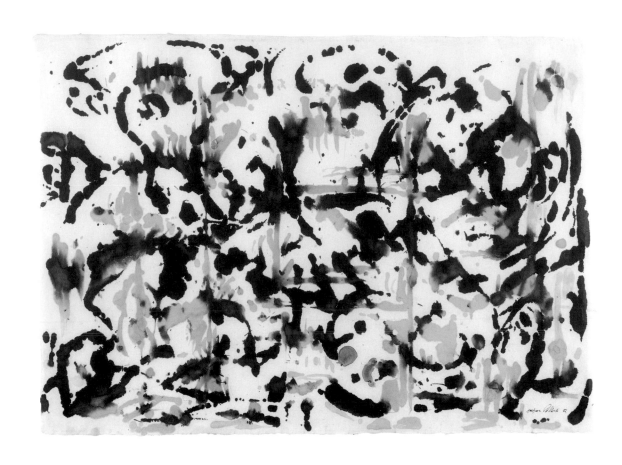

201. **Untitled**. 1951
Color ink on Japanese paper
24¼ × 34 in. (61.5 × 86.3 cm)
Collection Barbaralee Diamonstein and Carl Spielvogel. OT 825

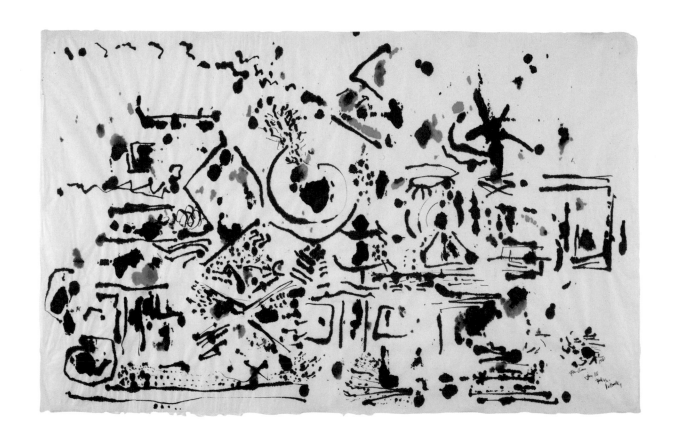

202. **Untitled**. 1951
Black and color inks on Japanese paper
24¾ × 39 in. (62.8 × 99.1 cm)
Collection Jane Lang Davis, Medina, Washington. OT 813

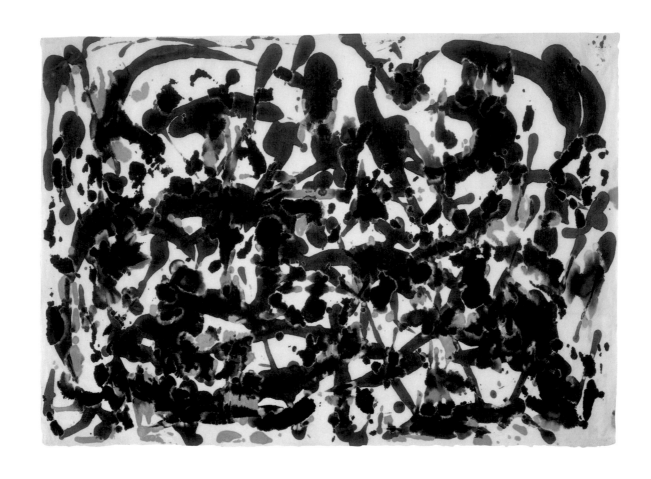

203. **Untitled**. c. 1951
Ink on Japanese paper
24⅜ × 34⅜ in. (62.1 × 87.3 cm)
The Museum of Modern Art, New York.
The Joan and Lester Avnet Collection. OT 823

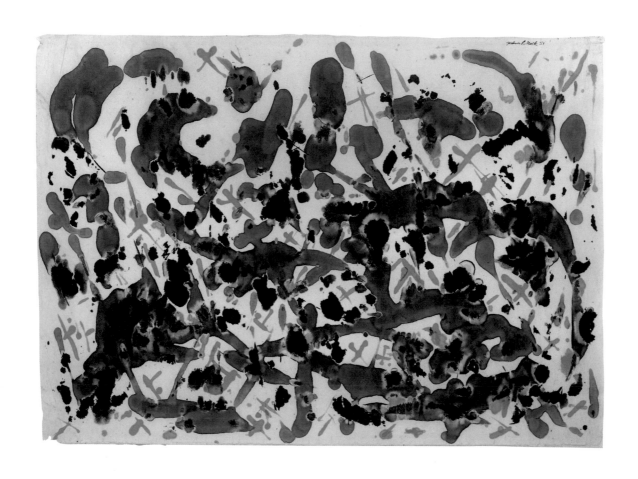

204. **Untitled**. 1951
Ink and watercolor on Japanese paper
24½ × 34 in. (62.2 × 86.3 cm)
Collection Barbara and Donald Jonas. OT 824

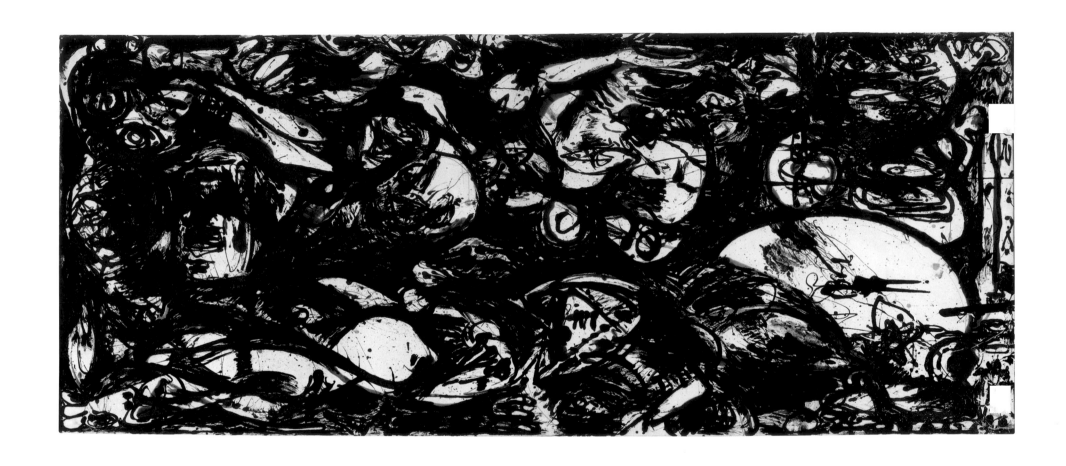

205. **Number II, 1951**. 1951
Enamel on canvas
57½ in. × 11 ft. 6⅜ in. (146 × 352 cm)
Daros Collection, Switzerland. OT 341

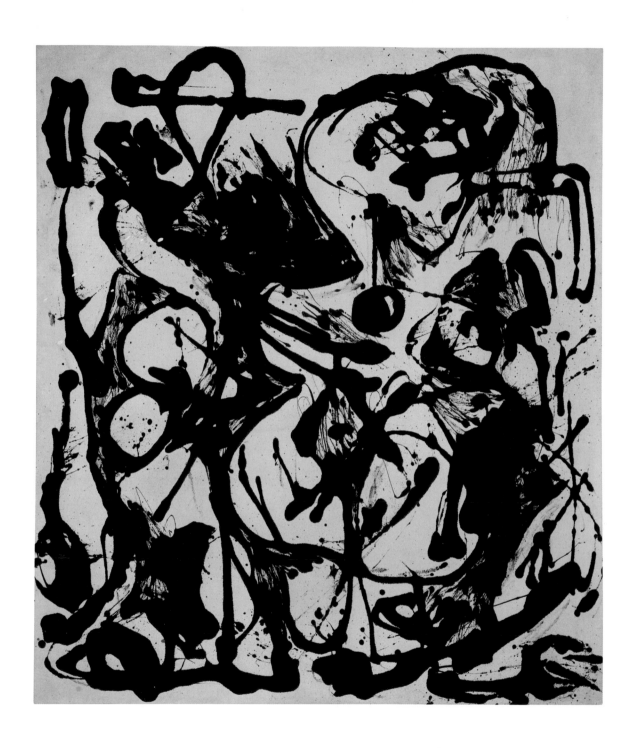

206. **Number 19, 1951**. 1951
Oil and enamel on canvas
61 × 53 in. (154.9 × 134.6 cm)
Collection Milly and Arne Glimcher, New York. OT 333

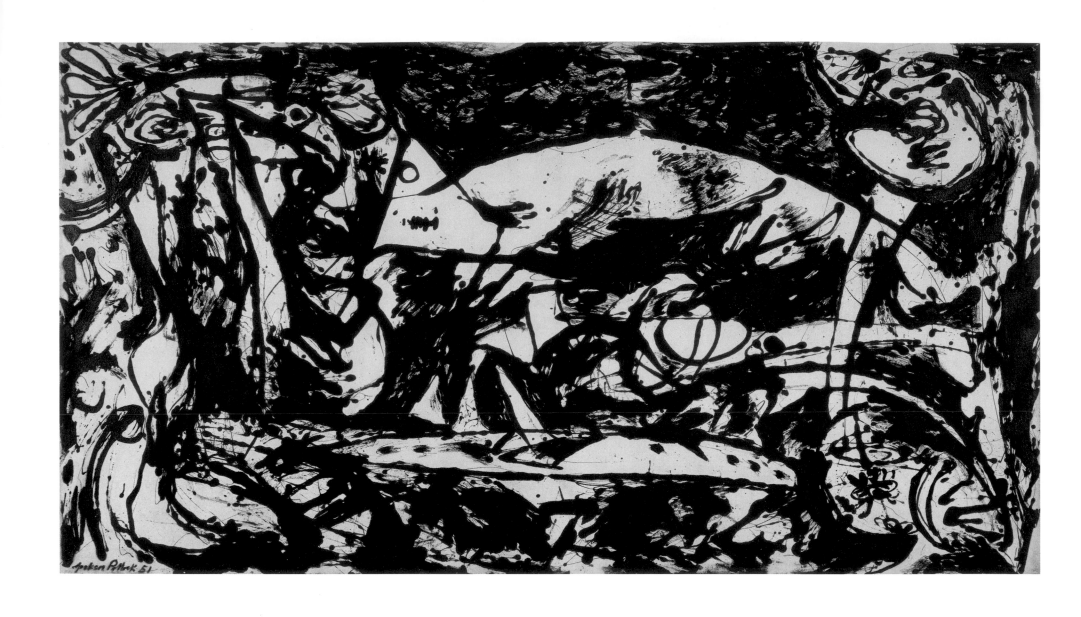

207. **Number 14, 1951**. 1951
Enamel on canvas
57⅝ in. × 8 ft. 10 in. (146.4 × 269.2 cm)
Tate Gallery, London. Purchased with assistance from the
American Fellows of the Tate Gallery Foundation, 1988. OT 336

294

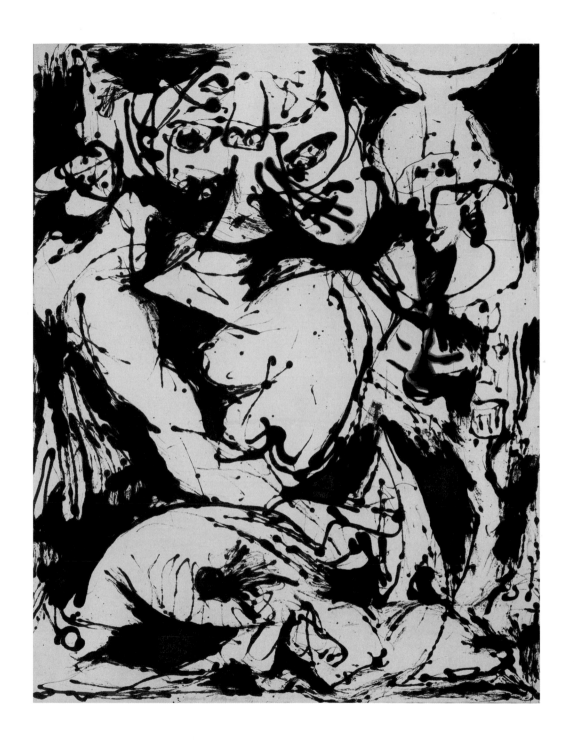

208. **Number 22, 1951**. 1951
Oil and enamel on canvas
58⅛ × 45⅛ in. (147.6 × 114.6 cm)
Collection Denise and Andrew Saul. OT 344

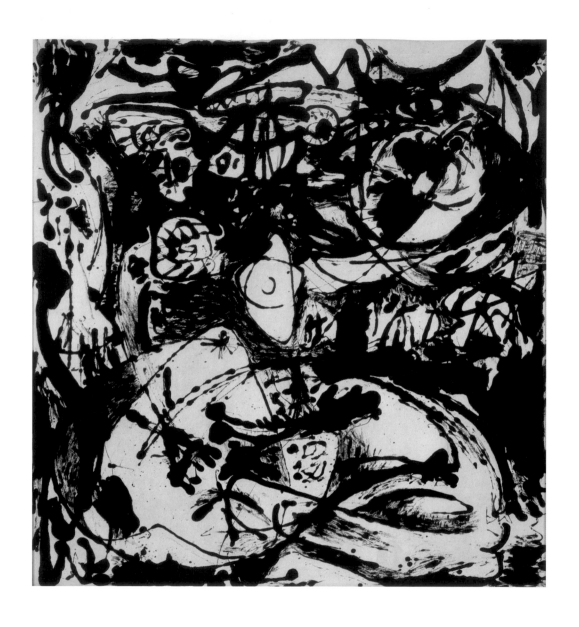

ABOVE
209. **Number 18, 1951**. 1951
Enamel on canvas
58¾ × 55½ in. (149.2 × 140.9 cm)
Collection Adriana and Robert Mnuchin. OT 343

OPPOSITE
210. **Echo: Number 25, 1951**. 1951
Enamel on canvas
7 ft. 7⅞ in. × 7 ft. 2 in. (233.4 × 218.4 cm)
The Museum of Modern Art, New York. Acquired through the
Lillie P. Bliss Bequest and the Mr. and Mrs. David Rockefeller Fund. OT 345

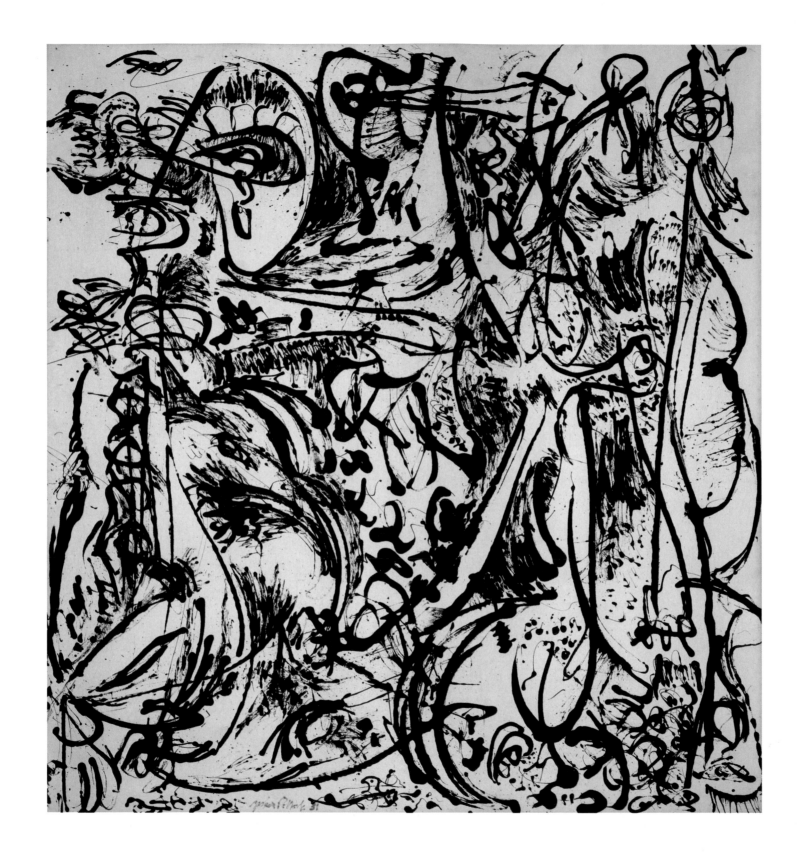

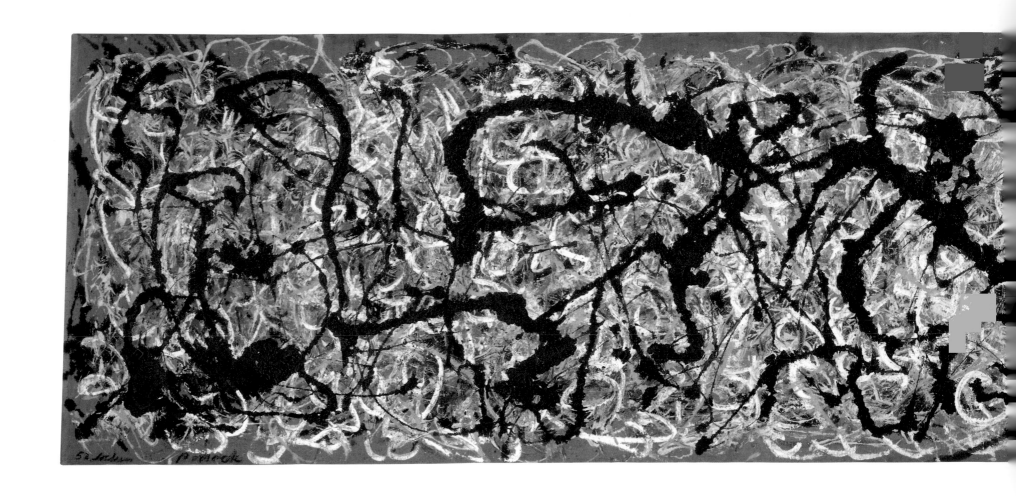

211. **Number I, 1952**. 1952
Oil on canvas
26 in. × 8 ft. 10 in. (66 × 269.2 cm)
Private collection. OT 358

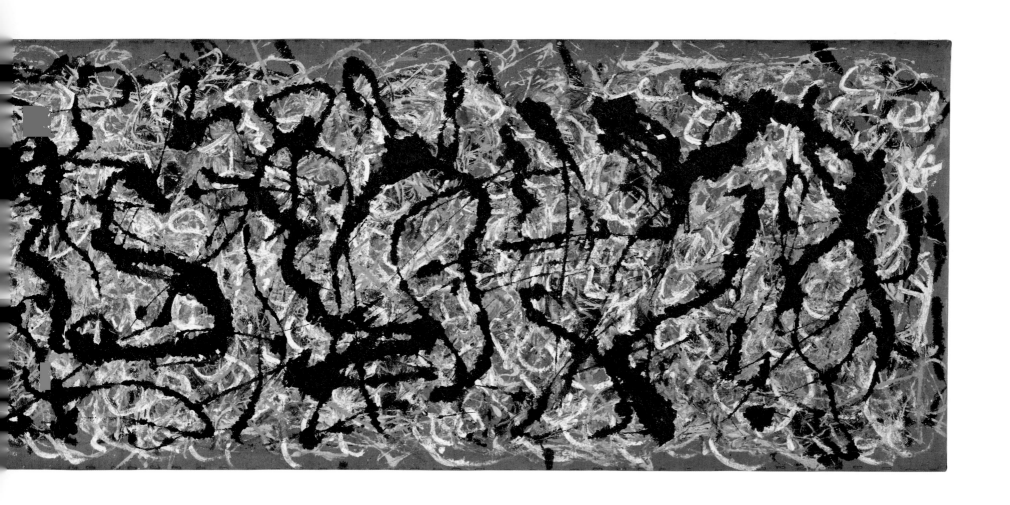

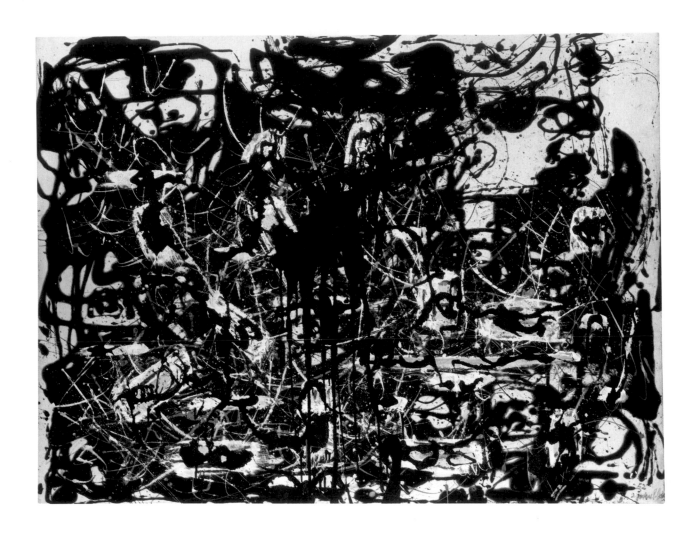

212. **Yellow Islands**. 1952
Oil on canvas
56½ in. × 6 ft. 1 in. (143.5 × 185.4 cm)
Tate Gallery, London. Presented by the Friends of the Tate Gallery (purchased out of funds provided by
Mr. and Mrs. H. J. Heinz II and H. J. Heinz Co., Ltd.), 1961. OT 365

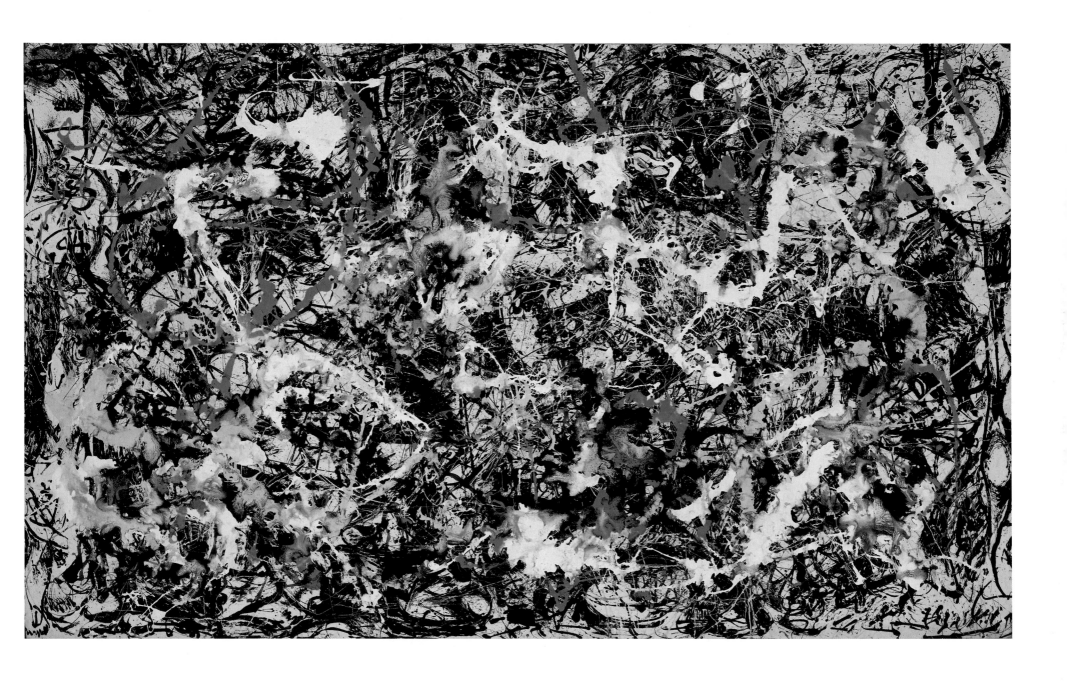

213. **Convergence: Number 10, 1952**. 1952
Oil and enamel on canvas
7 ft. 9½ in. × 12 ft. 11 in. (237.4 × 393.7 cm)
Albright-Knox Art Gallery, Buffalo, New York.
Gift of Seymour H. Knox, 1956. OT 363

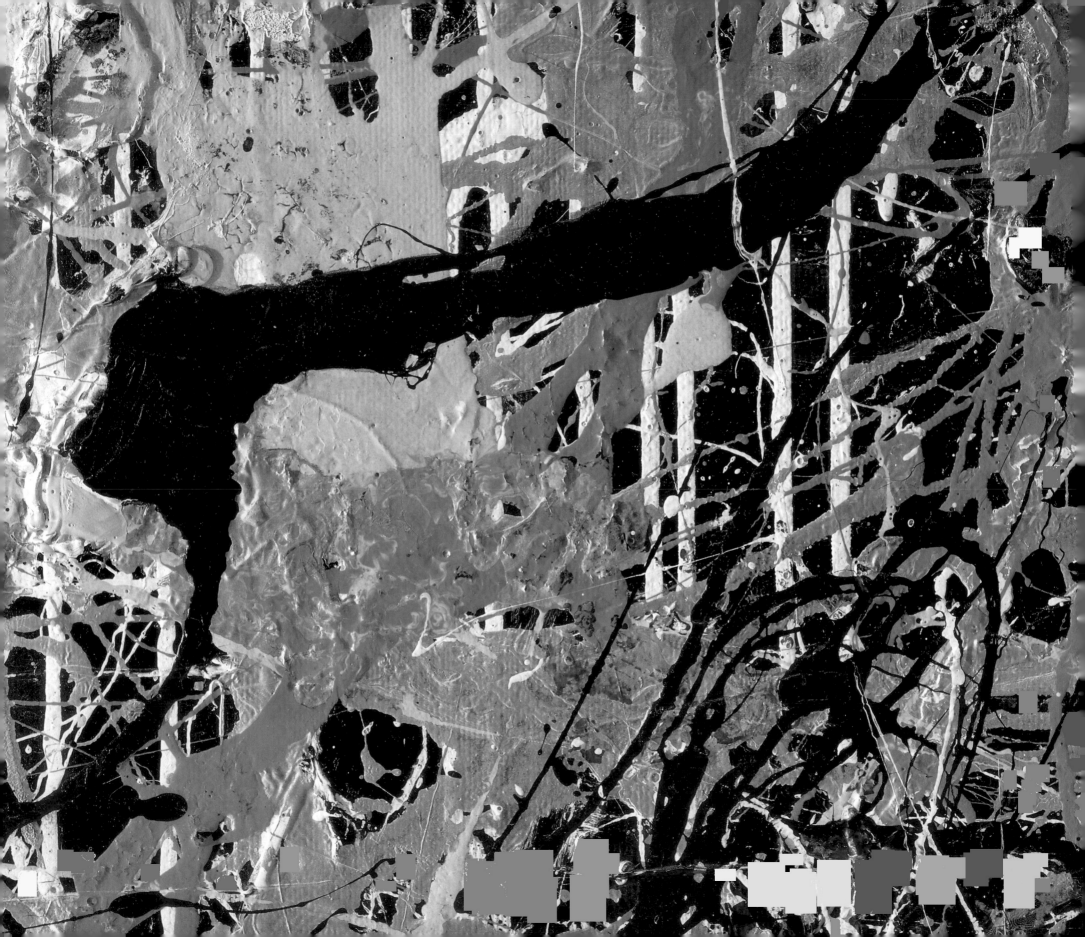

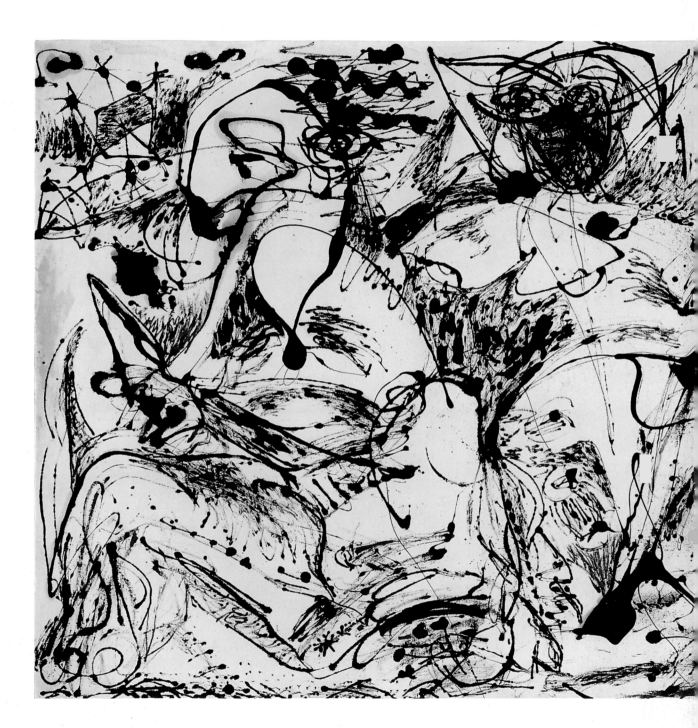

216. **Portrait and a Dream**. 1953
Oil on canvas
58½ in. × 11 ft. 2¾ in. (148.6 × 342.2 cm)
Dallas Museum of Art.
Gift of Mr. and Mrs. Algur H. Meadows and
the Meadows Foundation, Incorporated. OT 368

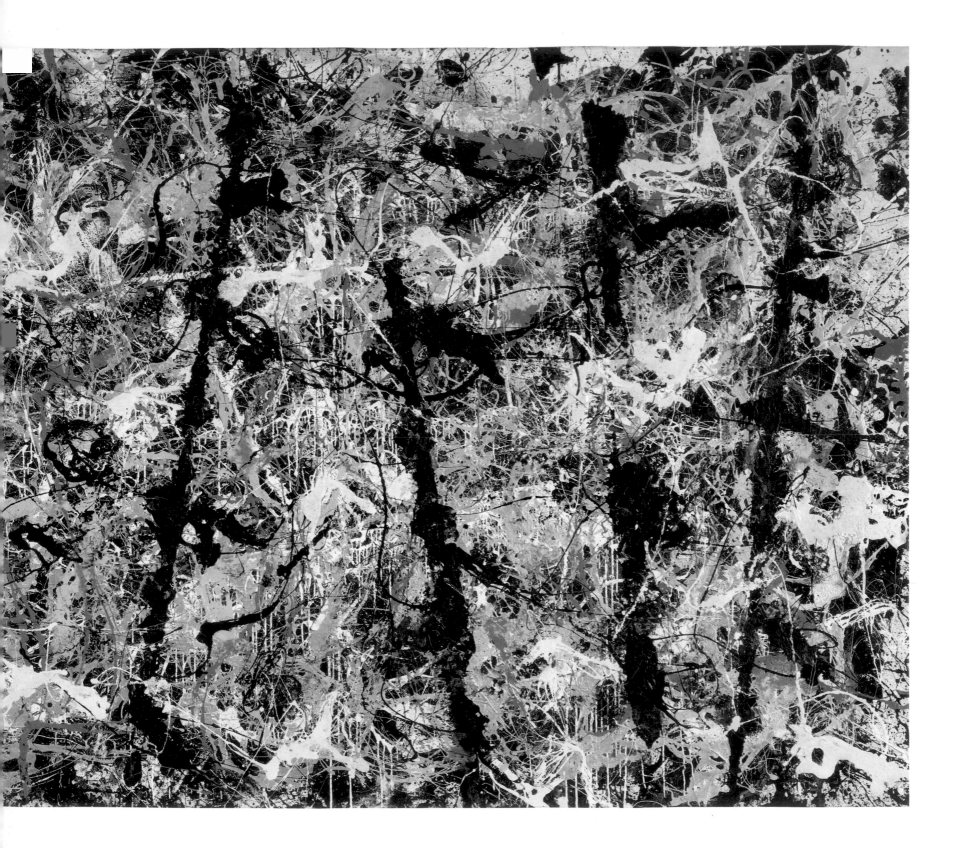

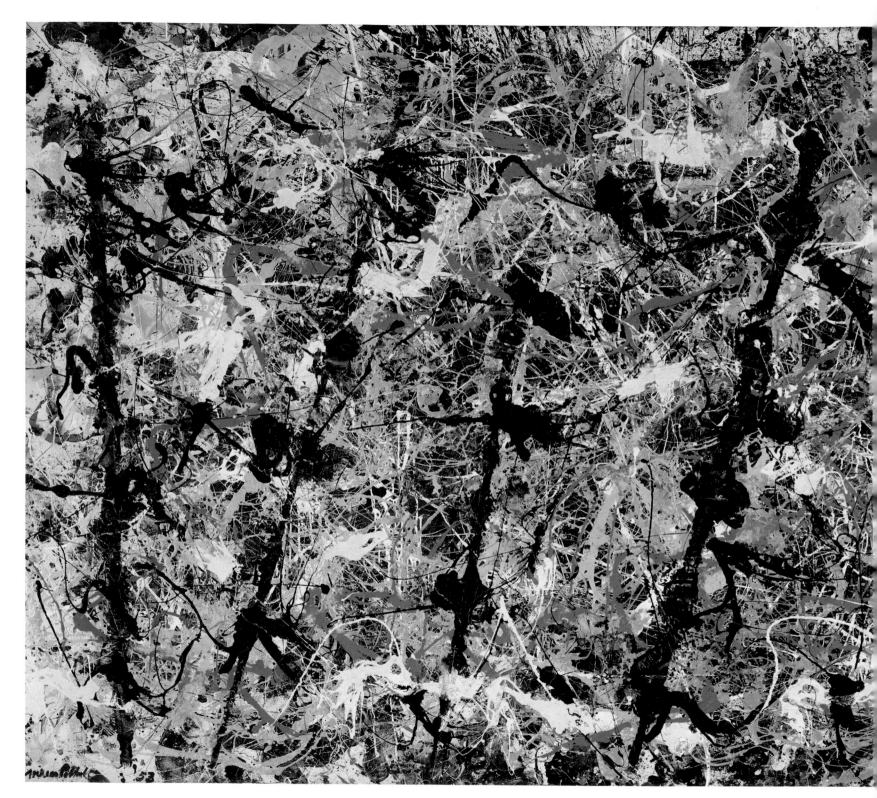

214 and 215. **Blue Poles:
Number II, 1952**. 1952
Enamel and aluminum
paint with glass on canvas
6 ft. 10⅛ in. × 15 ft. 11⅝ in.
(210 × 486.8 cm)
National Gallery of
Australia, Canberra. OT 367

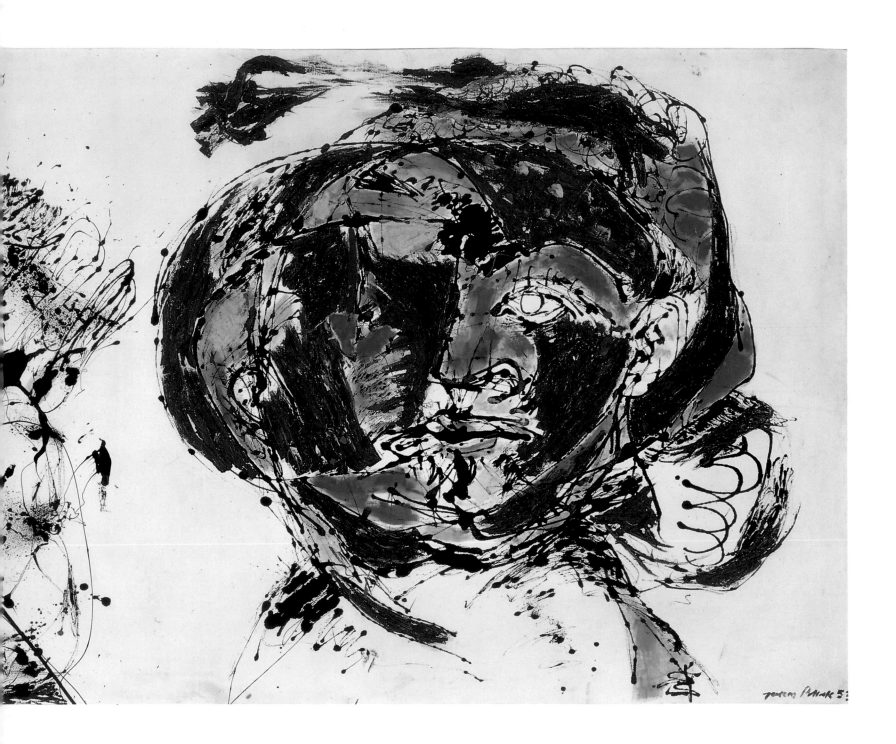

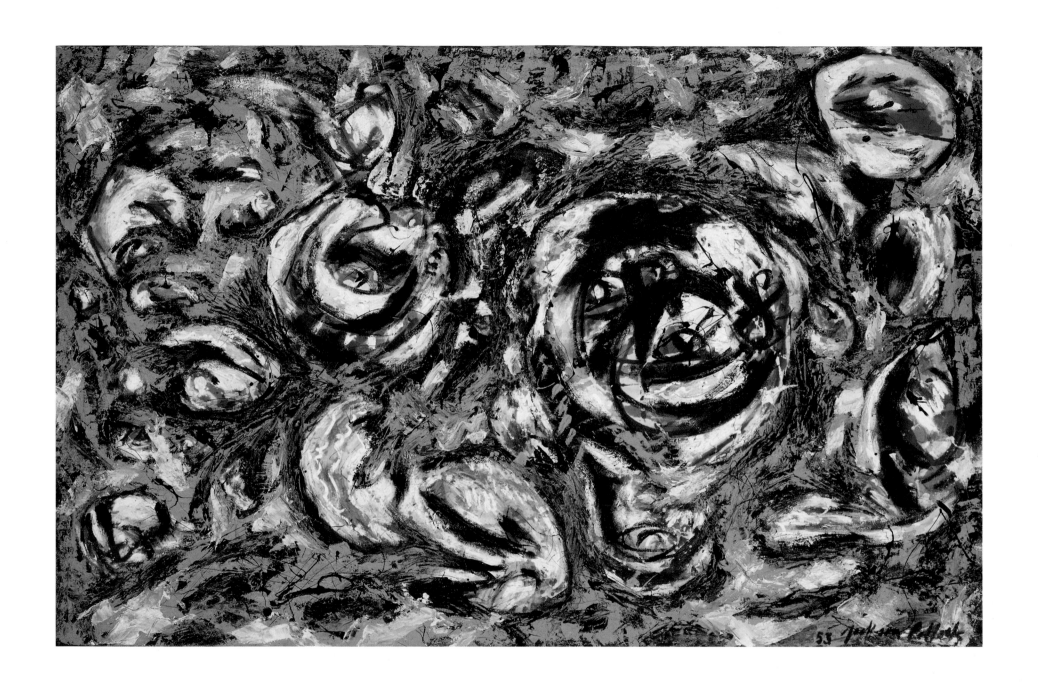

217. **Ocean Greyness**. 1953
Oil on canvas
57¾ in. × 7 ft. 6⅛ in. (146.7 × 229 cm)
The Solomon R. Guggenheim Museum, New York. OT 369

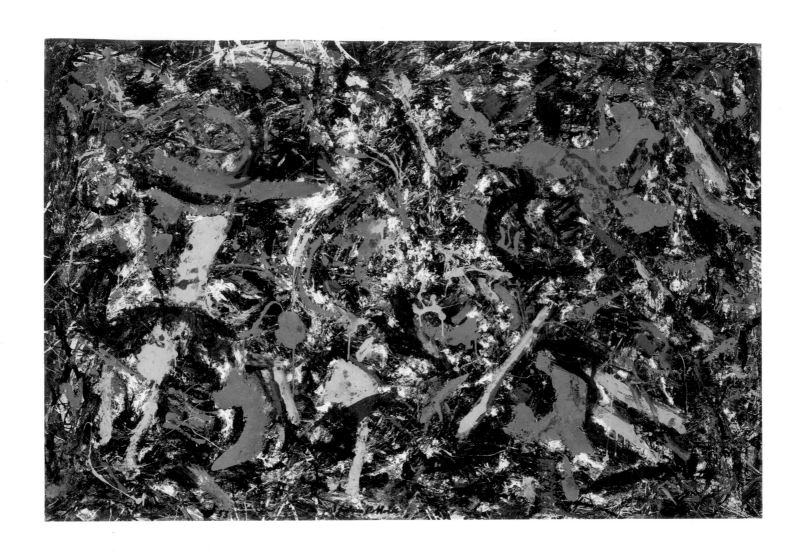

218. **Unformed Figure**. 1953
Oil and enamel on canvas
52 in. × 6 ft. 5 in. (132 × 195.5 cm)
Museum Ludwig, Cologne. OT 371

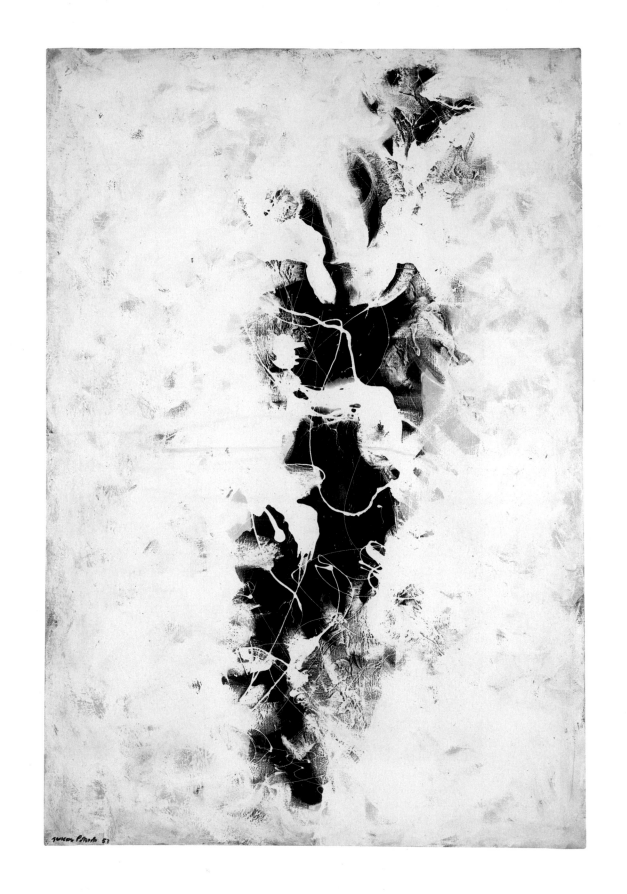

219. **The Deep**. 1953
Oil and enamel on canvas
7 ft. 2¼ in. × 59⅛ in. (220.4 × 150.2 cm)
Musée national d'art moderne, Centre de
Création Industrielle, Centre Georges
Pompidou, Paris. Donated by The Menil
Foundation, Houston, 1975. OT 372

220. **Easter and the Totem**. 1953
Oil on canvas
6 ft. 10⅛ in. × 58 in. (208.6 × 147.3 cm)
The Museum of Modern Art, New York.
Gift of Lee Krasner in memory of Jackson Pollock. OT 374

221. **Ritual**. 1953
Oil on canvas
7 ft. 6½ in. × 42½ in. (229.9 × 108 cm)
Collection Robert and Jane Meyerhoff,
Phoenix, Maryland. OT 376

OPPOSITE (DETAIL) AND ABOVE
222 and 223. **White Light**. 1954
Oil, enamel, and aluminum paint on canvas
48¼ × 38¼ in. (122.4 × 96.9 cm)
The Museum of Modern Art, New York.
The Sidney and Harriet Janis Collection. OT 380

311

224. **Untitled (Scent)**. c. 1953–55
Oil and enamel on canvas
78 × 57½ in. (99 × 146 cm)
Collection David Geffen. Los Angeles. OT 381

225. **Search**. 1955
Oil and enamel on canvas
57½ in. × 7 ft. 6 in. (146 × 228.6 cm)
Collection Samuel and Ronnie Heyman. OT 382

Chronology

Elizabeth Levine and Anna Indych

This chronology compiles and consolidates information published in the Jackson Pollock literature, including, most extensively, Steven Naifeh and Gregory White Smith's *Jackson Pollock: An American Saga*, published in 1989. It has benefited greatly from Francis V. O'Connor and Eugene V. Thaw's 1978 *Jackson Pollock: A Catalogue Raisonné of Paintings, Drawings, and Other Works*, B. H. Friedman's *Jackson Pollock: Energy Made Visible*, Ellen G. Landau's *Jackson Pollock*, and Jeffrey Potter's *To A Violent Grave: An Oral Biography of Jackson Pollock*.

In references to Pollock's exhibitions, works are listed when they are reproduced in this book. For those reproductions, see the Index of Illustrations on pages 333–34.

1912

January. Paul Jackson Pollock is born on Watkins Ranch, Cody, Wyoming. His mother, Stella May McClure (1875–1958), and father, LeRoy (Roy) Pollock (1876–1933), both of Scottish-Irish descent, were born and raised in Tingley, Iowa. (His father, born LeRoy McCoy, was adopted at the age of two by James and Elizabeth Pollock.) Jackson has four elder brothers: Charles Cecil (1902–1988), Marvin Jay (1904–1986), Frank Leslie (1907–1994), and Sanford (Sande) LeRoy (1909–1963).

November 28. On Thanksgiving Day, Stella and her five sons leave Cody, joining Roy in National City, California, a newly developed fruit-

The Pollock family in Phoenix, Arizona. From left to right: Roy, Frank, Charles, Jackson, Jay, Sande, and Stella. c. 1914–15

Jackson on the Phoenix farm. c. 1914

growing community located between San Diego and the Mexican border.

1913

August 11. The Pollock family moves to Phoenix, Arizona, where Roy buys a twenty-acre farm with an adobe house.

1916

The tip of Jackson's right index finger is accidentally cut off while he and an older boy are playing at chopping wood.

1917

In the summer, the Pollock family moves to Chico, in the central valley of Northern California, where Roy plans to farm an eighteen-acre orchard of peach, plum, and apricot trees.

1919

December 31. After selling their Chico farm, Stella and Roy Pollock buy a hotel, the Diamond Mountain Inn, in Janesville, California, 120 miles northeast of Chico. Except for Charles and Jay, who remain in Chico to attend high school, the rest of the family will move to Janesville in February 1920.

1920

October. Roy Pollock separates from his family but maintains contact with them, sending monthly letters and checks and visiting on holidays.

1921

Late Spring. Stella exchanges the hotel in Janesville for a small farm near Orland, California, about twenty miles west of Chico, where Charles and Jay are still attending high school. Frank, Sande, and Jackson move with Stella to the farm.

Late December. Visiting the family near Orland for the first time, Charles Pollock announces that he has quit high school to move to Los Angeles. Shortly after Charles's arrival in Los Angeles in early 1922, Arthur Millier, a local art critic, will help him find a job at the *Los Angeles Times*, first as a copyboy and then in the art department doing layout.

1922

Charles enrolls at Otis Art Institute in Los Angeles. He begins sending copies of *The Dial*, a monthly periodical containing fiction, poetry, book reviews, and black-and-white reproductions of fine art, to the Pollock family in Orland, providing Jackson with his first exposure to modern art.[1]

1923

May. Roy finds a surveying job in Arizona. The family reunites and returns to Phoenix.

September. Jackson enrolls in the sixth grade of Monroe Elementary School, in Phoenix.

1924

Summer. Roy joins the family at Carr Ranch, a summer retreat in the mountains east of Phoenix, where Stella is working as a cook.

Early September. Stella, Frank, Sande, and Jackson move to Riverside, California, approximately sixty miles east of Los Angeles.

1926

After several years in Los Angeles studying at Otis Art Institute, Charles moves to New York, where he registers as a student of Thomas Hart Benton at the Art Students League.

Jackson graduates from Grant Elementary School in Riverside. In the fall, he enrolls in Manual Training School, Riverside.

Jackson in Southern California. c. 1927–28

1927

June–July. Roy arranges for Jackson and Sande to live and work with a surveying crew near the Grand Canyon. Jackson takes his first alcoholic drink.

Fall. Jackson enrolls at Riverside High School and joins the Reserve Officers' Training Corps (ROTC) program. Although only fifteen, he is already drinking heavily. During the fall semester, while drunk, Jackson punches a student officer during an ROTC parade drill and is expelled from ROTC.

1928

March. After months of academic and emotional struggle, Jackson withdraws from Riverside High School.

Summer. The Pollock family moves to Los Angeles, without Roy, who remains in Riverside. Frank moves to New York.

September II. Jackson enrolls at Manual Arts High School, where he concentrates on art. Frederick John de St. Vrain Schwankovsky, head of the art department, introduces him to abstract art and to the writings of mystical thinkers such as Krishnamurti and Rudolf Steiner, the founder of Theosophy.

1929

March. Jackson is expelled from Man-

Jackson and Sande at the Grand Canyon. 1927

Jackson in the late 1920s

ual Arts for disciplinary problems.[2]

July. Jackson works briefly with his father in Santa Ynez, California, but soon decides to return to Los Angeles. A fist fight with his father ensues.

Fall. Jackson is readmitted to Manual Arts. He subscribes to the magazine *Creative Art* and is particularly impressed by an article on the Mexican muralist Diego Rivera.[3]

1930

Spring. Following a second expulsion the previous fall, Jackson attends Manual Arts on a part-time basis.

Jackson in Los Angeles before he left for New York. c. 1930

June. Charles and Frank return to Los Angeles for the summer. Jackson and Charles see José Clemente Orozco's *Prometheus* fresco in the recently completed Frary Hall of Pomona College, in Claremont, California.

September. Jackson follows Charles and Frank to New York City.

September 29. Having taken free sculpture classes at Greenwich House, a neighborhood association on Barrow Street, Jackson begins classes at the Art Students League on West 57th Street, enrolling with Charles in Thomas Hart Benton's class.

October. Benton begins his mural cycle *America Today* on the fifth floor of the New School for Social Research, at 66 West 12th Street.

A month later, José Clemente Orozco begins a mural cycle in the seventh-floor cafeteria of the same building.[4]

1931
June. Charles marries Elizabeth England.

Summer. Jackson hitchhikes with Manuel Tolegian from New York to Los Angeles, where they visit museums and galleries.[5] In late August, both work briefly as lumberjacks.

Fall. Jackson returns to New York, where he takes Benton's mural class and is tutored privately by the older artist.

1932
Summer. Jackson makes another trip to Los Angeles, where a friend introduces him to the Mexican muralist David Alfaro Siqueiros, a political exile living in the city since May.

Fall. Returning to New York, Jackson moves into Charles and Elizabeth's two-room apartment at 46 Carmine Street. Charles's studio fills the front room, while Jackson's bed and paintings occupy the back.[6]

October 3. Jackson is named class monitor in Thomas Hart Benton's mural class.

December. Benton accepts a commission to paint a mural representing the state of Indiana at the 1933 Chicago World's Fair and leaves New York for several months.

1933
January. Jackson enrolls in John Sloan's "Life Drawing, Painting, and Composition" class at the Art Students League. He also joins a stone-carving class at Greenwich House Annex, on Jones Street, and takes a part-time job there as a custodian.

February. Jackson quits Sloan's class and enrolls in Robert Laurent's evening clay-modeling class.

March. Roy Pollock dies on March 6, having fallen ill with malignant endo-carditis, a bacterial infection of the valves of the heart, in December 1932.

At the end of the month, Jackson drops out of Laurent's class to devote himself to stone carving.

April. Jackson moves with Charles and Elizabeth Pollock to 46 East 8th Street, where they rent an entire floor for $35 a month.

Jackson watches Diego Rivera paint his controversial mural in the RCA Building at Rockefeller Center.[7]

Fall. Jackson rents a room in a brownstone on 58th Street to try to live on his own, and begins painting again.

Benton returns to New York and resumes teaching at the Art Students League. Jackson takes part in Monday-evening meetings of the "Harmonica Rascals" at the Bentons' home.

Winter. Jackson renders small sketches for murals in lunettes at Greenwich House. The murals are never executed.

1934
Siqueiros arrives in New York early in the year.

Late Spring. Jackson visits the Bentons on Martha's Vineyard, where he will make regular visits through 1937.

Mid-Summer. Jackson and Charles journey cross-country in a 1926 Model T Ford. For Jackson, this is the fourth such trip in five years.

On returning to New York, Jackson moves to a small cold-water flat above a lumberyard at 76 West Houston Street.

October. Sande arrives in New York, moving in with Jackson on Houston Street.

Winter 1934–35. Charles, now a part-time teacher at the City and Country School at 165 West 12th Street, and Benton help Sande and Jackson get a shared job cleaning the five-story school for $10 a week. The Bentons' friends Caroline Pratt, the school's director, and Helen Marot, a teacher who has studied psychology, take an interest in Jackson; they will support and encourage his work throughout the rest of the decade.

At Rita Benton's initiative, Jackson attends a free ceramics workshop taught by Job Goodman at the Henry

Street Settlement House. Jackson sells a number of painted plates and bowls at an exhibition in the basement of the Ferargil Gallery, Thomas Benton's dealer.

Unable to make ends meet, Jackson and Sande sign up to receive direct government aid.

1935

February. Jackson paints a "vast, lewd mural in the style of Orozco" on the walls of his studio at 76 West Houston Street.[8]

February I–28. Jackson shows *Threshers* (OT 935) in the *Eighth Exhibition of Watercolors, Pastels, and Drawings by American and French Artists*, at the Brooklyn Museum.

February 25. Jackson is hired as a stonecutter by the New York City Emergency Relief Bureau, restoring public monuments for $1.75 an hour.

April. Benton leaves New York for Missouri, where he has been invited to become the director of the Kansas City Art Institute.

August. Jackson and Sande enlist with the Federal Arts Project of the Works Progress Administration (WPA). Sande, who has worked with Siqueiros in Los Angeles, is assigned to the mural division. To stay close to his brother, Jackson also joins the mural division rather than the easel division.

A WPA regulation prohibits one household from receiving two of the agency's

Jackson with David Alfaro Siqueiros (middle) and George Cox (left) at the May Day parade, New York. 1936

paychecks. To camouflage the fact that he and Jackson are brothers, Sande changes his last name to McCoy.

Charles leaves New York for Washington, D.C., taking a position at the Resettlement Administration.

September. With Sande, Jackson moves back to the 46 East 8th Street apartment vacated by Charles and Elizabeth.[9]

1936

Jackson continues working for the Federal Arts Project. Early in the year, he submits a proposal for a mural but fails to secure a commission.

March 2–April I9. The exhibition *Cubism and Abstract Art* is on view at The Museum of Modern Art.

April. Siqueiros establishes a "Laboratory of Modern Techniques in Art" in his loft at 5 West 14th Street. Jackson and Sande participate in the workshop, helping to prepare a May Day celebration with posters, banners, and a giant float. Siqueiros experiments with nontraditional materials such as

enamel paint, and with unconventional techniques of paint application: dripping, pouring, and airbrushing. Jackson will soon use an airbrush to color a lithograph (plate 9) and will subsequently make use of many of Siqueiros's materials and techniques.

July 25. Sande marries Arloie Conaway. Jackson, Sande, and Arloie will live in the 8th Street apartment.

Late Summer. Jackson, Sande, Philip Goldstein (later known as Philip Guston), and two other friends visit Dartmouth College, in Hanover, New Hampshire, to see Orozco's mural *The Epic of American Civilization*, in the Baker Library.

December 7, 1936–January 17, 1937. The exhibition *Fantastic Art, Dada, Surrealism* is on view at The Museum of Modern Art.

Winter. At a Christmas party, Jackson briefly encounters Lenore ("Lee") Krasner, but they will not meet again until 1942.

1937

January. At Sande's insistence Jackson begins psychiatric treatment for alcoholism, under the care of a Jungian analyst.

February 3–2I. Jackson exhibits *Cotton Pickers* (OT 12 and OT Suppl. 2) at the Temporary Galleries of the Municipal Art Committee, 62 West 53rd Street.

September. Sande closes off the front part of the Houston Street apartment for Jackson to use as a studio.

October. Jackson exhibits a watercolor in the first exhibition at the new WPA Federal Art Gallery, at 225 West 57th Street.

Winter 1937–38. Jackson spends Christmas with the Bentons in Kansas City. He also visits Detroit to see his brother Charles, who has recently moved there to work as an illustrator and muralist.

Jackson with the Bentons at their summer home in Martha's Vineyard. 1936 or 1937. Photograph: Alfred Eisenstaedt/*Life* magazine. © Time Inc.

1938

June 9. Jackson's employment with the Federal Arts Project is terminated due to "continued absence."[10]

June 12. In the hope of curing Jackson's drinking problem, Sande commits him as a "voluntary patient" in the Westchester Division of New York Hospital (Bloomingdale Asylum), located in White Plains, thirty-five miles north of New York City. Remaining there until September, Jackson makes a few copper plaques and bowls in the hospital's metal workshop (see plate 13).

November. Jackson is reassigned to the easel division of the WPA project.

1939

Jackson begins sessions with another Jungian psychoanalyst, Dr. Joseph Henderson. After several sessions, he starts to bring his drawings to Henderson, who uses them as therapeutic and interpretive tools.[11]

May. Jackson sees Pablo Picasso's *Guernica*, and preparatory sketches made for the work, at the Valentine Gallery on 57th Street, where it is exhibited by the Artists' Congress to help raise funds for refugees from the Spanish Civil War. Jackson returns to see it repeatedly, sometimes sketching.

July. The Federal Arts Project is reorganized as the WPA Art Program.

November 15, 1939–January 7, 1940. The exhibition *Picasso: Forty Years of*

His Art is on view at The Museum of Modern Art.

1940

May. Sande writes to Charles: "Jack is doing very good work. After years of trying to work along lines completely unsympathetic to his nature, he has finally dropped the Benton nonsense and is coming out with an honest creative art."[12]

June. Pollock watches Orozco at work at The Museum of Modern Art, where the Mexican artist has been commissioned to paint a portable mural, *Dive Bomber and Tank*, in conjunction with the exhibition *Twenty Centuries of Mexican Art*.[13]

June 3. Helen Marot dies. A period of sustained depression begins for Pollock, marked by increased drinking and little painting.

September. Dr. Henderson moves to San Francisco and refers Pollock to Dr. Violet Staub de Laszlo for continued therapy. Pollock will visit her twice a week for the next year.

1941

January 22–April 27. The exhibition *Indian Art of the United States* is on view at The Museum of Modern Art. Pollock attends the exhibition and watches Navajo artists execute sand paintings on the gallery floor.

May 3. Dr. de Laszlo writes on Pollock's behalf to the medical officer of Local Board No. 17, requesting draft deferment

for him on psychological grounds. After she submits another letter reporting Pollock's stay at Bloomingdale Asylum, and Pollock undergoes an examination at Beth Israel Hospital, he is classified 4-F—unfit for service.

July 13. Art collector Peggy Guggenheim arrives in New York from Europe, having shipped her art collection to the U.S. earlier in the year. She makes plans to open an art gallery showing the work of modern European masters.

1942

January 20–February 6. Pollock exhibits *Birth* (c. 1941) in *American and French Paintings* at McMillen Inc., at 148 East 55th Street. The exhibition, organized by John Graham, an influential artist and critic, includes works by Picasso, Henri Matisse, Georges Braque, and André Derain, as well as several American artists including Stuart Davis and Walt Kuhn. Lee Krasner, who is represented in the exhibition by *Abstraction*, seeks out Pollock after seeing his painting. The relationship that will develop between them marks a turning point in Pollock's life: Krasner supports and promotes Pollock's work, and introduces him to the influential German émigré Hans Hofmann and members of his circle, such as Mercedes Carles and Herbert Matter.

Spring. Herbert Matter invites James Johnson Sweeney to visit Pollock's studio. Sweeney tells Peggy Guggenheim that Pollock is "doing interesting work" and suggests she visit the studio.

Summer. Under the auspices of the War Services Division of the WPA Art Program, Krasner directs a project designing department-store window displays announcing war-related training courses at local schools and colleges. She makes Pollock an assistant on the project.

August. Sande, Arloie, and their daughter, Karen (born November 9, 1941), move to Deep River, Connecticut, vacating the East 8th Street apartment they have shared with Jackson. Krasner moves in.

Fall. Interested in breaking from the Surrealist movement in America, which is controlled by André Breton, Matta (Roberto Sebastián Matta Echaurren) seeks to build up a community of automatist artists in New York. Robert Motherwell helps him, and after Pollock attends a dinner party at Matta's apartment on 12th Street, they bring him into the fold. But Pollock soon becomes frustrated with the group, and by late winter the "workshop" has disbanded.

October. Having finished the WPA window-display project, Krasner is assigned a project designing posters for navy recruiting stations. She hires Pollock for the team. Two months later, however, the WPA will be terminated.

October 20. Peggy Guggenheim opens her gallery, Art of This Century, at 30 West 57th Street. A press release describes the gallery as a "research laboratory for new ideas" that will "serve

the future instead of recording the past."[14] Designed by the architect Frederick Kiesler, the gallery displays the collection of modern art that Guggenheim has been accumulating since 1938. In addition to showing European modernism, especially Surrealism, however, Guggenheim has become interested in discovering young artists, including emerging Americans.

Late 1942. Krasner and Pollock take up odd jobs to pay the bills. Through Joe Meert, a friend from the Art Students League, Pollock gets a night job at Creative Printmakers, on 18th Street, as a "squeegee man," silk-screening designs on lipstick tubes, neckties, scarves, and plates; he only lasts two months on the job due to heavy drinking and meager productivity. Pollock will use the silkscreen technique in several 1943–44 prints (plates 53–60).

Pollock ends therapy with Dr. de Laszlo.

December 7, 1942–January 22, 1943. Pollock exhibits *The Flame* (c. 1934–38) in *Artists for Victory*, an exhibition at The Metropolitan Museum of Art.

1943
April 16–May 15. Pollock exhibits *Collage* (now lost) in an international collage exhibition at Art of This Century. He is included at the suggestion of Howard Putzel, Guggenheim's gallery director, whom he had met the previous summer.

May 8. Pollock begins work as a custodian and preparator of paintings at The

Museum of Non-Objective Painting, at 24 East 54th Street. (In 1947 this museum will move to 1071 Fifth Avenue and in 1952 will be renamed the Solomon R. Guggenheim Museum.)

May 18–June 26. Pollock is included in the *Spring Salon for Young Artists* at Art of This Century, an exhibition almost exclusively of American artists, all age thirty-five and under. At Putzel's suggestion, Pollock submits *Stenographic Figure* (c. 1942) to the salon's jury—Marcel Duchamp, Piet Mondrian, James Johnson Sweeney, James Thrall Soby, Peggy Guggenheim, and Putzel himself. Guggenheim is initially unimpressed by *Stenographic Figure*, but Mondrian's response—"I'm trying to understand what's happening here. I think this is the most interesting work I've seen so far in America. . . . You must watch this man"[15]—convinces her to put Pollock in the show.

June 23. Guggenheim visits Pollock's studio. Putzel tries to convince her to offer Pollock a solo show, but she delays her decision until Duchamp has made a studio visit.

July. On the recommendation of Duchamp and others, including Matta, Sweeney, and Putzel, Guggenheim schedules a solo show for Pollock in November 1943. She signs a one-year contract paying him $150 a month as an advance against sales, which allows him to paint full-time.

Guggenheim also commissions a mural from Pollock for the entrance hall of

her East 61st Street town house.[16] She initially wants him to work directly on the wall, but Duchamp convinces her otherwise, arguing that a work on canvas will not have to be abandoned should she ever leave the town house. Pollock tears down a wall in his East 8th Street apartment so he can stretch the twenty-foot-long canvas.

November 9–27. Pollock's exhibition at Art of This Century, his first solo show, comprises fifteen oil paintings and an unrecorded number of works on paper, all executed between 1941 and 1943. The exhibition includes *Guardians of the Secret*, *The Mad Moon-Woman*, *Male and Female*, *The Moon Woman*, *The Moon-Woman Cuts the Circle*, *The She-Wolf*, *Stenographic Figure*, and six untitled paintings, plus gouaches and drawings. Prices range from $25 to $750. The show is the first solo exhibition by an American artist at Art of This Century.

Late December/Early January 1944. Pollock paints the mural for Guggenheim's East 61st Street town house.[17]

1944
February. A rehearsed interview with Pollock is published in *Arts & Architecture*. Asked why he prefers living in New York, Pollock responds: "Living is keener, more demanding, more intense and expansive in New York than in the West. . . . At the same time I have a definite feeling for the West: the vast horizontality of the land, for instance; here only the Atlantic ocean gives you that." Pollock says

Peggy Guggenheim and Pollock in front of the mural she commissioned for her New York town house in 1943. Photograph: Mirko Lion

that he rejects "the idea of an isolated American painting," but sees no reason to go to Europe. "I don't see why the problems of modern painting can't be solved as well here as elsewhere."[18]

May 2. The Museum of Modern Art acquires *The She-Wolf* for $650, on the initial recommendation of James Thrall Soby, the Chairman of the Museum's Department of Painting and Sculpture. Along with Sidney Janis (head of the acquisitions committee) and James Johnson Sweeney, Soby convinces Alfred H. Barr, Jr. (Director of Research in the Department of Painting and Sculpture), that the painting is a worthy addition to the Museum's collection. It is the first Pollock to be purchased by a museum.

Mid-June. Pollock and Krasner sublet their 8th Street studio and rent a stu-

**Pollock in Truro, Massachusetts. 1944.
Photograph: Bernard Schardt**

dio on Back Street in Provincetown, Massachusetts, for the summer; Putzel, who has left Art of This Century and is planning to open his own gallery, joins them for two weeks.

Fall. Back in New York, Pollock begins making prints in Stanley William Hayter's Atelier 17, across the street from his and Krasner's apartment (see plates 93–101).

Krasner persuades Pollock to visit her homeopathic doctor, Elizabeth Wright Hubbard.

November. Publication of Sidney Janis's book *Abstract and Surrealist Art in America*, which includes a statement by Pollock on *The She-Wolf*: "*She-Wolf* came into existence because I had to paint it. Any attempt on my part to say something about it, to attempt explanation of the inexplicable, could only destroy it."[19]

1945

March 5–31. Solo exhibition of Pollock's work at The Arts Club of Chicago. The exhibition comprises seventeen paintings and eight drawings. The paintings include *Guardians of the Secret*, *The Mad Moon-Woman*, *Male and Female*, *The Moon Woman*, *Pasiphaë*, and *Stenographic Figure*, plus eight untitled paintings. Later in the year a selection of works from the show will travel to the San Francisco Museum of Art.

March 19–April 14. Pollock's second solo exhibition at Art of This Century comprises thirteen paintings including *Totem Lesson 1*, *Totem Lesson 2*, *Night Mist*, *Two*, and *There Were Seven in Eight*. There are also gouaches and drawings. Visitors on the exhibition's opening day are invited to Peggy Guggenheim's town house to view *Mural*. Reviewing the exhibition in *The Nation*, Clement Greenberg champions Pollock as "the strongest painter of his generation and perhaps the greatest one to appear since Miró."[20]

April. Pollock's contract with Guggenheim comes up for renewal. She agrees to double his monthly stipend in exchange for receiving every painting but one (of his choosing) he will produce a year.

August. Krasner and Pollock visit friends in East Hampton, Long Island. The front porch affords a distant view of Accabonac Harbor to the west.

August 7. Howard Putzel dies of a heart attack.

September. Pollock agrees to Krasner's proposal that they should leave New York City. "We wanted to get away from the wear and tear," he will comment later.[21]

October 25. Krasner and Pollock marry, at the Marble Collegiate Church on Fifth Avenue. May Tabak, Harold Rosenberg's wife, is the witness. Guggenheim is invited but cancels at the last minute.

November 5. Krasner and Pollock move into a farmhouse at 830 Fireplace Road, The Springs, East Hampton, Long Island. Although their house is some distance from the ocean, their backyard looks out onto Accabonac Creek.[22]

Thanksgiving. Pollock's family visits to celebrate the holiday.

Winter 1945–46. During a harsh winter, Pollock and Krasner begin fixing up the house; there is no hot water, no bathroom, and they have no car. Pollock does not paint during these months.

1946

Pollock resumes painting, using an upstairs bedroom as a makeshift studio. *The Key* is painted on a canvas attached to a curtain stretcher laid on the bedroom floor.

Pollock designs the dust jacket for Peggy Guggenheim's controversial memoir, *Out of This Century*.

April 2–20. Pollock's third solo exhibition at Art of This Century. He shows eleven oil paintings, including *Troubled Queen*, and eight temperas. Clement Greenberg reviews the show favorably in *The Nation*, and it receives a generally positive response from other critics.

Summer. Pollock has the barn in the backyard moved to the side of the property so that it will not block the view of Accabonac Creek. He starts to use the barn as his studio, although it remains drafty and rough. Krasner begins using the upstairs bedroom as her studio.

Krasner will later describe Pollock's schedule at The Springs: "He always slept very late. Drinking or not, he never got up in the morning. . . . While he had his breakfast I had my lunch. . . . He would sit over that damn cup of coffee for two hours. By that time it was afternoon. He'd get off and work until it was dark. There were no lights in his studio. When the days were short he could only work for a few hours, but what he managed to do in those few hours was incredible."[23]

December 10, 1946–January 16, 1947. Pollock shows for the first time in the *Annual Exhibition of Contemporary American Painting* at the Whitney Museum of American Art, New York—the "Whitney Annual." He is represented by the 1943–45 canvas *Two*.

1947

January 14–February 1. Pollock's fourth solo exhibition at Art of This Century. He exhibits sixteen paintings, includ-

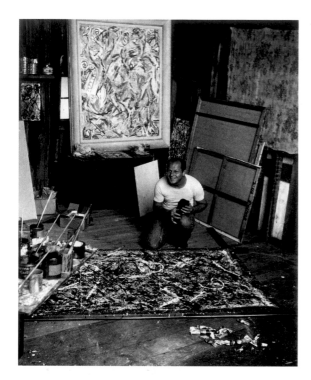

Pollock in the Fireplace Road studio with *Alchemy* on the floor. 1947. Photograph: Wilfred Zogbaum

ing Peggy Guggenheim's *Mural* and two distinct groups: the "Accabonac Creek Series" comprises paintings done in the upstairs bedroom before summer 1946; the "Sounds in the Grass Series" comprises paintings finished in the barn studio.

April I–May 4. Pollock exhibits *Mural* in *Large Scale Modern Paintings* at The Museum of Modern Art.

May 3I. Art of This Century closes its doors, after Peggy Guggenheim decides to return to Europe. After much coax-
322 ing, she persuades the dealer Betty Par-

sons to show Pollock's work. She will maintain her contract with Pollock until early 1948, at which point Parsons will enter into a similar agreement with the artist.

Fall. Pollock applies for a Guggenheim Fellowship but does not receive it.

October. In the English magazine *Horizon*, Clement Greenberg writes, "The most powerful painter in contemporary America and the only one who promises to be a major one is a Gothic, morbid and extreme disciple of Picasso's Cubism and Miró's post-Cubism, tinctured also with Kandinsky and Surrealist inspiration. His name is Jackson Pollock."[24]

Winter 1947–48. In a statement for the journal *Possibilities*, Pollock explains, "On the floor I am more at ease. I feel nearer, more a part of the painting, since this way I can walk around it, work from the four sides and literally be *in* the painting. . . . I continue to get further away from the usual painter's tools. . . . When I am *in* my painting, I'm not aware of what I am doing. It is only after a sort of 'get acquainted' period that I see what I have been about."[25]

December 6, 1947–January 25, 1948. Pollock exhibits *Galaxy* (1947) in the Whitney Annual.

1948

January 5–23. Pollock's first show at the Betty Parsons Gallery, at 15 East 57th Street. He exhibits seventeen paintings including *Gothic* and (in his new, "allover" drip style) *Alchemy, Cathedral, Comet, Enchanted Forest, Full Fathom Five, Lucifer, Phosphorescence, Reflection of the Big Dipper,* and *Sea Change.* The reviews are generally favorable.

May. Pollock participates in a protest at The Museum of Modern Art against art critics and museums hostile to abstract art.

May 29–September 30. Peggy Guggenheim's collection is shown at the XXIV Venice Biennale. The exhibition includes six works by Pollock. Among them are *Eyes in the Heat, The Moon Woman,* and *Two*. With an additional four pictures by Pollock, the show will travel to Florence in February 1949, and to Rome in June 1949.

June. Thanks to the support of James Johnson Sweeney, Pollock is awarded a one-year grant from the Eben Demarest Trust, which supplements his yearly income with four quarterly payments of $1,500.[26]

Through Betty Parsons, Pollock becomes reacquainted with Tony Smith, whom he had known at the Arts Students League in the 1930s.

Fall. Pollock begins treatment for alcoholism with Dr. Edwin Heller, a general practitioner who has recently arrived in East Hampton. Under Heller's care,

Pollock and Krasner at home in The Springs. April 1949. Photograph: Martha Holmes/*Life* Magazine. © Time Inc.

Krasner in Pollock's studio. c. 1949. Photograph: Harry Bowden

Pollock is able to stop drinking.

October II. *Life* magazine publishes "A *Life* Round Table on Modern Art." Pollock is included, along with Picasso, Miró, Georges Rouault, Matisse, Willem de Kooning, Adolph Gottlieb, William Baziotes, and Theodoros Stamos.[27]

1949

January. Peggy Guggenheim tries but fails to secure a one-man show for Pollock in Paris.

January 24–February 12. Pollock's second show at the Betty Parsons Gallery consists of twenty-six works painted in 1948, including (by their current titles) *Number 1A*; *Number 5*; *The Wooden Horse: Number 10A*; *Number 13A: Arabesque*; *White Cockatoo: Number 24A*; and *Number 26A: Black and White*. Works on paper include *Number 4: Gray and Red*; *Number 12A: Yellow, Gray, Black*; *Number 14*; *Number 15: Red, Gray, White, Yellow*; *Number 20*; *Number 22A*; and *Number 23*. Lee Krasner will later explain the reason for numerical titles: "Numbers are neutral. They make people look at a painting for what it is— pure painting."[28] Critical response is varied. Clement Greenberg, in *The Nation*, likens *Number 1A, 1948* to the work of "a Quattrocento master,"[29] but another reviewer finds that Pollock's paintings remind her of "a mop of tangled hair I have an irresistible urge to comb out."[30]

Mid-April. Pollock's mother writes to Charles Pollock of a visit to East Hampton, "Was out at Jack and Lee was so nice to be there and see them so happy and no drinking . . . he feels so much better says so they were getting ready to put in garden they have good soil Lee loves to dig in the dirt and she has green fingers."[31]

June. Pollock signs a contract with Betty Parsons through January 1, 1952,

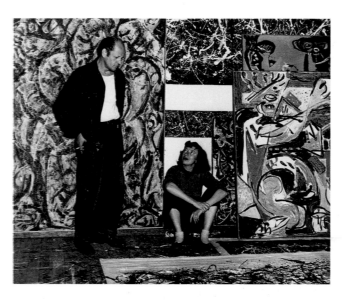

Pollock and Krasner in Pollock's studio. 1949. Photograph: Lawrence Larkin

with terms similar to those of his former contract with Guggenheim.

Pollock begins making terra-cotta sculptures in the studio of East Hampton neighbor Roseanne Larkin. He will work in her studio off and on through the spring of 1950.

Pollock meets fellow painter Alfonso Ossorio.

August 3–October 5. Pollock exhibits two sculptures in *Sculpture by Painters*, an exhibition organized by Jane Sabersky at The Museum of Modern Art. The show will travel to twelve U.S. cities from November 1949 to May 1951.

August 8. *Life* magazine publishes an unsigned article: "Jackson Pollock: Is he the greatest living painter in the United States?" (The author is Dorothy Seiberling.) It includes photographs by Martha Holmes of Pollock at work, as well as Arnold Newman's photograph of the artist standing in front of *Summertime: Number 9A, 1948*.

September 4–October 3. Pollock shows an untitled painting in *The Intrasubjectives*, an exhibition at the Samuel M. Kootz Gallery, New York, which also includes work by Baziotes, Arshile Gorky, Morris Graves, Hofmann, de Kooning, Motherwell, Ad Reinhardt, Mark Rothko, Mark Tobey, and Bradley Walker Tomlin. Kootz's exhibition helps define the movement that will become known as Abstract Expressionism.

November 21–December 10. Pollock's third solo show at the Betty Parsons Gallery. He exhibits thirty-five works, again with numerical titles. Some of these are works from 1948 that had been shown in the previous exhibition at Parsons but did not sell. In order not to confuse these with works from 1949, Parsons adds the letter "A" to the titles of the unsold 1948 paintings—for example, *Number 1, 1948* becomes *Number 1A, 1948*.[32] Also included in the show is Peter Blake's model for an "ideal museum," which incorporates small wire-and-plaster sculptures by

Pollock. At Blake's request, the Hungarian architect Marcel Breuer, who is designing a house for Mr. and Mrs. Bertram Geller in Lawrence, Long

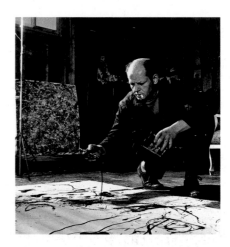

Photograph published in *Life*, August 8, 1949, with the caption: "Pollock drools enamel paint on canvas." April 1949. Photograph: Martha Holmes/*Life* Magazine. © Time Inc.

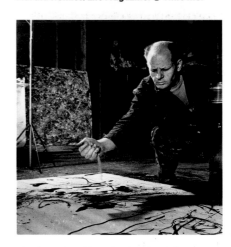

Photograph published in *Life*, August 8, 1949, with the caption: "He applies sand to give enamel texture." April 1949. Photograph: Martha Holmes/*Life* Magazine. © Time Inc.

Pollock and Krasner outside Pollock's studio, The Springs. Late 1940s. Photograph: Wilfred Zogbaum

Island, visits the exhibition; he immediately calls the Gellers and secures a commission for Pollock to paint a mural for their home.

December 16, 1949–February 5, 1950. Pollock exhibits *Number 14, 1949* (OT 256) in the Whitney Annual.

1950

January 27. The Museum of Modern Art acquires *Number 1A, 1948*.

Winter–Early Spring. Pollock and Krasner spend this period with Ossorio in his apartment on MacDougal Alley in New York.

March. Pollock begins *Untitled (Mural)* for the Geller House in Lawrence, Long Island.

Dr. Edwin Heller's death in an automobile accident ends his successful treatment of Pollock's alcoholism.

May 20. Pollock is among the signatories of a letter initiated by Barnett Newman attacking The Metropolitan Museum of Art for "contempt for modern painting. . . ." The artists refuse to take part in an upcoming juried show of contemporary painting.[33]

June 8–October 15. Pollock exhibits three paintings—*Number 1A, 1948*; *Number 12, 1949*; and *Number 23, 1949*—in the U.S. Pavilion at the XXV Venice Biennale. Pollock is one of six artists chosen by Alfred H. Barr, Jr., and Alfred Frankfurter for an exhibition of younger American painters, accompanying a retrospective of John Marin.

Summer. Pollock, Tony Smith, and Alfonso Ossorio begin discussion on the design and construction of a Catholic church to be built on Long Island. Smith, an architect at the time, is to design a large structure for which Pollock will do a program of paintings. Talks on the project will continue through 1952, but the church is never built.[34]

In an interview with William Wright taped for the Sag Harbor radio station, Pollock remarks: "Most of the paint I use is a liquid, flowing kind of paint. The brushes I use are used more as sticks rather than brushes—the brush doesn't touch the surface of the canvas, it's just above. . . . I don't use the accident—'cause I deny the accident. . . . I do have a general notion of what I'm

The Pollock family seated in front of *Number 2, 1949*, The Springs. Summer 1950

about and what the results will be. . . . The result is the thing—and—it doesn't make much difference how the paint is put on as long as something has been said. Technique is just a means of arriving at a statement."[35]

July. The Pollock family holds a reunion in The Springs and takes a family picture in front of *Number 2, 1949*.

July–August. The photographer Hans Namuth, who has rented a summer house in Water Mill, Long Island, asks Pollock if he can photograph him while he paints. Pollock agrees. Visiting the studio repeatedly, Namuth takes approximately 200 photographs[36] of Pollock at work on *One: Number 31, 1950* and *Autumn Rhythm: Number 30, 1950*; and several dozen posed shots of Pollock in his studio and garden. On a series of weekends extending into the fall, Namuth also shoots extensive film footage of

Pollock at work. (See Pepe Karmel's essay on Namuth's series, in this volume, pages 87–137.)

July 22–August 12/15.[37] Pollock has a solo exhibition of twenty paintings, two gouaches, and one drawing—all drawn from Peggy Guggenheim's collection[38]—at the Museo Correr, Venice. The exhibition includes *Alchemy, Croaking Movement, Enchanted Forest, Eyes in the Heat, Full Fathom Five, The Moon Woman, Reflection of the Big Dipper, Sea Change, Two,* and *The Water Bull*. In reduced form, the show will travel to the Galleria d'Arte del Naviglio, Milan.

Italian critic Bruno Alfieri describes Pollock's work as a manifestation of "chaos . . . absolute lack of harmony . . . complete lack of structural organization . . . total absence of technique, however rudimentary . . . once again, chaos. . . ." Yet Alfieri concludes that "Jackson Pollock is the modern painter who sits at the extreme apex of the most advanced and unprejudiced avant-garde of modern art." Compared to Pollock, he adds, Picasso "becomes a quiet conformist, a painter of the past."[39]

August. *The New Yorker* publishes a mildly mocking interview with Pollock and Krasner. Pollock says that he is grateful to Thomas Hart Benton's teaching: "He drove his kind of realism at me so hard I bounced right into non-

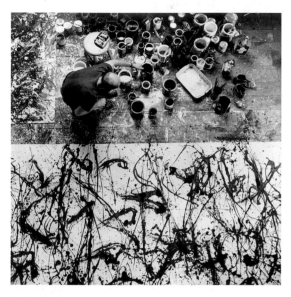

Pollock in his studio with *Number 32, 1950* on the floor. 1950. Photograph: Rudolph Burckhardt

Pollock at work on *Autumn Rhythm*. 1950. Photograph: Hans Namuth. © 1998 Hans Namuth Ltd.

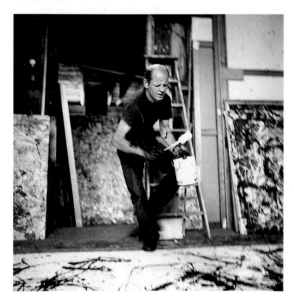

objective painting. . . . Abstract painting is abstract. It confronts you. There was a reviewer a while back who wrote that my pictures didn't have any beginning or any end. He didn't mean it as a compliment. It was a fine compliment. Only he didn't know it."[40]

October 23–November 11. Pollock shows *Number 8, 1950* in *Young Painters in U.S. & France*, an exhibition at the Sidney Janis Gallery, New York, organized by Leo Castelli.

November 10–December 31. Pollock exhibits *Number 3, 1950* in the Whitney Annual.

November 20. In an article titled "Chaos, Damn It!" *Time* magazine quotes the most negative parts of Bruno Alfieri's essay in *L'Arte Moderne*.[41] In a telegram to the editor, published in the December 11 issue of *Time*, Pollock will reply, "No chaos damn it. Damned busy painting as you can see by my show coming up Nov. 28. . . . Think you left out most exciting part of Mr. Alfieri's piece."[42]

November 25. On the Saturday after Thanksgiving, Namuth finishes filming Pollock at work on a painting on glass, *Number 29, 1950*. To permit the use of color film, the work

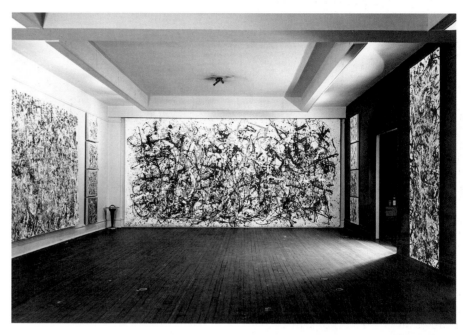

Installation of Pollock's 1950 exhibition at the Betty Parsons Gallery. Photograph: Hans Namuth. © 1998 Hans Namuth Ltd.

has taken place outdoors, despite increasingly cold weather. When the filming is over, Pollock goes inside and takes his first drink in two years, rapidly followed by several more. Drunk and angry, he stuns a group of dinner guests by overturning the dining table. From this moment until his death, six years later, alcohol will play an increasingly disruptive role in Pollock's life.

November 28–December 16. Pollock's fourth solo show at the Betty Parsons Gallery. All the works are from 1950 and include *Lavender Mist: Number 1*; *Number 3*; *Number 7*; *Number 8*; *Number 27*; *Number 28*; *Number 29*; *Autumn Rhythm: Number 30*; *One: Number 31*; and *Number 32*. The critical response is generally favorable.

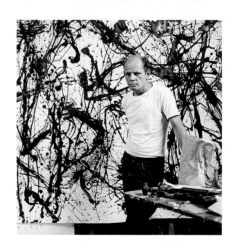

Pollock in front of *Number 32, 1950*. 1950. Photograph: Hans Namuth. © 1998 Hans Namuth Ltd.

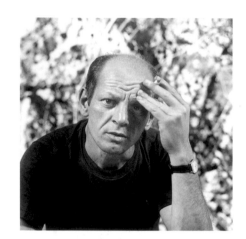

Pollock in front of *One: Number 31, 1950.* 1950. Photograph: Hans Namuth. © 1998 Hans Namuth Ltd.

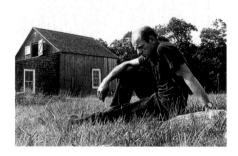

Pollock outside his studio, The Springs. 1950. Photograph: Hans Namuth. © 1998 Hans Namuth Ltd.

1951

January. *Artnews* selects Pollock's November–December show at the Betty Parsons as one of the three best exhibitions of 1950, along with shows by John Marin and Alberto Giacometti.

January 15. *Life* magazine publishes a photograph of Pollock and thirteen others of the "Irascible Eighteen"—a

group of artists protesting the juried exhibition of contemporary painting at The Metropolitan Museum of Art. The protesters become known as the "Irascibles."

January 23–March 25. *Number 1A, 1948* is included in the exhibition *Abstract Painting and Sculpture in America* at The Museum of Modern Art.

March 8–31. Pollock's *Number 8, 1950* is included in a group show, *Véhémences Confrontées*, organized by the French critic Michel Tapié at the Galerie Nina Dausset, Paris.

May. *Artnews* publishes the article "Pollock Paints a Picture," with text by the painter Robert Goodnough, five photographs by Hans Namuth showing Pollock at work on *Autumn Rhythm: Number 30, 1950*, and a photograph by Rudolph Burckhardt of paint cans on the studio floor. Other Namuth photographs are published in the 1951 issue of *Portfolio* magazine.[43]

May 21–June 10. Pollock shows *Number 1, 1949* in the *9th Street Show*, at 60 East 9th Street. The exhibition is organized by some of the charter members of "The Club," an artists' social group that includes Franz Kline, Conrad Marca-Relli, and John Ferren, along with Leo Castelli.

June 7. Pollock writes to Ossorio: "I've had a period of drawing on canvas in black—with some of my early images coming thru—think the non-objectivists will find them disturbing—and

The "Irascibles" in a photograph of 1950, published in *Life*, January 15, 1951. Pollock is seated in the second row center. Photograph: Nina Leen/*Life* Magazine. © Time Inc.

the kids who think it's simple to splash a Pollock out."[44]

June 14. Namuth's film of Pollock at work, coproduced and codirected with Paul Falkenberg, premieres at The Museum of Modern Art.

October 15–November 13. Krasner's first solo exhibition at the Betty Parsons Gallery.

November 26–December 15. Pollock's fifth solo show at the Betty Parsons Gallery. He exhibits twenty-one paintings including *Number 11, Number 14, Number 17, Number 18, Number 19,* and *Echo: Number 25*, plus watercolors and drawings, all from 1951. The paintings are done primarily with black paint on seemingly raw canvas, and appear to expose figurative images.

1952

January. Pollock's contract with Betty Parsons expires. Dissatisfied with his

Fashion photograph from *Vogue*, March 1, 1951, with *Lavender Mist* in background. Photograph: Cecil Beaton. Copyright © 1951 (renewed 1979) by the Condé Nast Publications, Inc.

Pollock at the Betty Parsons Gallery. 1951. Photographs: Herbert Matter

sales, Pollock wants to leave the gallery, but Parsons convinces him to remain with her until May, so that she can try to sell some of the pictures from the 1951 exhibition.

March 7–31. Ossorio arranges a one-man show for Pollock, titled *Jackson Pollock 1948–1951*, at Studio Paul Facchetti, Paris. Michel Tapié helps to organize the exhibition. Ossorio writes

Pollock being filmed for an episode of the television series *March of Time*, during his first retrospective exhibition, at Bennington College. 1952

Pollock that the exhibition has been received with great interest in the French art world.[45]

April 9–July 27. Pollock is included in *15 Americans*, an exhibition at The Museum of Modern Art, organized by Dorothy C. Miller. He shows eight paintings, including *Number 5, 1948*; *Number 2, 1949*; *Number 7, 1950*; *Number 28, 1950*; *Number 29, 1950*; *Autumn Rhythm: Number 30, 1950*; and *Number 22, 1951*.

May. Still unhappy with his slow sales, Pollock leaves the Betty Parsons Gallery and moves to the Sidney Janis Gallery, across the hall from Parsons at 15 East 57th Street.

November 10–29. Pollock's first solo exhibition at the Sidney Janis Gallery. He shows twelve paintings from 1952, including *Blue Poles: Number 11, 1952* and *Convergence: Number 10, 1952*.

November 17–30. *A Retrospective Show of the Paintings of Jackson Pollock*, organized by Clement Greenberg at Bennington College, Bennington, Vermont. The show will travel to Williams College, Williamstown, Massachusetts. The exhibition comprises just eight paintings; the earliest work shown is *Pasiphaë* (c. 1943) and the latest *Echo: Number 25, 1951*.

1953

January. *Artnews* votes Pollock's November show at the Sidney Janis Gallery the second-best exhibition of 1952, after an exhibition by Joan Miró.

April 9–May 29. Four paintings by Pollock—*The She-Wolf, Number 6, 1952* (OT 350), *Convergence: Number 10, 1952*, and *Number 12, 1952* (OT 364)—are included in *12 Peintres et Sculpteurs Américains Contemporains*, an exhibition organized and circulated by the International Program of The Museum of Modern Art, and selected by Andrew

Jackson Pollock. 1953. Photograph: Tony Vaccaro

Carnduff Ritchie. The exhibition opens at the Musée national d'art moderne, Paris, and will travel to Zurich, Düsseldorf, Stockholm, Helsinki, and Oslo.

October 15–December 6. Pollock shows *Number 5, 1952* (OT 353) in the Whitney Annual.

Pollock and Krasner. 1956

1954

Pollock is relatively inactive this year, painting only a few works.

February 1–27. Pollock's second solo exhibition at the Sidney Janis Gallery. He shows ten paintings, all from 1953 including *The Deep*, *Easter and the Totem*, *Ocean Greyness*, *Portrait and a Dream*, and *Unformed Figure*.

November. Pollock's mother, Stella Pollock, has several heart attacks.

1955

Summer. Pollock reenters analysis, coming into New York City for regular therapy sessions.

July. Pollock obtains a passport.

September 26–October 15. Krasner has a solo exhibition at Stable Gallery of her large collage paintings. As Krasner is beginning to emerge as an artist, Pollock is finding it harder and harder to paint.

November 28–December 31. Pollock has his third solo exhibition at the Sidney Janis Gallery. Because he has produced so little new work, the exhibition is organized as a retrospective titled *15 Years of Jackson Pollock*. Sixteen paintings are shown, including *The Flame* (1934–38), *Pasiphaë* (1943), *Gothic* (1944), *Totem Lesson 2* (1945), *The Key* (1946), *Eyes in the Heat* (1946), *White Cockatoo: Number 24A, 1948, Out of the Web: Number 7, 1949, Autumn Rhythm: Number 30, 1950, Echo: Number 25, 1951, Convergence: Number 10, 1952, White Light* (1954), and *Search* (1955), Pollock's last oil painting.

1956

Spring. Pollock has not painted in almost eighteen months.

The art historian Selden Rodman interviews Pollock, who rejects the usual labels for his art: "I don't care for 'abstract expressionism'. . . it's certainly not 'nonobjective,' and not 'nonrepresentational' either. I'm very representational some of the time, and a little all of the time. But when you're painting out of your unconscious, figures are bound to emerge."[46]

May. Pollock receives a letter from Andrew Carnduff Ritchie announcing that The Museum of Modern Art is to begin a series of exhibitions on artists in mid-career, and that Pollock has been selected to inaugurate the series. The exhibition is expected to include up to twenty-five pictures.

July. Krasner leaves for a vacation in Europe. Pollock considers joining her but decides to remain in The Springs. Their relationship has steadily deteriorated over the last several months as Pollock's drinking and depression have accelerated. Pollock becomes involved with Ruth Kligman, a young aspiring artist living in New York City. Kligman moves in with Pollock at The Springs for a brief period during Krasner's absence.

August 11. Driving drunk at 10:15 p.m., Pollock hits a tree on Fireplace Road and is killed. A passenger in the car, Edith Metzger, a friend of Kligman's visiting for the weekend, also dies;

Jackson Pollock. c. 1955–56. Photograph: John Reed

Kligman, the other passenger, survives.

Lee Krasner returns from Europe immediately for Pollock's funeral.

December 19, 1956–February 3, 1957. The Museum of Modern Art's Pollock show, intended as a mid-career exhibition, appears instead as a memorial retrospective. It includes thirty-five paintings and nine watercolors and drawings from the period 1938–56.

Notes

1. For more information on *The Dial* see the exhibition catalogue *The Dial and the Dial Collection: A Special Exhibition of Paintings, Sculpture & Graphics by Thirty American Artists at the Downtown Gallery* (New York: The Gallery, 1959).

2. The students produced two small "incendiary" brochures criticizing the administration for privileging athletics over serious academic scholarship. The extent to which Pollock participated in this revolt is unclear. Naifeh and Smith, in *Jackson Pollock: An American Saga* (New York: Clarkson N. Potter, Inc., 1989), p. 135, argue that while Pollock may have helped print the brochure, he probably did not play a role in writing the text.

3. Jackson Pollock, letter to Charles and Frank Pollock, October 22, 1929, in Francis V. O'Connor and Eugene V. Thaw, *Jackson Pollock: A Catalogue Raisonné of Paintings, Drawings, and Other Works* (New Haven: Yale University Press, 1978), 4:208, D6.

4. Laurance P. Hurlburt, *The Mexican Muralists in the United States* (Albuquerque: University of New Mexico Press, 1989), p. 44.

5. In Los Angeles Pollock and Reuben Kadish visited the Southwest Museum, where they saw Native American artifacts from the Southwest, the Plains, and the Pacific Coast. At the Los Angeles County Museum of Art, they saw ethnographic exhibitions of South Pacific cultures. See Naifeh and Smith, *Jackson Pollock: An American Saga*, pp. 203–4.

6. Charles and Elizabeth Pollock lived in an apartment across the street and used the 46 Carmine Street apartment only as a studio for Charles. See ibid., p. 222.

7. See Jeffrey Potter, *To a Violent Grave: An Oral Biography of Jackson Pollock* (Wainscott, N.Y.: Pushcart Press, 1985), p. 38.

8. See "A Note About Murals," in O'Connor, ed., *Jackson Pollock: A Catalogue Raisonné, Supplement Number One* (New York: The Pollock-Krasner Foundation, Inc., 1995), p. 52.

9. Pollock stayed in the East 8th Street apartment until he moved to The Springs, East Hampton, in 1945.

10. O'Connor, *Jackson Pollock*, exh. cat. (New York: The Museum of Modern Art, 1967), p. 23.

11. See C. L. Wysuph, *Jackson Pollock: Psychoanalytic Drawings* (New York: Horizon Press, 1970); also see note 44,

p. 80, in Kirk Varnedoe's essay in the present volume.

12. Sanford Pollock, letter to Charles Pollock, May 1940. In O'Connor and Thaw, *Jackson Pollock: A Catalogue Raisonné*, 4:224, D36.

13. Louis Bunce, interview with Rachel Rosenfield Lafo, December 1982, Portland, Oregon. The Northwest Oral History Project, Archives of American Art, Smithsonian Institution, pp. 33–34.

14. "Peggy Guggenheim to Open Art Gallery—Art of This Century," Press Release, October 1942, Exhibition Catalogues Collection, Archives of American Art, cited in Naifeh and Smith, *Jackson Pollock: An American Saga*, p. 440.

15. Mondrian's reaction is recounted by Jimmy Ernst in *A Not-So-Still Life· A Memoir by Jimmy Ernst* (New York: St. Martin's Press/Marek, 1984), pp. 241–42.

16. See Peggy Guggenheim, *Out of This Century: Confessions of an Art Addict* (reprint ed. New York: Universe Books, 1979), pp. 295–96, for Guggenheim's account of Pollock painting the mural for her home.

17. Naifeh and Smith discuss the various accounts of the mural's creation in *Jackson Pollock: An American Saga*, p. 866. See also B. H. Friedman, *Jackson Pollock: Energy Made Visible* (New York: McGraw-Hill Book Co., 1972), pp. 62–63; Potter, *To a Violent Grave*, pp. 74–76; and Guggenheim, *Out of This Century*, pp. 295–96. These reports, however, contradict information written by Pollock in a previously unpublished postcard to Frank Pollock and his wife, Marie, where he states that he painted *Mural* in the summer of 1943; "I'm anxious as hell to take a trip west—but that will have to wait until after—I painted quite a large painting for Miss Guggenheim's house during the summer. 8 feet x 20 feet, it was grand fun." The card is dated 1-15.44, postmarked 2-?-44, addressed to Mr. F. L. Pollock in Pittsburgh, and forwarded to California 2-24-44.

18. "Jackson Pollock," *Arts & Architecture* (Los Angeles) 61 no. 2 (February 1944): 14; see also see Varnedoe's note 65, p. 81, in the present volume, on how this interview evolved.

19. Pollock, quoted in Sidney Janis, *Abstract and Surrealist Art in America* (New York: Reynal and Hitchcock, 1944), p. 112.

20. Clement Greenberg, "Art," *The Nation* (New York) 160 no.14 (April 7,1945): 397.

21. Pollock, quoted in [Berton Roueché], "Unframed Space," *The New Yorker* 25 (August 5, 1950): 16.

22. The title to the house, dated November 5, 1945, is on file at the county clerk's office in Riverhead, Long Island. Peggy Guggenheim lent the Pollocks $2,000 for the down payment, deducting $50 from Pollock's stipend each month against this amount.

23. Lee Krasner, cited in Francine du Plessix and Cleve Gray, "Who Was Jackson Pollock?" *Art in America* (New York) 55 no. 3 (May–June 1967): 50–51.

24. Greenberg, "The Present Prospects of American Painting and Sculpture," *Horizon* (London) 16 no. 93–94 (October 1947): 25–26.

25. Pollock, "My Painting," *Possibilities* (New York) 1 (Winter 1947–48): 79.

26. Sweeney, who had been Director of the Department of Painting and Sculpture at The Museum of Modern Art from January 1945 to November 1946 was at this point a visiting lecturer at the Harvard Seminar on American Studies in Salzburg, Austria.

27. Russel W. Davenport, "A Life Round Table on Modern Art," *Life* (New York) 25 no. 2 (October 11, 1948): 62.

28. Krasner, quoted [Roueché], "Unframed Space," p. 16.

29. Greenberg, "Art," *The Nation* (New York) 168 no. 9 (February 19, 1949): 221.

30. Emily Genauer, *New York World–Telegram* 81 no. 185 (February 7, 1949): 19.

31. Stella Pollock, letter to Charles Pollock, mid-April, 1949. In O'Connor and Thaw, *Jackson Pollock: A Catalogue Raisonné*, 4:243, D77.

32. See O'Connor and Thaw, *Jackson Pollock: A Catalogue Raisonné*, 2:1.

33. The letter, which was sent to the Metropolitan Museum's president, Ronald L. Redmond, was excerpted in the May 21, 1950, issue of the *New York Times*. The letter is published in its entirety in Friedman, "The Irascibles: A Split Second in Art History," *Arts Magazine* (New York) 53 no. 1 (September 1978): 98.

34. See E. A. Carmean, Jr., "The Church Project: Pollock's Passion Themes," *Art in America* (New York) 70 no. 6 (Summer 1982): 110–22, and Rosalind Krauss, "Contra Carmean: The Abstract Pollock," *Art in America* (New York) 70 no. 6 (Summer 1982): 123–31, 155. See also Naifeh

and Smith, *Jackson Pollock: An American Saga*, pp. 761–62, and Friedman, pp. 203–4.

35. Pollock's interview with William Wright was taped in the summer of 1950 at Fireplace Road for the Sag Harbor radio station, but never aired. It was subsequently broadcast on radio station WERI, Westerly, R.I., in 1951. A transcript is published in O'Connor and Thaw, *Jackson Pollock: A Catalogue Raisonné*, 4:248–51, D87, as well as in Hans Namuth, *Pollock Painting*, ed. Barbara Rose, with essays by Rose, Namuth, Rosalind Krauss, et al. (New York: Agrinde Publications Ltd., 1980), n.p.

36. Namuth, in *Pollock Painting*, cites the total number of negatives as 500. This number, however, is not borne out by the contact sheets which indicate around 200 negatives for this particular series. This number of 500 may count all of the images that Namuth took of Pollock, including images from 1952–53 and later.

37. Pamphlets and publications of the time list both dates in August.

38. Two of these works, *The Water Bull* and *Reflection of the Big Dipper*, had been given by Guggenheim to the Stedelijk Museum, Amsterdam, which then lent them for this show.

39. Bruno Alfieri, "Piccolo discorso sui quadri di Jackson Pollock (con testimonianza dell'artista)," *L'Arte Moderna* (Venice), June 8, 1950.

40. Pollock, quoted in [Roueché], "Unframed Space," p. 16.

41. "Chaos, Damn It!" *Time* 56 no. 21 (November 20, 1950): 70–71.

42. See Pollock, "Letter to the Editor," *Time* 56 no. 24 (December 11, 1950): 10.

43. "Jackson Pollock," in *Portfolio: The Annual of the Graphic Arts*, ed. George S. Rosenthal and Frank Zachary (Cincinnati: Zebra Press, 1951), n.p.

44. Pollock, letter to Alfonso Ossorio, June 7, 1951. In O'Connor and Thaw, *Jackson Pollock: A Catalogue Raisonné*, 4:161, D99.

45. Ossorio, letter to Pollock, n.d., cited in Naifeh and Smith, *Jackson Pollock: An American Saga*, p. 681.

46. Pollock, quoted in Selden Rodman, *Conversations with Artists* (New York: The Devin-Adair Co., 1957), pp. 76–87. This interview took place approximately two months before Pollock's death.

This selected bibliography will be supplemented in a second volume published in conjunction with a scholarly symposium to be held at The Museum of Modern Art in January 1999.

Artist's Statements and Interviews

"Jackson Pollock." *Arts & Architecture* (Los Angeles) 61 no. 2 (February 1944): 14.

Statement. In Sidney Janis, *Abstract and Surrealist Art in America*, p. 112. New York: Reynal and Hitchcock, 1944.

Application for Guggenheim Fellowship, 1947. In Francis V. O'Connor and Eugene V. Thaw, *Jackson Pollock: A Catalogue Raisonné of Paintings, Drawings, and Other Works*, vol. 4, p. 238, D67. New Haven and London: Yale University Press, 1978.

"My Painting." *Possibilities* (New York) 1 (Winter 1947–48): 78–83.

Letter to the Editor. *Time* (New York) 56 no. 24 (December 11, 1950): 10.

[Roueché, Berton]. "Unframed Space." *The New Yorker* 25 (August 5, 1950): 16. Interview with Jackson Pollock and Lee Krasner.

Interview with William Wright, The Springs, Long Island, 1950. Broadcast on radio station WERI, Westerly, R.I., 1951. Published in Francis V. O'Connor and Eugene V. Thaw, *Jackson Pollock: A Catalogue Raisonné of Paintings, Drawings, and Other Works*, vol. 4, pp. 248–51, D87. Also in Hans Namuth, *Pollock Painting*, edited by Barbara

Rose, n.p. New York: Agrinde Publications Ltd., 1980. Excerpts published in "The Artist Speaks: Part Six." *Art in America* (New York) 53 no. 4 (August–September 1965): 111.

Narration for the color film by Hans Namuth and Paul Falkenberg, 1951. In Hans Namuth, *Pollock Painting*, n.p.

Interview with Selden Rodman, spring 1956. In Rodman, *Conversations with Artists*, pp. 76–87. New York: The Devin-Adair Co., 1957.

Handwritten statements. Reprinted in Francis V. O'Connor and Eugene V. Thaw, *Jackson Pollock: A Catalogue Raisonné of Paintings, Drawings, and Other Works*, vol. 4, p. 253, D89 and D90.

Interviews with Lee Krasner

Du Plessix, Francine, and Cleve Gray. "Who Was Jackson Pollock?" *Art in America* (New York) 55 no. 3 (May–June 1967): 48–59.

Glaser, Bruce. "Jackson Pollock: An Interview with Lee Krasner." *Arts Magazine* (New York) 41 no. 6 (April 1967): 36–39.

Friedman, B. H. "An Interview with Lee Krasner Pollock." In *Jackson Pollock: Black and White*, exh. cat., pp. 7–10. New York: Marlborough-Gerson Gallery, Inc., 1969. Reprinted in Hans Namuth, *Pollock Painting*, n.p.

Rose, Barbara. "Jackson Pollock at Work: An Interview with Lee Krasner." *Partisan Review* (New York) 47 no. 1 (1980): 82–92.

Monographs

Arts Magazine (New York) 53 no. 7 (March 1979). Special issue on Pollock, with essays by Andrew Kagan, B. H. Friedman, David S. Rubin, Irving Sandler, Barbara Rose, Stephen Polcari, Donald B. Kuspit, Elizabeth L. Langhorne, Jonathan Welch, Dore Ashton, and Mark Roskill.

Cernuschi, Claude. *Jackson Pollock: Meaning and Significance*. New York: Icon Editions, HarperCollins Publishers, 1992.

Frank, Elizabeth. *Jackson Pollock*. New York: Abbeville Press, 1983.

Friedman, B. H. *Jackson Pollock: Energy Made Visible*. New York: McGraw-Hill Book Co., 1972.

Kambartel, Walter. *Jackson Pollock: Number 32, 1950*. Stuttgart: Philipp Reclam Jun., 1970.

Landau, Ellen G. *Jackson Pollock*. New York: Harry N. Abrams, Inc., 1989.

Lieberman, William S. *Jackson Pollock: The Last Sketchbook*. Facsimile of Pollock sketchbook, with introduction by Lieberman. New York: Johnson Reprint Corporation, Harcourt Brace Jovanovich, 1982.

Naifeh, Steven, and Gregory White Smith. *Jackson Pollock: An American Saga*. New York: Clarkson N. Potter, Inc., 1989.

Namuth, Hans. *Pollock Painting*. Edited by Barbara Rose, with essays by Rose, Francis V. O'Connor, Rosalind Krauss, et al. New York: Agrinde Publications Ltd., 1980. Originally published as *L'Atelier de Jackson Pollock*. Paris: Macula/Pierre Brochet, 1978.

O'Connor, Francis V., and Eugene V. Thaw. *Jackson Pollock: A Catalogue Raisonné of Paintings, Drawings, and Other Works*, vols. I–IV. New Haven and London: Yale University Press, 1978. Also O'Connor. *Jackson Pollock: A Catalogue Raisonné of Paintings, Drawings, and Other Works. Supplement Number One*. New York: The Pollock-Krasner Foundation, Inc., 1995.

O'Hara, Frank. *Jackson Pollock*. New York: George Braziller, Inc., 1959.

Potter, Jeffrey. *To a Violent Grave: An Oral Biography of Jackson Pollock*. New York: G. P. Putnam's Sons, 1985. Reprint edition: Wainscott, N.Y.: Pushcart Press, 1987.

Ratcliff, Carter. *The Fate of a Gesture: Jackson Pollock and Postwar American Art*. New York: Farrar, Straus & Giroux, 1996.

Robertson, Bryan. *Jackson Pollock*. New York: Harry N. Abrams, Inc., 1960.

Rohn, Matthew L. *Visual Dynamics in Jackson Pollock's Abstractions*. Ann Arbor: UMI Research Press, 1987.

Solomon, Deborah. *Jackson Pollock: A Biography*. New York: Simon and Schuster, 1987.

Exhibition Catalogues

1943

Art of This Century, New York. *Jackson Pollock, Paintings and Drawing*. Brochure with text by James Johnson Sweeney.

1967

The Museum of Modern Art, New York. *Jackson Pollock*. Catalogue, with essay, by Francis V. O'Connor.

Exhibition directed by William S. Lieberman. Traveled: Los Angeles.

1969
Walker Art Center, Minneapolis. *Jackson Pollock: Works on Paper.* Book by Bernice Rose; published by The Museum of Modern Art, New York, in association with The Drawing Society, Inc. Exhibition circulated by The Museum of Modern Art, New York. Traveled: Chicago; Seattle; Baltimore; Montreal; Waltham, Mass.

1970
Whitney Museum of American Art, New York. *Jackson Pollock: Psychoanalytic Drawings.* Book by C. L. Wysuph; published by Horizon Press, New York.

1978
Yale University Art Gallery, New Haven. *Jackson Pollock, New-Found Works.* Essays by Eugene V. Thaw, Francis V. O'Connor, Andrea Spaulding Norris, and David Bourdon. Traveled: Washington, D.C.; Chicago.

1979
The Museum of Modern Art, Oxford. *Jackson Pollock: Drawing into Painting.* Catalogue, with essay, by Bernice Rose. Exhibition organized by The International Council of The Museum of Modern Art, New York. Traveled: Düsseldorf; Lisbon; Paris; Amsterdam; New York.

1980
The Institute of Contemporary Art, Boston. *Jackson Pollock: The Black Pourings, 1951–1953.* Essay by Francis V. O'Connor.

1981
Guild Hall Museum, East Hamp-

ton, New York. *Krasner/Pollock: A Working Relationship.* Catalogue, with essay, by Barbara Rose. Traveled: New York.

1982
Centre Georges Pompidou, Musée national d'art moderne, Paris. *Jackson Pollock.* Catalogue, with essay, by Daniel Abadie. Additional essays by Dominique Bozo, William Rubin, Barbara Rose, Hubert Damisch, Flavio Caroli, Georges Raillard, Marcelin Pleynet, E. A. Carmean, Jr., Pierre Restany, Françoise Choay, Yoshiaki Tono, and G. C. Argan. Traveled: Frankfurt.

1988
The Gerald Peters Gallery, Santa Fe. *Jackson Pollock: The Early Years.* Essay by William S. Lieberman. Traveled: Dallas.

1989
Kunstmuseum, Bern, and Musée des Beaux-Arts, Bern. *Lee Krasner–Jackson Pollock: Kunstlerpaare, Kunstlerfreunde.* Catalogue by Sandor Kuthy and Ellen G. Landau.

1992
Duke University Museum of Art, Durham, N.C. *Jackson Pollock: "Psychoanalytic" Drawings.* Catalogue by Claude Cernuschi. Traveled: New Jersey; San Francisco.

1992
Jason McCoy Inc., New York. *Jackson Pollock. Pollock in the Mid-Forties: A Close-Up.* Essay by Elizabeth Frank.

1993
ACA Galleries, Munich. *Jackson Pollock.* Essay by Ellen G. Landau.

C&M Arts, New York. *Jackson Pollock: Drip Paintings on Paper, 1948–1949.* Essay by Carter Ratcliff.

1996
The Museum of Fine Arts, Houston. *Jackson Pollock: Defining the Heroic.* Catalogue, with essay, by Barry Walker.

1997
The Metropolitan Museum of Art, New York. *The Jackson Pollock Sketchbooks in The Metropolitan Museum of Art.* Book by Katharine Baetjer, Lisa Mintz Messinger, and Nan Rosenthal, accompanying the facsimiles published on the occasion of the exhibition *Jackson Pollock: Early Sketchbooks and Drawings.*

Selected Articles

Alfieri, Bruno. "Piccolo discorso sui quadri di Jackson Pollock (con testimonianza dell'artista)." *L'Arte Moderna* (Venice), June 8, 1950.

Alloway, Lawrence. "Notes on Pollock." *Art International* (Lugano) 5 no. 4 (May 1, 1961): 38–41, 90.

"The Best?" *Time* (New York) 50 no. 22 (December 1, 1947): 55.

"Chaos, Damn It!" *Time* (New York) 56 no. 21 (November 20, 1950): 70–71.

Carmean, E. A., Jr. "Jackson Pollock: Classic Paintings of 1950." In *American Art at Mid-Century—The Subjects of the Artist,* exh. cat., pp. 127–53. Washington, D.C.: National Gallery of Art, 1978.

———. "The Church Project: Pollock's Passion Themes." *Art in America* (New York) 70 no. 6 (Summer 1982): 110–22.

Chave, Anna C. "Pollock and Krasner: Script and postscript." *RES*

(Cambridge, Mass.) 24 (Autumn 1993): 95–111.

Clark, Timothy J. "Jackson Pollock's Abstraction." In Serge Guilbaut, ed., *Reconstructing Modernism: Art in New York, Paris, Montreal 1945–1964,* pp. 172–243. London and Cambridge, Mass.: The MIT Press, 1990.

Coates, Robert M. "The Art Galleries: Edward Hopper and Jackson Pollock." *The New Yorker* 23 (January 17, 1948): 56–57.

———. "The Art Galleries: Extremists." *The New Yorker* 26 (December 9, 1950): 109–11.

Damisch, Hubert. "La Figure et l'entrelacs (l'oeuvre de Jackson Pollock)." *Les Lettres nouvelles* (Paris) 33 (December 9, 1959): 36–43, and 34 (December 16, 1959): 33–34. Reprinted in Hubert Damisch, *Fenêtre jaune cadmium, ou les dessous de la peinture* (Paris: Seuil, 1984), pp. 74–91.

[Eliot, Alexander.] "The Champ." *Time* (New York) 66 no. 25 (December 19, 1955): 64–65.

Farber, Manny. "Jackson Pollock." *The New Republic* (Washington, D.C.) 112 no. 6 (June 25, 1945): 871–72.

Fichner-Rathus, Lois. "Pollock at Atelier 17." *Print Collector's Newsletter* (New York) 13 no. 5 (November–December 1982): 162–65.

Fitzsimmons, James. "Jackson Pollock." *The Art Digest* (New York) 26 (December 15, 1951): 19.

Fried, Michael. "Jackson Pollock." *Artforum* (San Francisco) 4 no. 1 (September 1965): 14–17.

Goodnough, Robert, with photographs by Hans Namuth. "Pollock Paints a Picture." *Artnews* (New York) 50 no. 3 (May 1951): 38–41, 60–61.

Goossen, E. C. "The Big Canvas." *Art International* (Lugano) 2 no. 8 (November 1958): 45–47. Reprinted in Gregory Battcock, *The New Art* (New York: E. P. Dutton, 1973), pp. 57–65.

Gordon, Donald E. "Pollock's 'Bird,' or How Jung Did Not Offer Much Help in Myth-Making." *Art in America* (New York) 68 no. 8 (October 1980): 43–53.

Greenberg, Clement. "Art." *The Nation* (New York) 27 no. 22 (November 27, 1943): 621. Reprinted in John O'Brian, ed., *Clement Greenberg: The Collected Essays and Criticism* (Chicago and London: University of Chicago Press, 1986), 1:164–66.

———. "The Present Prospects of American Painting and Sculpture." *Horizon* (London) 16 no. 93–94 (October 1947): 20–30. Reprinted in O'Brian, ed., *Clement Greenberg: The Collected Essays and Criticism,* 2:160–70.

———. "The Crisis of the Easel Picture." *Partisan Review* (New York) 15(1) no. 4 (April 1948): 481–84. Reprinted in O'Brian, ed., *Clement Greenberg: The Collected Essays and Criticism,* 2:221–25. Revised version published in Greenberg, *Art and Culture: Critical Essays* (Boston: Beacon Paperback, 1965), pp. 154–57.

———. "'American-Type' Painting." *Partisan Review* (New York) 22 (Spring 1955): 179–96. Reprinted

in O'Brian, ed., *Clement Greenberg: The Collected Essays and Criticism*, 3:217–35.

———. "Jackson Pollock: 'Inspiration, Vision, Intuitive Decision.'" *Vogue* (New York) 149 (April 1, 1967): 160–61. Reprinted in O'Brian, ed., *Clement Greenberg: The Collected Essays and Criticism*, 4:245–50.

Heron, Patrick. "The Americans at the Tate Gallery." *Arts* (New York) 30 no. 6 (March 1956): 15–17.

Hess, Thomas B. "Pollock: The art of a myth." *Artnews* (New York) 62 no. 9 (January 1964): 39–40, 62–65.

Horn, Axel. "Jackson Pollock: The Hollow and the Bump." *The Carleon Miscellany* (Northfield, Minn.) 7 no. 3 (Summer 1966): 80–87.

Jewell, Edward Alden. Review. *New York Times*, November 14, 1943, sec. 2, p. 6.

Judd, Don[ald]. "Jackson Pollock." *Arts Magazine* (New York) 41 no. 6 (April, 1967)· 32–36.

Kaprow, Allan. "The legacy of Jackson Pollock." *Artnews* (New York) 57 no. 6 (October 1958): 24–26, 55–57.

Kozloff, Max. "Art." *The Nation* (New York) 148 no. 7 (February 10, 1964): 152.

Krauss, Rosalind. "Jackson Pollock's Drawings." *Artforum* (New York) 9 no. 5 (January 1971): 58–61.

———. "Contra Carmean: The Abstract Pollock." *Art in America* (New York) 70 no. 6 (Summer 1982): 123–31, 155.

———. Chapter six in *The Optical Unconscious*, pp. 243–93. Cambridge, Mass.: The MIT Press, 1993.

Langhorne, Elizabeth L. "Jackson Pollock's 'The Moon Woman Cuts the Circle.'" *Arts Magazine* (New York) 53 no. 7 (March 1979): 128–37.

Leja, Michael. "Pollock & Metaphor." Chapter five in *Reframing Abstract Expressionism: Subjectivity and Painting in the 1940s*, pp. 275–327, 365–69. New Haven and London: Yale University Press, 1993.

Morris, Robert. "Anti Form." *Artforum* (New York) 6 no. 8 (April 1968): 33–35.

O'Connor, Francis V. "The Genesis of Jackson Pollock: 1912 to 1943." *Artforum* (New York) 5 no. 9 (May 1967): 16–23.

Pleynet, Marcelin. "Le syllogisme de Pollock à propos des dessins analytique." *Art Press* (Paris) no. 24 (January 1979):12–13.

———. "Jackson Pollock et la littérature." *Tel Quel* (Paris) no. 84 (Summer 1980): 17–31.

Polcari, Stephen. "Jackson Pollock and Thomas Hart Benton." *Arts Magazine* (New York) 53 no. 7 (March 1979): 120–24.

———. "Orozco and Pollock: Epic Transfigurations." *American Art* (New York) 6 no. 3 (Summer 1992): 36–57.

Rose, Barbara. "Hans Namuth's Photographs and the Jackson Pollock Myth. Part One: Media Impact and the Failure of Criticism," and " . . . Part Two: *Number 29, 1950*." *Arts Magazine* (New York) 53 no. 7 (March 1979): 112–16, 117–19.

Rosenberg, Harold. "The American action painters." *Artnews* (New York) 51 no. 8 (December 1952): 22–23, 48–50.

———. "The search for Jackson Pollock." *Artnews* (New York) 59 no. 10 (February 1961): 35, 58–60.

Rosenblum, Robert. "The abstract sublime." *Artnews* (New York) 59 no. 10 (February 1961): 39–41, 56–57.

Rubin, William. "Jackson Pollock and the Modern Tradition," parts I–IV. *Artforum* (New York) 5 no. 6 (February 1967): 14–22; 5 no. 7 (March 1967): 28–37; 5 no. 8 (April 1967): 18–31; 5 no. 9 (May 1967): 28–33.

———. "Pollock as Jungian Illustrator: The Limits of Psychological Criticism," parts I–II. *Art in America* (New York) 67 no. 7 (November 1979): 104–23; 67 no. 8 (December 1979): 72–91.

[Seiberling, Dorothy]. "Jackson Pollock: Is he the greatest living painter in the United States?" *Life* (New York) 27 no. 6 (August 8, 1949): 42–45.

Steinberg, Leo. "Month in Review: Fifteen years of Jackson Pollock. . . ." *Arts Magazine* (New York) 30 no. 3 (December 1955): 43–44, 46.

Stuckey, Charles F. "Another Side of Jackson Pollock." *Art in America* (New York) 65 no. 6 (November–December 1977): 80–91.

Valliere, James T. "De Kooning on Pollock." *Partisan Review* (New York) 34 (Fall 1967): 603–5. An interview with Willem de Kooning.

———. "The El Greco Influence on Jackson Pollock's Early Works." *Art Journal* (New York) 24 no. 1 (Autumn 1964): 6–9.

Wagner, Anne M. "Krasner's Presence, Pollock's Absence." In Whitney Chadwick and Isabelle De Courtivron, eds., *Significant Others*, pp. 223–53. London: Thames and Hudson, 1993.

Weinberg, Jonathan. "Pollock and Picasso: The Rivalry and the 'Escape.'" *Arts Magazine* (New York) 61 no. 10 (Summer 1987): 42–48.

Photographs of works of art reproduced in this volume have been provided in most cases by the owners or custodians of the works, identified in the captions. Individual works of art appearing herein may be protected by copyright in the United States of America or elsewhere, and may thus not be reproduced in any form without the permission of the copyright owners. The following and/or other photograph credits appear at the request of the artist's representatives and/ or the owners of individual works.

© 1997 Albright-Knox Gallery, Buffalo, New York. Photograph by Biff Henrich: 301, pl. 213. Courtesy Albright-Knox Gallery. Photograph by Biff Henrich: 286, pl. 197.

David Allison: 198, pl. 89; 205, pl. 99; 235, pl. 131; 265, pl. 166; 288, pl. 201; 295, pl. 208.

© Addison Gallery of American Art, Phillips Academy, Andover, Massachusetts. Photograph by Greg Heins, Boston: 226, pl. 122.

© 1997 The Art Institute of Chicago; All Rights Reserved: 213, pl. 109. Photograph by Greg Williams: 195, pl. 86.

Cecil Beaton. Courtesy *Vogue* March 1, 1951. © 1951 (renewed 1979) by Condé Nast Publications, Inc: 326 bottom right.

San Francisco Museum of Modern Art. Photograph by Ben Blackwell: 176, pl. 66.

Harry Bowden. Courtesy Jackson Pollock Papers, Archives of American Art, Smithsonian Institution, Washington D.C. Rephotographed by Lee Ewing: 322 bottom.

© Rudolph Burckhardt: 61, fig. 32; 325 top left.

C & M Arts, New York: 298–99, pl. 211.

Eduardo Calderon: 289, pl. 202.

Collection Charles H. Carpenter, Jr. Courtesy Carnegie Museum of Art, Pittsburgh: 167, pl. 50.

Courtesy The Cleveland Museum of Art: 200, pl. 91.

Courtesy Christie's New York: 75, fig. 48.

Courtesy Paula Cooper Gallery: 71, pl. 44.

Clive Cretney: 253, pl. 149.

© 1998 Trustees of Dartmouth College, Hanover, New Hampshire: 27, figs. 11, 12.

Alfred Eisenstaedt/*Life* Magazine © Time Inc: 25, fig. 4; 318 bottom right.

Lee Ewing: 194, pl. 85.

M. Lee Fatherree: 190, pl. 81; 228, pl. 124; 229, pl. 125.

Allan Finkelman: 240, pl. 136.

Robert Fiore. Courtesy Whitney Museum of American Art, Archive: 71, fig. 45.

Courtesy Forum Gallery. Photograph by Lee Stalsworth: 55, fig. 25.

Gianfranco Gorgoni, New York: 99, fig. 26.

Greg Heins, Boston: 161, pl. 42.

© The Solomon R. Guggenheim Foundation, New York. 41, fig. 23. Photographs by David Heald: 174, pl. 64; 189, pl. 80; 215, pl. 111; 217, pl. 113; 223, pl. 119; 230, pl. 126; 305, pl. 217. Photograph by Mirko Lion: 320. Photograph by Martucci Sergio, Venice: 214, pl. 110.

Jeff Heatley. Courtesy Pollock-Krasner House and Study Center, East Hampton, Long Island: 14, frontispiece.

Ken Heyman: 98, fig. 24.

Hirshhorn Museum and Sculpture Garden, Smithsonian Institution. Photograph by Lee Stalsworth: 172, pl. 62; 208, pl. 103; 261, pl. 159.

Martha Holmes/*Life* Magazine © Time Inc.: 61, fig. 31; 322 top; 323 top right, bottom right.

Jackson Pollock Papers. Archives of American Art. Smithsonian Institution, Washington D.C. Rephotographed by Lee Ewing: 21, fig. 3; 315 all; 316 all; 317; 318 above; 324 all; 327 bottom left; 328 left.

Estate of Reuben Kadish. Courtesy Jackson Pollock Papers, Archives of American Art, Smithsonian Institution, Washington D.C.: 128, fig. 97.

Knoedler & Company, New York. Photograph by Judith Goldman: 75, fig. 49.

The Kunstsammlung Nordrhein-Westfalen, Düsseldorf. Photograph by Walter Klein: 276, pl. 178; 277, pl. 179; back cover.

Lawrence Larkin. Courtesy Jackson Pollock Papers, Archives of American Art, Smithsonian Institution, Washington D.C.: 323 left.

Nina Leen/*Life* Magazine © Time Inc: 326 top right.

© Estate of Roy Lichtenstein. Photograph by Robert Häusser, Mannheim: 70, fig. 40.

Matthew Marks Gallery, New York: 72, fig. 47.

Herbert Matter, courtesy Staley Wise Gallery: 327 top left.

Courtesy Jason McCoy Gallery: 168, pl. 51.

The Menil Collection, Houston. Photograph by Hickey-Robertson: 285, pl. 195.

© 1981 The Metropolitan Museum of Art, New York: 275, pl. 177. © 1990: 147, pl. 14; © 1993: 148, pl. 16, 17; 149, pl. 18; © 1994: 147, pl. 15; 150, pl. 20; 151, pl. 23; 163, pl. 46; © 1995: 149, pl. 19; © 1998: 25, figs. 5, 7; 26, fig. 9; 123, fig. 91; 151, pl. 22; 162, pl. 43–44; 179, pl. 69; 196,

pl. 87; 232, pl. 128; 280, pl. 182; 281, pl. 183.

Courtesy Robert Miller Gallery. Photograph by Adam Reich: 156, fig. 35.

Moderna Museet, Stock-holm. Photograph by Per-Anders Allston: 130, figs. 101, 102; 251, pl. 147.

Thomas Moore: 188, pl. 77.

© 1998 Estate of Robert Morris/A.R.S. Photograph by Rudolph Burckhardt, courtesy Leo Castelli Gallery: 76, fig. 50.

Munson-Williams-Proctor Institute Museum of Art, Utica, New York. Photograph by David Revette: 258, pl. 156.

Musée national d'art moderne, Centre de création industrielle, Centre Georges Pompidou, Paris: 169, pl. 52; 248, pl. 144; 307, pl. 219.

The Museum of Contemporary Art, Los Angeles: 259, pl. 157.

The Museum of Fine Arts, Houston: 119, fig. 82; 145, pl. 11; 168, pl. 51. Courtesy The Museum of Fine Arts, Houston: 173, pl. 63.

© 1998 The Museum of Modern Art, New York: 153, pl. 32; 183, pl. 73; 188, pl. 78. Photograph by David Allison: 72, fig. 47; 297, pl. 210. Photographs by Tom Griesel: 143, pl. 9; 150, pl. 21; 164, pl. 47; 170, pl. 53–57; 171, pl. 58–60; 184–185, pl. 74; 188, pl. 79; 202, pl. 93; 94; 203, pl. 95–97; 204, pl. 98; 206, pl. 100; 216, pl. 112; 287, pl. 199, 200. Courtesy The Museum of Modern Art, New York: 142, pl. 7. Photograph by Tom Griesel: 271, pl. 173. Photographs by Kate Keller: 69, fig. 38; 126, fig. 95; 145, pl. 12; 153, pl. 31; 154, pl. 33; 165, pl. 48; 192, pl. 83; 209, pl. 105; 243, pl. 139; 278, pl. 180; 290, pl. 203; 308, pl. 220. Photograph by Erik Landsberg: 178, pl. 68. Photograph by James Mathews: 71, fig. 43. Photographs by Mali Olatunji: 221, pl. 117; 263, pl. 163; 311, pl. 223. Photographs by Soichi Sunami: 26, fig. 8; 37, fig. 18. Photograph by Malcolm Varon: 268, pl. 170. Photographs by John Wronn: 220, pl. 116; 242, pl. 138; 279, pl. 181; 310, pl. 222.

© 1998 The Museum of Modern Art. Photocomposites: 108, figs. 34, 35; 109, figs. 38–43; 110, fig. 44; 111, fig. 48; 114, figs. 65, 66; 116, figs. 73, 74, 76; 117, fig. 77; 118, figs. 79, 80; 119, pl. 81; 121, pl. 86; 122, figs. 88, 89; 123, figs. 90, 91; 126, fig. 94; 127, fig. 96; 131, fig. 103.

©1998 The Museum of Modern Art and Hans Namuth Ltd.: front cover and endpapers; 112, figs. 50–53; 113, figs. 54–57; 118, fig. 79.

© 1998 Hans Namuth Ltd.: 15, figs. 1, 2; 47, fig. 24; 65, fig. 34; 67, fig. 35; 86, frontis; 89, figs. 1, 2; 90, figs. 3–5; 91, fig. 6; 93, figs. 7–14;

figs. 15–17; 95, fig. 18; 96, figs. 19–21; 97, fig. 22; 98, fig. 23; 99, fig. 25; 107, figs. 30– 32; 111, figs. 45–47, 49; 114, figs. 59–64; 115, figs. 67–72; 116, fig. 75; 118, fig. 78; 120, figs. 83–85; 125, figs. 92, 93; 132, figs. 105, 106; 133, figs. 107–14; 325 bottom left, top right, bottom right; 326 top left, bottom left.

© 1998 Board of Trustees, National Gallery of Art, Washington D.C. Photograph by Richard Carafelli: 273, pl. 175. Photograph by Lyle Peterzell: 272, pl. 174.

National Gallery of Canada, Ottawa: 70, fig. 41. Photographs by John Sargent: 113, fig. 58; 130, fig. 102; 274, pl. 176. Courtesy National Gallery of Canada: 253, pl. 149.

William Nettles, Los Angeles: 210, pl. 106.

Neuberger Museum of Art, Purchase College, State University of New York. Photograph by Jim Frank: 260, pl. 158.

© Arnold Newman: Frontispiece; 59, fig. 29; 60, fig. 30.

© Arnold Newman/Time Inc.: 59, fig. 28.

Edward Owen: 309, pl. 221.

Ellen Page Wilson: 293, pl. 206.

Douglas Parker, Los Angeles: 193, pl. 84; 246, pl. 142.

Philadelphia Museum of Art. Photograph by Graydon Wood, 1994: 175, pl. 65.

© 1998 Estate of Pablo Picasso/Artists Rights Society (ARS), N.Y. Photograph courtesy Photographic Archive, Museo Nacional Centro de Arte Reina Sofiá: 33, fig. 16. Photograph © The Museum of Modern Art, New York. Courtesy Museo Nacional Centro de Arte Reina Sofiá: 33, fig. 15. Photograph © 1998 The Museum of Modern Art, New York. Photograph by Kate Keller: 34, fig. 17. Photograph by Soichi Sunami: 32, fig. 14.

Gerald Peters Gallery, Santa Fe, New Mexico: 141, pl. 5.

Robert Pettus: 266, pl. 168.

Pollock-Krasner House and Study Center, East Hampton, Long Island. Jackson Pollock Catalogue Raisonné Archive: 39, figs. 20–22; 63, fig. 33; 104, fig. 27; 107, fig. 33; 130, fig. 100.

Thomas Powel: 313, pl. 225.

John Reed. Courtesy Jackson Pollock Papers, Archives of American Art, Smithsonian Institution, Washington D.C.: 328 right.

© Rheinisches Bildarchiv: 306, pl. 218.

Museum of Art, Rhode Island School of Design. Photograph by Michael Jorge: 161, pl. 41.

Charles Rumph: 286, pl. 198.

Clive Russ. Courtesy The Metropolitan

Museum of Art, New York: 146, pl. 13.

Bernard Schardt. Courtesy Jackson Pollock Papers, Archives of American Art, Smithsonian Institution, Washington D.C. Rephotographed by Lee Ewing: 321.

Courtesy Jeffrey Potter: 38, fig. 19.

Schenck & Schenck, Claremont: 26, fig. 10; 71, fig. 44.

Ben Schultz. Courtesy Peter Blake: 57, fig. 26.

The Seattle Art Museum. Photograph by Paul Macapia: 222, pl. 118.

© Harry Shunk and the Estate of Yves Klein. Courtesy Yves Klein Archives: 68, fig. 36.

Sotheby's New York: 285, pl. 196.

Stadelsches Kunstinstitut, Frankfurt. Photograph by Ursula Edelmann: 254, pl. 151.

Staley Wise Gallery, New York: 327 top left.

Terry Thorpe: 262, pl. 160; 264, pl. 164.

Michael Tropea, Chicago: 142, pl. 6; 197, pl. 88.

Courtesy *Cy Twombly Catalogue Raisonné of the Drawings and the Paintings*, Berlin: 69, fig. 37.

David Ulmer: 267, pl. 169.

© Copyright 1959 The University of Iowa Museum of Art; All Rights Reserved: 180, pl. 70; 181, pl. 71.

© Tony Vaccaro: 327 right.

© Virginia Museum of Fine Arts. Photograph by Ron Jennings: 241, pl. 137.

Volker Naumann, Stuttgart: 256, pl. 154.

Joan T. Washburn Gallery, New York, and The Pollock Krasner Foundation, Inc. Photographs by John Lamka: 57, fig. 27, 139, pl. 1, 141, pl. 4; 152, pl. 24–30. Courtesy Joan T. Washburn Gallery: 160, pl. 40. Photographs provided by the Jackson Pollock Catalogue Raisonné Archive, Pollock-Krasner House and Study Center, East Hampton, New York: 108, figs. 36, 37; 121, fig. 87; 284, pl. 192–94.

John Weber Gallery, New York: 76, figs 51, 52.

© 1998 The Whitney Museum of American Art, New York. Photograph by Geoffrey Clements, New York © 1996: 71, fig. 42. Photograph by Geoffrey Clements: 163, pl. 45; 72, fig. 46. Photograph by Robert Fiore: 71, fig. 45. Photograph by Steven Sloman: 270, pl. 172; 109, fig. 40.

Yale University Art Gallery: 249, pl 145. Photograph by Joseph Szaszfai: 239, pl. 135.

Wilfred Zogbaum. Courtesy Jackson Pollock Papers, Archives of American Art. Smithsonian Institution, Washington, D.C. Rephotographed by Lee Ewing: 322 left; 324 left.

Lenders to the Exhibition

Stedelijk Museum, Amsterdam

Addison Gallery of American Art, Phillips Academy, Andover, Massachusetts

The Baltimore Museum of Art

Museum of Fine Arts, Boston

Albright-Knox Art Gallery, Buffalo, New York

National Gallery of Australia, Canberra

The Art Institute of Chicago

Dallas Museum of Art

Kunstsammlung Nordrhein-Westfalen, Düsseldorf

Städelsches Kunstinstitut und Städtische Galerie, Frankfurt

The Menil Collection, Houston

The Museum of Fine Arts, Houston

The University of Iowa Museum of Art, Iowa City

Nagashima Museum, Kagoshima City, Japan

Ohara Museum of Art, Kurashiki City, Japan

Tate Gallery, London

Los Angeles County Museum of Art

Wilhelm-Hack-Museum, Ludwigshafen am Rhein

Yale University Art Gallery, New Haven, Connecticut

The Solomon R. Guggenheim Museum, New York

The Metropolitan Museum of Art, New York

The Museum of Modern Art, New York

Whitney Museum of American Art, New York

Munson-Williams-Proctor Institute Museum of Art, Utica, New York

Joslyn Art Museum, Omaha, Nebraska

Musée national d'art moderne, Centre Georges Pompidou, Paris

Philadelphia Museum of Art

Museum of Art, Rhode Island School of Design, Providence

San Francisco Museum of Modern Art

The Seattle Art Museum

Sintra Museu de Arte Moderna

Virginia Museum of Fine Arts, Richmond

Hirshhorn Museum and Sculpture Garden, Smithsonian Institution, Washington, D.C.

National Gallery of Art, Washington, D.C.

National Museum of American Art, Smithsonian Institution, Washington, D.C.

Norton Museum of Art, West Palm Beach, Florida

Dr. David Abrahamsen

Phyllis and David Adelson

Harry W. and Mary Margaret Anderson

Anonymous

John P. Axelrod

Frieder Burda

Blake Byrne

Charles H. Carpenter, Jr.

Daros Collection

Jane Lang Davis

Barbaralee Diamonstein and Carl Spielvogel

Gecht Family Collection

David Geffen

Arne and Milly Glimcher

Peggy Guggenheim Collection, Venice

The Solomon R. Guggenheim Foundation, New York

The Guerrero Family

Mr. and Mrs. Stanley R. Gumberg

Samuel and Ronnie Heyman

Barbara and Donald Jonas

Charlotte and Duncan MacGuigan

Mrs. Beatrice Cummings Mayer

Robert and Jane Meyerhoff

Adriana and Robert Mnuchin

Leonard Nathanson

Muriel Kallis Newman

Private Collection

Private Collection, Berlin

Private Collection, Canada

Private Collection, Los Angeles

Private Collection, New York

Private Collection, Toronto

Denise and Andrew Saul

Mr. and Mrs. Eugene V. Thaw

Thyssen-Bornemisza Collection

Mr. and Mrs. Bertram L. Wolstein

The Gerald Peters Gallery, Santa Fe, New Mexico

Staatsgalerie Stuttgart

Joan T. Washburn Gallery, New York, and The Pollock-Krasner Foundation, Inc.